About the author

Helma Lutz is professor of women and gender studies in the Department of Social Sciences at Goethe University, Germany. Recognized internationally as a leading scholar on gender, migration and domestic work, she has spent more than twenty-five years researching these subjects. She has produced numerous publications in German, Dutch and English (including five edited books in English). She is an associate editor of the *European Journal of Women's Studies*, for which she recently edited a special issue on domestic work.

THE NEW MAIDS

transnational women and the care economy

Helma Lutz

translated by Deborah Shannon

Zed Books

LONDON | NEW YORK

The New Maids: transnational women and the care economy was first published in 2011 by Zed Books Ltd, 7 Cynthia Street, London N1 9JF, UK and Room 400, 175 Fifth Avenue, New York, NY 10010, USA

www.zedbooks.co.uk

Translated from the German by Deborah Shannon

Set in OurType Arnhem and Futura Bold by Ewan Smith, London
Index: ed.emery@thefreeuniversity.net
Cover designed by Safehouse Creative
Printed and bound in Great Britain by the MPG Books Group, Bodmin and King's Lynn

Geisteswissenschaften international – Translation Funding for Humanities and Social Sciences from Germany

A joint initiative of the Fritz Thyssen Foundation, the German Federal Foreign Office, and the German Publishers & Booksellers Association

Distributed in the USA exclusively by Palgrave Macmillan, a division of St Martin's Press, LLC, 175 Fifth Avenue, New York, NY 10010, USA

A catalogue record for this book is available from the British Library
Library of Congress Cataloging in Publication Data available

ISBN 978 1 84813 287 0 hb
ISBN 978 1 84813 288 7 pb

Contents

Acknowledgements

But for the generosity of the interviewees who gave of their time and themselves for the sake of this study, and the committed support of many other helpers, this book would never have been written.

On countless occasions, Susanne Schwalgin and I reflected on the research questions, the obstacles to field research and the design of the research project, and adapted these accordingly. Without her remarkable gift as an interviewer and her creativity in locating potential field-research respondents, it would have been impossible to assemble such an extensive volume of data or to present such profound and nuanced material in the case studies. It was much to my regret that our original plan to write the book as co-authors proved unrealizable. My thanks also go to Umut Erel and Bettina Völter, Karla de la Barra and Monika Kisiali, who likewise conducted interviews. Olga Fekete, Kathrin Gawarecki, Katrin Huxel, Ewa Palenga-Möllenbeck, Karen Möhring, Dorothee Schwendowius, Rebekka Schwingel, Holk Stobbe and Birte Uhlig worked 'behind the scenes' to produce transcriptions, search out information and draft excerpts from the literature, and laid groundwork for this book through their efforts. Elisabeth Scigajllo and Angela Tóth-Dorn kindly helped us to set up field-research contacts.

For their assistance with editorial work on the original German manuscript and with reworking it for publication in English, I am grateful to Christine Grote and MariaTeresa Herrera Vivar; Helen Keller, Ewa Palenga-Möllenbeck and Linda Supik.

Over the course of time, friends and colleagues have read different versions of the various chapters and annotated them with constructive comments. For this, I am grateful to Marianne Krüger-Potratz, Claudia Rademacher, Wolfgang Schröer, Kathy Davis, Barbara Henkes and, especially, Gul Ozyegin.

Not unlike the migrants who are its central concern, this book has an itinerant history of its own: it has been written in several locations. A sabbatical year at the Netherlands Institute

for Advanced Study in the Humanities and Social Sciences (NIAS) in Wassenaar, where I was privileged to spend the academic year 2004/05 on a fellowship, provided me with the time to write the German book and an intellectual environment that was very conducive to doing so. I am indebted to the NIAS for numerous contacts, including friendships with Esther Benbassa, Jean-Christophe Attias and Barbara Waldis which have been a continued source of inspiration. One chapter of this book was written in March 2006 during my guest professorship at the Sorbonne; I thank Esther and Jean-Christophe for inviting me there, and for their humorous and stimulating company. I am grateful to the Volkswagen Foundation for the financing of the research project 'Gender, Ethnicity and Identity: The New Maids in the Age of Globalization' (2001–05), and I must particularly mention Antje Gunsenheimer, who expertly and supportively mentored the project.

The English version of this book would not have come about without the support of Tamsine O'Riordan and, most especially, Jakob Horstmann of Zed Books; for that, I sincerely thank them. After searching at length I found, in Deborah Shannon, an excellent translator who engaged with the material with great enthusiasm and empathy, and whose translation skill I have found invaluable. I am grateful to her in every respect for her work.

My life partner Rudolf Leiprecht has been a companion throughout the highs and lows of not only the research project but also both book projects, and has supported me in every conceivable way. He travelled to visit me in Wassenaar and in Paris, read version after version of each chapter on the train journeys back and forth, and suggested important improvements. A very special thank-you for that.

I dedicate this book to my parents, Hedemarie and Werner Lutz. Although they have not always shared my perspective, the theme excites them as much as it does me, and I thank them for making important suggestions. My two grandmothers (one worked as a maid in her youth and the other, being an employer of servants, kept in touch with former employees into old age) are now both long departed. This family-biographical legacy nevertheless enabled me to connect personally with the theme and to embed it historically; what a pity they were no longer around to answer all the questions I had.

I would like to thank my German publisher Barbara Budrich

for supporting my application for the funding to make the English translation possible. To the Börsenverein des Deutschen Buchhandels (German Publishers & Booksellers Association), the Fritz Thyssen Foundation and the German Federal Foreign Office, which jointly awarded me a 'Prize to Support the Translation of Works from the Humanities' in 2008, I express my gratitude for the trust invested in me. My abiding hope is that English-speaking readers will share the jury's verdict that this is a book for an international audience.

Frankfurt, Spring 2011

1 | The new division of domestic labour

A woman mopping the globe. The picture on the cover of this book evokes associations with the feminine ideal of the Western housewife of the 1950s, in a trim dress and high heels, striking a mildly sexualized pose. At first glance it seems to bear little relation to the women who are the subjects of this book. The migrant women whose narratives fill these pages would scarcely draw attention to themselves with such attire or such a posture in the domestic households in which they work. Indeed, whether they are searching for employment or doing a day's work, they must be permanently on their guard against sexualized imaginations.

Nevertheless, one connection at least can be established between the fantasy figure on the book jacket and the real people and work-settings that will be its main focus: the onus for keeping the world 'spick and span' rests with the same people now as in that era; it is women who do the job.

In Western industrialized countries, in spite of all emancipatory rhetoric, the domestic tasks of cleaning, caring and cooking are persistently viewed as women's work. Even in the twenty-first century, the demand first voiced by the women's movement of the 1970s for equal distribution of domestic work between the genders remains unsatisfied. Instead, redistribution processes within the same gender-category are now afoot, with the result that this work is now outsourced by one woman to another – to a migrant woman from an economically disadvantaged country. In other words, the work remains feminine-gendered. The vision of the first- and second-wave women's movement, that a balance could be struck between gainful employment and domestic work if men and women shared both forms of work, never came to fruition – either in periods of economic prosperity or in times of economic crisis. This study not only enquires into the causes of this persistent absence of distributive equality, but also shows which tasks are outsourced and in what ways, how the process of outsourcing is organized between female employers and female migrants, what problems arise, particularly from the viewpoint of the 'new maids', and what legitimization discourse has arisen in relation to this outsourcing process.

1

Calling this group of female migrant domestic workers 'the new maids of Europe' evokes questions about changes and continuities between the old maids, female servants of the nineteenth and early twentieth centuries, and those of our age of globalization. What exactly is the difference between the life of an eighteen-year-old servant working in a bourgeois Berlin household in 1900 and that of a Polish woman cleaning a multitude of Berlin middle-class houses in the year 2000?

In order to find answers, I focused not only on the detailed description of the employment relationships today, but also on the question of how this relationship influences communication and identity models between the people involved. What is the resultant work-identity for the migrant women, whose educational level is not infrequently on a par with their employers' (i.e. they, too, are members of the middle class in their country of origin)? What are the operative recruitment mechanisms and networks of the newly emerged (informal) labour market? Does the commodification of domestic work make any difference to the setting that is defined as the household? What changes take place in transnational migrant women's relationships with their families, and possibly also in their definitions of the family? What does it mean to them to live and work in conditions of illegality, and what are their prospects for the future?

This book, which adopts the idiom of a lifeworld description but keeps one eye constantly on global framework conditions and can therefore be understood as a contribution to 'global ethnography' (Burawoy et. al. 2000), is an attempt to document the many facets of migrant domestic labour as it is perceived from the perspective of transnational female migrants and their employers. Key questions are whether and how domestic/care work changes when it becomes commodified; whether gender transformations take place in the employers' households as a result of the 'new maids' working there, and if so, in what direction; and finally, what consequences this transnational service employment has for family and gender relationships in the countries of origin. Contrary to other scholarship in which relations between the female employers and employees are frequently characterized as a genuine 'exploitative relationship' between the global North and South, this book puts forward the thesis that in fact these relations are far more complex. The case is built up by describing the mutual dependencies, which are anything but symmetrical, and refraining from drawing hasty conclusions. The aim is thus to trace both continuities *and* changes in domestic/care work in the twenty-first century, so as to arrive at a better analysis of shifts and re-formations of care work.

All in all, it can be said that 'maids' represent an important link between the bourgeois lifestyle of the nineteenth and the twenty-first centuries, and that multiple axes of social inequality continue to be relevant in the sphere of domestic/care work, albeit in new forms.

In order to contextualize the historic specificity of the new maids, this chapter begins by taking stock of the changes in models of work and family life that have taken place in many Western industrial countries.

1.1 The male breadwinner: labour of love – love as labour

In their well-known essay 'Labour of love – love as labour' (*'Arbeit aus Liebe – Liebe als Arbeit'*, 1977), Gisela Bock and Barbara Duden refer to the unspoken and unremunerated work that housewives and mothers are required to perform, by virtue of their womanly purpose, as a 'labour of love', which takes the form of 'love as labour'. The authors challenge central aspects of the 'labour of love' by calling it 'serving background work'. One key target of their criticism is the division of society into private and public spheres which are simultaneously gendered and socially contextualized, while another is the consolidation of this division in an implicit contract between the genders whereby the public (= paid labour = male) and private (= reproductive labour = female) spheres are specifically differentiated by gender. Within this division, professional employment enjoys high social esteem, whereas the work of caring for the family is regarded as trivial. Thus the gender-specific differentiation also constitutes a hierarchical distinction.

In their essay, Bock and Duden dissect the so-called bourgeois family ideal, which they refer to as the 'single breadwinner model' or the 'housewife marriage'.

The fact that millions of wives were willing (voluntarily) to contribute serving background work drew the following comment from the American economist Kenneth Galbraith (1973: 33): 'The conversion of women into a crypto-servant class was an economic accomplishment of the first importance. Menially employed servants were available only to a minority of the pre-industrial population; the servant-wife is available, democratically, to almost the entire present male population.'

The ideal of the male breadwinner has retained its validity as a normative construct in many Western countries to this day, but is coming under increasing legitimization pressure. The debate on family forms and the gender-specific division of labour has developed into a central theme in gender studies since the 1970s. Regina Becker-Schmidt (1987), for instance, has analysed the 'double socialization' of women

as one aspect of the gender-specific reproduction of social inequality; by this, she means the dual orientation of women to family and work, which under existing conditions leads to a situation where the responsibility for housekeeping and for minding, caring for and bringing up children, as well as caring for older family members, results in them being seen as women's tasks, to be performed in addition to women's professional employment if necessary. This does not mean that men's socialization is 'singular', but rather that their orientation is directed more towards a breadwinner model in which their part in providing for the family is contributed by pursuing a career and thereby earning an income.

The persistent influence of this gender code is confirmed, in more recent German studies, by the fact that young fathers react to the birth of their first child by intensifying their commitment to their careers rather than taking on a greater share of family duties (Bundesministerium für Familie, Senioren, Frauen und Jugend 2006: 183).

The women's movement of the early 1970s took up cudgels against this 'implicit contract between the sexes', for instance by launching the 'wages for housework campaign'. In demanding payment for domestic labour, their intention was to test out 'forms of struggle which immediately break the whole structure of domestic work, rejecting it absolutely, rejecting our role as housewives and the home as the ghetto of our existence, since the problem is not only to stop doing this work, but to smash the entire role of housewife' (Dalla Costa and James 1972). The demand for 'wages for housework' was in no way linked to actual wage demands, but was understood as a contribution to the reshaping of society; the goal was the 'abolition of patriarchy' as a fundamental step towards the transformation of the capitalist system. At the time, the radical nature of this fundamental rejection of the housewife's role garnered too little support to become a broad-based movement. No one could have imagined that in the twenty-first century the 'wages for housework' slogan would shed its metaphorical meaning and, in a wayward turn of events, don the mantle of a very realistic phenomenon. It can only be assumed that the present-day developments charted in this book were not at all what feminist activists in the 1970s had in mind.

Although today, in the year 2010, rising numbers of women in all Western countries are entering gainful employment, in some countries – Germany among them – a conservative breadwinner model is being perpetuated (see Pfau-Effinger 2000). Indicators of this are tax rules such as allowance-splitting between spouses, the mini-job regulations

on part-time work, or the free extension of health insurance coverage to spouses.[1] Nor is any equal distribution of housework and family duties on the principle of partnership in sight: according to time-budget studies (Statistisches Bundesamt 2003: 14ff.), German women continue to perform twice as much housework as men. Admittedly, the modernization discourse has altered the demands made upon fathers. De facto, however, these are honoured only after work and at the weekend (see Grunow 2007).

Another observation on the second half of the twentieth century is that, despite evident alleviation of some of the burden of domestic work by rationalization and technological mechanization, no overall reduction was seen in the total time devoted to work in the household. Modern daily family life is making new demands upon parents, who are expected to have extensive knowledge pertaining to health, child-rearing, education, recreation and time-management, for instance, plus a raft of new social competencies required for dealing with institutions (school, kindergarten, etc.). Accordingly, good parenthood and partnership call for a higher commitment of time and emotional work (Kettschau and Methfessel 2003: 4).

The increased demands of 'family duties' correspond to changes in the labour market: many sectors nowadays require levels of mobility and flexibility that are very hard to combine with reliable care arrangements. 'More than half of high-status employees in a firm work longer than 40 hours (52%), and the actual working time for one-fifth of them is over 48 hours' (Bundesministerium für Familie, Senioren, Frauen und Jugend 2006: 390). Overall, paid employment remains the most powerful pace-setter for families and the inherent logic of care work has to take a back seat to the demands of working life (Jurczyk et al. 2009).

1.2 The adult-worker society

Bearing in mind the rising educational status of women, their departure from the labour market the moment that they become mothers is branded, by economists especially, as resource-destruction of female human capital; in scenarios on the future of paid work in the OECD countries, this was underscored in the following terms: 'The main policy addressed is that of encouraging a higher participation by mothers in paid employment. This is important to maintain their labour market skills, to ensure adequate resources for families and women living by themselves, and to make further progress *towards gender equity* [my emphasis] ... the skills of mothers will be increasingly

needed in the labour market as the population of working age in most OECD countries begins to shrink' (OECD 2001b: 129).

The primary strategy for the realization of gender equality, to paraphrase the view of the OECD, is via the entry of women into paid employment. This means that *paid employment* and not *care work* is deemed to be the central mode of social participation. What is advocated is the universalization of labour market participation in an *'adult-worker society'* (Lewis 2004), in which all adults capable of working – men *and* women – are considered to be individualized market subjects, as 'autonomous worker-citizens' (Manske 2005). This scenario of full-time work for all employable adults is already being pushed at EU level and, following the model of the Scandinavian countries, successively integrated into social systems throughout the EU.

Nevertheless, the ideal of women's integration into the labour market, which indeed coincides with the demands of the women's movement, cannot be realized in the absence of clarification as to who will take charge of the care work that was previously performed on an unpaid basis. Resolving this issue tends not to be accepted as a public task in many countries but is left as a problem to be solved individually; that much is apparent from the debate conducted in the EU under the heading of work–life balance (European Foundation for the Improvement of Living and Working Conditions 2006; OECD 2007; Gregory and Milner 2009). This debate, however, is proceeding on thin ice, for in the majority of EU member states, such an emphasis on the economic necessity of women's employment is at odds with the tenacious hold of conservative cultural codings, which consider care to be a primarily female activity and take a dim view of the desirability of associating care with masculinity (Plomien 2009). To all appearances, the 'new' gender script of the EU is at loggerheads with reality.

1.3 The multiple facets of care work

The first new aspect of the current debate about 'care work' is that caring is now understood as work, and has ceased to be treated as a characteristic that is peculiar to women and synonymous with their female nature. Care, however, is not just an activity (taking care of) but encompasses an emotional component (caring about). Arlie Hochschild (1995) and Joan Tronto (2008) understand care work in its full breadth as consisting of caring 'knowledge, action and feelings' and thus comprising different (informal) activities ranging from comforting someone to feeding and bodily care.

Nancy Fraser (1994) even presupposes a definition of 'care' which not

only spans the tasks of emotional and physical caring throughout the life cycle (childhood–old age, health–illness), which are done essentially by women, either informally or professionally, but also tasks in the fields of social pedagogy and social work addressed to specific age groups (similarly, see Thomas 1993; Lewis et al. 1998).

One objection to such a broad concept of care, which takes in work performed both in the household and in institutions (kindergartens, schools, old people's homes), is its blurring of rigorous conceptual distinctions. It not only obscures the division between the private household and the external social domain, but also the distinction between professionals and 'lay people' performing this work (see also 2.2, 'Care economy').

However, an understanding of this precise distinction between professional and non-professional care work is pivotal to the discussion on domestic work.

In the course of the debate on whether and how domestic work might be professionalized, in Germany the following description of the activity has become established: personal services in the domestic setting are differentiated according to *object-related* domestic tasks, which include cooking, washing, cleaning, laundry, etc., and *person-related* tasks such as social support and care services addressing the needs of children, the elderly and sick people. This clear-cut division seems useful for profession-analysis purposes and usable in the applied sectoral context, but draws a veil over the current practice in which these activities intermingle.

A more appropriate approach, established in the anglophone debate by Bridget Anderson, would appear to be the description of the entire domain of *domestic work* in terms of the three Cs: *Cooking, Caring, Cleaning* (Anderson 2000). This is rooted in the view that work performed in the private household is often found to consist of combined and overlapping elements from these areas of work. Pursuing this argument, in the present book the use of the term 'domestic/care work' refers to duties performed in the private household involving caring, child-rearing, attending to daily object-related and person-related demands, and providing support and advice.

The debate about the professionalization of this work proceeded from an original assumption that the status of domestic work changes when it is performed on a professional basis. Rising demand, it was thought, would promote the development of professional standards and contribute to the recognition of domestic service occupations. A thesis defended by economists, in particular, is that in our society,

which is currently developing from an industrial to a knowledge and service-based society, the labour market of the future depends on tapping the potential of work in the provision of personal services (Kommission für Zukunftsfragen 1997; Hartz et al. 2002). This idea is very much in keeping with the current neoliberal policy doctrine that is driving forward the transformation of formerly unpaid or state-funded services into market-based paid work. There is certainly no objection to the idea of payment for domestic work or *care work* as gainful employment, particularly from the perspective of gender equity. In many EU countries in the past few years, increasing pains have been taken to formalize domestic services by promoting a regularized market (Jaehrling 2004). Arrangements promoted include service pools or service agencies, professional organizations which offer domestic services, and the offer of tax incentives via so-called 'household cheques' to those wanting to make use of these services legally. So far, the primary impediment to a legal solution has been the unwillingness of many employers to pay the comparatively high wages in this sector (Weinkopf 2002, 2005). A secondary but important aspect, glossed over by the economic debate, is that this work is a *gendered*, structurally devalued sphere of activity which tends to resist efforts towards professionalization. The status of domestic work does not automatically change simply by being performed as paid work. Domestic work differs from traditional paid work essentially by virtue of the differences in the inherent institutional logic of the family and that of the employment system (see Krüger 2001): speed, effectiveness and efficiency, for example, which are highly rated in working life, tend to be rather counterproductive when dealing with small children and older people; in those settings, patience and flexibility are required. A further characteristic of *care work* is the proximity to the constellation of private relationships and to everyday competencies; this makes it difficult to delineate clearly between the action of lay people and professionals (see Rabe-Kleberg 1997). The feminist analysis shows that the skills required in the household are considered to be *everyday skills* and therefore elude or resist evaluation according to meritocratic principles (Thiessen 2004: 333). Furthermore, current political practice is characterized by the fact that, depending on the economic climate, domestic work swings between the twin poles of work in formalized employment arrangements, and unpaid rendering of services to family or neighbours (Karsten 2000).

Defining the necessary skill-set is one of the most basic prerequisites for professionalization, however. How, for example, should the

all-important key qualification of 'patience' be measured? How can the 'endurance' required for the work of nursing and child-rearing be expressed in technical standards? How should the ability 'to behave responsibly in conditions of uncertainty' (Thiessen 2004: 379) be translated into professional technicalities? Barbara Thiessen (ibid.) suggests that qualifications in social skills (such as patience, consideration, empathy or balancing between closeness and distance) should be incorporated into training concepts. Whether this can and will be done remains unclear as yet. But feminist analysis is hopeful that the vocational education system has no choice but to integrate, standardize, define and professionalize quasi-domestic personal service work. Nevertheless, this optimism must be tempered by the fact that the requisite *revaluation* of work in society remains unclarified: futurologists and planning commissions stress the need for a general development of care skills, even defining them as a basic requirement for the strengthening of civil society (Beck 2000a), but at the same time they question neither the existing value and structure of paid employment nor the relationship between care work and paid employment. Yet this would appear to be an essential precondition for the extrication of personal services from their current positioning within a rigid gender dualism, so that progress can finally be made towards removing the 'odour of privacy' that surrounds domestic work (Krüger 2003). In other words, unless there is a debate about society's differential valuation of paid employment and family duties as the expression of asymmetrical gender structures, no amount of discourse about professionalization will lead to models of work with any prospect of future sustainability.

To recapitulate, it can be said that the debate about the professionalization of care/domestic work is by no means over; in the course of the reorientation towards an adult-worker society, it has only just begun. The Janus-headed aspect of care/domestic work is that, on the one hand, this work historically done by women is considered to be feminine-gendered and anchored in the private sphere, and on the other hand, since the dawn of the bourgeois society it has been deemed to be unproductive, in contrast to paid employment. In her work *The Human Condition* (1998 [1958]; German: *Vita Activa*) Hannah Arendt traces back the distinction between 'productive' and 'unproductive' work, and the branding of household work as 'unproductive', to the two great economic theorists of the modern age, Adam Smith and Karl Marx. Both, according to Arendt, shared a contempt for 'menial servants' and despised their toil as 'parasitical, actually a kind of perversion of labor, as though nothing were worthy of this name

which did not enrich the world' (ibid.: 86). Accordingly, work in the private household is categorized as 'unproductive' work, identified with slavery in all ages prior to the modern (ibid.: 87). While productivity is contributed in the workplace and the public sphere, the private sphere is defined by consumption. The dialectical pairing of productivity and consumption has remained core to the analysis of the work society (and particularly of the adult-worker society, as already mentioned) to the present day, and consequently, despite the many metamorphoses of the work society since its inception, the asymmetrical evaluation of paid work and housework is still as relevant today as ever.

In this book I will show that a) this asymmetry is not expunged by the intervening development of a commodification of care, nor by the fact that a 'global market in domestic work' has been established, in which migrant women take charge of the domestic work in economically wealthier countries; b) the extrication of housework and care work from the private sphere ranks among the most insuperable challenges of the twenty-first century.

1.4 Commodification – redistribution of care and domestic work to non-members of the household as a new gender arrangement

The redistribution of domestic/care work, in which the 'female' part of the arrangement remains in female hands – not those of the woman herself, but of some (ethnically and socially) other woman to whom this work is passed on – is referred to by Marianne Friese (1996) as a new gender arrangement. It is a phenomenon known to exist in more or less all EU countries, but there is little in the way of reliable statistical data on its scale, and the prevailing impression is of an informal market, a twilight zone of the shadow economy. In Germany, for instance, the Socio-Economic Panel 2005 concludes that one household in every ten employs some form of domestic help.[2] 'The private household', says the Seventh Report on the Family (Bundesministerium für Familie, Senioren, Frauen und Jugend 2006: 159), 'is the sector of employment with the highest proportion of unprotected, illegal employment.'[3] Evidently, families are increasingly developing load-lightening strategies by stepping into the employer role themselves and relying on the labour of outsiders.

This redistribution of family duties on to non-members of the household today marks the reintroduction of paid employment in the bourgeois household, which existed throughout the nineteenth century in the form of the 'domestic service system', and which gradually disappeared from the start of the twentieth century.

Since the mid-1990s, preliminary empirical studies have addressed the issue that migrant women make up the vast majority of these non-members of the household. The German section of the Europe-wide survey by Bridget Anderson and Annie Phizacklea, *Migrant Domestic Workers* (1997), points to the presence of eastern European women in Berlin households; Małgorzata Irek (1998) describes the phenomenon of migrants commuting between Poland and the German capital, also taking domestic work into consideration; Norbert Cyrus (2001, 2003) looks at the situation of Polish women in West Berlin and considers the changes since the fall of the Wall. Barbara Thiessen (1997) describes the situation of female immigrants working in Bremen households, while Kyoko Shinozaki (2003, 2005) focuses on Filipino women migrants living in a large western German city. The focus of the study by Sabine Hess (2002; Hess and Puckhaber 2005, 2006) is Slovakian au pair girls in Germany; she points out that au pairs – who feature directly in only one case in my own study – should equally be regarded as a phenomenon of the private household labour market.[4] Other studies describing care work in the private home are those conducted by Philip Anderson (2003) in Munich and Jörg Alt (2003) on the situation of illegal immigrants in Leipzig and Munich.[5] The German research is echoed by many more recent individual studies which give insights into a field that is increasingly being explored in European research (Lutz 2008). While the situation in Great Britain and the Mediterranean countries seems to be most thoroughly researched, there are gaps in coverage with regard to Scandinavia (although for Sweden, see Platzer 2006; Gavanas 2010; for Norway, see Isaksen et al. 2008) and the new eastern European member states of the EU, which are both home and destination countries for migrant domestic workers, where this phenomenon is only slowly being taken up in research (for Poland, however, see Kindler 2008; Kalwa 2007; Slany 2008; Morokvašic et al. 2008).

Despite the host of incisive differences in the different countries, today increasingly widespread evidence can be observed throughout Europe – from Turkey to Portugal, from Greece and Poland to Norway – of migrant domestic work. The eastern European countries, in particular, currently serve as countries of origin, although Poland is not only the most important country of origin for Germany but also a destination country for migrant women from Ukraine and Belarus. (On the care-chain that extends from Ukraine to Poland and from Poland to Germany, see Lutz and Palenga-Möllenbeck 2010, 2011.)

The new maids of Europe are, therefore, not exclusively, but at least for the time being, primarily European women.

1.5 Research on maidservants

Historians (such as Sarti 2008) rightly point out that parallels can be identified between the present-day situation and the previous two centuries. A look at the historical dimension of the debate is therefore in order.

Manservants and maidservants have existed since time immemorial. In ancient times they were principally slaves, taken in conquest and forced to work in the households of the victors. Only the work society of the modern era elevated servanthood to an occupation, to which the traits of servility and dependency were as integral as the collective and individual employee rights which, over the course of time, constrained the whims of the 'masters' to a certain extent. Disposition over domestic staff, whose duty it was to perform the 'lowly' but necessary chores of the household, was a privilege of the bourgeois family. Retaining domestic staff not only elevated one's status but provided a means of exerting social dominance. The sociologist Trutz von Trotha (1994) described this by citing the extreme example of the colonial family. In the colonies '... the domination of servants in colonial society took place at precisely the intersection point where political and social domination visibly meet; where political dominance is translated into social dominance in the eyes of all. In exerting power over [...] servants, the conquerors visibly became a ruling class. In terms of the sociology of dominance, therein lies the significant function of servanthood' (ibid.: 216f.).

In Europe the occupation of manservant had become feminized in the nineteenth century, and in the German Empire, around the turn of the century, about a million women were working as maidservants.[6] In the rapidly growing urban centres, in particular, many young women from poor families or from orphanages moved from the countryside to the city, where they found a position in a bourgeois household. In her study of the domestic service proletariat that formed in nineteenth-century Bremen, Marianne Friese (1996) writes that the maidservants of that time were instructed by the bourgeois 'mistress of the house' not only in maid service but also in the bourgeois cultural habitus:

What the daughters of respected craftsmen and merchants had learned in the late eighteenth century in an educated middle-class milieu was not to be withheld from their sisters from the countryside. Bourgeois citizens at the time were well aware that their maidservants married proletarian men. Thus a connection suggests itself between their interest in improving their servants' level of cultivation and improving the

working class, setting forth the bourgeois housekeeping regime and family idyll as a model for the proletariat. (Ibid.: 250)

From this it is clear that the project of the bourgeoisie was undoubtedly not only to assign the men to their workplaces outside the home, but also to turn day-labourers and peasants into workers, and simultaneously to reinforce the cultural dominance of the bourgeois lifestyle, which maidservants were obliged to learn and admire in their masters' homes, but which they could barely aspire to or realize on their own accounts.

Hence, the three most important social place-markers of the master/servant society in Germany and its colonies have now been identified: gender, 'race' and class.

Towards the end of the nineteenth century, demands mounted for the improvement of working conditions. The first trade union for 'maids, washerwomen and cleaners' was formed in 1906, and a thousand women attended its founding event in Nuremberg. The long-contested and hard-won abolition of the Servants Law (*Gesindeordnung*), which was finally achieved in 1918, did not quite bring about parity with the 'free workers'. Nevertheless, it reined in the personal whims of employers, gave guaranteed controls of adherence to working hours, better food and payment, a monthly right to give notice, and established health insurance and educational facilities. In the long run, professionalization raised the costs of labour and led to the gradual disappearance of the profession in the second half of the twentieth century.

Early in the twentieth century, young German women were still being recruited in large numbers as servants in other countries (France, the Netherlands, Canada, the USA, etc.), which enabled many to embark on emigration ventures. In many countries that drew in immigrants, white women were sought (as wives) for white settlers (see Harzig 1997); the same applied to the (German) colonies, where fear of 'racial mixing' and men's sexual deprivation gave rise to huge demand for maidservant-wives (see Walgenbach 2005).

Finally, under German fascism, the exaltation of the German woman as mistress of her own home – rather than a servant in another household – reactivated a device of the colonialist discourse. An interesting example of this was the programme of 'Maidservant Repatriation' from the Netherlands, instigated by the German government in 1938, when special trains were chartered to bring German maids back home. Of the 40,000 German maids recruited in the inter-war period, following

the occupation of the Netherlands in 1940 only 3,500 finally remained (Henkes 1995: 173ff.).

On the other hand, during the Second World War the German army had deported and conscripted a total of 500,000 women and girls aged between fifteen and thirty-five from the occupied eastern territories (Russia, Poland, Ukraine, Czechoslovakia, etc.), an estimated 100,000 of whom were assigned to German private households, where they were made to perform 'forced labour in the nursery' (Mendel 1993; Winkler 2000).

In the reparations negotiations which took place from the year 2000 onwards, compensation payments for forced labour in German private households were initially refused, the reason being that such work was unproductive in nature (Leuther 2000; Deutscher Bundestag 2005).

Thus Adam Smith's contempt for 'menial tasks and services [which] generally perish in the instant of their performance and seldom leave any trace or value behind them' (Smith, quoted in Arendt 1998 [1958]: 94) has been upheld right into the twenty-first century.

In summary, it can be pointed out that for all the historical differences, one common feature emerges: the majority of these migrant domestic workers were women. The feminization of this occupation began in the mid-nineteenth century, a trend that has not been halted to the present day, despite the global rise in educational levels among women.[7] On the contrary, domestic helps of the twenty-first century are women who are better educated than all their predecessors, having not only passed advanced school leaving qualifications but even gained university degrees (see Appendix 1 of this study). Women who contemplate working abroad must know a foreign language, or at least have the ability to find their bearings in a foreign country. System transformation in the sending countries has devalued or rendered them superfluous in their chosen professions (eastern Europe), or else their earnings abroad as domestic workers are incomparably higher than the income from their (academic) jobs back home.

The situation a century ago differed from today's in a number of ways:

a) in addition to live-ins – principally au pairs and twenty-four-hour carers for old people in need of nursing – who become resident members of their employer's household, many migrants take live-out domestic employment, either on an hourly basis or for certain parts of the day;

b) employees are often from the middle class in their countries of

origin, clearly indicating that this migration – which is characterized as 'unqualified' in migration research – is by no means undertaken by unqualified female migrants;

c) their average age is higher;
d) their ranks include many mothers who have had (no choice but) to leave behind children and/or elderly parents in their homeland;
e) the women make efforts to commute back and forth to see their families at regular intervals, and lead transnational lives;
f) the most important category-difference between employers and employees is not rooted in any educational disparity but in the economic weakness of these migrants' countries of origin;
g) the hard-won achievements of professionalization in the past have been jeopardized by the slippage of domestic work into the informal and illegal sector.

The book

Chapter 2 ('The household as a global market for women's labour') contextualizes the phenomenon within the international debate on feminized migration and domestic work. Such activity has grown to constitute the largest labour market worldwide; as the (welfare) state in many countries withdraws from the provision of care facilities for children, the elderly and the sick, the privatization of such provision is a widespread phenomenon; the premise of 'purchasing' workers as cheaply as possible has spurred on the transnationalization of services. The new demand is being met by a supply of workers from parts of the world which have to contend with poverty, economic collapse or system transformation. The contextualization of the theme within the debate on globalization and migration trends is concluded by theoretically embedding it in the intersectionality debate.

Chapter 3 ('Domestic work and lifestyles: methods and first results') explains the methods of the study and takes the opportunity to present some initial findings. The mix of methods applied consisted of a) expert interviews with representatives of non-governmental organizations that advocate the interests of migrants in this domain, with doctors and social workers, and with representatives of the (Catholic) Church; b) qualitative interviews with (mainly female) employees and employers in three different cities (Münster, Hamburg and Berlin); and c) participant observations in a household and in the social milieu of the female employees. This chapter elaborates on the survey and evaluation steps, and explains the presentation of the data in the form of case reconstructions.

Chapter 4 ('Domestic work – a perfectly normal job?') sets out the different facets of the work performed in private households, based on the descriptions of their work by the domestic workers themselves. Overall it becomes clear that in addition to physically strenuous work, an additional dimension of emotional or relationship work is required, which can be called the invisible surplus value of domestic work. The intention in taking an ethnographic view of the household from the outsider's perspective is to present not only the elements of the work itself but also the web of relationships surrounding this area. Equally, the (professionalization) strategies of the migrants are described.

Chapter 5 ('Exploitation or alliance of trust? Relationship work in the household'), prompted by four case studies drawn from interviews with domestic employees and their respective employers, is devoted to the highly complex relationship structures between the parties concerned. Contrary to the work of researchers who describe the relationship between employers and domestic employees purely in terms of an exploitative relationship or refeudalization, here the asymmetry of the relationship is analysed in the context of the egalitarian principles or rhetorics. Rather than a straightforward exploiter–exploitee schema, the phenomenon identified is rather a two-way (ethnicizing) process of boundary demarcation. This 'boundary work' takes place on both sides but need not necessarily be complementary. There is a cross-over here between (doing) gender and (doing) ethnicity, since ethnic justification models are invoked to legitimize asymmetrical power relations.

Chapter 6 ('Transnational motherhood') concerns women who have left their children in their homeland and are practising a kind of 'virtual motherhood'. Under conditions of physical distance, they maintain contact with their children. Among these women's most important motives for migration are financial support for their children's education and the medical care needed by husbands, parents, siblings and other family members, as well as the purchase of their own homes. How they define and construct their motherhood and the gains and losses they experience become core themes of their biographies. With reference to case studies, the diverse experiences and solutions found by these women for their way of life are elucidated.

Chapter 7 ('Being illegal') deals with the question of what it means to live as an illegalized person in Germany; in general, this means being confronted with workplace, housing, health, orientation and integration problems. As well as considering the legally relevant aspects of illegality, here we are concerned both with presenting the different exploitation and dependency relationships, and the (structural) choices

open to the protagonists involved. The most important finding, which is illustrated with two biographies, relates to the fact that the strategy for dealing with illegality varies from individual to individual, and is less dependent on ethnic or national background than on (successful) deployment of biographical resources; whether this social capital is accessible to migrant women in Germany depends largely on access to supportive networks.

Chapter 8 ('Migrant women in the globalization trap?') sums up the dilemmas of the current situation and presents an outlook for possible political solutions. The thesis is put forward that this discussion properly belongs at the intersection of gender, migration and welfare regimes and can be taken forward only by addressing these multiple aspects. In the process, a number of other research desiderata are addressed.

2 | The household as a global market for women's labour

'Global woman' is the expression used by Barbara Ehrenreich and Arlie Hochschild (2002) to describe the migrants who, thousands of miles from their country of origin, work in private households, as live-in staff in many cases. But this neologism, reminiscent of the 'woman of the world', loses its lustre when the underlying reality is described. As a consequence of the rising global demand for domestic workers, according to Ehrenreich and Hochschild, this state of affairs must be interpreted as the 'female flip-side of globalization'. It has been touched upon in the previous chapter and bears repeating here that this phenomenon, which many characterize as something new, has historical antecedents; for example, the emigration of maidservants from Europe to North America and Australia in the late nineteenth century (Harzig 1997). What needs to be explored, then, is how the present situation differs from earlier migration scenarios, which factors have contributed to its genesis and continuance, and which theories serve to analyse and explain it. In other words, the issue at hand is the conjunction of factors that affect both the demand for domestic workers and the supply of labour, and which have led to the feminization of migration. In addition, the transnationalization of service provision will be theoretically embedded within the context of the intersectionality debate.

2.1 The feminization of migration

In recent years, a number of international studies have pointed towards a 'feminization' of migration since the end of the twentieth century (see Castles and Miller 1993; Sassen 1999; Koser and Lutz 1998; Phizacklea 1998, 2003; Hess and Lenz 2001; Sachverständigenrat für Zuwanderung und Integration 2004). It can now be observed that the 'feminization of migration' comprises a series of different phenomena: of the estimated 200 million migrants worldwide, the proportion of women has been rising and has on average now drawn level with, if not overtaken, the proportion of men (Castles and Miller 2009 [1993]).[1] In some parts of the world, cross-border migratory flows now consist

mostly of women – in the Philippines, for example, where 70 per cent of migrants are female (Oishi 2002), but also in Sri Lanka (Gamburd 2000), Indonesia and recently in some countries of Latin America.[2] Furthermore, female internal migration from rural areas to urban centres (in China, for instance) takes place on a vast scale (Gransow 2003).

The proportion of women migrating alone has also increased, not least because host countries make it undesirable or even impossible for children and other family members to travel with them. The proportion of female migrants without documents is higher than ever before, again as a result of restrictive migration regimes (Phizacklea 1998; Kofman 1996; Andall 2003). Emigration is linked to three main areas of employment: domestic work, catering and the entertainment industry and/or prostitution (see www.iom.int), of which domestic work is now the most important sector globally. As with the feminization of other fields of work, the 'gender' of the work is identified with the gender of the workers by a process of analogy-building.

Numerous studies now corroborate the existence of a global market for female domestic workers.[3] Traditional fields of work in which female migrants are found have always been characterized by low pay and poor social security. This is certainly true of domestic service, which is organized to a high degree by recruitment and placement agencies as well as collective networks operating in both the destination countries and the countries of origin (Momsen 1999: 5). International employment agencies and the Internet are important supply channels for this market,[4] particularly in countries in which recruitment can take place within the law – such as the United States and Canada, where the desired candidate can be contacted with a click of the mouse (see, for instance, www.filmo.com/maids.htm). Where the labour market is unregulated, arrangements can often be made through private contacts, and in some Mediterranean countries (e.g. Spain and Italy) the Catholic Church is also active in this domain (Andall 2000, 2003; Parreñas 2001a, 2001b).

Migrant domestic labour is indeed a global phenomenon, but this should not obscure the fact that there are huge differences between the various migrant-sending and receiving countries. A new study by the non-governmental organization Human Rights Watch (2006), which undertakes a global comparison of the abuse of migrant domestic workers, has revealed that the majority of migrants from the Philippines, Sri Lanka and Indonesia have to endure inhuman living and working conditions in households in the Middle East, Singapore, Malaysia or Hong Kong.[5] Despite the many dissimilarities attributable to human rights regimes in receiving countries, according to Human Rights Watch

there are also factors that are common to both highly developed in-dustrialized countries and the countries of the South: domestic work is excluded from employment law almost everywhere; consequently there are no means of detecting abuse and imposing sanctions on employers or employment agencies. All over the world, domestic work tends to be hidden from public view (Andall 2003: 39), since it takes place in a private realm, in which – huge cultural differences notwithstanding – state control is taboo. A related finding is that high levels of irregular (i.e. undocumented, paperless) migrants occur not only in countries without official recruitment channels for domestic workers, but even in countries where recruitment is legally regulated (Human Rights Watch 2006: 2; for Europe, Andall 2003). Few if any receiving countries appear to be interested in fundamentally changing this situation, and the sending countries, owing to their geopolitical status, either have limited leverage to improve employment rights for their emigrant citizens or else they are so dependent on the billions sent home in remittances by these emigrants – which can be an important, if not *the* most important, con-tribution to a country's GDP – that they keep their silence and intervene only in cases of gross abuse. Greater efforts are devoted to stressing the obligations of female emigrants to remain emotionally and financially loyal to their homeland, since their contribution is necessary for the improvement of the national economic situation.[6] In the Philippines, for instance, annual prizes are awarded to the best migrant domestic workers and they are honoured as ambassadors for their country (see Parreñas 2001b, 2005; Shinozaki 2005). Like their historical forerunners, the majority of these women appear to nurse greater loyalty to family members left behind (husbands, parents, children, relatives) than male emigrants do (Momsen 1999; Pessar and Mahler 2003).[7]

As a long-term outcome of female migration, Saskia Sassen (1998) presumed, the women concerned would gain power within the family, and traditional, patriarchal role expectations would change because these women's remittances make them the breadwinners for their families back home. However, this thesis has since been qualified (Bryceson and Vuorela 2002), or even contradicted: Gamburd (2000) and Parreñas (2005), for example, describe how the countries of origin are no different in defining domestic work as female work, and how even in the sending countries it remains in women's hands, or is passed on to other women, perhaps to daughters, (grand)mothers or other female relatives, who may also be paid for it.[8] Since today's domestic workers are generally older than their historical predecessors, and may have already started a family of their own and had to leave it behind,

there are rising numbers of transnational households and transnational mothering arrangements (Hondagneu-Sotelo and Avila 1997).

In this connection, Arlie Hochschild (2000) coined the term 'global care chain', which has since become an influential concept in academic debates on migrant domestic labour. The concept aims to illuminate how economic inequalities between highly industrialized countries and Third World countries and eastern Europe have abetted the commodification[9] of emotional care work and the uneven distribution of reproductive labour. The withdrawal of 'care capital' has meant a 'care drain' from the countries of origin (see Parreñas 2005: 12ff.). This analysis seems so important because in some of the sending countries, this human resource is the only exportable 'raw material' they have left. Even though the World Bank now regards this raw material, monetized via the mechanism of remittances, as the main contribution to national economic development in many so-called developing countries (see Sørensen 2005), it cannot be ignored that migrant mothers and their children remain at the tail end of this chain, and that they pay the emotional and social price for this depletion of care resources. An additional factor is that, owing to the years of spatial separation, the bond between mother and child is expressed chiefly through providing the means of subsistence and a good education in private schools or universities, giving rise to a commodified version of motherhood (Parreñas 2005).[10]

Over and above these aspects, feminized migration from developing countries is also a consequence of improved (or, in the case of eastern Europe, traditionally good) education and communications, as well as better opportunities to travel or the relaxation of border-crossing restrictions in sending countries, at a time when living conditions have been worsening or stagnating in the countries of origin. More and more women are inclined to emigrate and leave their home countries, not so much despite as because of their increased educational capital, which they cannot put to appropriate use in their native regions. This often exposes them to high risks – that of an illegal existence, for example. They may be unable to anticipate the problems associated with migration. Quite the opposite: dismissal or denial of the difficulties could well be an essential prerequisite for these people's very readiness to become migrants.

2.2 Care economy

In her book *Globalizing Care Economies and Migrant Workers*, Nicola Yeates (2009) analyses the economic dimension of the global care chain in a way that develops the analysis set out by Sassen (1991). Sassen

sees feminized migration as resulting from the concentration of global capital in global cities, where a transnational division of labour has emerged between an 'upper circuit' of high-fliers in the financial capital sector and a 'lower circuit' of service providers imported from the countries of the global South. Yeates assumes these connections between service providers and service recipients to be 'textured by wider socio-economic inequalities resulting from hierarchies of states, classes (and castes), gender and ethnic groups' (Yeates 2009: 42). At the same time, she points out that the use of migrant women as service providers is not merely a corollary of the higher female employment rate but is also – in Middle Eastern countries, for instance – a matter of 'maintenance of social status' (ibid.: 49). For the migrant women and their families in sending countries, many of whom are themselves middle class and very well educated, as our study also confirms, the key issue is maintenance of lifestyle as well as maintenance of social status by such means as enabling their children to get a good education, given that education has become an expensive commodity in many countries of origin. The global care chain bears comparison with the global manufacturing system since the care sector similarly involves many actors on different levels (caregivers and their families, care receivers and their families, networks, brokers, social welfare and care regimes, migration regulations). And, like other goods produced transnationally, care can be viewed as a commodity that is distributed, marketed and consumed 'and materially connects economies, firms, workers and households' (ibid.). However, various other factors make it difficult to accept the comparison between care and goods production uncritically. One significant difference between care and goods production is that the profit and surplus from care provision flows primarily to individual actors and not to national economies (except indirectly, through the reproduction of labour power).

Important as it is to quantify and make visible the value of care, and hence the value of emotional work, all things considered the view of care as a commodity is and remains problematic, because the value and the costs of emotional work accrue not only to the person performing such work and the person for whom it is performed, but are also highly relevant to those deprived of it: the families left behind by migrant women in their countries of origin. These countries lose not only well-educated workers but also the care capital embodied by female migrants. The social costs of this care drain, while not immediately apparent, are manifested over longer periods of time (see also Chapter 6; Lutz and Palenga-Möllenbeck 2012, in preparation).

2.3 Bottom-up transnationalism?

Migration processes today involve a number of new aspects which only add to their impetus; one such phenomenon is the compression of space and time. An Ecuadorean housemaid working in present-day Hamburg now has IT and transport options that were not available in the past; she can be in daily touch with her children and family via email or instant messaging at a local Internet café, or by using cheap call providers. Telecommunications enable migrants to maintain more constant links with their family networks than ever used to be possible. This also means that information can be exchanged about living and working conditions in Spanish, American, Argentine, Canadian or German households in which these women's sisters, sisters-in-law, aunts or friends are employed. Information chains and resources are thus created to an unprecedented extent. A Polish woman in Florence could potentially consider whether she wishes to remain there, with secure residency status but as a live-in maid with limited mobility and under the constant control of her employer, or whether she might prefer to be a cleaner or care worker in Berlin households. The latter would mean choosing the rocky road of illegality, since the rules of the German Residence Act discourage and penalize this kind of work-motivated migration; but a move would mean no more living under her employer's roof, and a degree of autonomy in a city much closer to her home country (Cyrus 2003). Migrants' decisions about migration are informed and justified by the information they receive via their informal networks.

Since Thomas's and Znaniecki's 1920s classic *The Polish Peasant in Europe and America*, the pace of this may have escalated, but the reasons for migration and the coupling of personal decisions to collective networks have changed rather less. The real novelty is the greater degree of mobility already mentioned, which does in fact lead to new types of migrant trajectories and biographies, so that migrants often utilize the opportunity structures of not one but several host countries to achieve their goals. For Polish domestic workers, this might mean that they work for brief or longer periods in Germany and Austria, or in Spain and Italy. Thus, for many, multilocality has become not merely a psychological but a physically experienced, 'serially sojourned' reality. These processes are regarded as the development of a kind of 'settledness in mobility' (Morokvašic-Müller 2003: 102) or as 'bottom-up transnationalism' (Smith and Guarnizo 1998), i.e. these authors place the emphasis on the action perspectives of migrants rather than the immigration policies of host states.[11] This

approach certainly runs the risk of seeing transnational migration in terms of an overinflated concept of resistance against border controls and geopolitical domination, in which case the structural distinctions are frequently lost from the analysis. But Annie Phizacklea (2003: 81) rightly points out that this view is accurate insofar as it refers 'to the many and varied transactions and processes that migrants maintain between "home" (as in "where I was born") and "home" (where I am now)'. Such transactions are undoubtedly shaped by a host of asymmetrical relationships with regard to gender, ethnicity, nationality, age and religion. Yet it seems important to note that migrants are not puppets of their respective economies or national states, but human individuals seeking to improve their living conditions across frontiers. The contributions they make to changing society in their countries of origin and reception, as much as the structural restrictions and obstacles to migration they encounter, are part and parcel of their life stories. 'Bottom-up transnationalism' is therefore a metaphor for the appreciation of this contribution.

2.4 Transnational services at the intersection of welfare, gender and migration regimes

Feminized migration is a response to expanding demand for affordable – meaning cheap – services in private, middle-class households in the Western industrialized receiving countries as well as wealthy households in the oil states and the Third World. Apart from the fact that in non-Western countries domestic staff are hired mainly to raise social prestige rather than to replace family work previously undertaken by the employer, the following observation can be made about the general 'market': not only does the increased demand boost the supply of migrant domestic workers, but the increased supply in turn creates new demand and fosters a change in the attitude towards housework.[12]

At the upper end of the global care hierarchy, according to Ehrenreich and Hochschild (2002), are the well-looked-after children and mothers of the West, who benefit emotionally and economically from the employment of a migrant worker. These mothers fulfil their maternal duties by outsourcing their responsibility for care, and because this takes place in their own private sphere, their own affinity with this social space is not called into question. Thus, Ehrenreich and Hochschild contend, they are able to regard themselves as successful career women, capable of combining professional work and family duties perfectly well, i.e. 'doing it all'. However, such an evaluation

of this phenomenon assigns all the 'guilt' one-sidedly to the respective employers. What Ehrenreich and Hochschild overlook is that this gainful employment is the main source of income for many migrant women and their families, and that no solutions have yet been found to the ensuing dilemma. The authors also ignore the fact that this situation in the receiving countries is a result of the failure of other debates and discourses – for example, those concerning redistribution or the need for the state to enhance the status of family work (or 'care work') and to give it appropriate support.

It is important to note here that US authors, in particular, tend to generalize from the situation in North America, thereby obscuring its major differences from Europe in such matters as state (welfare) provision.

While state assistance for childcare and geriatric care has always been minimal in the United States, and paid domestic employment corresponds there to the deregulation and privatization of this sector within a weak welfare system, the situation is somewhat different in Europe. Some countries of western and especially northern Europe have established (strong) welfare systems over decades, whereas such provision has traditionally been more rudimentary in the Mediterranean region; and in eastern European countries, the state – officially, at least – took charge of the bulk of care provision.

The term 'welfare regime' (Esping-Andersen 1990, 1996) refers to the specificity of national models of social policy and sheds light on the relevant relationship between state, market and family in each case. In analysing the interplay of these actors, Anttonen and Sipilä (1996) identify two distinct European models: the Nordic social care regime with a high female employment rate and extensive state support for the care of children and old people; and the southern European family care regime with lower female employment rates and less extensive supply of care services. Between these extremes they place, on the one hand, Germany, Britain and the Netherlands, where responsibility for children before they start school, as well as outside school hours, rests with the family, regardless of whether mothers are employed or not; and, on the other hand, Belgium and France, where the labour market participation rate for women has traditionally been high and the state offers full-time childcare provision, particularly for the pre-school age group. A further model to be mentioned is the eastern European model, which was also followed in the former German Democratic Republic, where women were compelled to engage in paid employment and were relieved of the greater part of their care work. In virtually all of these

countries, the system transformation after 1990 and the subsequent introduction of neoliberal redistribution policies have decisively altered the picture. The commodification and transnationalization of the three Cs (cooking, caring and cleaning) can be observed in all of the above countries, to varying degrees and in different forms depending on the traditional welfare regime: the eastern European model is being rolled back but has not yet disappeared entirely; countries in southern and western Europe (Britain, Spain, Italy, France, the Netherlands, Austria) have encouraged the entry of migrants into private households by offering individual cash payments, tax breaks or 'household cheques' (see Williams and Gavanas 2008). To understand this phenomenon, however, it is necessary to look at the interaction between the welfare regimes and the gender or migration regimes.

Feminist critiques of Esping-Andersen's model (see, e.g., Lewis 1992) have proved its redundancy if the gendered dimension of the connection between productive and reproductive work – the 'gender regime' (Sainsbury 1999) – is left out of the analysis. The term 'gender regime' denotes a complex of rules and norms that is rooted in, and institutionally underpinned by, the gender order of the society in question. Here, the relevant institutional arrangements depend on whether social protection systems promote gender difference or gender equality with regard to the recognition of family or care work (see Gerhard et al. 2005). The interplay of state, market and family is now changing, as mentioned above, owing to the fact that many states want to leave (some) care work to be arranged via the market and leave such arrangements to private households. But here, the third 'regime' comes into play: the migration regime, with the help of which states regulate employment in the private household. In the case of the migration regime, too, various expectations and guiding principles are activated which serve to legitimize the state's control instruments: either migration to private households is encouraged, or it is tolerated on a laissez-faire basis, or else actively curbed. Whereas in southern Europe and Great Britain migrants are being recruited for care work or have been legalized via a system of a posteriori regularization, states such as Germany, the Netherlands and northern European countries have thus far refused to accommodate the rising demand in this sector by relaxing their immigration laws. An analysis of the interlocking nature of these three regimes is therefore essential for an understanding of this phenomenon.[13] Apart from payment, which is lower in southern Europe than in the west or north, the main differences among countries lie in the prevalence of live-in or live-out arrangements, which are also regulated through im-

migration quotas. In Italy, Spain and Greece, the live-in model prevails, especially when it comes to care for the sick and elderly, who in these countries are mostly looked after in their own homes until their lives end, while the live-out model is dominant in childcare and housekeeping. Even if, at first glance, the live-in model appears to reduce costs and spares domestic workers the trouble of finding accommodation, most of them prefer the live-out model because it helps to minimize tensions. Among the countries of origin, eastern European countries such as Poland, Slovakia, Ukraine, Bulgaria, Romania and Moldova are as strongly represented as several Latin American countries (Ecuador, Bolivia, Peru) and the Philippines (see Lutz 2008). In all countries, workers in this category, including those in legal employment, have only limited citizenship rights, and in no case is there regular supervision of the domestic workplace.

Alongside the legally registered immigrants,[14] the number of illegally employed workers appears to be rising in all receiving countries, which makes for increasingly precarious living and working conditions: '... irregular employment is an immanent feature of the domestic labour sector. There are estimates stating that one in four domestic workers is employed illegally' (Andall 2003: 39). In this context, Andall (ibid.) speaks of the introduction of a 'service caste' and the establishment of a new 'caste system' in Europe, while Arlie Hochschild (2003) goes so far as to argue that the phenomenon of migrant domestic work represents a 'Copernican revolution' in the social structure of European states.

Even if that conclusion may be overdone, it is nevertheless clear that in all cases a restoration of social inequalities in the context of globalization is generating new relations of dependence. But these do not work as one-way dependencies. Instead, 'a global relationship evolves, which in certain respects mirrors traditional gender relationships. The First World assumes the role of a traditional male in the family – spoilt, entitled to make demands, incapable of cooking, cleaning or finding his socks. Poor countries assume the traditional female role – patient, caring and nurturing, and self-denying' (Ehrenreich and Hochschild 2002: 11f.). Ehrenreich and Hochschild do point out, however, that it would be wrong to see this relationship of global dependence through the metaphor of a marriage; it could better be cast as a secret affair that neither the globalization movement nor feminist activists have yet noticed (ibid.: 12). The metaphor of a traditionally gender-specific relationship superbly illustrates the complexity of the dependency relationship in its global dimension. In a conservative

gender arrangement, there is indeed an asymmetry of power, but this is multilayered and may operate inconsistently across the economic, social and emotional levels: for instance, the economically dominant partner may be emotionally dependent on the non-dominant partner and respond to his or her loss and absence with a degree of social disorientation. Another important and pertinent element that the gender metaphor expresses is the embedding of individualized and personalized relations in a globalized macro-societal context, in which not only individuals but also nation-states as receiving and sending countries collude in and/or benefit from the unequal power relationship. Domestic work may thus be analysed as a paradigm for relationships of dependence in a global perspective.

2.5 Doing gender and doing ethnicity – 'boundary work' in the private household

This chapter concludes by revisiting the question of which theories help to explain the phenomenon of the 'global woman'. Why, despite the waning significance of the housewife marriage and the declining rates of male participation in the labour market, has there been no redistribution of family or care work between gender groups? Why is it preferable to pass on this work to another woman from another country?

One possible answer can be found using the theoretical approaches of ethnomethodology.[15] I start from the premise that family or care work is a gendered activity of a very special kind that creates identity and, as a core part of 'doing gender', maintains the gender order of society (where 'doing gender' describes gender as an ensemble of everyday actions; as routines of perception, representation and attribution). Heterosexual gender-binarism is taken not as an ontological starting point but an effect of social practices. Since the social order is unstable, it has to be repeatedly produced through the routine of 'gender display'. The resulting gender arrangement is not random, however, but is socially acquired in childhood, especially in the home, as the 'central gender code'.[16] The 'doing gender' approach therefore does not require an ontological understanding of gender in order to explain gender-specific behaviour. Resistance to change, which is expressed in the uneven distribution of care-work responsibilities, can be explained indirectly in terms of the identity-defining logic of 'doing gender': the reallocation of household and care work to another woman conforms to the logic of conventional patterns of identity, and these need never be scrutinized.[17] For instance, by resorting to tradi-

tional care models (e.g. wet-nurse, governess) which do not trespass on gender-specific, segregative symbolization, the self-image of the 'good mother' can safely be upheld.

The 'doing gender' theory has its limitations, for it is unable to explain whether, when and under what conditions changes in gender relations might occur. The authors in question focus only on the perpetuation of the repetition, not on '*un*doing gender'; there is no reference to the fact that both female and male subjects are capable not only of imitating and repeating but also of diverging, changing and resisting, and therefore of destabilizing gender dualisms. At the same time, it is important not to assume a single universal form of gender subjectivization, but rather to take account of class and ethnic differences within a gender group. With regard to globalized domestic labour, it seems important to view ethnicity as a category that conveys social structure. Ethnicity, according to Stuart Hall (1992), is not considered an attribute of minorities that marks the group of 'others', but as a central category in social positioning. In line with the 'doing gender' debate, it is no longer asked what ethnicity is, but how in the course of 'doing ethnicity' it is produced by action and interaction. Likewise, as a relational category 'doing ethnicity' is hierarchically structured and habitualized. Just as for gender, the analysis centres upon process and construction, and only exceptionally is the category of ethnicity made the object of conscious reflection.

The private household as a work setting presents much cause to negotiate ethnicity: first, because the home is the designated forum for individual marks of distinction and family habitus, and, second, because it is here that identity is negotiated among the active players through affirmation and exclusion. 'Doing ethnicity' is the operative method of 'boundary work' (Lan 2003) by means of which social positioning is negotiated between employers and employees, and the private household is the arena for this negotiation. Here, 'doing ethnicity' may very well go hand in hand with class-specific patterns of action and positioning, but this is not a compelling necessity.

It may be going too far to regard 'doing ethnicity' as a variant of 'undoing gender'. However, 'doing ethnicity' does help to mitigate the asymmetry of 'doing gender', while 'doing gender' is simultaneously passed along and acquires a new form.[18] This means that, by focusing on categories of difference (ethnicity, class) within a gender group, it can be shown that asymmetries in one category may be attenuated or amplified by the forms in which other markers of social position are negotiated, noting in the process how the respective categories

may themselves gain or lose significance. Applying this to Ehrenreich and Hochschild, it can be said that their gender metaphor is not sufficient to explain the international reallocation phenomenon, but that once combined with ethnicity in its gendered form, the significance of gender diminishes somewhat.[19] The theoretical model that draws these points together is the one associated with intersectional analysis, which builds upon earlier approaches from the race-class-gender debate.[20] It does not treat structural categories as cumulative (in the sense of a 'triple oppression'), nor does it assign each social actor to a single 'status group', but, as Nancy Fraser (2003: 57) puts it: 'Rather, individuals are nodes of convergence for multiple, cross-cutting axes of subordination. Frequently disadvantaged along some axes and simultaneously advantaged along others, they wage struggles for recognition in a modern regime.'

Intersectional analysis[21] has proven most useful as a research tool for identity constructions (see Lutz and Davis 2005). In the case studies discussed in this book, categories of difference will be presented not only as negative or positive ascriptive categories, but also as symbolic capital that may be deployed differently in different situations.

3 | Domestic work and lifestyles: methods and first results

The challenge of this research project was the empirical investigation of a subject that is still largely taboo in the public discourse. A first hurdle was the 'double' illegality already mentioned, pertaining to both the employment relationship and the affected migrant workers' (lack of) work and residence permits. Furthermore, the fact that this study took place in private homes, normally shielded from the public gaze, surely contributed in equal measure to the problems of gaining access to employers and employees. The home is considered and idealized as a protected zone, a space for the shaping of individuality and identity, a place of rest and withdrawal, relatively free from public legitimization pressures. Questioning and observations about people's habitual living arrangements in this sphere are thus viewed as an unwelcome intrusion and arouse suspicion. As previous studies on people of irregular status have shown, a systematic survey of the working and living conditions of this group of migrants is so difficult because the uncovering of their work and residency status usually leads to deportation and loss of livelihood (Anderson 2003; Alt 2003; Cyrus 2004). We, too, were therefore unable to search for interviewees systematically, but had to rely on the snowball effect. This chapter sets out to explain the study's terminology and categories of differentiation, data collection methods, sampling techniques and mix of methods. It includes information on which languages were used for questioning, and goes into the evaluation and linguistic processing of the interview material, and our decisions about the presentation of the interviews in the book. An account will be given of how we approached the field research, in order to outline how, despite all the problems, we found our interviewees. The chapter ends with a number of considerations relevant to biographical theory.

3.1 Terminology and differentiation categories of the study

In the context of this book, the terms 'employer' and 'employee' seem at first sight to be euphemisms. After all, there is no legally recognized work contract that would justify designating and treating

them as such. The employers in question make no social insurance contributions, nor do many of them give holiday pay or end-of-year bonuses. In case of illness, the employees must forgo continued payment of wages, and usually they must also bear the costs of an accident in the home. The *choice* of this terminology in spite of all this is justified by the fact that the arrangement in question is a verbal employment agreement entered into by both parties that may last for years or even decades: some of these women have worked for a decade or more in the same household. In the course of this book it will be shown what kind of employment relationship this situation engenders. One striking, indeed astonishing, feature is that it is based on trust rather than contractual agreement, and can only really function as an alliance of trust. Chapter 5 will illustrate how both the absence of a contract and the fact that the work is performed in the private sphere give rise to functional and termino-logical diffuseness. For example, the lack of legal protection may lead a domestic worker strongly to reject the term 'employee' (see the case of Anita Borner, Chapter 4) and to present herself expressly as a service provider working for a client. What this leaves out of the equation, however, are the real-world (residency status and labour law) power relations, which afford migrant workers no legally protected scope for action. Employers, too, like to see their domestic workers as service providers; in their case, it is largely a form of exculpatory rhetoric which conveniently diverts the debate away from relations of power and dependence, since the (academically) educated upper-middle-class clients will usually know that they are not party to a legally safeguarded service-provider contract.

Based on these considerations, we have decided to stick with the terms 'employer' and 'employee', even though they do not stand up to legal scrutiny. We also refer to 'domestic workers', a term which highlights the location of the work in the private household and is a blanket term for all work performed in the household. In the analytical presentation of the case studies, however, the individual chapters will distinguish clearly between the activities performed.

Four differentiation categories will be used in this book: regional differences in the phenomenon of domestic work; domestic workers' different countries of origin; differing features of the work performed; and the family and parental status of the employers and employees.

Regional differentiation is understood to mean a breakdown accord-ing to the three locations of the study: Münster, Berlin and Hamburg. The choice of these cities evolved from the consideration that Berlin

and Hamburg, as 'global cities' (Sassen 1991), exhibit an increased demand in the area of domestic work, a phenomenon fuelled by a significant number of two-earner households and those with above-modal income. Furthermore, Sassen works on the assumption that the upscale services in the 'new economies' have created a type of employee in these cities who has heavy professional commitments and works very flexible hours, and who tends to outsource domestic or care work, thus becoming an employer him/herself. Since the existing literature contains little evidence that this phenomenon is also prevalent in medium-sized cities, Münster (a provincial capital with a population of 280,000) was also included in the study. It turned out that domestic work is also widespread in Münster – but that it was more of a taboo than in Berlin and Hamburg. Berlin is particularly interesting because of its geographical proximity to and traditionally close connections with eastern Europe; it was reported back in the 1980s that Polish men and women were travelling there for the weekend to work as cleaners (Morokvašic and de Tinguy 1993; Irek 1998), and this trend grew stronger after the fall of the Wall. Hamburg was of interest to us as a port city with a traditionally broad spectrum of migratory flows and immigrant groups, particularly the large Latin American community, which also became the focus of our study in Hamburg.

The second category of differentiation relates to countries or regions of origin, with eastern Europe and Latin America as the main centres of attention. Apart from Poland and Ecuador, interviewees also came from Ukraine, the Czech Republic, Hungary, Georgia and Lithuania, and from Colombia, Uruguay, Chile, Peru and Brazil (see Appendix 1). Interestingly, according to our estimates, among the migrants working in domestic settings, more new immigrants are found than immigrants who entered Germany as *Gastarbeiter* ('guest workers') or their dependants under earlier labour recruitment programmes. One reason for this is probably that people with secure residency rights have no need to embark on illegal employment; another is that, in this labour market, the relatively high educational level of new immigrants and their ensuing or inferred affinity with the employers' own lifestyle help to make these employees preferable to members of established immigrant groups.

Other researchers have repeatedly pointed out that German women are also present in the domestic employment sector (Gather and Meissner 2002; Mayer-Ahuja 2004); these are either unskilled housewives from traditional working-class homes, who have social insurance cover through their husbands, or older women whose pensions are so small

that they take on domestic work as a means of overcoming the precariousness of their livelihoods.

This study was limited to interviewing migrant workers, not only to keep the number of differentiation categories within bounds and to avoid over-complicating our research structure, but also because we have the impression that the numbers of migrants have been growing and that this phenomenon has scarcely been investigated until now.

The third category, namely differentiation by the characteristic features of the work, refers to the tasks performed by the employees. Appendix 1 lists the dominant activities for each employee. When we began the study, we assumed that clear demarcations existed in this sphere between the tasks of cleaning, housekeeping and care work. However, in Chapter 4 ('Domestic work – a perfectly normal job?'), it becomes clear that differentiating the various tasks is not that simple. In cases where children are looked after (on an hourly or daily basis), the domestic worker usually also cooks and sometimes cleans; in the case of care for the elderly, she often cleans the house but also shops and does the washing and ironing. In most households, some tidying is necessary before the cleaning can be done; tidying and cleaning are usually combined with washing and ironing. In the great majority of cases, moreover, some emotional work is also performed – as described in detail in Chapter 5. Our working assumption is that most domestic workers are active in more than one household and combine a number of different tasks.[1]

The final category relates to differentiation by the family-status attributes of both employer and employee. For example, a third of all the employers we interviewed (see Appendix 2) were older people, usually living alone, and many of those with infants or children of school age were bringing them up alone.

Turning to the migrants, the majority of domestic workers in the study used part of their earnings to support children, nieces and nephews, parents and siblings, and husbands back home; sometimes even ex-husbands, despite being divorced. Twelve of the twenty-seven domestic workers we interviewed were mothers, of whom seven (more than half) had for a long time been living apart from their children; three of these seven came from eastern Europe (Poland and the Czech Republic), four from Latin America (Ecuador, Colombia, Brazil). Some childless interviewees, too, were supporting dependent family members back home, although there were clear differences in this respect depending on country of origin. The majority of childless migrants in our sample came from eastern Europe and reported that they had no

obligations towards their families. Only two of the migrants from Latin America in our sample had no children. One of them, together with her sister, supported her family with regular remittances, to provide both medical care for her parents and to fund the education of her siblings. The children of three women had also migrated to Germany, though as adults and in connection with their studies. Only the grown-up son of the Colombian Monica Ríos had come, like his mother, on a tourist visa. Another four women had given birth to their children in Germany, and only at a time when their residency status had been resolved, at least provisionally. Only two women had been able to emigrate to Germany together with their children. Maria la Carrera's daughter, whose migration story is presented in detail in Chapter 4, is already an adult. Like her mother, she travelled to Germany on a tourist visa and married a German man shortly afterwards. The Chilean Rosa Perrez, alone among our interviewees, came to Germany accompanied by her husband and son; the family has secure residency status in Germany by virtue of the husband's Spanish citizenship.

Few of the employers or the migrants were living in traditional nuclear-family units. Rather, our study confirms Judith Stacey's (1998 [1990]) theory that in the late-twentieth and early-twenty-first centuries there has tended to be a shift from the modern nuclear family to the postmodern family. The latter is characterized by a greater diversity of household types, so that different social arrangements and relation-ships may exist simultaneously across multiple locations. Moreover, in the case of the South American women, family structures of the kind traditional in Europe have been and remain rather rare in their countries of origin.[2] In Chapter 6 ('Transnational motherhood') it will be shown that all migrant mothers who have to make care arrange-ments for their own children must, of necessity, come to grips with the transnationalization of their family. This entails fragmentation, multilocality and heterogeneity of family forms and often long-term physical separation of mothers and children, as well as the major logistical and emotional effort of coping with it.

On the employer's side, the absence or dissolution of traditional family forms is sometimes experienced as liberating, sometimes as painful, but in no case does it mean fragmentation and months or years of geographical separation between parents and young children comparable to that of the employees. Whereas in Germany legal entitle-ments and childcare facilities for single parents are better regulated nowadays and – as will be shown in the case study in Chapter 5 – make an important contribution to financial security, the same is not true

for migrant domestic workers. Even if they succeed in legalizing their residency status through marriage – as was the case for a third of the mothers in this study – they may not be able to take full advantage of the right to be reunited with their children, since the father of the children or family members who have been looking after them in the country of origin may refuse to let them go.

The results of this study point to a definite transnationalization of households on the employee's side. The entry of a migrant worker into the home also brings changes on the employer's side, especially if it is the first time that the family has been in close contact with a migrant. Often a curiosity develops about the employee's experiences of migration. Equally, there are employers who are not interested and do not want to be confronted by the conditions of their employee's life.

The age and educational level of migrants did not constitute a differential category of its own in this study, since we were unable to build it systematically into the selection of samples. The compilation of the descriptive data in Appendix 1 shows that a majority of interviewees had completed secondary school and a course of higher education, and were over the age of thirty.

3.2 Data collection, sampling, field access and the mix of methods

Data collection took place between December 2001 and December 2003. Towards the end of this period, the German government's announced policy of criminal prosecution as of 2004 was causing great disquiet among employees.[3] Fortunately, most of our interviews had already been conducted by that time, since the general discussion was stirring up insecurity, and employers and employees alike were now less willing to provide information.

Altogether, seventy-three interviews were conducted with twenty-seven employees (mostly on more than one occasion) and nineteen employers. It is regrettable that there was only one man among the employees interviewed, since we knew of several young men from eastern Europe – mostly homosexuals – who performed domestic work and looked after children or old people. Despite renewed efforts on our part, we could persuade only one man to be interviewed. It is not yet possible to say whether these men performed the same duties as the female interviewees and, if so, whether the gender coding of the work as 'female' should be looked at more closely – or, on the contrary, whether the work performed by the men in question is seen as 'demasculinizing'.

As stated earlier, there are still no reliable figures that describe the full extent of the phenomenon of migrant domestic workers. But our research confirms the conclusion drawn in studies by Bridget Anderson (2000), Jörg Alt (2003), Norbert Cyrus (2004) and Philip Anderson (2003) that more than 90 per cent of domestic labour is performed by female migrants.

In this sense, our sample reflects the reality of the workplace. The majority of the employers we interviewed were also women; of the nineteen interviewees, four were men. We assume, however, that the number of male employers, especially men living alone with (above) modal income, is much higher than the percentage in our sample suggests. But here, too, we had to rely on people's willingness to provide information and, as many qualitative studies have shown, this willingness differs gender-specifically; in other words: women are more likely to agree to being interviewed.

The interviews with employers and employees were spread more or less equally across the three cities. Field access was beset with varying difficulties in each city. In Münster, it was not possible to use personal networks, and so we initially interviewed specialists from Christian social institutions such as the migration department of Caritas[4] or the pastoral care service of church communities and then, with their help, tried to get in touch with domestic workers. But in the end this approach yielded few contacts with relevant individuals, and it was through one of our students that we eventually made contact with a number of Polish domestic workers. The way in which representatives of various institutions responded to our requests allows some important conclusions to be drawn about the peculiarities of how this phenomenon is dealt with: all the individuals in question (social workers, advisers, spiritual guides such as a priest) emphasized that, although they were familiar with the phenomenon, it had hardly ever come up in their advisory work. They also said that access to migrant domestic workers was extremely problematic, since the precariousness bound up with their doubly illegal status meant that they preferred to remain inconspicuous; the fact that their place of work was the private household abetted their invisibility. It turned out that illegality was much more of a taboo subject in a city like Münster than in the metropolises of Berlin and Hamburg. In Münster, moreover, representatives of institutions displayed a greater aversion to the idea of formal interviews.

Specialists spoke about their professional (or personal) experience with illegal domestic workers only when we abandoned formal

interviews in favour of less formal conversations that we wrote up afterwards instead of using recording equipment. Our experiences in Berlin were markedly different, for unlike Münster, where no social or church institutions are specifically geared towards illegal migrants from various countries, Berlin and Hamburg offer a wide range of social institutions and non-governmental organizations whose work focuses on this group of people. Among others, we made contact with the following projects in Berlin (some of which no longer existed by the time the first edition of this book was published):

- ZAPO, a drop-in centre for commuters from eastern Europe, was an institution of the Polish Social Council that offered social and legal advice mainly to Polish migrants in Berlin. It specialized in advice on labour law, but domestic workers used its services to a much lesser extent than employees in the construction and agricultural sectors.
- SUSI, an intercultural women's centre, offers social and legal advice in their own languages to women from regions such as Russia, Poland, Latin America and Asia. According to people working there, the majority of women who consult them are employed as domestic workers. Nevertheless, they are never consulted for advice on the legalities of domestic employment; the focus is on questions concerning residency status and relationship problems.
- Ban Ying, a non-governmental organization, offers advice to women from Asian countries. In its advice work, it deals mainly with domestic workers from the Philippines who have come to Germany as employees of foreign diplomats and endure especially precarious working conditions, including unpaid wages, mental and physical violence, and the withholding of their passports.
- Malteser Migrantenmedizin (MMM, the St John medical centre for migrants) offers medical assistance to people without documents. According to the responsible doctor there, most of the women who use its services are domestic workers.
- Lesbisches Bündnis für Arbeit (Lesbian alliance for work) is a support group for illegal domestic workers, the only specialist non-governmental organization (NGO) of this kind among the ones we contacted in Berlin. It played a considerable part in setting up a German Respect network. Respect (see www.respectnetworkeu.org/) is a European initiative that brings together, and coordinates the political work of, NGOs specializing in illegal domestic workers. On the one hand, this group of supporters explicitly pursues the

political goal of raising the working conditions of illegal domestic workers for critical public debate. On the other hand, it provides concrete support with problems such as finding accommodation, finding employment, etc. Unlike the other NGOs contacted, this group includes migrants themselves among its members.

In Hamburg, we contacted some organizations that offered advice targeted towards Latin American women. They are:

- Amnesty for Women, which offers social and legal advice, including advice to women without papers, and coordinates the EU Tampep project in Germany. Tampep (www.tampep.com) is directed at migrant women active as sex workers, and offers information on health issues to both domestic and sex workers; some women appear to be active in both areas of work.[5]
- Mujeres sin Fronteras (Women without borders) is an NGO whose members are Latin American women. They provide voluntary social and legal support for Latinas (of irregular status) who are active as domestic and/or sex workers.

Even this list of the organizations that we contacted in Berlin and Hamburg shows that at least there is a public perception that the phenomenon of (illegal) domestic workers is given much higher priority in these two cities than in Münster. Two conclusions may be drawn from this. First, the greater presence of organizations working in this field probably reflects a greater relevance of the phenomenon in terms of numbers; however, this could only be verified if figures were available on the full extent of migrant domestic work in Germany. Secondly, the various support structures also seem to confirm the thesis that the whole issue is less of a taboo in large cities such as Hamburg and Berlin.

Despite these differences, our experiences with NGO representatives in all three cities had a number of common features. It was often more conducive to establishing contact if conversations were kept informal and not conceived as formal interviews. Although NGO representatives in all three cities showed a great willingness to share their experience, a certain mistrust was also felt, presumably directed towards the academic approach, which practical workers sometimes regard as a rival and/or unsuitable means of solving the problems that exist. In some cases, strong collegial relations were established, and we were invited to give lectures or engage in collaboration, which made it possible to discuss and reflect on our own interpretations. Reports

from advice centres helped to confirm or reject ideas that had been suggested by individual cases.

At the same time, the plan to find interview partners via this route did not bear fruit; it was evidently difficult enough for some of them to develop a relationship of trust with their target group and they did not want to jeopardize it by acting as recruiters for an academic survey. Others did attempt to win over conversation partners for the project but failed because the clients were afraid.

Only one recruitment attempt via an organization was successful: in Münster, we made contact with a church agency that found domestic employees for older members of the community. The agency operated a pre-selection process and mainly catered to pensioners who, in its view, were interested in issues of migration, integration and cultural exchange; it regarded its services as a contribution to intercultural understanding (see also Chapter 5). This institution operated on the assumption that all the workers were students, but it did not check up on this. As will be shown in the course of the book, many of the women enrolled for university studies are in fact unable to make ends meet as students and have to take up domestic work on a full-time basis.[6]

In all three cities, personal networks proved to be the most successful strategy for obtaining employers and domestic employees as interview partners; these connections and their own networks could then be used to find further interviewees by a snowball effect. Undoubtedly this has entailed a certain degree of selectivity of subjects, but in light of the difficulties of gaining access to this group at all, there seemed to be no alternative. Despite the positive experiences with personal networks, our efforts to interview both sides of the employment relationship – employers and domestic employees – were successful in a few cases only.[7] Moreover, the employers were interviewed first, and they put us in contact with their domestic employees. Such a procedure is possible only where no serious, overt conflicts exist between the two parties. The reverse approach, through the domestic employee to the employer, was not successful in a single case; we may assume that the employees found it too onerous to make the necessary request, or feared that it might aggravate tensions.

Our original intention of interviewing both parties with a focus on the household as a unit of investigation had to be given up in the end as unrealizable. Only once was participant observation in a household possible; in this case, we interviewed both the employing couple and the domestic worker. It took a great deal of effort to set up, however,

and came about at all only thanks to the fortunate circumstance that the interviewer knew everyone involved personally.

3.3 Synchronous and single-location research

Although we had originally planned to conduct our fieldwork in Münster, Berlin and Hamburg consecutively, we eventually opted for a synchronous approach instead – though periods of further research were used to deepen the study of the individual locations, as planned. This synchronous procedure proved successful. On the one hand, comparison among the three cities made it possible to keep the research questions under review; a first evaluation of interviews with domestic workers from Münster and Hamburg thus led to the thesis that location-specific ways of dealing with illegality also had an impact on migrants' strategies for coming to terms with experiences of illegality (see Chapter 7). On the other hand, the synchronous approach had the advantage that, while preparing for the fixed-location periods, contacts could already be established that facilitated access *in situ*. Since the interview transcripts and first evaluations were made at the same time as the surveys, it also became possible – from the point of view of theoretical sampling and further work on the contrasting criteria – to refine the search for interview partners in Berlin and Hamburg. In Münster, and in Berlin initially, most of the interviewees were eastern Europeans, but over time we were made aware of how many domestic workers there were from Latin America. We therefore conducted interviews with *Latinas* in Hamburg (and eventually to some extent also in Berlin). The contrasting criterion here was not so much the national or ethnic origin of the migrants as the assumption that transnational relationships with Latin America, on the one hand, and eastern Europe, on the other, were maintained in different ways owing to the factor of geographical distance or proximity.

3.4 Participant observation and lifeworld inquiries

Observation of employer–employee interaction occurred only in one case, where the interviewer accompanied the domestic worker to a house, assisted her with her work, and drafted a report about it (see Chapters 4 and 5). Problems with this research step became clear when the report came to be evaluated: the feeling came through that the participants were fabricating an artefact, i.e. were far removed from a natural situation. In the end it had to be assumed that participant observation in a domestic context yields results only when it takes place over long periods of time and the researcher herself becomes

part of the everyday setting.[8] In our own case, this would have meant abandoning the multilocality of the research design, which we did not wish to do. In contrast, participant observation in the wider social milieus in which the domestic workers moved was more successful. Relationships of trust, built up through several interviews with the same migrants, also made it possible to observe some parts of their daily lives. Invitations would come our way, for instance, to parties or shared leisure pursuits, and we would accept them.

In addition, the work of two non-governmental organizations was observed in Berlin. An interviewer worked once a week for several weeks as an assistant receptionist at Malteser Migrantenmedizin (the St John medical centre for migrants), which gave her good insight into healthcare problems and options for migrants without papers. She also attended various meetings of support groups on several occasions, which gave her a deeper understanding of the problems faced by irregular migrants.

3.5 Conducting the interviews

Originally we had planned to devise an interview guide for both employers and employees and to conduct interviews focusing on specific themes. It soon became clear that this approach indeed made sense for the interviews with employers. The interviews began with questions about what considerations had led them to take on domestic help (a cleaning lady, a nanny) and how they had recruited somebody; how the employment relationship was initiated and organized, and how it was functioning at present. Informants were then asked to describe the types of communication that took place (e.g. whether present or absent during the employee's hours of work, notes left with instructions, usage of notebooks or telephone calls) and, more generally, to reflect on the nature of the employment relationship.

An interview guide for the employees had originally been devised as well, but it proved not to be an adequate means of pursuing the research question of how migration, transnational motherhood and life as an irregular migrant had shaped or changed their identity. It was necessary to apply a method that did justice to the continuities and discontinuities of their life paths, and how these were managed. We decided to elicit an autobiographical narrative using the narrative interview technique (Schütze 1984), i.e. to ask informants to tell us the story of their life. This request allowed the interviewees to narrate their biographical transformations (Schütze 1981; Fischer-Rosenthal 1995; Breckner 2005; Breckner et al. 2000) in the course of organizing and processing their experiences.

In most cases, a number of follow-up interviews were conducted, which served more detailed enquiry by means of questions designed to prompt supplementary narratives. These enabled us to understand how the person in question had coped with biographical disruptions, mobilized individual or collective resources for the process of migration, positioned herself in the new society and handled various new events in her life. The interviews with migrants lasted up to five hours, while those with specialist advisers and employers lasted two hours on average. All were transcribed word for word and subjected to textual analysis.[9]

All but one of the interviews with eastern Europeans were conducted in German. In contrast, only one interview with a Latin American informant was conducted in German, all the others taking place in Spanish or Portuguese with the help of a translator who had been trained as a co-researcher.[10] Most of the eastern Europeans we interviewed had a fairly good to excellent command of German, but all these interviews contained linguistic inaccuracies and grammatical errors that were reproduced in the transcriptions. The interviews conducted with the Latinas and one Polish woman in their mother tongues, however, had a different quality in translation (into German), since they reflected the full nuances of a mother-tongue narrative. In order to remedy the apparent variations in verbal competence due to these different processes, the language of the quoted material was smoothed out considerably in the course of presenting the data.[11]

One objection to this practice, of course, might have been that much of what is authentic was lost; for example, the creative ways in which non-native speakers expressed themselves in German. Many informants impressed with their linguistic inventiveness, turning idioms and turns of phrase from their mother tongues into very telling German descriptions. However, the linguistic analysis of such inventiveness would have exceeded the bounds of this study, and therefore had to be put to one side. The main focus here was to present the phenomenon of domestic work and those active within it. A further argument in favour of linguistically smoothing the interviews prior to presentation is that language functions as an instrument of power and, at the same time, an expression of social hierarchies.[12] In public discourse on migrants and migration, linguistic assimilation – that is, a perfect command of standard German – continues to be regarded as the expression of a willingness to integrate. An imperfect command of German thus becomes a marker of a socially weak, subordinate position.[13] The last thing we wanted was to entrench this positioning

by relaying the migrants' linguistic errors, thereby underlining their precarious social status and vulnerability. It will become clear in the course of the book that migrants by no means see themselves as weak, helpless or even unfortunate, but engage actively with their social environment, of which communication is very much a part. Most of our migrant interviewees with a command of spoken German had managed to acquire this without any formal language tuition.[14]

For the purpose of the transcription, the interviews were anonymized, generally by inserting pseudonyms chosen by the informants themselves. Subsequently, a contrasting case selection was carried out, then the key interviews we had selected were evaluated using the hermeneutical method of interpretative case analysis (Rosenthal 2005; Völter 2003; Breckner 2005).

Our description of the empirical procedures will now be concluded with a few considerations on biographical theory.

3.6 The exploration of transnational migration biographies

The central question in interpreting the employees' autobiographical narratives was whether, and if so, how, their migration had influenced the meaning-horizons of their biographies. In what ways do experiences of migration impact on identity issues? When and where are questions of belonging and exclusion posed in a way that specifically associates them with migration? When in a person's life is migration presented as an experience of continuity or discontinuity, i.e. when does it dominate their autobiographical narrative, and when is it subordinated to other life events (marriage, a family, etc.)? Such questions must be answered for each specific case; but from these it is possible to derive 'typical' migration trajectories and their notable variations by gender, age, class or ethnicity, because these accumulated layers of personal experience provide a window on both collective and individual stocks of knowledge.

Biographies also reflect structural barriers and stumbling blocks that may require the abandonment of purposive action schemas, so that an individual can no longer act but only react. They shed light on the response of (institutionalized) society to such 'non-standard trajectories' (Riemann and Schütze 1991; Schütze 1996) and on actions intended to overcome them (see Chapter 7 in particular). As we shall see, analysis of the autobiographical narratives further suggests that migration and illegality do not in and of themselves either constitute or trigger critical events in a person's life. Rather, biographical analysis must be used as an aid to analyse the specific experiential contexts,

from which it can be inferred how biographical discontinuities are embedded in the overall structure of the life story (see Breckner 2003, 2005; Rosenthal 2004, 2005).

For the analysis of transnational biographies, it is advisable to follow Roswitha Breckner (2003: 242) in distinguishing between two important development and processing forms: on the one hand, migration may become 'a symbol of the *uprooted* life' (original italics); on the other hand, it may be seen as 'a highly relevant but essentially goal-oriented means for the continuation of the biography'. Into which of these modes of experience the life story is embedded depends on the individual's biographical resources and competencies, e.g. any past experience of discrimination, status loss, etc., but also on whether or not institutional procedures for the recognition of biographical competencies exist in our society. Since even in modern societies transnational migration is still viewed as a departure from 'normal biographies', it is viewed as a *special case*, a biographical *deviation*. As Breckner rightly emphasizes, transnational migration is not tied to any specific period of socialization or education, nor does it have any socially defined setting, for it can occur at any time of life. It is therefore *transversal* to other experiential contexts. In the formation of identity – this is also important for the adult migrants we interviewed – migration is generally not associated with rites of passage, nor are relevant achievements celebrated at any point in time. In other words, there is no socially underpinned recognition procedure, no biographical set of rules that make it easier for individuals or groups to deal with the experience of migration. This is true not only of Germany and other countries of destination, but also of the migrants' societies of origin, in which the domestic workers' remittances are welcome but the attitude towards these women (and men) is very ambivalent.

One common feature of all autobiographical narratives is that they are told retrospectively, with the benefit of hindsight, and are thus coloured by the current point of view and today's insights into the course of the narrator's life. In our case, this means that migrants look at themselves not only from the normative perspective of their society of origin, but also through the eyes of the society in which they are now living and working. The two perspectives are not necessarily compatible, which can result in friction. Some present their biography as an emancipation project, while others emphasize coming to terms with diverse experiences of loss. It is our view that, with the help of autobiographical narrative, action-perspectives for 'doing biography' (see Bukow and Spindler 2006) may indeed be uncovered and analysed.

However, the main problem of analysis in relation to transnational biographies is that, over and above the narrative, the possibilities are distinctly limited for reconstruction of the 'lived biography' (Rosenthal 1995) – i.e. analytical confrontation of the narrated material with historically contemporaneous, socially relevant events, regional and collective references – especially if, as in this study, the investigation focuses on a number of different countries of origin.

Thus, studies of this kind stretch the available analytical methods beyond their limits. Here it would certainly help, as the anthropologist Gisela Welz (1998) proposes, to study the 'moving targets' by practising 'roving ethnography'. Welz assumes that researchers wishing to study the mobility of migrants must themselves be mobile: 'They [migrants] do not keep still, do not remain where they were born and raised, and anyone who seeks to keep them in their sights must be prepared to move around' (ibid.: 194). It remains to be seen whether this kind of 'roving ethnography' can solve all the problems that have been noted here. It would certainly be beneficial to augment the research design with field research in the countries of origin, by interviewing family members left behind.[15]

4 | Domestic work – a perfectly normal job?

Can domestic work be a normal form of gainful employment, ask Gather et al. (2002), if it is performed within a (legal or illegal) employment relationship? It must be stated from the outset that there was not one instance of a legal employment relationship in our sample. As a rule, the employment situation consisted of cumulative part-time occupations in up to fifteen households per week, for a working week spread over seven days. The working hours in any one household ranged from two to fifteen hours a week, depending on whether the work involved straightforward cleaning, tidying, washing and ironing, or whether other services had to be performed, such as shopping and care duties in the case of elderly employers, or looking after and caring for children. Domestic cleaning was mostly done once a week, or sometimes once a fortnight (taking between two and six hours); caring for children or old people was more time-consuming, and varied with the client's needs.

Many domestic employees communicate with their employers via slips of paper, which are used to note both their own requirements for cleaning materials and any special requests the employer may have. Payment for the work done is similarly left ready for the employee; many employees who only do cleaning have a key to let themselves into the apartment. Once they have legalized their residency status, many employees combine legal and illegal part-time jobs, obtaining minimal social insurance cover from the former. Only one person in our sample can be considered a live-in employee, i.e. she lives in a room of her own in the employer's home (see Chapter 5). All the others either live in shared accommodation with one or more family members or compatriots or, as is most often the case, they live alone.

In the course of this chapter we will see that it is very rare for the employment relationship, which is based not on a written contract but on verbal agreements and trust, to become a settled status quo. Working conditions and changes have to be continually renegotiated, even if solid communication routines are established over the years. Conflict situations can arise at any time – for example, if employers expect additional services, if employees ask for a pay rise, or if there

is some other cause for irritation. The functional limits of the alliance of trust become especially apparent when a dispute breaks out that leads to the termination of the employment relationship. Such situations are described in detail in this chapter, since they point to the highly sensitive, sometimes precarious nature of the relationship.

The main purpose of this chapter is to describe the nature of domestic work from both sides involved, i.e. from the viewpoint of the employers and the employees. How physically and mentally stressful is the work? Do the different parties have a different understanding of it? And lastly, what understanding do domestic employees, who mostly started out as amateurs, eventually develop of their work and their own identity?

4.1 Introduction: the working week of a domestic employee

When asked about her typical working week, the Brazilian Gizelha Santos, who has been living in Germany illegally for five years, reports that she started out doing cleaning work seven days a week, Saturdays and Sundays included. When she developed health problems and suffered severe weight loss, she gave up the weekend jobs after about two years and passed these on to other Brazilian women. She now works Mondays to Fridays.

> Well, in the mornings I work from nine till twelve, and every day
> between twelve and one I have time to go from one workplace to the
> next. On Mondays I work from nine to twelve, take a break until one
> o'clock, then I work from one to five; there are some apartments where
> I do four hours' cleaning. And I go home at five o'clock. On Tuesdays I
> now work in F.'s storeroom from ten till six – and in the evening I clean
> the surgery.

Gizelha Santos cleans two to three households a day, in addition to a doctor's surgery. For her fellow-countryman F., who runs an import-export business for clothing from Nepal and Brazil, Gizelha Santos does a full day's work packing items of clothing. Unlike with her cleaning jobs, she continues to be paid even when F. has to be away on business, often for several weeks at a time. She is also allowed to use the telephone there. In people's homes, she usually works alone and receives neither holiday pay nor a Christmas bonus; periods of inactivity due to the employer's absence (on business or vacation) are unpaid. So Gizelha Santos manages six to nine pure working hours per day; moreover, in a large city like Hamburg, travelling between workplaces can take up to two hours. The trajectory of her employment career is

typical in the sense that most migrants accept any work that is offered them to start with but, over the years, work towards establishing a clientele that requires little or no weekend or night work.

What exactly happens during a domestic employee's day? What is the nature of the work required of her? To ensure that the working environment of the household is not taken for granted as something with which we are all familiar, we begin by looking at the terrain through the eyes of the domestic employees.[1]

4.2 The order of things in de-ranged homes

Adam Pavel:[2]

I work for a couple. She's a journalist, he's a musician, and when I went there for the first time, I almost had a heart attack. It was, it was just *unbelievable*! They have a big apartment, right, nearly 200 square metres. In the whole apartment there is *one* cupboard – yes, *one* cupboard. And two clothes rails. And the woman is – how shall I put it? – a fashion doll or something like that. She buys new outfits almost every week. The way it works is that I stay out of the bedroom; I ignore it because from the door, all you can see are piles and piles of clothes. It's the same in the corridor with the shoes; there are, I don't know, I haven't counted them, but there must be around 60 or 70 pairs of shoes. And then, coming into this apartment, I went into the kitchen. She quite likes cooking and I can't understand why she doesn't have a proper kitchen; all there is is a stove, a sink and a little table. And all over the floor there are piles of crockery, just stacked on the floor. Everything in piles, no cupboards! Isn't that incredible?!

The introduction to this household is like a scene from a film. Like a camera, we pan around a large Berlin apartment inhabited by a busy couple. We see piles of clothing, shoes, crockery, pots and pans. No order of things can be discerned; there is no 'system of classification that assigns each object a specific place within a larger order', as it was expressed by the French sociologist Jean-Claude Kaufmann (1999: 19). A sense of disorientation and bewilderment creeps up on us. In this apartment, no visible order has been predefined; one will have to be created. The first task to be accomplished here by the domestic employee, following Kaufmann's line of argument, is the imposition of civilization: establishment of the most elementary forms of order and cleanness. Adam Pavel describes this as 'tidying up', assigning things a place, in order to gain even a preliminary overview:

And, hmm – I've already been there a year and a half. I've put the kitchen in order, somehow.

I: How did you do that, then?

Well, I shifted some old shelves they had, put them in there – stuff like that. Hmm, and then, the living room I can clean after a fashion, but not properly, because one side is full of shelves with CDs and records. Because he's a musician and constantly needs them, for some reason. So they're all over the floor. And every time, you have to pick them up every time, and – it's, it's so grim, it just kills you.

The dramatic quality of this description may be explained by the fact that Adam Pavel used to work in theatre, and counts many people from that world among his clientele. But there is no reason to doubt the veracity of his account. The flat he describes resembles a second-hand shop or a storeroom. Before any cleaning can be done at all, chaos must be eradicated and an agreement reached about what tasks can be performed. Adam Pavel looks back contentedly:

Now, after a year and a half, the way it works is that I go straight from the front door to the kitchen. First I clean the kitchen, then I clean the bathroom, then bits of the living room, then bits of the dining room; I can't get into the study, because there are piles of paper, books and stuff all over the place. You can just about see a computer at the back, through all the stuff. And in between, there's also a clothes airer. And it will be full, with the same clothes, for two or three weeks. And in the bathroom there's a huge pile next to the washing machine, and it's always the same size [laughs]. It's bigger than me [laughs] – it's unbelievable. And – hmm, at first, I always felt I had to put the flat in order, or something. Now I just ignore it. I know they're satisfied if I clean the important things: the stove, the sink, the bathtub, the toilet and the floor. I vacuum round everything – and that's it. It takes me four hours, once a fortnight.

When employees step into a private household, they enter unfamiliar terrain and they are almost always in for a surprise. They take their own ideas of order and value systems into a different system, which they first have to discern and then understand, respecting its aesthetics and functional principles. The employers stipulate the rules, or – as in this case – stand back and leave it to the domestic employees to figure out what is expected of them. With regard to the employers described here, Adam Pavel has to create a system of order without giving free rein to his own aesthetic categories and sense of order. He

must learn to accept that any radical move to create order in line with his own ideas would involve too much effort, and would last only if the employers themselves were to embrace this imposed order and the maintenance of it. As he cannot expect that to happen, Adam Pavel tries to find a way of creating acceptable working conditions for himself. To keep his workload to manageable proportions, he excludes certain parts of the home (study, bedroom) from his domain of responsibility.

Although we are dealing with an extreme case here, it gives us some insight into the challenges that arise in every household, especially if the clients are academics who do part of their work in their private apartment. The 'order of things' on the employer's desk is usually not identifiable to the domestic employee; any disturbance of the chaos could even spark a serious conflict. The same applies to bookcases, to the interiors of wardrobes, kitchen cabinets and other cupboards, and to the overall arrangement of an apartment. This means that when a domestic employee enters an employer's apartment, value systems and ideas of order are activated on both sides, but it is the employees who have to accommodate any compromises. For them, the start of any new employment relationship demands a high degree of tolerance, sensitivity and adjustment of personal standards, although this does not necessarily exclude long-term negotiations and a learning process on the employer's part. Here is the account that Adam Pavel gives of another employer:

Yes, I told her: 'I really like you – but the *ideas* you have are *so* annoying!' You see, she started to collect old metal toys, for some reason, chickens. And they'd be scattered all over the place. Forty of them on one shelf. And each time, you have to tidy and dust them – it's annoying, it really is! And then other ideas she gets: for example, a rug in the bathroom, a shag pile rug, a flokati with hairs 25 centimetres long. And every time she stepped on it with wet feet, the hairs stuck to her. It was red, this rug, dark red. So the hairs stuck to her feet, and when she went from the bathroom into the apartment, she trod the hairs everywhere. And after three days this red fluff is everywhere. In every nook and cranny. And, the first week she had the rug, she didn't realize anything like that could happen. She called me on the third day, and was really quite unfriendly, and asked me what I'd been doing. Whether I'd actually done *anything at all*. These red hairs were all over the apartment, three days after I'd been in. I told her: 'it's normal, it's what happens'. So she vacuumed it up herself, but after three days it was back again. And now the rug's gone. That was another campaign of

mine. I said: 'Listen, you'll go into the bathroom one day and there'll be a 20-centimetre bug in the rug, looking up at you.' And she [laughs], she's really afraid of spiders and bugs, for some reason – I knew that [laughs].

This description of an employer differs greatly from the first. In the previous case, things first had to be put in order, whereas here the existing order keeps changing, which brings about additional problems. The employer collects objects which from the employee's perspective are just dust traps that add to the cleaning time. Adam Pavel has to resort to a ruse to solve the problem of the shaggy rug: he is aware of his employer's phobias and applies this knowledge to improve his work situation. Thus, a knack for observation, some everyday psychology and an intuition for the right moment to make a stand are vital skills when cleaning other people's homes. From the cleaner's point of view, many employers simply lack any practical sense or personal experience of cleaning; they would look differently at the materiality of their home and the practical obstacles in the way of maintaining their chosen aesthetic if they could see things from their employee's point of view. Here is Adam Pavel again:

> If they did any cleaning themselves, they wouldn't put little trinkets all over the place because it makes wiping down the shelves *un-believ-ably annoying*! On top of that, you have to watch out that you don't break anything. *That's* annoying as well. That she has, I don't know, 50 different bottles in the bathroom with different perfumes. Every time, I have to take them all off, dust them, and put them back. And what happens if I accidentally drop one? And that's really, really bad for my nerves as well.

Items that employers regard as hygienic, decorative or self-representative, or which give expression to their personal aesthetic and thus create identity, are viewed from the domestic employee's perspective as hindrances or irritations which make working in this place more difficult. Homes where the employer has a fetishistic relationship to objects and develops an exaggerated sense of cleanliness are considered especially problematic. Adam Pavel described one male client, actually an employer he had found for his sister Sylwia when he had helped her to come to Berlin and find work:

> It's an almost empty apartment, a perfectly clean place. But both the men there are really fussy somehow. And after she's finished cleaning, he comes round in white gloves and checks everything. And if an object

has been moved, it has to be put back exactly where it was, to the centimetre.

This employer is described as 'sick'; but Sylwia Pavel is dependent on the work and has to put up with such treatment until she has broadened her clientele enough to choose whom she wants to work for. Although every domestic employee reported one or two homes of the former kind, they are usually regarded as the exception. Gizelha Santos describes them as 'crazy' (*louco* in Portuguese):

> Yes, most of all the, the kitchen – dirty and, well, just kitchens where lots and lots of work has to be done. And everything lying around on the floor, their things, clothes, books, everything, lots of things, all over the floor. Always on the floor. ... I can't vacuum there if everything's on the floor. *That* is annoying! I can't begin to understand, why people do that ... crazy. So actually it's two jobs in one – because I can never arrive and just clean, because there's a yogurt carton and a spoon on the floor, and I have to pick up clothes and put them on the chair; somehow I have to pick things up, if you know what I mean, before I can start cleaning.[3]

She confirms here what has already become clear: the job is made up of several tasks that need to be performed. Creating a system of order (*ordering*), re-establishing that order (*tidying*) and, finally, the *cleaning* of various objects. The word *verrückt*, used in the German transcription to translate Gizelha Santo's *louco*, also has the sense 'deranged', which very appropriately underlines the point that things seem out of place and unstable, i.e. literally 'de-ranged'. 'Crazy' or 'deranged' may equally well be a description of the employer's eccentric lifestyle or unusual working hours, which can also have a negative effect on the employment relationship.

Self-employed people and academics often inform their domestic employee at short notice that they are going abroad for an extended period and will not need his or her services for quite a long time. As a rule, this means a loss of earnings for the employee and an interruption of the employment relationship.

What is striking in the above accounts by employees is that certain tasks are described as 'annoying'. This refers to tasks that exceed routine work and require additional activities, such as dusting newly acquired decorative items or picking up clothing and other objects left lying around, etc. It can be deduced from this that employees develop a mental map of the objects that define their routine tasks

in every household. Anything that is added or exceeds the routine is bothersome. However, before this mental map takes shape, there must be a process of familiarization with the given order of things. Here is an extract from a participant observation report filed by the researcher who accompanied a domestic employee and shared her duties.[4]

> I carry the vacuum cleaner from the cellar to the top floor, which is quite hard. U. makes a remark like, 'Hard, isn't it?' Upstairs, she takes over the vacuuming, and I'm meant to do the dusting. I dust the corners of the room, then the stairwell. As time goes on I see the house and the work from a different perspective. You tidy things, clear things away, look what needs to be done next, check things off, then you admire the results with a certain satisfaction. In a way, I'm making the house my own, and suddenly I'm no longer bothered by colours and shapes that I found ugly at first. When I look closely, they actually go quite well, or I'm getting used to them.

4.3 Cleanness, disgust, shame

Anita Borner:

> Imagine you need a home help. You look for someone you can simply give your house keys to, and you can be sure she won't open your drawers or your letters, and you'll come home and find everything tidy. It's very hard ... She's supposed to fold your underwear, do your bedroom and make your bed – can you imagine what that's like? That's really very specific. We go deep inside people's private, personal lives. Deep inside.

In her famous study *Purity and Danger* (2002 [1966]), Mary Douglas argues that there are considerable cultural differences in the concepts of cleanness and order, and that these play an important role in the organization of a society. The assessment and production of cleanness, as well as handling intimate spaces (bedroom, bathroom, toilet) and objects (sanitary items, underwear, cosmetics, erotica), are sensitive matters for domestic employees.

In this fragment, Anita Borner refers to the special nature of personal services. It is necessary to win the trust of employers, to give them a sense of security that their home and the valuable objects within it, as well as the knowledge accumulated there, will be treated with care, respect, and far-sightedness. Intimacy and taboos have to be dealt with. Overcoming reservations and ironing someone else's underwear or getting a stranger to iron your own can be very dif-

ficult, as becomes evident in a report by a researcher (see above) who describes a working day of the domestic employee Ursula Hell, whom she is accompanying in her work. The present employer (A. = Andrea Landau) instructs the researcher on the task of ironing, which takes place in her study:

> A. shows me the ironing things. She explains that her daughters insist
> on her ironing their things, at least a little. She hates ironing. When
> I say, well, maybe the daughters could start doing some ironing, she
> explains that they did want to, but they could only do it while she stood
> over them, and that went too slowly for her. She feels a little embar-
> rassed that I'm now doing the ironing for her, but she adapts to it
> pretty well and sits with her back to me working at the computer while
> I iron her daughters' things and her husband's underpants.

This fragment makes it clear that the process of looking after and bringing up children involves, among other things, processes of nego-tiation that develop through dealing with dirt and cleanness. In this case, the employer feels obliged to justify her task assignment – not least because she knows that the researcher is an academic of roughly the same age as herself, with a child of her own. One of the levels addressed in this account is the question of whether parents consider it necessary, or have the time and patience, to instruct their children in the production of order and cleanness ('it only worked when she stood over them, and that went too slowly for her'). More on this in a moment.

Many employees stated in the interviews that it was new for them to work in someone else's home and that they had to learn how to deal with this gradually, but that their socialization had equipped them with good qualifications for the job. Anita Borner, for example, says:

> Of course, I know a lot of things already from Poland. Well, as women
> in Poland, as young girls, we're still prepared for housework. That's the
> mentality there, every woman must be able to do that. ... Women *must*
> cook and keep the house clean. We have it in our blood, so to speak.
> Of course – this is funny too – we don't have as many stain removers as
> here, but we still know the natural method. Anything to do with stains:
> if you have an ink stain, you just use fresh lemon juice. Or if it's dried
> on, then use milk and hot water. Lots of things like that I know from
> back home.

Anita Borner is among those who emphatically point out that such work is bound up with specific knowledge that they have had to acquire through lots of effort:

This job needs knowledge, too. It's not like lots of people imagine: that you can just walk in and get started. That's wrong. I know exactly what I can use on marble, antique furniture or silverware, what and how and why.

Through her socialization, Anita Borner, who will be introduced at greater length in Chapter 6, has acquired skills that make it easier for her to deal with 'marble, antique furniture or silverware'. Although she says that, when necessary, she also uses natural methods, she and many others insist on having the right tools and cleaning products to perform their job as well as possible. She describes one conflict that arose:

I work for one family, and they're environmental protectionists: all the cleaning products are made from natural ingredients. And of course they just don't work; for me that's not protection. I use twice as much water and twice as much effort, but the effect is as good as zero. Zero point zero. For example, there was mould in the bathroom, in the shower, and I said: 'There's a special product for mould.' – 'Yes, but it's toxic! You should scrub it instead.' (We call each other '*du*', that's not a problem. 'You [*du*] should scrub it.') And I said: 'Listen, I'm also under environmental protection.'

This is a good example of the conflict over the limits of what is considered reasonable. Unlike maidservants a hundred years ago, today's employees are able to point out that modern cleaning products may be more effective than scouring sand and plain water. The quotation also shows, however, that it is not always left up to cleaners to choose which cleaning products they use. For employers, cleanness and cleaning products are one aspect of their lifestyle, of their familial habitus, just like food, clothing, taste and aesthetics. As a rule, they have a very clear idea of what does *not* fit their lifestyle: ecologically minded employers reject chemical products, and so their employees are not allowed to use them either. The objection of ineffectiveness and increased physical effort – which Anita Borner raises in the quotation – does not seem to be accepted at first as a counter-argument against ecological principles. Although there is evidently a relationship of trust between employer and employee ('We call each other "*du*", that's not a problem'), this does not mean that Anita Borner's point of view is taken on board by her employer. Only when she points out that people are also part of nature and should be treated with care and protected ('I'm also under environmental protection') is there a

change of attitude. Anita Borner describes her refusal to bow to her employers' rules as a 'strike': 'Sometimes I also have to draw a few lines. And funnily enough, my sense of pride helps me to do that.' In confronting the employer's value system with this pride, she questions that system and immediately demonstrates its absurdity. Especially those domestic employees who value the quality and professionalism of their work emphasize that they demand the provision of good cleaning products from their employers. Adam Pavel says:

> But things work a bit differently in each place, because people have particular preferences. I have apartments where they only want organic products, for example, then of course they have to buy them. For other apartments I buy ordinary cleaning products at Schlecker's or a drugstore.

Some employers obviously have no time for shopping and leave the money out for the domestic employee. In such cases it may certainly be said that the employer regards the employee as a service provider, who – like a handyman or a chimney sweep – goes to work with his own implements and tools, which he brings and maintains himself. But many employers know perfectly well which products and implements are used for cleaning, because they make them available themselves. Adam Pavel reports a disagreement over whether kitchen roll can be used to clean glass or tile surfaces, referring once again to his sister Sylwia:

> We often use kitchen roll for mirrors and glass surfaces, or to dry the toilet, bath and washbasin. Because for me, it's more hygienic than using cloths. And it was, in one of Sylwia's apartments, that was a problem. She wasn't allowed to use kitchen roll because it was too expensive. Because she, one session she used up half a roll. Half a roll – and that was too expensive for the woman.

The employer had explained to her that, after all, there were enough cloths in the house for cleaning. Sylwia resolved the conflict by buying kitchen roll out of her own money, thus bringing along her own materials.

Particularly from the interviews with older employers, it emerges that they not only have rigid ideas about cleanliness, but give detailed instructions on how the work should be carried out and keep a close eye on and control the proceedings. The retired civil servant Anneliese Metzer, for example, aged seventy-three, had used various eastern European cleaners and reported that they were 'strongly influenced

by advertising' and liked to use 'strong stuff' for cleaning. But as this was also harmful to the environment, she insisted that they should use only two cleaning products: plain soap and scouring sand:

> They are the two products that – that I think are sufficient. And then they usually go along with it. Only once I did see some – and she'd gone by then as well, Mrs K. it was; I thought, darn it, she bought that herself.

Anneliese Metzer also demands that the windows are polished with a cloth more than a hundred years old, which comes from her grandmother's dowry. She says it is woven from solid material and is boiled regularly: 'It's really properly rough, you know, and there's no fluff on it.' Older employers also insist that the floor should be washed with cleaning cloths and scrubbing brushes, rather than with modern wide-headed mops. They expect the employee to carry out the work in just the same way they did when they were still fit enough. Often the employees do not take kindly to such demands, even bringing along their own materials if they have to.

This practice also demonstrates the divergences in the feelings of shame and disgust that have to be negotiated between employees and employers. The employee's refusal to remove the employer's dirt with the materials provided in the house (cloths, discarded vests and under-pants) is a method of distancing herself. Working with rubber gloves and kitchen towels allows her to create a certain distance between herself and the employer's dirt, and points to the disgust associated mainly with cleaning the bath and toilet. Barbara Thiessen believes that, for both sides, employers and employees, the handling of dirt is a 'delicate business': 'Employing a home help makes private dirt public; habits of private life that cause dirt become known to a stranger' (Thiessen 2004: 174). She thus constructs domestic employees as strangers who are not part of the household in which they work. But our research does not confirm this thesis. On the contrary, it emerges that both sides can try to develop a practice of inclusion. According to Thiessen, the reason why German employers prefer migrants as employees is the fact that this guarantees a distance between their respective lifeworlds; they are hardly likely to meet in leisure hours, and the employer feels less scrutinized by a woman from a different cultural group. These claims are not confirmed by our interviews with employers. Rather, the interviews suggest that feelings of shame or disgust on the employee's side were not even perceived or discussed, as only a small number of employers regarded their own household from

the employee's point of view or actively engaged with their feelings of aversion. In general, it becomes clear that domestic employees regard the cleaning of various parts of the private domain as an especially demeaning activity that costs them considerable effort. Although these interviews, as with Anita Borner, repeatedly refer to the sensitive nature of dealing with intimacy, it is nevertheless noticeable that the employer's sex life is not discussed. It is true that no questions were asked about it either, but there were many opportunities to say something about the subject. It can therefore be assumed that the intimate lives of employers are either not perceived as outrageous by domestic employees and/or that they maintain a disciplined silence on this matter in their narratives. It could equally be the case that employers, for their part, make an effort to remove any signs, i.e. traces, of sexual activity. Evidently the taboo on discussion of matters of sexuality operates on both sides.

From what has been described above, it can be deduced that the home is a terrain of boundary demarcation activities for both parties involved; a place where different value systems are negotiated. This applies especially when the work involves minding and bringing up children.

4.4 What children need

As outlined in the fragment from the above participant observation report, there may be a clash of ideas about children's upbringing in the household. With her objection ('well, maybe the daughters could start doing some ironing'), the researcher expresses the view that children should be trained to take care of their own clothes. Here is another quotation from the same report:

> We begin the cleaning in the twelve-year-old son's room. A lot of stuff
> is lying around on the floor, and clothes are just tossed down. I wonder
> whether a home help can find it humiliating, having to pick up and
> fold a little upstart's clothes.

None of our interviewees described such activity as 'humiliating'. However, there is a widespread view that a child who is not taught to clear things up after himself will never learn to do so later in life and will end up living in the kind of 'de-ranged' home described above as an adult. In the case observed by Völter of the Landau family, who have been employing domestic help for seventeen years, Mrs Andrea Landau reported that she had never had much of a sense of dirt or untidiness, and that she now recognizes the same attitude in her

son. She thereby declares this trait as a social legacy and legitimizes it. Thus, in the Landau family, as with many other employers, it cannot be assumed that protests on the part of a domestic employee would lead to changes in their child-rearing practices; such requests are usually not even made in the first place. Employers also use lack of time and patience to legitimize why they do not intervene in their children's upbringing and instead leave the domestic employee to keep the children's rooms tidy. Ursula Hell, the Landaus' domestic employee, reports that their twelve-year-old son praises her for her work when he comes home: 'What a lovely job you've done, Ursula!' Such an account does not point to feelings of shame or guilt, but rather to the son's internalization of an employer's attitude at his young age.

Problems of a different kind occur when the domestic employee cares for infants. Gudrun Bäumer is a single mother working on her doctorate, and for some time Sylwia Pavel has been caring for her young child four times a week. This baby-minding arrangement gives rise to problems.

Sylwia Pavel:

> Hmm, she's very fixated on the child. To start with, she barely put her down, even to go to the toilet, almost. It was really – not normal. There were problems with the pram, because Gudrun always carries Katy on her back.

The child would start protesting as soon as Sylwia Pavel put her in the pram, since she was not used to a lying-down position without physical contact, and would start screaming.

> Hmm, and then there were other problems. For example, Gudrun wanted me to take the baby to the park; but there's nothing interesting there for the baby to see. So she always screams there. But she was fairly calm in the street, where she could see cars and people and so on. ... Hmm, but that wasn't right, Gudrun didn't want that and – it was terrible. It was in the winter, when there's nothing at all to see in the park. Now the children are there and it's a bit better.

Such conflicts finally lead to the termination of her employment soon after the interviews. Sylwia Pavel is confronted with a child who has a strong maternal bond; special demands are made on the carer. The fragment makes it clear that mother and carer have divergent ideas about what is necessary for the child's development: for the mother it is important that the child should be taken to the park, whereas Sylwia Pavel prefers to take the child, unsettled by the unfamiliar

position in the pram, to lively parts of the city where the child would be distracted by interesting impressions. The precise nature of the conflicts becomes evident when, for purposes of contrast, the mother's perception is consulted. During the period of the study, Gudrun Bäumer has childcare support not only from Sylwia Pavel but also from her mother (who has to travel several hours by train), and a German woman who is paid under a Berlin Senate scheme for single parents.[5] Gudrun Bäumer has worked out different time slots for the three women, so that she can dedicate as much time as possible to preparing her doctoral thesis. The Senate-funded childcare by the German woman covered three weekdays, while the other weekdays and the weekend were divided between Gudrun Bäumer's mother and Sylwia Pavel. Gudrun Bäumer had employed Sylwia Pavel to do the cleaning, and then took her on as a 'baby-minder' when she learned that she too was a mother, whose five-year-old son was living with her mother in the Czech Republic. Gudrun Bäumer:

> When Sylwia was out with her, I could never really settle. A few times, I actually had little panic attacks here. What's she – what might be happening with my child, you know. So I called her on her mobile phone and asked: 'Where are you right now?' And she said: 'On Mollstrasse.' And I thought: Mollstrasse? Isn't that that four-lane thundering highway down there, what's she doing with my child on *Mollstrasse*? But she couldn't explain it to me either. The next day I called her again on her mobile, and somehow or other she was on Alexanderplatz. I thought, this can't be for *real*! That's not on, for me to be paying her quite good money for her to – go shopping – on Alexanderplatz, dragging Katy round the department stores.

Rather than trusting her baby-minder, Gudrun Bäumer checks up on her via her mobile phone. She is angry that Sylwia Pavel apparently does not stick to the guidelines. A fierce argument seems to have ensued (Sylwia Pavel: 'It was terrible'). Gudrun Bäumer accounts for the disagreements in terms of Sylwia Pavel's inadequate command of German; in her view this makes communication between them impossible. Gudrun Bäumer, who continually compares the childcare arrangements she has with the three women, cites the high hourly wage she pays Sylwia Pavel (eight euros[6] – which is less than the ten euros she pays for cleaning) to justify her disappointment that Sylwia Pavel is ignoring her wishes and resisting her instructions.

In contrast, Irene Heiser, the older, Senate-funded German woman, conforms completely to her ideas. She had always 'asked about every

little detail'; she is 'kind', brings presents for mother and child, cooks for the child and washes up: 'she fits in with us'. Gudrun Bäumer, who lives in West Berlin, stresses that Heiser is a 'tough' East Berliner.[7] As a mother of four children and as a grandmother, Irene Heiser has already gathered plenty of experience. Gudrun Bäumer emphatically refers not only to the difference in systems (between East and West) but also to class differences: Irene Heiser worked in a biscuit factory, various (large) kitchens and a snack bar before she started in the Senate's childcare scheme. She comes from a different world, but takes great interest in her employer's world. She has had disagreements with her over child-rearing principles – for example, about the importance of cleanness and dealing with the child's aggression. While Gudrun Bäumer still breastfeeds her child, believing in a kind of free upbringing that leaves the initiative for the next developmental stage to the child, both Irene Heiser and Sylwia Pavel are critical of this approach. But Irene Heiser's objections do not seem to arouse nearly as much emotion as those of Sylwia Pavel. 'Irene Heiser', Gudrun Bäumer says, 'has a *real* employee's soul, through and through! She doesn't mind carrying out instructions in the least – and doesn't get into battles about her own way of seeing things.' In other words, the childminder Irene Heiser is obliging and affordable, and adapts well to Gudrun Bäumer's life. By contrast, Sylwia Pavel apparently lacks 'a real employee's soul' and is seen by her employer as more of a rival. Gudrun Bäumer feels as if she is being watched and judged by her:

> Then, there were various – quite funny things. She probably, well, I had kind of noticed she was thinking: Huh, her and her weird child-rearing – *whims*, you know, ideas. But it wasn't especially a problem. It was just a – you only notice it when you're dealing *directly* with each other. Over food, for instance. Over food – now *there* the trouble was that she mixed these weird porridges and I said, *no!* The child mustn't have milk, OK, and she thought that was – *whaaat?* How come the child mustn't have milk? Well, she didn't have any cow's milk for the first year – that's the latest *Bessi* advice on nutrition. Because of allergies and so on. But that hasn't got through to Czechia yet. And – well, that was why I had to put up with the baby-minder giving me strange looks, *too*. Because I only buy – rice milk, and don't give the baby sweet pap with milk. Ah, well.

This fragment again highlights the highly complex, ambivalent relationship between employer and employee. Initially, the employer seems by no means insensitive to the other's perception of her, to Sylwia Pavel's (imputed) point of view, which she tries to present as

trifling ('quite funny things') at first. At first glance, she seems perfectly capable of seeing herself through her childminder's eyes.[8] She refers ironically to her own child-rearing ideas as 'whims', scorns them as weird, and denigrates the organic nutritional guidelines as '*Bessi* advice on nutrition'. At the same time, however, the perspective shifts with the mention of '*Bessi*', which modifies the German word for 'better' (*besser*) to rhyme with '*Wessi*', the colloquial term for someone from western Germany. This evocation of the former East–West divide makes it clear that Gudrun Bäumer is constructing her baby-minder Sylwia Pavel as a stranger, objectifying Sylwia Pavel as 'the Other' that she encounters in her own home, as an intruder. Finally, Gudrun Bäumer exposes the *ignorance* underlying Sylwia Pavel's perception of her, associating this with her country of origin and grossly denigrating it in the process ('she mixed these weird porridges'; 'but that hasn't got through to Czechia yet'). The fact that she speaks of 'Czechia' rather than the Czech Republic[9] leads one to suspect that she has taken little or no interest in Sylwia Pavel's homeland. The quotation also hints at the fact that Sylwia Pavel is not the only person who criticizes Gudrun Bäumer and causes her to justify her dietary prescriptions ('the baby-minder giving me strange looks, *too*'); but criticism from the 'baby-minder' appears to be especially unacceptable.

Her evaluation of Sylwia Pavel is not unequivocally negative, however, since Gudrun Bäumer does seem to consider the other's point of view: Sylwia Pavel has brought up a child of her own and that should qualify her for this job. If now and again her daughter 'doesn't get an organic banana' (Gudrun Bäumer laughs) while she's out with Sylwia, 'but some other kind of junk, it won't kill her or anything'. Yet the doubt evidently gnaws at her that this 'other junk' may not be doing right by her child or by herself.

These conflicts can certainly be understood as an organically minded mother's reflection on her child-rearing principles, and on the confrontation with her baby-minder, who rejects these principles. In this case, however, there is more to it. Ultimately, it becomes clear that there are other sources of tension: a confrontation between mothers of different ages. At this point in time, Gudrun Bäumer is thirty-five years old, while Sylwia Pavel, who had her own child very young, is only twenty-five. For Gudrun Bäumer this is obviously a problem. She does not yet feel herself to be a 'fully *mature*, adult woman'.

> But I've seen myself from her – through her eyes, I've certainly looked at myself like that. The thing is, she's in her mid-twenties, but her

child's older than mine. And the way she sometimes looks at me or her general attitude, it made me realize, well, she's very much a woman in her mid-twenties, and I – it's simply that I'm ten years older. So then, in a way, I saw how I look at – I mean, how people can look at women of that [meaning: her own] age.

In her employee's eyes, Gudrun Bäumer becomes older than she would like to be; she becomes an old mother. The status she claims for herself as a young mother in need of support is thus denied her. The image of femininity that Sylwia Pavel exudes becomes an antipole for Gudrun Bäumer, and thus potentially threatening. She mentions Sylwia Pavel's looks – which she omits to do in the case of Irene Heiser – and describes her as casual, long-legged, well dressed and, above all, relaxed in dealing with the child.

Now and again, I think, she's sat down in the child's room leafing through her magazines. I wouldn't say it … *bothered* me at all. In a way, I thought it was nice that she was just getting on with something while Katy played beside her. But I've seen her down at the sandpit, reading her book there as well … and then I can't help thinking, is she actually watching, too, in case Katy puts a cigarette-end in her mouth or something?

Ultimately, this quotation highlights the insidious nature of the conflict, the discomfort of the mother who keeps looking for arguments to legitimize her own ideas, for herself and vis-à-vis her employee. Evidently she was only prompted to hire the baby-minder by a desperate situation she found herself in, and therefore did not properly ascertain how their ideas about child-rearing differed; probably she does not even realize that such a clarification might have been necessary. As Sylwia Pavel's German is still very poor at this point in time, and as Gudrun Bäumer had no interest in the Czech language, such a process of negotiation would hardly have been possible in any case. Implicitly, Gudrun Bäumer assumes that, being the employer, her views should be accepted and applied – which is how it works without any problems in the case of Irene Heiser. Even if the above quotations reveal Gudrun Bäumer's latent desire to project a relaxed and easy-going personality and parenting style, it is a yearning that she casts aside in the very next breath; it does not seem compatible with her alternative, organic conception of child-rearing.[10]

Conflicts between mothers and childminders repeatedly centre on the question of what children need, and on the ideas and ideals

bound up with a good mother's performance. Diet, physical contact, communication and attentiveness to the child (how much active attention, how much 'fresh air' does a child need?), sleeping and waking periods, toilet training, encouragement or discouragement of the urge to move around, ways of dealing with aggression: these are some of the fundamental issues that parents have to face, especially in looking after small children. The discourse on the pedagogical principles of upbringing that has taken place in all Western countries since the 1960s has favoured egalitarian over authoritarian approaches: that is, parents have been encouraged to negotiate with children in a way that requires a high capacity to explain things to their offspring and to be prepared for verbal clashes with them. The mushrooming availability of scientific advice and simultaneous popularization of (early) childhood education in the form of magazines, handbooks, radio and television programmes, parental training courses and much else besides have meant that parents (may) reach a near-professional awareness of the fact that early childhood development decisively shapes children's paths in life and any risks that might prevent optimal support should be avoided. This is especially true of (upper) middle-class parents – precisely those who employ domestic staff. In other words, parents know they must avoid mistakes if their children are to be given a good start in life.

In the terminology of the French sociologist Pierre Bourdieu, we might say that the societal value of the social and symbolic capital acquired within the family puts pressure on parents to ensure that this capital is readily and fully available to their offspring. By implication, then, a clear distinction must prevail between the lifestyle and behaviour of the private sphere, on the one hand, and the environment beyond the family, on the other. It is precisely this boundary demarcation which is potentially up for negotiation when someone is employed in the home. Well-rehearsed family actions and rituals with a solid emotional underpinning, such as carrying the child on the parent's back, have to be explained; the childminder must be told about them, or even chosen based on whether she is prepared to adopt them or, even more conveniently, already shares them. This raises the question of how class and ethnic differences are dealt with in households; the former are not new as a historical phenomenon. But given the gradual disappearance of servants from German homes around the turn of the twentieth century, dealing with class differences is no longer a standard element of know-how for the middle and upper classes. Potentially, a lack of knowledge could be overcome by drawing on historical models

or on experience of dealing with educational differences. But most of the employers in our sample have problems with a hierarchical model of society, which contradicts modern notions of equality. The 'old' hierarchical way of treating 'maids' therefore no longer works. Another difference takes its place, however, namely the difference of ethnicity, which is generally perceived – in line with the dominant discourse in Germany – as a cultural difference. This was clear in the case described above. Language plays a central role in the construction of cultural difference. Which language will be spoken with the child is therefore a major factor in the choice of a childminder. Some parents want their children to have early access to a foreign language with the domestic employee's help; usually these languages are English (see Shinozaki 2003) or Spanish, but parents of this kind scarcely featured as employers in our sample. Most employers think it important that German should be spoken with their child. As most employees do not have a perfect command of German, however, there is often a linguistic asymmetry which always has the potential to be transformed into a social asymmetry; i.e. children learn to regard their minders as linguistically deficient and begin to develop the idea that ethnicity[11] is associated with deficiency. Employees in our sample reported that they mainly sang songs in their own languages to children in their care – but, as the following case shows, even that can create problems. Olga Kovacs, a Hungarian, has been the part-time minder for the two children she speaks about here for many years:

> I went with the children to a bank, where there's a wooden rocking horse. ... I had to sort something out, and the children sat on the horse. And then they came out with a nursery song, because – I don't know any nursery songs in German, only in Hungarian. So they started singing this Hungarian song really loudly, on the horse, and the people in the bank were completely silent. And they were singing the song really loudly. At first I felt very glad, in a way; it touched my heart at first. But then I ... oh! Now everyone will notice that these children are foreigners, and that was too much. Because nowadays it's not at all, it's not necessarily an advantage, the kind of trouble I landed them in! [laughs]. That was my second thought. But now I think, who cares? It made me happy and that was that! And that was lovely.

This passage illustrates the precarious boundaries between the private and the public. Apart from the fact that even a German song would have caused embarrassment in the sober, serious atmosphere of a bank, these children (unintentionally) transgressed (secret) rules

by bringing into the public sphere a form of communication that had arisen in, and was exclusively reserved for, the private sphere. A *foreign* language is potentially a problem as soon as it is heard outside the home; such boundary-crossing may be perceived as a threat, because it steps outside the invisibility of private space. This passage provides insights into the subtle link between self-images and perceptions through the eyes of others, and their significance for the identity of those involved; about the perception of social positioning and the allied exclusion factors. Olga Kovacs fears that people around her will react negatively to public use of *this* foreign language ('Now everyone will notice that these children are foreigners, and that was too much'). To speak *this* foreign language makes the children foreigners. For, although hardly anyone would be able to tell it was Hungarian, it was obviously not an easily identifiable language such as English, French or Spanish – languages that people in this conservative middle-class neighbourhood could identify and recognize as educated languages. Olga Kovacs generally speaks German with the children, since that is their parents' wish. She immediately feels guilty that she has 'landed' the children with a defect, as if she had caused them an injury ('the people in the bank were completely silent'). As she has become highly sensitive to the symbolic significance of language and is aware that a hierarchy of languages exists in Germany, which simultaneously functions as a signifier of social hierarchies, she finds the situation embarrassing. She fears that by having taught them a nursery song in her own language, she has inflicted the ensuing social deprecation on the children ('nowadays [...] it's not necessarily an advantage'). She prefaces her account with an apology ('I don't know any nursery songs in German, only in Hungarian'), at the same time excusing herself for not having lived up to her employer's wishes. On the one hand, the quote may be read as a reflection on perceptions through the eyes of others. But it also expresses an inner ambiguity and a wish to oppose such perceptions ('At first I felt very glad, in a way; it touched my heart at first'). This gladness is immediately called into question, but Olga Kovacs ultimately returns to the first emotional response that touched her heart. The conclusion ('It made me happy and that was that! So that was lovely') sounds almost triumphant. Had her residency status been illegal, she could certainly not have reacted in the same way, for irregular migrants associate any kind of attention with fear of discovery.

This passage was intended to underscore that even when the matter at issue seems trifling, both employer and employee perform complex relationship and boundary work, in which boundaries are

negotiated between the private and the public, belonging and non-belonging, and between the moral and aesthetic weighting systems of employers and employees, and questions of acceptance or denigration are addressed. What strategies have employees developed in dealing with their occupation? What personal and structural resources do they make use of in conflicts? Does this occupation, as gainful employment, have an identity-creating function for them, or do they look for professional satisfaction in other areas? What function does payment have in this? How do employees manage to make a success of the employment relationship, or at least consider it as such? We shall analyse the case of Maria la Carrera as representative of our sample, and subsequently discuss the divergences we found.

4.5 Domestic workers' strategies: Maria la Carrera – 'la cleaner', the professional

> I'm a realistic person, with both feet on the ground. And I know my limits, and one of my limits, ever since I was little, is that I have trouble learning languages.

With these words Maria la Carrera,[12] who has been living in Germany for about ten years, begins her explanation of why she earns her living by cleaning. She cleans private homes and doctors' surgeries, because she lacks the language skills to work in a different industry in Germany: 'I clean because I can't speak,' she says.

Maria la Carrera comes from Uruguay and has a command of both Spanish and French; by now she also understands German very well. Why, then, does she say that she cleans because she lacks language skills in German? First of all it could be deduced from such a statement that she has weighed up which formal skills are necessary for this kind of work, and verbal interaction seems, to her, not to be one of them. Considering the education she received – an unfinished course in architecture and retraining as a textile engineer, both of which require manual skills but can hardly dispense with verbal communication – her estimation is quite understandable at first: the repetitive nature of cleaning work does not seem to call for much verbal communication skill at first glance. Yet, in the course of our interviews, it became clear that communication skills are an important factor in her line of work.

Maria la Carrera's emigration to Germany was not the first time she went to live abroad. As a young woman she was politically active in Uruguay together with her husband, but shortly after the birth of her daughter (whom she left in her mother's care) she had to go into

hiding for several months; she then spent thirteen years in exile in Argentina before returning to her native country.

In the middle of the 1990s, when she is already in her mid-forties, she moves to Hamburg with her then nineteen-year-old daughter. She plans only to accompany her daughter (who has fallen in love with a young German man) on the trip to Germany; it is not her intention to remain there, but to begin with she has no choice but to earn some money to repay her travel debts and to meet her living expenses. She begins to work in a hotel owned by a German female friend of hers, with whom she and her daughter live before she moves to an apartment of her own.

a) Competencies She had already got to know this woman through a politically motivated visitor's programme for Germans in Uruguay; she finds all her subsequent jobs through this contact. Once in Hamburg, Maria la Carrera draws on her previous experiences of exile in Argentina, where she discovered her special talent for creating (aesthetic) order out of disorder. An acquaintance whose flat she had helped to tidy advises her to earn money using this ability. In conversation, Maria even refers to this competency as deviant behaviour on her part, a 'quirk': she can tidy up well and now makes use of this ability. 'And if I can do all that so well – cleaning, cooking, decorating, and all that – then I can also charge a lot of money for it.' What is interesting about this description is that she does not highlight cleaning as a competency at first, but putting things in order – an artistic, creative act which helps to upgrade her occupation, or is at least viewed as having higher social prestige than cleaning.

In the past ten years, personal recommendations have found her jobs in twenty private households, a video production company, a dance studio and a cinema. While her work was limited to the cleaning of private households at first, the focus of her activity has shifted and expanded: la Carrera still cleans the cinema, as well as two doctors' surgeries and three private households (in one of which the employer is also the owner of one of the surgeries). Since she acquired legal residency status through marriage a few years ago, she is also in a position to accept work that is covered by social insurance. She is now also a cook in a café bar. With regard to her various cleaning jobs in the last decade, she says that she prefers semi-public spaces to private homes; there, she feels part of a larger work collective, an enterprise. 'You're a cog in the machine there: you're necessary, they need you.' The anonymous nature of the work – she usually works alone, either very early or very late in the day – does not bother her;

on the contrary, she feels part of something 'bigger', a community, and she is paid for doing her job just like any other legal employee. This way, she can construct a work context for herself that is based on recognition and equivalence of effort.

She describes the personalized form of work in the private home as the antithesis. Although Maria la Carrera found her work through personal contacts, and that meant that her employers came primarily from a politically or culturally active Latin American support milieu, this also seems to be the crux of the problem. Initially, Maria la Carrera is taken on by her employers because she has been recommended by acquaintances. What matters is not only the ability to create order and clean well; the fact that her mother tongue is Spanish also – perhaps even mainly – makes her popular with employers who like to speak Spanish, have travelled to Latin America or have a Latin American lover or partner. In short, she potentially has more to offer employers than a German. So Maria la Carrera cannot withdraw from verbal interaction, because it is expected of her as cultural surplus value.[13] This, however, gives rise to further conflicts.

b) Work ethic This is illustrated by the following example, in which she explains the termination of one employment relationship. An older lady, who speaks Spanish very well and is helping her translate the documents for her marriage, asks her to do three hours of cleaning for her weekly. This lady, according to Maria la Carrera, 'entertains' her each week with tea and classical music; they chat about politics, music and culture before Maria goes on to do the cleaning and ironing. Everything 'was wonderful', until the employer asks her a few weeks before Christmas to clean the windows, too – a task that her husband usually carries out. As a rule, Maria excludes window-cleaning from her 'work agreements', as she is afraid of heights. But this time, she agrees to perform this special service within the agreed time period. The next week, her employer criticizes her for spending too much time on the windows and neglecting other tasks as a result; furthermore, she had cleaned the windows on the wrong side of the house. In the ensuing argument, Maria tries to point out that there had obviously been a misunderstanding. But the employer retorts: 'You really should have known what I wanted.' 'She expected magic from me,' says Maria. After this incident, the final quarrel occurs the following week, when the employer accuses her of developing her own ideas instead of doing what is asked of her. Maria feels this is a lack of respect, discrimination, and hands in her 'notice':

Well, for me there just aren't any differences to do with profession or skin colour. Everyone who works and earns money, who gets paid for this exchange, work in return for money, deserves to be treated with respect.

This illustrates that Maria la Carrera has a clear work ethic, an idea of justice that involves mutual respect and the basic principle of anti-discrimination. Her vocabulary here reflects her political education and years of political struggle. Her politicized biography is continued in her work for the NGO Kein Mensch ist illegal (No person is illegal), for which she has given public talks. With her reference to skin colour, she is simply indicating one possible axis of discrimination. Discrimination in Uruguay is usually directed at indigenous people by people of European heritage; she herself belongs to the latter group.

A sense that she was being treated disrespectfully led her to terminate another employment relationship. Maria la Carrera works for two people who run a dance studio – a German woman, Iris Jungclaus, and a Latin American man, Jorge – and cleans both the studio and the couple's private home. When the couple separate, she cleans the single apartments that each now has and becomes a mediator between the two of them. Against her principles, she not only cleans for Jorge but also darns and mends his clothes, does his shopping, cooks his favourite meals and swaps books with him. This creates problems: he doesn't pay her monthly as agreed, but irregularly and only after she repeatedly reminds him of the outstanding sum. She finds this struggle to get her due hurtful, and eventually hands in her notice. On the other hand, Maria la Carrera realizes that she quits working as soon as possible for anyone who constructs a stark social distance between employer and cleaner. 'Some of them make you feel you're a bad person.' She prefers not to work for such a 'mistress' or 'lady of the house'.

c) Avoiding role diffusion: demarcating boundaries Although Maria la Carrera mainly cleans and irons in the private homes in which she works – that is, performs activities with a clearly visible result – she is also expected to display 'soft', communicative skills. Personal involvement brings about a certain role diffusion. What is expected of her is not clearly defined, but she is 'a bit of a friend, a bit of everything'. Maria la Carrera herself describes this as a consequence of the various household activities that are associated with various social roles: 'because you do everything in the home'. Especially in the case of employers who live alone, ambiguities arise, among other things owing

to the feeling that she is 'part of that person's life'. She seems to find this particularly hard to bear with one employer, who is ill with cancer. By leaving jobs on the pretext that she wants to return to Uruguay, she has been known to terminate conflict-laden work relationships, and is now trying to avoid situations where a personal friendship might come about.

Her aim is to develop a detached attitude in the face of diffuse expectations. She now cleans only where she can work alone in the employer's absence and does not have to converse. The difficulty of striking a balance between closeness and distance is one of the key problems in domestic work as gainful employment (see Chapter 1). Maria la Carrera now tries to take on only jobs where she can maintain a distance, and to work in places where she can understand the 'order of things', or produce it in a way that is acceptable to the employer.

By now, she is charging 14 euros an hour and is the top earner in our sample. Based on her self-conception as a service provider, she has professionalized her approach. When she is offered a new job, she pays the person a first 'visit'. She inspects the apartment, asks what will be expected of her and finds out what this potential employer's 'delicate areas' are likely to be:

> And there's a certain psychology ... everyone reveals their sensitive spot. ... it's enough for them to say, but the kitchen and the bathroom, and then I know I have to clean the kitchen and the bathroom especially well. The rest of the house only needs routine maintenance.

This calls to mind the approach of doctors and care workers on a first home visit. A case history is created, which is not limited to the facts but also includes the psychological subtext. This way, Maria la Carrera tries to anticipate sources of conflict. She states what tasks she will not perform, e.g. window-cleaning, i.e. she makes demands of her own. She thus constructs a contractual agreement for herself, an employment contract that both sides must accept and in which the expected standards are laid down.

Maria la Carrera has managed to build a solid core of employers. As she receives more offers than she can handle, she is at liberty to turn some of them down. She has worked out a strategy for avoiding the role diffusion inherent in the work and tries to establish clarity. Right from the start, she makes an effort to define boundaries, to anticipate potential sources of conflict, to name the individual areas of work and to negotiate over them. Her intention is to create a zone of freedom, within which she has relative autonomy.

d) Time management and sense of responsibility The way in which
Maria la Carrera speaks of another aspect of her work, namely her
control of her work tempo, also shows how important this balance
is for her. When she cleans offices and cinemas, she cuts short the
allocated time and finishes early; she also does this in private homes
when the employer is not there. She works more slowly when the
employer is present. She knows from experience that she will likely be
asked to do something else if she finishes her usual tasks early, and
that whenever she spontaneously does additional tasks as a special
service, the employer will come to expect them as part of the normal
service next time:

> If you normally only have to clean the windowsills or the floor, it might
> suddenly occur to you: oh, I could just do this as well, because I have
> some time left. But what can happen is that next time they'll expect you
> to do it again.

She disrupts this mechanism through the way in which she manages
her time. This is another example of her independence and a highly
developed need to avoid heteronomy. Maria la Carrera immediately
reacts to loss of control by trying to restore her freedom of action.

One important aspect of her work identity is the sense of responsibil-
ity she shows towards employers, in return for which she expects them
to have trust in her abilities. She speaks of one company for which she
cleaned in the evenings, and where she had to operate a complicated
alarm system. One day, because of an incident with another employee,
the owner suddenly asked to see her papers. Maria la Carrera had already
worked there illegally for two years and had always operated the alarm
system correctly. So she felt the employer's demand to be an abuse of her
dependent position as an irregular migrant, an act of harassment, since
the employer had known all along that her employee did not yet have
the necessary residence and work permits. Maria resigned forthwith.

Whenever her competencies are called into question or she can
no longer distance herself sufficiently, i.e. when the balance between
closeness and distance breaks down, she feels deprived of her capacity
for autonomous action. She defends herself. Interestingly, she gives
a biographical reason for this fighting spirit. As a militant leftist she
had to flee the Uruguayan dictatorship, and learned through suffering
that work is not the most important thing in life. 'I do my work and
it's my work – full stop.'

She confronts degrading or discriminatory experiences with a pro-
fessional self-conception. She does not see herself as someone who

receives and follows orders, but as a self-confident actor who offers high-grade services and claims the right to have a say in the definition of her working conditions.

For these reasons we can describe her as a professional – a qualification that she herself suggests, not least because she refers to her occupation as 'la *Putzfrau*' ('la cleaner'). Maria la Carrera did not invent this Spanish–German combination for lack of an equivalent for 'cleaner' in Spanish, but rather to express that the specific form of her work has developed in a German context. 'La *Putzfrau*' has become the term she uses to describe her way of life and her work identity in Germany. By using the foreign (German) self-designation, she also manages to establish an ironical distance (see Lutz and Schwalgin 2006).

4.6 Provisional conclusions: limits on professionalization

This case has highlighted examples of aspects that are also cited in the professionalization discourse and regarded as necessary: managerial talent, diligence, psychological know-how, empathy, patience, perseverance, tolerance of frustration, a sense of proportion, discipline, self-reflection, emotional intelligence and a good memory. In other words, what really matter here are social qualifications, the ability to perform emotional work alongside the practical elements of the job. Striking a balance between closeness and distance, patience, care and empathy is the core of the social skill-set necessary for carrying out this work to the employer's satisfaction. The six aspects that have been expounded in this case description – competencies, work ethic, avoidance of role diffusion through boundary demarcation, time management and a sense of responsibility – are all elements of a self-constructed professionalism. They accord with a rhetoric in which 'service providers' deliver 'a perfect product' to their 'clients': the work acquires a higher value through being defined as a contractual arrangement akin to a business relationship. This reflects a highly topical form of the management of difference, which, as this project makes clear, has become necessary in the private as well as the public sphere. Here, too, we can see that even if migrants like Maria la Carrera do not have a good command of the German language, they are able to develop a sharp sense of hierarchies and the finer nuances of their employers' discourse. Such an attitude or viewpoint should not necessarily be interpreted as accepting the way they are constructed by others, although it certainly involves an element of this. The attempt to create distance by defining the work as a professional activity can nevertheless be regarded as a more or less successful attempt to sep-

arate work identity from other aspects of identity. But this construction nevertheless remains a sensitive one: for a friendly relationship may develop (unintentionally) between employer and employee that is always in danger of breaking down because of the kind of conflicts described above; or else the employer may become seriously ill and the domestic employee may feel morally obliged to help and support her. The death of an employer can trigger deep feelings of despair that the employee has to handle by herself. Since this employment relationship is marked by personalization, it may at any time become precarious. In contrast to the case of the professionalized employee, a number of domestic employees prefer to think of themselves as 'part of the family' – and are actually referred to as such by their employers. There are echoes here of historic variants ('our little gem'). Such employees stress that it is important for them to feel 'needed'. Their identity is created through a personalized work relationship that emphasizes mutual loyalty and dependence.[14]

All the interviewees in our sample sought to develop a professional attitude to their work.[15] Nevertheless, all had problems in maintaining distance in their work relationships, and a close emotional bond with their employer was the reason why some of the women kept postponing the end of their migration project.

Both employers and employees spoke of the fact that the work took place in the shadow economy, and regarded this as unfortunate, but they also went to great pains to 'normalize' the work, i.e. to characterize it as a perfectly normal employment relationship. The interests of both sides coincided here. Mark Landau, for example, the husband of the previously mentioned Andrea Landau, works eleven to thirteen hours a day as a professor and clinic director, and thinks it a 'good arrangement' that he no longer has to spend his free time doing domestic chores since he and his wife engaged their first home help seventeen years ago. His viewpoint is that employees perform a 'service': 'You do your job, whatever it is, and get something in return.' The employer thus outlines the picture of a functionally differentiated society in which each member performs a particular task and is paid for it. When his wife points out the overqualification of most of their employees over the years, which she attributes to the asymmetrical conditions in the world economy, he dismisses this point and says that he does not wish to get involved in a debate about the uneven global distribution of resources. On the other hand, he supplies his employees with medicine and, if necessary, helps them to find a doctor who treats irregular migrants. For him, as for many other employers,

this work is a perfectly normal activity. He would be happy to legalize the employment, but as yet he has seen no way in which this could be done, as many of the workers he employs do not have legal residence in Germany. His understanding of the work as a service is also common among many employees. Anita Borner, for example, says:

> In my view the term 'employer' is wrong. I always say: what employer? Excuse me, he doesn't pay any health insurance for me, I get no holiday pay, I get no insurance cover, I have to pay for that myself: I'm self-employed. They are my clients, right.

On the one hand, it might well be objected that this normalization strategy amounts to a modernized form of self-exploitation. On the other hand, the emphasis on autonomy and self-determination is the only way for domestic employees to symbolically upgrade their status, instead of presenting themselves as victims of circumstance or pawns of fate. Their normalization efforts correspond to a wish to construct a positive work identity, and hence a perspective in which they are active players. Most domestic employees do not conceal the fact that the work is physically burdensome, but they try to lighten it by adjusting the pace of work and using more appropriate implements.

In conclusion, the main question in this chapter – whether domestic work becomes a 'perfectly normal job' when it is performed by paid employees as gainful employment – can be answered with a definite 'no' for the following reasons:

- The household as a workplace is not referred to as such, since it belongs to the private sphere; it is not publicly accessible and therefore defies workplace supervision.
- The place of work is the private space of the employer. Today, private space still counts as a realm where, in contrast to public space, individuality and the personal habitus can be cultivated. Domestic work and the way in which it is arranged affect the 'safety zone' of those for whom the household is a place of relaxation and reproduction. The domestic employee must familiarize herself with the topography of private space, learn to handle 'charged artefacts' (Kaufmann 1999) and respect 'the order of things'.
- Even a semi-normalized employment relationship cannot hide the fact that a hierarchical difference persists between the institutional logic inherent in work in the private space and the logic of the formal employment system. Domestic work still tends to be a gendered activity with little prestige, mostly performed without remuneration

by women. At any time that financial circumstances dictate, it may be converted from the paid into the unpaid form – that is, be performed by women as a service to their family and neighbours. The work is not only technically and physically demanding, but also highly emotionally charged.

5 | Exploitation or alliance of trust? Relationship work in the household

The headline of the newspaper column read 'She was almost part of the family' and the strapline continued: 'Discovering your cleaner has been hoodwinking everyone is a painful reality-check'. Written by Berlin journalist Barbara Dribbusch, the piece was published in *Die Tageszeitung* (*taz*) on 13 May 2004 (p. 14). It recounted the woes of a woman named Britt, who had recently poured out her heart to her columnist-friend over afternoon drinks. The other protagonist in this story was Krystina, Britt's Polish cleaner and childminder, whom Britt had just dismissed – after 'working together' for ten years – on account of dishonesty: 'Britt did exactly that: quite by chance, she found out that for all those years, Krystina had been charging her for four hours of cleaning but had often left the house after three hours, and sometimes only two.' Krystina had been paid 40 euros for cleaning, which Britt claimed was more than the usual rate for the job. In the course of the column, the relationship that the author's friend describes as 'working together' is fleshed out more precisely: in addition to her weekly cleaning duties, Krystina also cared for the woman's daughter Anna when she was ill or when her parents went out together. She put Anna's hair into French braids and taught her a Polish lullaby. Thus, Britt thought of Krystina 'practically as one of the family', mentioning also that 'all our discarded clothes, kitchen gadgets and furniture went to Poland'.

This friend, according to the author, who could obviously relate very well to her feelings, had felt disillusioned because all that mattered to Krystina the cleaner was the money. 'Human attachments, trust, it all counts for nothing.' The article ends with the scene of Krystina dropping the door key through her employer's letterbox, watched by the author along with Britt and daughter Anna; Anna waves her a sad goodbye.

The astonishing feature of this column is not so much its content as the fact that it was published at all, particularly in *taz*, a cooperative-owned newspaper that aspires to be a critical alternative to the mainstream German press. More than any other type of article, columns are

directly addressed to the core readership of the newspaper in question and tailored to the worldview and lifestyle of its readers. By implication, then, consumers of *taz* have evidently joined the ranks of those who employ domestic help. Now lifting the taboo on this issue for left-liberals and Greens might be seen as a welcome development; however, this would mean exposing the scandal of the phenomenon as a whole, i.e. instead of dwelling on the employee's dishonesty, also examining the ethics of the employer who illegally employed a migrant.

For our context, this episode is interesting because it raises a series of questions that are important for this chapter. Employment relationships in the private more than in any other sphere are reliant on the ability to establish a mutual relationship of trust. If this is disturbed in any way and an imbalance is created, serious problems arise. Evidently communication is not the only way to solve them, and they can be brought to an end as in the above case with a so-called dismissal. Britt, the employer, felt that her trust had been abused. This trust consisted in the fact that she had given her employee the door key, and hence access to her private sphere, as well as entrusting her with the care of her daughter from time to time. Obviously she herself had construed the relationship not as a vertical employer/employee hierarchy but on a more horizontal plane ('working together'). She was defining it as a quasi-familial relationship, which was expressed not only in the reciprocal use of an egalitarian mode of address (first-name terms) but also in the transfer of discarded household chattels from Berlin to the employee's Polish household, in the function of a symbolic bond between the members of this extended family. At least in the eyes of the employer the employee's dishonesty was a rupture of the symbolic family attachment, the breach of a trusting relationship.

Is it right to assume that the employer and employee will have the same ideas about respect and trust, and by the same token, exploitation and discrimination? Or might they define them very differently? Does domestic work amount to cooperation among 'kin by choice', characterized by reciprocal trust, or is it a particular kind of exploitation in which the employer expects to be shown respect but, for her part, need only pay the scantest regard to the subordinate's position?

This chapter sets out to describe and analyse the relationship structures and communication structures that emerge between the domestic worker and her employer as well as the other people living in the household – children or a spouse/partner. The analysis will bring out the multilayered and complex nature of the interrelationships between all the parties involved. What do the employers know about their

employees, and vice versa? What self-perceptions and what perceptions in the eyes of others are produced in this situation?

The construction of the working relationship is beset with uncertainties, one expression of which is the mode of address adopted between employers and employees as mentioned above. Seen from a macro-societal perspective, the private sphere is reserved for familial and quasi-familial relationships. Are efforts made for that reason to bring domestic workers inside the orbit of these relationships and modes of address? Or are we looking at a revival of feudal dependency relationships, obscured by this veil of familiarity? Who actively participates in defining these relationships? And are the modes of address used reciprocally?

Before proceeding to investigate these questions in the remainder of the chapter, drawing on material from four case studies, we turn our attention to a subject that has already been touched upon, the matter of trust.

5.1 Trust in place of contracts

This discussion must be prefaced with the remark that both legal and illegal domestic employment relationships require all parties to take a leap of faith. Even if there were an employment contract, which was never the case in this study, the employers would still need to trust the employee to treat their property and their children or parents carefully, responsibly and lovingly. For employers, the lack of a written, legally recognized contract also means that they have little or no recourse in the event that their employee cheats or otherwise harms them. Employees, for their part, must be able to trust their employer to pay them their money and not to report their illegal employment or their illegal residency status to the authorities; in other words, they must trust that they will not be directly exposed to the risk of criminal prosecution, which could potentially result in the employee's deportation.

That employers are perfectly willing to make the leap of faith is evident from the fact that many employees are given a door key on the very first occasion they visit the household and verbally agree on their duties. This is especially true of households consisting of working men and women, who are generally absent while the work is undertaken – an astonishing phenomenon in a society characterized by high functional differentiation, in which working relationships are defined in written contracts and contractual compliance is governed by an extensive regulatory system.

Comparison of the present-day situation with that of domestic ser-

vants one or two centuries ago makes it clear that in those days, unlike today, duties and wages were very specifically laid down in a written contract. In principle, the advance of modernization, with its distinctive standards of rationality and constant expansion of knowledge, has added to the complexity of employment and contract law and prompted increasingly sophisticated codification of employers' and employees' rights and obligations. Yet this has not extended to the unregulated sector of domestic work, where trust now takes the place of contracts. How can this be explained? Is it a revival of feudal relationships, or at least a revival of feudalization in one sector?

Trust,[1] which in certain respects replaces all-encompassing knowledge in modern societies, essentially becomes relevant on three levels. The first is an objective level: it serves to reduce complexity; the second is a social level: it creates a stable framework for action and interaction processes; the third is a temporal level: it serves to maintain stable social relationships and to perpetuate the social order (Endress 2002: 11; see also Endress 2004).

Anthony Giddens differentiates between trust relationships in 'faceless commitments' in modern societies and the pre-modern 'facework commitments' that become relevant in relationships of co-presence (1990: 88). Within relationships of co-presence, intimacy and loyalty relationships are closely allied.

In intimate relationships like friendships and loving relationships, it is necessary to express affection that goes beyond trust (Endress 2002: 73). However, relationships of trust, such as professional interactions between doctor and patient, are founded on trust in the competence, work quality and reliability of the service provider (ibid.). Of course, as an ideal-typical notion, loyalty can also exist without trust but would then have to be placed somewhere in between friendship and trust in a profession; in other words, we are talking about points on a continuum.

Trust can be defined as the mutual expectation that neither party in a mutual relationship will exploit the vulnerability of the other (Sabel 1993). It always hinges on expectations of reciprocity on both sides; risk and doubt must be suppressed in favour of trust.

For our context, George Simmel's definition of trust also seems relevant. In addition to faith, knowledge and feeling, he distinguishes a fourth form of trust: the ability to remain silent (Simmel 1992: 424), by which he means keeping quiet about a jointly committed crime or a breach of law or morals. The fact that the employer and employee have not legally formalized the working relationship requires them, in a sense, to establish a co-conspiracy.

Historical research on maidservants provides confirmation that maids did indeed have to be prepared to keep a range of secrets, and that they made use of these on occasion to blackmail their employers (Henkes 1995: 63 ff.; Henkes and Oosterhof 1985: 48–151). Employers, for their part, tested their employees' honesty by setting a 'servant trap': items of value were left rather obviously on view, and if they were handed back the employer's fears were allayed. This type of honesty test is probably used even today, although none of the employers or employees we interviewed mentioned this explicitly.

The situation of dishonesty described above by the columnist, in which the employee finishes work early if the employer is not around, has already been characterized by one of the employees we interviewed in the previous chapter as a time-management strategy. Maria la Carrera justifies this behaviour with the very rational argument that she puts extra energy into her work in order to finish in a shorter time and gain extra leisure time. By no means can she put this into practice in every household, because the physical strain would be too much. Without knowing the motives of the 'Krystina' mentioned in the *taz* column, it still seems reasonable to ask why a four-hour work schedule was agreed if the residence could obviously be cleaned in less time? Here is evidence to indicate that employers are often not in a position to assess for themselves the scale of the task and the time it will take, and therefore entrust this calculation to an expert, so to speak. It is this form of trust, in the service provider's professional competence, which is breached in such a case. In any legally formalized working relationship it would have to be followed up with a disciplinary interview before the employee could be dismissed. As shown in the previous chapter, however, many relationships between employers and employees are not exclusively professional. When the employer, Britt, talks about shattered 'human', familial bonds, she is expressing her disappointment in the non-reciprocation of her affection.

The employer's fear of being cheated has already been discussed in the previous chapter (in the case of Gudrun Bäumer and Sylwia Pavel). A distinction has to be made between breaches of trust in relation to care work (caring for a child or an elderly person) and fears of possible theft or damage to property. An example of the first form of breach of trust is reported by the employer Mark Landau (see also previous chapter); he describes an incident which probably hastened the family's parting with Paula, the children's nanny at the time.

Shortly before Paula finished with us [laughs], for some reason I came

home early one day, and she just wasn't there. So I come in, and who do I find but this unknown woman, with – uh – a serious case of premature ageing [Andrea:[2] and a thick Rhineland accent] and a thick Rhineland accent, sitting in our kitchen, chain-smoking unfiltered cigarettes! And the two children – because Paula had a child the same age as our son, which was great actually [Andrea: that's why we thought she'd be good], – so there they were, playing, and I just looked, well, I was pretty horrified, because the smoke was literally hanging in the air, and I thought 'What on earth is *she* doing here?' And then she said [imitating Rhineland dialect]: 'I'm Paula's mother, she couldn't come today but I'm just as good with children. Come and sit with Gran'ma, Pumpkin!' [Laughter] To me, that was a bit – dodgy.

Mark Landau is clearly not at all impressed that the nanny has resolved a last-minute emergency by drafting in her own mother. Having given Paula his trust, he now feels let down. Incidentally, the way in which he recounts the situation emphasizes the class disparity between the employer's and the employee's family to theatrical effect.

Granted, employers certainly take a risk, but the risk taken by the employees is disproportionately greater. The fact of their employment can be exposed by a chance mishap, with consequences that are usually unforeseeable, as the following report from Anna Koscinska makes plain (see also Chapter 7). This experience dates back to the first few months after she arrived in Germany for the second time. Anna Koscinska has just succeeded in enrolling as a student of economics. One of her employers is a widower over eighty years old whose apartment she cleans. When he is not at home, she picks up the key from his neighbour, an old woman. One day she is unable to open the door. It turns out that the man has had a heart attack; another key is wedged in the keyhole from the inside, and the police have to force their way into the apartment. A few days later, Anna Koscinska is summoned to police headquarters, where she is accused of theft:

So the dead man's neighbour had the key, the spare key; this woman over eighty years old, she's had some money stolen, quite a lot. And I was only in her flat for a very short time, in the hallway, because I had to ask for the neighbour's key. But I was in there. And there we are, the money went missing. So who took it? The foreign woman, of course.

There was another carer who came in sometimes, a German woman, and she had to pin the blame on whoever had been there in between: the Polish woman. And, well, that was all there was to it. But by that time I already had my student ID, and about then, I found work in a

lawyer's office. I went there and cleaned twice a week. Very nice people. I got a key to the office right away. They didn't mind what time I came in. Of course, I showed them my student ID, gave my address, my phone number, and signed to say that anything I saw, all the files, any information I happened to hear, I would keep to myself. And got the key right away.

Anna Koscinska is fortunate that the lawyer for whom she started to work at the time helped her to fend off the accusation. The interesting thing about this fragment is the connection made by Anna Koscinska. Her riposte to the police's lack of trust and the theft victim's accusations is to cite the trust vested in her by the lawyer. She utilizes this scenario to emphasize that she is a trustworthy person. Her experience with the police, who refused to believe her and failed to arrange an interpreter (at the time, she had not yet gained a good command of German), and of being insulted as a Polish migrant and accused of being a liar, deeply wounded Anna Koscinska and became a lasting reminder of the weakness of her social situation and her continuing vulnerability to discrimination. She described the deceased as a humorous and kind employer, for whom she was not even able to grieve in the situation that arose, given that it jeopardized her right to remain in Germany.

The diverse facets of the concept of trust should have become clear from these examples. The 'facework commitment' in relationships of co-presence, which are the prevailing kind in the context of domestic employment, requires the reciprocal vesting of trust coupled with the willingness to take risks and to overcome doubts, to a degree virtually unparalleled in other domains. Trust takes the place of contracts.

This prerequisite of trust operates along a scale with fluid transitions between friendship, loyalty and professionalism within the private sphere. In the remainder of the chapter, reference will be made to example cases which demonstrate that the relationships cannot be defined unequivocally because of this tendency for different elements on the trust scale to coalesce. The first two case examples follow on from the thesis put forward in the previous chapter that domestic employment goes beyond physical work and also encompasses emotional work. The repercussions of this on relations between the parties involved will now be discussed.

5.2 More than a cleaning lady – cultural surplus value and 'othering': Maria la Carrera and Iris Jungclaus

Like many other employers, Iris Jungclaus states her rationale for the employment of a cleaning lady, in her case Maria la Carrera (see

previous chapter), in terms of conflicts between herself and her partner Jorge over fair sharing of housework. Being professional associates in the running of a dance studio as well as partners, the couple had been short of time to keep on top of the housework. She had become, in her words, an employer 'against her will'. After various arguments about her partner's share of the cleaning, she explained, he had opted to buy himself out of the problem by employing Maria la Carrera. She had finally agreed, and matters had taken their course. Jorge had not been present at the first interview with Maria la Carrera – a situation that is typical of most couples and indicates the positioning of such work as feminine, including the task of passing it on to another woman.

Like many others, Iris Jungclaus emphasizes that she was beset by major insecurities during the initial interview with the employee. She was unable to behave appropriately as an employer because she was unused to giving instructions for work in the domestic setting. She also felt that handing the cleaning work over to someone else was a decadence or luxury that was out of keeping with her social situation: her home was not a 'magnificent edifice'. Her difficulty in striking the right conversational tone, which she also perceives as a lack of capability on her own part, is the immediate result of coming face to face with the employee and leads to self-doubts:

> What image am *I* projecting? And at the same time: what does she think of, uh, of our relationship, how we share out the housework? Maybe she thinks, um, I'm not pushing this South American guy hard enough?

In this case, employing a domestic worker seems also to be a solution for highly charged relationship conflicts which have a clearly symbolic character: up for debate are not just different guiding principles on the equal distribution of housework, but also the question of gender identity. Iris Jungclaus worries about her reputation as an *emancipated German* woman, which seems incongruous with unequal distribution of work in the household. Taking responsibility for domestic chores is integral to the balance of power in the relationship, and interviewing the domestic employee for the first time is akin to conceding a defeat. Iris Jungclaus is giving up her ideal conception of a lifestyle of gender equality. Her misgivings that Maria la Carrera might consider her feeble and incapable of asserting herself are manifested in the construction of an external perspective on the asymmetry of her relationship with her partner ('I'm not pushing this South American guy hard enough'). Clearly the conflicts with Jorge are about more than the

gender-specific division of housework; she also hints that his cultural background makes the housework-sharing issue even more fraught. Jorge is not presented here as an individual, but objectivized as the representative of a group about which certain (negative) ideas exist, including doubt as to whether its sense of masculinity is compatible with gender equality. In the same breath, Iris Jungclaus constructs Maria la Carrera as a moral authority whose condemnation she fears.

Maria la Carrera obviously picked up on the subtext, because Iris Jungclaus calls the first meeting with her a 'trust-building day'.

> Hmm, well, basically I was the insecure one and she was more secure, but she fell into line, so she didn't rush through the apartment like an express train, saying 'This place needs a good clean-up!' but actually she respected my boundaries or instinctively steered clear of my sensitivities or the embarrassment, and when I said: 'Sorry, it's not always this bad' [laughs] or whatever. And um – so right away she actually got to know a relatively vulnerable side of me, and a personal side; not intentionally, that's just the way it was.

The state of the apartment seems to be the manifestation of a disorderly emotional state that Iris Jungclaus is ashamed of. She is all the more relieved, then, that Maria la Carrera approaches the situation considerately and clearly knows how to deal appropriately with the psychological message. Invoking the employee's psychological sensitivity bears the hallmarks of an expectancy mindset in a therapeutic setting: 'I was the insecure one'. Iris Jungclaus stresses on reflection, however, that this was probably asking too much of the employee. The important thing for her is that Maria la Carrera engages with the subtle significance of this encounter. As years go by, Maria la Carrera increasingly takes on the role of Iris Jungclaus's accomplice, mediator and counsellor on relationship and professional issues. Maria la Carreras's 'motherly manner' touched her, says Iris Jungclaus, who recognizes it as 'rather old-world', a 'servants' culture' which used to be found in high-society and upper-middle-class households but was simply no longer existent. This kind of reflection and the recourse to historical examples make it clear that Iris Jungclaus struggles to describe the function that her employee has assumed for her. Like all employers in our sample, the majority of which can be assigned to the (upper) middle class, on the one hand she feels committed to egalitarian and modernizing ideals and avoids references to early modern traditions which are deemed to be hierarchical (see also Lan 2003, 2006). Like Iris Jungclaus, most employers endeavour to minimize social boundaries

by addressing the employees by their first names and/or referring to their help, support and sometimes even friendship. The relationship between the employer Iris Jungclaus and the employee Maria la Carrera is marked out – at least from the employer's perspective – as a friendly relationship of trust. This places it towards the 'closeness' end of the trust scale mentioned above. In the interview, Maria la Carrera makes no comment on her perception of her relationship with Iris Jungclaus. Since she is professionally minded, however, and takes pains to maintain a distance, as described in Chapter 4, it may be suspected that she views this relationship differently.

Beyond the nostalgic resonances, Iris Jungclaus's recourse to 'old-world culture' makes it clear that what she understands by this is a form of loyalty in conjunction with distance and discretion. Equally, this can be seen as an indication that so far there are no established linguistic forms for expressing the modern status differences in the private sphere that are described here. Either the terminology of family and friendship is appropriated, or else designations going back to an age in which domestic staff constituted an accepted occupational category. The reciprocity of the relationship of trust is demonstrated by the many employers who prefer their employees to address them by their first names. This in no way eliminates objective asymmetries. Nevertheless, it differentiates the present-day situation from that of the early modern period in that there is a need on both sides for relative status levelling.

Iris Jungclaus presents Maria la Carrera as a remarkable personality who has become something of a life counsellor for her in many respects; with regard to her relationship with her partner, she considers Maria la Carrera an expert who can speak from experience: 'After all, she herself has an intercultural relationship with a German.' When the relationship with Jorge breaks down, Maria la Carrera works for both households and for a long time remains the mediator between both parties (see previous chapter). Furthermore, Iris Jungclaus sees Maria la Carrera as a model of female entrepreneurship:

> If I was ever going through a bad patch, or things were getting me down, after all it's not that easy here for freelancers and artists and women and – she would just briefly say what *her* situation was like, and uh, without any finger-pointing or 'you have it darned easy, please spare me your complaints or *I'll* be in a state next', she simply picked up on it really intuitively, I didn't need to say very much at all. And I found that very encouraging, very remarkable.

With the tactic of assigning the employee to the collective category of 'freelancer, artist and woman' to which she feels she herself belongs, Iris Jungclaus constructs similarity and comparability between her own life situation and that of her employee. This, too, can be seen as an attempt to level out existing asymmetries, because in doing so Iris Jungclaus simultaneously ignores the social divide between the two women. The fact that Maria la Carrera has long been living in Germany illegally is used to corroborate her own fear as a self-employed person of potential social slippage. Iris Jungclaus describes Maria la Carrera not as a victim but an activist: 'She has supported other Uruguayan women here, too, from a position of illegality. And I mean, doing it all from a position of illegality somehow.' Although Iris Jungclaus emphasizes that she does not want to glorify Maria la Carrera, this woman acts as a contrasting foil for her own life blueprint. She takes this to the point of considering Maria la Carreras's maternal nature as an alternative to the motherliness of her own mother. Iris Jungclaus, who is a university graduate in Sinology, Japanology, economics and Slavic studies, who has travelled extensively, and worked as a dance teacher, journalist and arts administrator, is twenty years younger than Maria la Carrera. Here, the age difference is integrated into a familial relationship model and the employee acquires the role of an (ambivalent) maternal role model within this construct.

Iris Jungclaus's narrative is typical of a communication strategy commonly encountered among employers. At first glance, these are very keen to level out (ethnic, national or class) boundaries, i.e. to keep hierarchies flat. But looking again, it becomes clear that subtly, and below the egalitarian surface, cultural boundaries are created in the same instant: Iris Jungclaus 'makes' Maria la Carrera into the 'other' – and thereby establishes distance.[3] In this case, Maria la Carrera's Latin American homeland is imagined as an authentic resource which Iris Jungclaus utilizes both for her own professional practice in the intercultural sphere and for her relationship management. For her, Maria la Carrera is not just a keeper of order in the material sense but also in a metaphorical sense: she can also explain to her the man and his culture, and draws on personal experience in dealing with intercultural conflicts.

For Iris Jungclaus, Maria la Carrera generates surplus value which goes far beyond her work as a cleaner. As elaborated in the previous chapter, Maria la Carrera also benefits from this cultural construct by her employer, which she can utilize as symbolic capital – she is hired *because* she is a Latin American, a quality particularly valued by those

employers who have their own biographical connections with Latin America. Nevertheless, such a construct is always sensitive and prone to misunderstandings and conflicts, not least because the different parties' motives for upholding it can differ.

5.3 Repairing gender identity with the domestic worker's help: Aurora Sanchez and Simon Nickel

Simon Nickel is a thirty-year-old single male author and theatre director. His daughter, Lea, was originally raised by her mother and has now turned eighteen. When Lea moved in with him a few years ago, he imagined that his new-found family life might work like a house-share. He expects his daughter to do a share of the housework, but Lea refuses. In response, according to Simon Nickel, he had to resort to 'educational arm-twisting': he threatened to deduct the money for a cleaner from her pocket money. In this case, the intended purpose of the cleaner was to be an instrument for disciplining the daughter. Only later did it become clear that the cleaner would not be easing the daughter's load but primarily the father's. Particularly when he was under pressure of work (around the time of premieres, for example), the interview gradually reveals that he neglects his apartment. At those times, the state of it would overwhelm him and he would no longer be capable of the most basic chores:

> When it's been standing around for a week, that's still OK, but after a week or so there will come – a breaking point, where things need throwing out and maybe there's a bit of a stench, you know, stuff that's been standing around a long time obviously starts to go off, it *has* to go out, and then, well, then I *do* tackle bits and pieces at least.

In the final phrase, Simon Nickel makes some attempt to allay the impression of a chaotic bachelor household that is a complete mess at least part of the time. Nevertheless, the abiding impression of the overall interview is that his cleaner does not just keep his apartment tidy but saves it from squalor. For him, the moment of action ('breaking point') seems to come only when his home is threatening to degenerate into a rubbish tip ('there's a bit of a stench'). When the dirt has been eliminated by his cleaner and order restored, he feels himself restored to a position where he can work. Without this help he has difficulty in overcoming his psychological resistance; cleaning seems pointless to him:

> Then when she came along, that did actually motivate me to start

doing a bit more again myself, I have to be honest. Because there are times, you know, when it's all so pointless and then I think: 'What does it matter if I do this washing up or not [laughs] when actually, it's such a mess anyway.'

When daughter Lea moves in with Simon Nickel, his life undergoes an incisive change and he notices he cannot live up to his own standards. This propels him into a crisis. He seeks out a talking therapist who advises him to hire a cleaner. While visiting a female friend, he recruits the Latin American Aurora Sanchez, having spotted her there cleaning the rehearsal room. At that moment, it is not immediately clear to him that in doing so he is also undermining a parenting maxim, namely to teach his daughter to take responsibility in the household. He himself cannot lead by example, and his educative measure ends with the outsourcing of the housework to a woman. He also emphasizes that he is incapable of performing the necessary systematic housework because its character is not in keeping with his nature: housework is monotonous, invisible and constantly needs to be redone. In contrast, he finds the creative projects he works on anything but boring and invisible. Both housework and caring work make him aggressive and depressive. When his daughter moves in with him, he grudgingly changes his routine:

How it was when Lea moved in, uh, basically having housework to do for an hour and a half every day, at some point after three or four months, um – I really started having problems with how I was feeling in my role. As a father taking on this mother role, so to speak. I just never really felt comfortable with it. Although in those days I did quite a lot because Lea was much younger, and then I really did have to cook meals every day, and even get up for breakfast and so on, but, um, it was never really my thing.

His point, that he is struggling to move on in his life from the status of single person to single parent ('even get up for breakfast'), is reinforced by his comment about the role diffusion that crops up or is exacerbated as soon as he has to take on caring and parenting tasks. He seems totally overtaxed by the activities of day-to-day caring, and the 'mother role' clashes with his sense of masculinity, which he describes in the following in terms of a generalizing 'you'.

There's a certain image of a man that you kind of internalize. Which simply means something different from spending all day washing up or in the kitchen. And afterwards, even when you're in the street, you feel

different as well. As if you know 'someone is there to do that for me', that kind of feeling.

Whereas the first two sentences refer to his own masculine self-image, the last two make it clear that his cleaner's work eases his load in many respects and makes him happy. The connection established between private and public is especially revealing because it shows that housework is not just work, but a particularly gendered type of work. This quote gives an insight into the underlying deep social structure of the gender-specific division of labour, in which the question of who carries out what work has a symbolic character and bestows identity. Simon Nickel's aversion to housework, which he as an art producer legitimizes in terms of its uncreative nature, is fuelled by his perception of it not just as any old uncreative work, but *feminine work*, work that is incompatible with his masculinity. His masculine sense of self therefore depends upon whether the housework is done *for him*. He derives emotional well-being from being able to return home from his *work* to a clean apartment. Simon Nickel places paid work and domestic work in a distinct value hierarchy: the former is important to society, the latter just has to be done. The role of Aurora Sanchez is to carry out the counterpart of paid work on his behalf and create the conditions that he needs for the reproduction of his labour-power. Consistently enough, he does not see her work as a professional occupation either; it is just a job, 'traipsing from one apartment to another and doing the cleaning'.

It can be shown from this example that domestic work as a core activity of 'doing gender' (see also Chapter 2) is as crucial as ever in upholding society's gender system. It ensures that people in their day-to-day actions know what it means to be masculine and feminine. This explanatory approach can be traced back to the early insights of Erving Goffman (1977), who dealt primarily with the question of how gender arrangements are brought forth in day-to-day interactions through practices of repetition and routine. Goffman believes that a 'central gender code', which is presented as a 'natural' code, is acquired socially during childhood, particularly in the home. This is a process of learning a convincing display of one's gender affiliation; action produces and reproduces gender differences. This is particularly true of tidying and cleaning activities. Aurora Sanchez fulfils the function for Simon Nickel of repairing the 'natural' gender code that is missing from his private life as a single person. Furthermore, with her help he can uphold his identity as a creative artist and keep day-to-day chores

from interfering with his creative output. Interestingly he introduces a topic of conversation that links his ideas of femininity ('There is someone to do things for me') with the subservient demeanour of his domestic employee. He talks about his travels to Asia, particularly Indonesia, where he became familiar with the submissive body language of servants. He mentions that he also noticed this 'willingness to serve' in Aurora Sanchez:

> Aurora is the same, she always stoops when she walks past me. That's what reminds me of it. And another thing, she is always totally kind, and solicitous, and so on. And yesterday on her way here she got caught in the rain and she was totally soaked – and – then an hour and a half later, she asked me if she could put her hat on the radiator to dry. And the way she asked, with so many apologies and giving so many reasons, that otherwise her head would get so cold and so on – of course it's great to be asked nicely first, so why not? But she does ask nicely, uh, and she knows how, and I quite like that, when someone's quite, not exactly submissive but, you know, quite reserved. When they say: '*Would* it be OK with you *if* I did such and such?'

What Simon Nickel describes here is a form of boundary-setting that is maintained by both parties: it makes it easy for the employer to distance himself from the employee without having to introduce hierarchy-accentuating rules for this purpose. Aurora Sanchez's behaviour obviously meets this need. From the interview we conducted with her, however, there is no indication that she is aware of this. Without mentioning the working relationship with Simon Nickel, she emphasizes that she prefers to work for older people since they treat her like a human being: 'There are people *who are so cold*! Where they don't even offer you a glass of water!' Except for her wages, she says, she receives no recognition for her work from these people; whereas when she works for old people, she finds that she has more time because they have tidied up the apartment before she arrives. This allows her to use the time in her own way.

It can be assumed that employer Simon Nickel is neither aware of the distinction made by his domestic employee Aurora Sanchez between tidying up and cleaning, nor that he might be expected, over and above paying her, to 'offer' her anything else. Aurora Sanchez's subservient demeanour is probably a blend of different aspects: now in her late thirties, Aurora Sanchez lacks high-level educational qualifications and ran a school canteen before she followed her sister to Hamburg. Today she lives alone and very isolated, leading her life in

illegality; she lives in permanent fear of discovery and her sole source of consolation is the church. She has not informed her employer about her situation. Simon Nickel knows little about her way of life; he is aware that she comes from Ecuador, has a son whom she has left behind with her family, earns her money exclusively from cleaning and sends the greater part of it home. He does not know her residency status. It has struck him that Aurora Sanchez is nervous – which he takes as a sign of poor self-confidence, an individual quality, and one that he has not noticed in other 'Latinas'. As the above fragment clearly reveals, the resultant subservient demeanour is very much to his liking. Yet he is by no means unreflective; it is just that, through the lens of his travels in Indonesia, he contextualizes Aurora Sanchez's servile demeanour as an expression of (post-)colonial conditions which advantaged him as a European. He most certainly has ambivalent feelings about his position as a private domestic employer, not least because his friends from the 'alternative milieu' chide him about it:

> In a way it was as if I'd said, something like, oh wait – 'I'm voting Conservative at the next election' or something like that.

Nevertheless, Aurora Sanchez's work makes him feel good, not just in the apartment but also 'in the street'. The reduction of contact to a minimum by both parties is very congenial to him. He concedes that Aurora Sanchez has certainly made attempts to tell him something about her life, e.g. her sorrow over her separation from her son. She gave vent to this when his daughter Lea was taken to hospital, to which Aurora Sanchez, according to Simon Nickel, 'reacted very compassionately, if not despairingly'. Since he mistrusted this outbreak of empathy, however, or at least found it unsettling, he had discussed it with his girlfriend at the time, another '*Latina*', who cast doubt on the story that Aurora Sanchez had told. Every domestic worker from Latin America told that kind of story, she had remarked. While Simon Nickel emphasizes that he trusts Aurora Sanchez, at the same time he has no desire to be informed about her private situation. After all, he pays her the princely sum of nine euros an hour, and she is expected to provide a service in return. He would rather not be burdened with her life, because ultimately he hired her to solve his own problems.

Following the analysis of Pei-Chia Lan (2003), this type of delimitation by employers can be called a distanced hierarchy, the salient features of which include clear social detachment strategies and an absence of role reflection. The latter is distinctly in evidence here. Unlike Iris Jungclaus, Simon Nickel does not wonder what effect his way

of life has on Aurora Sanchez, for example. Simon Nickel and Aurora Sanchez exemplify a working relationship that is rather distanced and depersonalized and which, beyond the bounds of the job alone, also serves the purpose of identity management for the employer: Aurora Sanchez restores and upholds Simon Nickel's gender identity. For Simon Nickel, the crucial element is not the person but her work, which has symbolic significance for him.

These two cases (Jungclaus/La Carrera and Nickel/Sanchez) and those in the previous chapter serve to demonstrate the operative principle of 'boundary work'. On the basis of her study of Filipina domestics and Taiwanese employers, Pei-Chia Lan (2003, 2006) uses the term 'boundary work' as a theoretical tool to analyse the interactive dynamics of reproducing, contesting and negotiating processes of social inequality in the household. She describes the interplay of two sets of social boundary-setting mechanisms; on the one hand, socio-categorical boundaries established by means of class, gender, ethnicity and nationality, and on the other hand, the socio-spatial boundaries within the private sphere which serve to demarcate the boundaries between domesticity and privacy. Whereas Lan discusses this boundary work with reference to live-in situations, our examples provide an excellent demonstration of the applicability of this concept to the analysis of live-out employees as well. As we have seen, the matters at issue are the strategies and practices used in order to construct, uphold and modify cultural categories, and hence to define boundaries in the private sphere. Although this boundary-setting takes place on both sides, it need not necessarily be complementary. Employers and employees resort to their own different strategies and employ different criteria for demarcating their separate spaces. These processes generally take place unconsciously; by means of a hermeneutic case analysis, however, they can be made visible.

A recurring principle is the complicated matter of dealing with status differences. Even where efforts are made to describe this relationship as a friendship or family relationship, the underlying asymmetry is visible. Although familiar personal interaction may make a working relationship look like a friendship or family relationship, all parties involved nevertheless attach importance to keeping the attendant danger of mix-ups and misunderstandings under control (see also Ozyegin 2001: 11). Provided no conflicts arise, the definition of the relationship is largely shared; as soon as disputes occur, however, the boundaries are accentuated.

Whereas the distanced hierarchy in the Nickel/Sanchez case satisfies

the employer's need for delimitation and the employee makes very few attempts to establish a more personal relationship, in the Jungclaus/La Carrera case the personalization (strong personal attachment) of the relationship is outlined from the start by the employer. The verbalization of affection and self-reflection tends to be a more prominent trait of female employers than of male. This may be explained by the fact that domestic and care work is a core aspect of women's 'doing gender' but not of men's. Female employers thus see themselves forced to legitimize to themselves and others the relinquishment of this work to another woman.

The next case concerns a working relationship that is defined and experienced by all parties involved as a quasi-familial relationship. The parties concerned are the only au pair in our sample and her employer. The case study throws up a host of peculiarities which were found in no other case, and for that reason it must be designated an exception, even though at the same time it usefully exemplifies for analytical purposes a number of mechanisms relevant to late-modern family relationships.

5.4 From 'skewed nuclear family' to elective kinship – gender reordering in the family? Tamara Jagellowsk and Ursula Pelz

Tamara Jagellowsk is nineteen years old when she leaves her home town south of Kiev in 1995 and travels to a German city to take up a position as an au pair. She has completed a vocational qualification as a nursery teacher and already gained some work experience in a kindergarten. Tamara Jagellowsk learned German at school but does not speak it fluently to begin with. After a train journey lasting almost two days she arrives at her destination. She is picked up by her employer, Ursula Pelz, who immediately explains her duties for the next day. Ursula Pelz, who was holding down a full-time teaching job at the time, is separated from her husband and lives with her two children, boys aged a year and a half and six years. She had previously parted company with a string of western European au pairs before she 'was sent' Tamara Jagellowsk, as she puts it – a turn of phrase that makes some sort of allocation system spring to mind. According to Ursula Pelz, these 'young ladies' had been very sensitive.

Contact had been established with Tamara Jagellowsk through the intervention of Ursula Pelz's parents, who are actively engaged in Ukraine assistance programmes. On the morning after she arrives, Tamara Jagellowsk is already expected to look after the toddler, take him to play group, shop at the supermarket and do the housework.

Tamara Jagellowsk manages all of it; in the interview she outlines the high demands imposed by the very swift transfer of enormous responsibility, yet at the same time she emphasizes that, despite this breathtaking speed, she 'copes fine' with the situation. Today she holds nothing against Ursula Pelz, but tries always to maintain control of precarious situations competently and effectively. Ursula Pelz is very satisfied with her from the start:

> And she was definitely not as sensitive as these other young ladies – well, she, or rather the situation, was *certainly* outside her comfort zone, too, to begin with, but – she's just extra-resilient, you know – that's probably an advantage of eastern European women [laughs], isn't it, that they're not so, let's say, not so spoilt.

Even if it remains unclear at this stage precisely what Tamara Jagellowsk had to withstand or accomplish or what she agreed to, it becomes clear that Ursula Pelz is not praising the person but ethnicizing her willingness to suffer and perform as an intrinsically eastern European quality.

By hiring an eastern European as a live-in through an au pair programme, Ursula Pelz is in step with the trend. Since the early 1990s thousands of eastern Europeans have come to Germany through different au pair agencies. Eighty per cent of the young women on the agencies' books are now from this region. Interestingly, au pair programmes in Germany now fall within the remit of the Federal Employment Agency, although their original purpose is cultural exchange, living and learning in a German host family. In return for free board and lodging, au pairs have to do thirty hours of domestic work per week (not heavy housework); they should not have to work more than five hours per day or more than two evenings per week; they are entitled to a day off at the weekend and 200 euros pocket money per month, and should be funded by the host parents to attend a language course, in accordance with the European au pair contract (see Hess and Puckhaber 2005). In practice, however, little effort is made to check compliance with these rules, which are therefore rarely adhered to. Au pair programmes have developed into a flexible live-in labour market.

In the course of the interviews carried out with both parties, it gradually becomes clear why the phrase 'extra-resilient' is used to characterize Tamara Jagellowsk: her work and commitment go far beyond the demands of an au pair contract. Over the years, she takes charge of the housework in its entirety: cooking, tidying, cleaning, washing, washing up, ironing, and disciplining and supervising the children.

She also escorts the children on trips to their grandparents, who all live a long distance away, some out of the country. She becomes the mediator between Ursula Pelz and the children's father, with whom they also stay intermittently. Tamara Jagellowsk sees it as her role to ease Ursula Pelz's load, and thus she also takes on non-routine duties such as taking the children shopping for clothes. She purchases the gifts for St Nicholas's day, Christmas and birthdays, and presents for the children's friends when they are invited to birthday parties.

Nine years have passed and Tamara Jagellowsk is still living in the Pelz household. After the expiry of her first visa as an au pair, she can secure a visa for a further year as a language-school student. With excellent language skills, she then legalizes herself by enrolling for a pre-university preparation course at the university of a neighbouring town; between 1998 and 2001 she is enrolled at this university as a student of languages and literature. She breaks off her degree course after the standard period of studies without graduating, and legalizes her residency status in 2001 by means of marriage; more on that later. Currently she is training as a European secretary; today she receives 300 euros pocket money per month, out of which she pays her public transport costs among other things.

Ursula Pelz reports that ten years ago she had been trapped in a deep marital crisis. At the time, she had been primarily responsible for the childcare; her husband had successfully pursued his own professional career as an academic, whereas a career of her own was not possible. In the role of a mother she felt written off, had become depressive ('half dead') and consequently sought a solution for setting herself free: 'I had no choice, I had to farm the children out, so to speak, before I could feel halfway better.' After a few failed attempts with childminders and crèches, she discovers the au pair solution:

> And – from that point of view, I never had that uncomfortable feeling
> with the au pairs, and so on – uh – because I never had the impression
> that I was just dumping the children, you know? Essentially they were
> at home and there was just somebody else there or somebody else res-
> ponsible.

This fragment reflects both the resource of the private sphere and the gender resource which enables Ursula Pelz to continue declaring her life as 'family life' that takes place in the private sphere. She views Tamara Jagellowsk's role as a substitute for herself in person ('somebody else there or somebody else responsible'). By means of this construction, she succeeds in remaining a 'good mother' who does not

dump her children on strangers but who takes *care* that the children continue to be *cared for* by a woman. She thereby establishes a domestic organization in the sense of the traditional, gender-specific division of labour, which enables the children to be cared for and supervised in a household in which somebody is always there for them. Over the years, Ursula Pelz has gradually handed over the private sphere to Tamara Jagellowsk while she devotes herself completely to her work:

> Of course I do some vacuuming, too, now and then, but – normally she does that on a Saturday, you know, as a matter of course and, uh – that means I can really concentrate properly on working and – she's *always* there when, when any need arises.

Ursula Pelz views her professional work as the productive work with which she earns her money and has made a career. Since Tamara Jagellowsk's arrival, in rapid succession alongside her work as a teacher Ursula Pelz has completed her doctorate, started her professorial thesis, held a two-year guest professorship and has finally taken up an academic research post in a university town 600 kilometres away which holds out the prospect of a professorship in the near future. The latter position necessitates a three-day absence from home. During this time, Tamara Jagellowsk has sole charge of the children, cooks for them, supervises their homework, accompanies them to the doctor, and is actively involved in their extracurricular activities. Since she has no driving licence, she transports them to their free-time activities by bus. Ursula Pelz defines the distribution of tasks as follows: Tamara Jagellowsk is responsible for the interior space whereas she herself 'takes charge of outward representation'. She sums up the solution that she has found with Tamara Jagellowsk as a successful model:

> Yes. I would recommend all women to do the same [laughs] rather than persevering within the skewed – skewed structures of the traditional nuclear family. I really believe it's a good alternative model, and for me it was a liberation – a liberating model, you know. It's been – well, ever since then I've felt significantly better and – uh – well, not right away, of course. I mean, you always have to get back out there first, and find work and all that, you know. But – anyway, I feel significantly better today than I did – ten years ago or so. Yes. And to me, it really is an alternative. Quite apart from the fact that it's a way of creating jobs and providing – uh – services, etc.

It becomes clear at this point that she is aware of how much she herself benefits from this arrangement: in this way she can liberate

herself from the traditional family model, and now lives her life on an 'alternative model' that she extols as a valid counter-proposition to the 'skewed family model'. Furthermore, she underscores the purported market-economic benefit of this solution ('a way of creating jobs and providing services'). Since Ursula Pelz does not pay Tamara Jagellowsk a salary, only pocket money, this statement can be qualified as a failed attempt to legitimize the quasi-familial arrangement which has led her to flee from a 'skewed family model'.

The arrangement equates to the classic gender positioning in which the outward position is reserved for the man and control of the interior is the woman's preserve, except that the man's place is taken by a woman who has appropriated this masculine role. From the perspective of 'doing gender', this is a case of a structurally gender-conformist substitute solution in which the migrant has been given the role of the wife: she takes charge of reproductive tasks, develops no career ambitions of her own or puts them on hold, and is 'always there when any need arises'.

Tamara Jagellowsk has not gained a single qualification during this period. Although she has attained an excellent standard of German, so far she has not been able to employ this skill to improve her cultural capital. To date, she has not managed to move on from her quasi-family, and says:

> Sometimes I do think, maybe it would have been better if five years ago, four years ago, I'd taken advantage of some moment or other to say, I'm leaving. But I mean, I've often brought up the idea indirectly. But I've never had any clear answer from, from Ursula and from, from Paul, because in this family it's like a permanent *tornado*. There is no *resting state*.

Tamara Jagellowsk describes the family situation as one of permanent movement and change, a not unusual state of affairs for those in academic careers. Added to that is the fact that, in this case, the children's father spends part of his time abroad, one set of grandparents live abroad and the other hundreds of kilometres away, and during the times when the father is in town, the children have to divide their week between two homes. The one static element in this patchwork family is Tamara Jagellowsk. Especially for the children, she tries to compensate for the tornado and to ensure continuity. Amid such chaos, there is no space to formulate and pursue her own ambitions and future plans, and nor does she try to make the space. She loves the children, sees herself as the social mother of the younger son, is proud of him and her own child-rearing achievement. All these years, she

has always made her own needs secondary to those of the children and to Ursula Pelz's work schedule. Although she holds an excellent pre-university preparatory qualification, and subsequently chooses a degree programme very closely related to Ursula Pelz's discipline, she does not take her examinations. The daily commute from home to university takes four hours in total; the youngest son regularly has to be collected from kindergarten at 4 p.m., and if a child is sick it is Tamara Jagellowsk, not Ursula Pelz, who stays at home. Tamara Jagellowsk epitomizes the traditional view of total self-sacrifice for the sake of the family. Ursula Pelz, for her part, is evidently very glad that she need not worry about the progression of Tamara Jagellowsk's studies on top of everything else. Tamara Jagellowsk is primarily meant to be there for her, not the other way round.

Today Tamara Jagellowsk is almost thirty years old. As yet she has gained no qualifications and has remained in the Pelz household. To get to the bottom of why she rates the outcome of her migration project as neither particularly positive nor definitively negative, more precise analysis is necessary of her scope for negotiation as well as the development of trust within the household.

As already mentioned, it fills her with pride that she can meet the demands made of her in every respect. She occupies an important position in the family, for she is a special attachment figure both for the children and for the adults (the children's parents and grandparents), a mediator. Over time she has conquered and consolidated her own bastion, the interior space, in which she determines what happens. Since arriving in the household, she has introduced her own rules:

> No, *they can't*, uh, play basketball in the apartment or that kind of thing, because it really irritated *me*. The whole place, as well – the whole room looked so devastated, and so on, and who had to keep on top of it all? *Me*, so, there you go. And that's why, uh, it was really quite – um, the habit of not taking *shoes* off when they came indoors, naturally that really struck me here, I must say. I get the feeling it's not, uh, like this in all German homes, thank goodness, but you do notice if – *hmm*. So that's what I did – Dominique especially was about six by then. René, I think, still always takes his shoes off. With *him* it always worked fine because he never *knew any different*.

This conflict over Tamara Jagellowsk's insistence that shoes should be taken off on entering the apartment is also described by Ursula Pelz, who reluctantly complied. Emblematically, it points up the intercultural conflicts that arise in the household when the 'order of things' is at

stake (Kaufmann 1999; see Chapter 4). Just such trivialities, the etiquette, gestures and rituals of day-to-day interaction, are fundamental elements of the construction of everyday life which imbue life with fixed points and meaning. Rules direct the management of cleanliness and dirt, inside and outside, chaos and order.

Disputes between domestic workers and their employers revolve around the different ideas of civilization and rituals of cleanliness associated with these attitudes and actions; these elements become the focus of negotiation. As a rule, it is the employers who have very precise ideas of how everything should be cleaned, cooked or washed. They are vigilant that the order they impose is maintained or restored. Nevertheless, this very same area harbours scope for negotiation by the employees. They utilize this scope in order to make demands, e.g. with regard to equipment, cleaning products and the type of service provided (extra payment for cleaning windows or dusting books, etc.).

In no other case that we studied were so many compromises found as between Tamara Jagellowsk and Ursula Pelz. Tamara Jagellowsk imposed her ideas of cleanliness and tidiness all the way along the line: the inner space begins at the apartment door, and from that point on Tamara Jagellowsk stipulates the norm. Her training bears particular fruit with the youngest son, who has internalized her ideas of cleanliness and tidiness. His 'good behaviour' is a credit to her child-rearing efforts. Tamara Jagellowsk always combined the induction of her norms and their legitimization as 'normal' with open criticism of her employer's laissez-faire child-rearing style:

> I told them off, for sure. I don't let them think I'm a – *soft touch*, like
> a favourite aunt or – a granny, maybe, a *nice, kind granny*, I'm not
> like that. I always said, no way, you can try telling that to your *mother*,
> but not to me – with me you do things differently.

Ursula Pelz obviously only fought back up to a point, and thereby ultimately ensured that Tamara Jagellowsk was legitimized to consider this domain as her own. While she disapproves of Tamara Jagellowsk's traditional ideas on child-rearing, at the same time she obviously perceives no harmful influence on her children as a result. Thus, she retreats from the domain, yields the floor to Tamara Jagellowsk, and concentrates on her professional work. At times, however, this retreat leads her to experience a sense of loss. For instance, she reports that it makes her sad when she calls home from her present workplace and finds out that she is not missed. Tamara Jagellowsk and the children obviously cope with her absence well.

Tamara Jagellowsk knows the children's lifeworld better than Ursula Pelz, and shares with them a love of trivial consumer culture – computer games, pop music and RTL television – whereas Ursula Pelz prefers classical music and art, and would also like to transmit this to her children. Ursula Pelz complains during the interview about the 'stroppy tone' that Tamara Jagellowsk habitually uses, and jokingly expresses anxiety that she will soon have no say at all in her own home. Tamara Jagellowsk has also established excellent relations with her employer's mother, which makes Ursula Pelz feel under surveillance and control. She remonstrates that her mother hears about her love affairs from Tamara Jagellowsk. However, because she can always rely on Tamara Jagellowsk one hundred per cent, particularly in difficult times, she puts up with this. In the private sphere, she also puts up with the fact that two very distinct forms of the feminine habitus have developed in parallel, which sometimes conflict with one another. Looking at a recent family photo, she says:

That's Tamara, there. Beautifully turned out for the occasion, as usual. She sometimes plays this little-girl role, you know? Which is absolutely nothing like her, but still; and then she drops her eyes and looks slightly coy [laughs]. That's the lovey-dovey girly look she always goes for. [Laughs].

Tamara Jagellowsk takes a great deal of time over a very feminine self-presentation, according to Ursula Pelz. Also entirely alien to her is the manner in which Tamara Jagellowsk habitually treats her male friends:

The way she *slates them*, unbelievable! Putting them down, you know, or when they come to the door, she'll need another half-hour before she's even *ready*! And keeps them waiting; and *stands on ceremony,* in a way I never would have. But then her ladyship steps out in style, no question. Dressed up and made up and turned out in very particular style. She just spends much more time on it. I've never spent time on that in my life! Near enough never.

On the one hand, this reveals a latent competitiveness between Ursula Pelz and Tamara Jagellowsk; on the other hand, Ursula Pelz also shows a modicum of understanding and is inclined to excuse the younger woman's foibles. Since Tamara Jagellowsk is mainly interested in men with big cars, according to Ursula Pelz, the problem of competition for the same men seems not to be an issue.

Over the years a strong mutual dependency has obviously devel-

oped. Whenever a new solution has to be found to extend her au pair's residency permit, Ursula Pelz springs into action. She has taken this to the extreme of agreeing, at Tamara Jagellowsk's instigation, to take part in a same-sex civil partnership for legalization purposes. She emphasizes that she has no legal or moral problems with this, reasoning that evidence of cohabitation going back a number of years can be produced with ease. Hardly anyone in either woman's circle is aware of this step; Tamara Jagellowsk, in particular, is ashamed of it and dares not tell her acquaintances; the date for the dissolution has already been set.

There is no other case in our sample in which the mutual dependency is so deeply enmeshed as in this one. What this case exemplifies very well, specifically because it has led to the activation of extreme measures, is the complexity of emotional order in the private sphere. Equally, it sheds light on the ambivalence of the associated feelings, and the problematic nature of any attempt to unravel them.

It is not necessarily surprising, therefore, that in the interviews with these two women, great uncertainties emerge about what they should actually call themselves. Tamara Jagellowsk sees herself as a 'substitute mother', a 'second mother', and is sometimes called 'sister' by the children. Although she does not properly know her 'status', at any rate she is 'one of the family'. Ursula Pelz talks about 'sisterly interaction', which is not particularly intimate but corresponds in principle to a sisterly code of etiquette. She labels this a 'hybrid relationship' characterized by clear demarcations (exterior–interior space) and in which the hierarchy is determined by the fact that she earns the income and is therefore the employer; nevertheless she, too, stresses the expectations of the relationship. However, her sisterly attentiveness stops short of any concern for whether Tamara Jagellowsk can manage her professional future and obtain a qualification: 'It would be too much for me, I think, if I had to take responsibility for that whole side of things as well.' She emphasizes that she 'must show her gratitude' for Tamara Jagellowsk's commitment. The fact that despite fleeing from the 'skewed nuclear family structure' she has ended up, at least legally, in another one can perhaps be seen as an irony of the social system of the Federal Republic of Germany. The arrangement thus remains governed by the logic of the traditional family. Ursula Pelz:

> Sometimes she talks about how one day maybe *after all* we might move into a house or a *nicer* apartment, you know? Which always makes me think, *bloody hell*! I'm the one bringing the money home and on the

other side there are these constant demands. A *nicer* apartment and a *better* car and ... [laughs].

Both women mention a desire to plan a future in which they will live independently from one another. Even so, at the same time they seem to anticipate that this might be unachievable. Ursula Pelz:

Sometimes I think, I must really articulate this properly because, in fact, maybe I *don't* want to pay her way for the whole of my life, if you know what I mean.

In the interview, Tamara Jagellowsk compares herself with her girlfriends in Ukraine, all of whom are now married with children, and expresses the feeling that in comparison to them she has failed. At the age of thirty she already feels very old, which is no surprise considering the responsibility she shouldered at a very early age.

Today both women appear to be in a quandary: they are unable to exit the relationship just like that. Ursula Pelz also emphasizes that she cannot and will not simply jettison her material and moral obligations. This arrangement that the employer extols as a reordering of the private sphere is unmasked, on closer examination, as a substitute model with a strong similarity to the old one. Ursula Pelz assumes the role of the breadwinner and all its consequences; she entrusts the family management to Tamara Jagellowsk, who takes her place in that context in the role of wife and mother. The partner-substitute model that has emerged here remains within the confines of the habitual gender-specific patterns for the division of labour, each reproducing its own specific power resources: Tamara Jagellowsk is dependent on Ursula Pelz's salary, and therefore it can only be in her own interests for Ursula Pelz to pursue her career. Ursula Pelz needs her while the children are still growing up and not yet able to take control of their own lives. A classic dilemma arises, which is familiar from many traditional couple relationships. When the children leave home, it is often too late for the wife to build up a career of her own. Although both sides are at pains to remove hierarchies and practise egalitarian behaviour, the asymmetry of a classic marriage persists. Rather than an alternative family form, if anything this model is more a case of *business as usual* with a new partner arrangement.

5.5 A 'blessed' daughter – elective kinship beyond the grave: Anneliese Metzer and Magda Niemen

In the previous examples the relationship models oscillated between distanced depersonalization, on the one hand, and girlfriend, sister

and partner-substitute, on the other. The last case study in this chapter relates to the relationship pattern between a domestic employee and her elderly female employer. As a rule, these employment relationships are particularly tricky when they involve female employers who have comparatively rigid ideas about cleanliness, are constantly present during working hours, and check up on how the work is carried out. Deviations from their own methods are only grudgingly tolerated; sometimes they also consider themselves to be 'working together', with the employee accepting the role of assistant and accepting instructions. These relationships are characterized by asymmetries in the modes of address used: the employee is addressed by her first name and the familiar '*du*', while the employer is addressed by her surname and the formal '*Sie*'.

For many older employers, interaction with their employees is their sole contact with migrants. Normally they place most emphasis on the given employee's standard of spoken German. Seventy-three-year-old Anneliese Metzger, for instance, has hired fifteen different cleaners in the past fifteen years, all of which were recruited via the senior citizens' office of her church parish. Only the very first women were German by birth. Later they were followed by women from Latin America, Morocco, Iran, Poland and Russia. Anneliese Metzer can recall every one of them very well, still knows their names, and can tell a little story about each woman; she recounts their appearance, their clothing, their intelligence ('Intelligent foreigners do better work') and their faith. For instance, she had engaged in disputations about Christianity and Islam. The Iranian woman had repeatedly drawn her attention to the common roots of the Christian and Islamic religions: 'Abraham and so on'. As a committed Christian, she had contradicted this, she said, for she particularly abhorred the oppression of women in Islam. Dolefully she remarks: 'I never managed to explain the Trinity to her, either.' In our study, none of the domestic workers interviewed were live-in carers for an old person. The work was far more likely to be cleaning, shopping, ironing, and only very rarely cooking, for old people who were still living independently. For this group, the employees also fulfil the function of bringing the world into the employer's home. At the same time, however, it is apparent from many examples that people of this age have had little or no personal experience of interacting with migrants. This can give rise to anxieties, but can also result in crass discrimination. For the employees, it is not easy to deal with those kinds of comments and verbal denigration, because they largely have a respectful attitude towards old people and cannot very well fight back.

Magda Niemen, aged thirty, came to western Germany at the end of the 1990s and has since been a cleaner, mainly for older women. She left Poland following a relationship crisis, in the hope that she would experience less discrimination in Germany as a lesbian woman. By enrolling at a university she legalized her residency status, and has a very good command of German.

Magda Niemen's case study is representative of the migration history of those women who, despite having the support of a network of male and female friends, go through an identity crisis after they have migrated and have great difficulties in developing a future perspective, e.g. a new relationship or career plans (see also the case description of Anna Koscinska in Chapter 7). For these migrants, unlike the employees with a professionalized habitus introduced in the last chapter, the personalization of the relationship is very important. They wish to be perceived as human beings and not to 'feel like robots'. They are delighted by expressions of overt approval of their work. They seek a 'family attachment'.

Magda Niemen recounted that one older woman among her clientele never greeted her when she arrived. Magda Niemen said that although this hurt her, she had come to realize that she was not the only one whom this employer treated that way. The woman was very surly in all her relationships. After the son had let her into the apartment, Magda Niemen started on the cleaning.

> I just wait and see! I do my work – and I think to myself, well, if you can't see me, then fine ... Sometimes I say, I – I'll *leave* her *high and dry*. ... I'll just say I don't feel like gritting my teeth next week and that's that. But somehow or other I can carry on; I just think of the money.

On the one hand, she feels helpless in such situations and wishes to terminate the working relationship because she obviously reaches the limits of her frustration tolerance ('I don't feel like gritting my teeth'). On the other hand, the relationship seems ambivalent, for even this employer is not completely insensitive towards her.

> Of course it stands to reason that – that sometimes you're going to be unlucky and have to meet people like that, but in the end there's no choice. [...] But when I see her, and when she wants to tell me something, what to do – what I should do and what I should do differently. Then it makes my blood boil, most times. But she notices that pretty quickly, and then – then she'll start to be a bit nicer [laughs]. Then she humours me.

In the interview with Magda Niemen, what comes across is the importance she attaches to developing respect and trust. Although initially it appears that she is somewhat helpless in the face of her employers' moods, later it becomes clear that she has developed a series of resistance strategies. Thus she reports that she does not enjoy working in people's homes if they are present for the duration of her working hours and check up on how the work is carried out: 'Yes, I don't like it when somebody's there and I, you know, when somebody's sitting there and I'm vacuuming or dusting.' She seems also to train her employers to get out of the room in which she happens to be working.

I just won't go *into* the room if there's somebody [laughs] sitting there, for example. Once they know that they have to let me know, or I say I have to clean here now, I'm coming in [laughs], I – I just have to vacuum in here, or whatever. And that's a signal for – [laughs].
 I: And do they go then?
Yes. Most of the time.

Her special relationship with older women is illustrated by the example of a ninety-two-year-old woman with cancer, who employed her for two years. The story of the relationship begins with this woman's death, and is narrated retrospectively from that standpoint, as a résumé.

The positive relationship with this woman is a matter of some astonishment, initially, for the work situation described is complicated. The employer is 'strict and fussy'. She insists that Magda Niemen should clean the floor by shuffling around on her knees, wearing towelling pads which she first has to attach around her knees with safety pins. Magda Niemen describes this with great comedy, which cannot fully be conveyed in the transcription. When questioned, she elaborates:

Yes. She said: I can't have you ripping your trousers, not in my house, and then getting yourself all dirty ... And she was really fussy, incredibly fussy, and every little corner had to be – I had to clean something or other that was clean already.

She did carry out the employer's instructions, but

I always shut my eyes, and she knew when she'd gone a bit too far because I simply went quiet, quieter and quieter, because I never reacted in any way. And then, oh: 'Don't get upset. You know me – I'm old' and so on [laughs], she'd probably say.

By means of the theatrical presentation, she distances herself from the woman's moods, and at the same time explains that her silent

protest was not ineffective. The employer apologizes to her; therefore she is entirely capable of reflection ('I'm old'). Twice a week, Magda Niemen does the cleaning for this employer, who is the first person that she sees dying. In almost biblical language ('her days were already numbered') she talks about a moment of the utmost closeness, the moment of farewell at the deathbed.

> So I sat at the bedside, because I had to, because there was nothing to clean, nothing else needed cleaning. I wasn't coming to clean any more, but the granddaughter also had to work and she said, yes, just sit here – sit down, read something. Well – of course I didn't want to read, I just sat – I held – her hand and – hmm, and she just didn't react at all and before I knew it, it was time for me to go. Then she suddenly woke up and then she said – she held on to me so tightly – and then she said: stay with me, stay with me. Twice she said it. Over and again, and – hmm, at some point I had to go, and that was the last time – I saw her alive. And I found that quite – upsetting.

Of course, this involuntary deathbed vigil could also be narrated quite differently; perhaps in remonstrating tones, because after all it was the granddaughter who urged Magda Niemen to stay there. But that is not what she does. Retrospectively, the relationship with this woman takes on an important meaning in her life: 'Yes, she was a – simply a very good person.' Magda Niemen describes the relationship with the elderly lady as one for which she made sacrifices. She adapts her personal schedule to the cleaning appointments and postpones her trip to Poland, travels back and forth between the home of her mother, whom she visits at weekends, and her workplace 200 kilometres away even though the high costs of travel mean that the work is no longer worthwhile financially. She is simply unable to leave the old woman in the lurch:

> If I wanted to go to Poland for a week or so, I couldn't just leave her alone, because I knew that she – that she'd need something like two months to get used to a new person.

The great empathy for this woman, her high moral standards and her sense of responsibility are turned into premises for individual action. Moreover, this developing relationship gives her something that she misses in others:

> Well, what I – meant by that, is that she always radiated so much *joie de vivre* and optimism – I always felt recharged by it. Incredible in comparison to young people sometimes, where they just – drag each other

down – she was incredible. So much enjoyment of life at that age, not to mention that illness, where she knew very well – she absolutely knew what – what was wrong with her and – hmm.

Magda Niemen obviously derives surplus value on an emotional level from working in this woman's home. She has a strong sense of affection for her employer and feels spurred on by her to open up and talk. She admires the woman for being able to hide her pain and concentrate on another person.

She just said – ah – I don't feel well today but we don't want to talk about that; so how are you? And a smile – and that was it. ... But that smile was worth it – always – and this energy that she always gave me.

It is not just the woman's appreciation and trust which make the work a special experience for her but also the inner tranquillity and satisfaction that she perceives radiating from this woman, and which she herself – at least in her situation at the time – does not possess. Magda Niemen is very religious, and given her focus on the aspect of hardship, it is likely that she found a source of support here during a crisis in her own life. Towards the end of the interview, she comes back to this woman and calls her 'Grandma'. In a longer description, she reports that just before Christmas she had to carry out some extra cleaning work for this woman.

Yes, and then she came in with an envelope, and there were stars, golden stars stuck on it – but that doesn't matter. Anyway, she said 'A happy Christmas, a blessed Christmas, dear Marga.'

The envelope contained 400 Deutschmarks. Apart from the fact that the large sum helped her to make ends meet in a precarious financial situation, she had seldom received such a gift. She had never been lucky enough, she said, to inherit or win anything:

I, I never, ever had such luck. Other than my mother, yes, family. But otherwise never, never in my life, and for me that was – and I wept, and kept repeating, 'blessed'. But it was blessed, oh yes [laughs], it really was blessed.

For Magda Niemen, such gifts obviously belong in a family context, and on the strength of this experience, the employer is declared a family member – a grandma. She had never known her own grandmother. She interprets the 'blessing' that came her way here as the reward for hard work and as a special form of appreciation. The money becomes

her salvation in adversity, and the story resonates like a Christmas fairy tale. Within the family she has kept the name given to her by this woman, Marga instead of Magda, and Magda has adopted it for herself. Since the 'grandma's' death, she has been cleaning for the granddaughter. The case is one example of how elective kinship can also be constructed by the employee, even if Magda Niemen never actually used such a form of address ('Grandma') to the old lady's face.

5.6 Provisional conclusions: egalitarian aspirations versus boundary work

The position taken up by our research differentiates it from the work of other scholars who analyse the relationship between employers and domestic employees as a relationship of exploitation or refeudalization. Various of our case studies have shown that the relationships between the parties involved are extremely complex, and cannot be shoehorned into a straightforward exploiter–exploitee schema. Moreover, the egalitarian tenets of present-day Western society are ingrained in these relations, with consequences for the organization of relationships in the private household. It is clear from the mutual uncertainty regarding modes of address and designations (female friend, sister, daughter or partner) that drawing uncritical parallels with historical precursors is not a tenable option, since the hierarchies of the master/servant society have no place in a modern habitus. But at the same time it is a working relationship that is characterized by multiple interlocking asymmetries, which cannot simply be ignored. The modes of address between the parties concerned in the form of family designations can therefore also be seen as an attempt by employers to gloss over and mask the real hierarchies that exist. The lack of rule systems and established behavioural conventions, and the ensuing uncertainties, are evident in the communication of the parties involved.

In this chapter it also becomes clear that the social interaction between employers and migrant employees represents a certain form of intercultural communication, which can be classified as ethnic boundary work. It revolves around the construction of cultural categories, with the help of which boundaries are set in the private sphere. This boundary-setting takes place on the part of both employers and employees, but need not necessarily be complementary. There is a crossover here between the above-mentioned process of *doing gender* and that of *doing ethnicity*, in that ethnic justification models are resorted to in order to legitimize asymmetrical power relations.

6 | Transnational motherhood

As already mentioned in Chapter 2, a concomitant of feminized migration is that a growing number of migrants are mothers, who leave behind husbands and children in their countries of origin. Our sample indicates a tendency for women to assume financial obligations towards their families of origin, and to feel a strong sense of loyalty towards loved ones left behind. All in all, a picture emerges that is also underscored in historical studies (such as Henkes 1993; Harzig 2003). Nevertheless, single female migrants strive – probably harder than in the past – to establish a life of their own; a concern that is especially fraught with problems if they are forced to continue living in conditions of illegality (see the next chapter).

In general, then, our interviewees planned their migration as a temporary measure and in no way does migration induce them to give up relationships with family members left behind in the home country. Most women have no intention of lifelong emigration, and particularly for those who leave children behind in their home countries, the prime concern is to overcome acute economic and/or social problems. They decamp from home, as Mirjana Morokvašic (1994) puts it, precisely as a means of staying at home, or at least maintaining a stable home.

The upshot is that eastern Europeans can operate a self-organized rotation system which enables them to commute rather than having to emigrate, whereas women from Latin America rely on the (usually vain) hope of being able to return home before too long (Morokvašic-Müller 2003; Cyrus 2003; Rerrich 2002b). The female migrants remain emotionally attached to their families of origin across wide geographical distances while taking very onerous economic obligations upon themselves. A crucial element of these obligations consists of money transfers or remittances, which not infrequently become the most important sources of income for the households in the home location.[1] Recent calculations for eastern Europe have been published which suggest that one third to one half of the population benefits from remittances (Okólski 2004).

That aside, the ever-accelerating speed and affordability of communications technologies enable people to maintain regular communication,

the basis of close social and emotional relationships (Vertovec 2004). In this way female migrants can remain involved in household decisions and, as mothers, can continue to fulfil child-rearing responsibilities and remain primary attachment figures for their children in spite of the vast geographical distances that separate them.[2] How tenable and successful is 'mothering from a distance' (Parreñas 2001b) or 'transnational motherhood' (Hondagneu-Sotelo and Avila 1997) of this kind? What emotional and psychological costs does it entail for female migrants and their families? How and to what degree does it alter or consolidate hierarchical relationships between genders and generations? These are the key questions to be discussed in this chapter, referring to examples from two case histories. Before moving on to portraits of the protagonists of these case histories, a few concepts central to this chapter will be elucidated in more detail: the concepts of transnational motherhood and the transnational family.

6.1 The transnational mother

The phenomenon of 'mothering from a distance' and of 'transnational motherhood' is far from new. From historical research it is known that the overwhelming majority of maidservants in Europe and on other continents lived in their employers' households. Within this employment arrangement, servanthood and motherhood were irreconcilable. Unless they wanted to jeopardize their jobs, they had to leave their children in the care of other, often paid, minders. Likewise, the female migrants recruited into Germany's industrial workforce in the 1950s initially came to Germany without their husbands and children (see Erel 2002). Another example from more recent history is black maids in South Africa, who always had to leave their children with relatives.[3]

Only very recently has 'transnational motherhood' become a topic of research and garnered more in-depth consideration in association with transnational livelihoods. Studies to date have primarily focused on the US-American-Mexican/Latin American and Caribbean regions of migration (Hondagneu-Sotelo 2001; Hondagneu-Sotelo and Avila 1997; Chamberlain 1997; Fog Olwig 1999, 2002). For the European context, recent studies have only just investigated the migration movements of mothers between Spain and various Latin American countries, especially Ecuador and Peru (cf. Escrivá 2004; Sørensen 2005). In contrast, barely any analysis of transnational family networks between Germany and Latin America or Germany and Poland has taken place so far.

To date, the best available documentation of transnational motherhood and its impacts on stay-behind children relates to Filipino female

domestic workers. The studies by Rhacel Salazar Parreñas (Parreñas 2001a, 2001b, 2002, 2005) in this regard have been influential in mapping out the conceptual field.[4] These studies principally emphasize the tangible emotional handicaps perceived by mothers and children as a result of long-distance mothering. In contrast, other studies point to the potential of transnational families, and stress that constant mobility accompanied by networking among community members across wide geographical distances can enable them to maintain a functional community and create a collective identity. For instance, Mary Chamberlain (1997) describes a long tradition of emigration by young women in the Caribbean, who remain at home until they have given birth to one or two children and then emigrate in search of work. The children are cared for by their grandmothers or other female relatives. Chamberlain considers that this childcare arrangement underpins the strong propensity for mobility within these communities (cf. Lutz 2000; see also Fog Olwig 1999, 2002). With regard to the Caribbean migration region, it is assumed that this arrangement offers a successful means of combining the care and upbringing of children with migration, making it a proposition capable of yielding acceptable life outcomes for future generations as well.

The approaches mentioned differ first and foremost in their representation and evaluation of motherhood. While Rhacel Parreñas draws attention to the losses that arise through the physical separation of mother and child, Chamberlain and Fog Olwig emphasize that in the case of the Caribbean family structure, motherhood is understood in a broader sense: what is meant by motherhood is not just direct care *for* a child, where the natural or the social mother is responsible for the child's daily care and upbringing. On the contrary, this can equally be entrusted to other (female) family members while the natural mother demonstrates her care *about* the child in the form of financial contributions (see also Lutz 2000). This interpretation of motherhood goes hand in hand with a more collective sense of family, in which other family members as well as the biological parents share in decision-making about the children's development.

Another significant difference between these two research approaches is that they are based on differing evaluations of the influence of agency and given social structures on practices of transnational family life. One approach emphasizes agency, and hence the potential of transnational families to put family members in a position to forge and maintain bonds of community across national borders, despite the considerable distances involved. The other places more emphasis

on the restrictive political structures engendered by the social and emotional deficits of 'motherhood from a distance'. For the analysis of transnational family life, both approaches are valuable since they clarify the correlation between constrained agency in heteronomous structures and the potential capacities of female migrants.

Pursuing these considerations, we understand the concept of 'transnational motherhood' as a descriptive term which characterizes the efforts of biological mothers to perform social mothering across wide geographical distances, with all the entailed constraints, and in this way to combine *caring about* their children with *caring for* them.

In many societies, it remains the prevailing assumption that a child thrives best if it is physically close to its biological mother, and that children grow up most successfully if the home and family settings coincide. The associated normative stipulation is historically linked to the emergence of the nuclear family, and is most widespread precisely where this form of family is most commonplace. Yet there are certainly important research findings which cast doubt upon this normativity. Comparative cross-cultural anthropological studies on childcare and upbringing have, for example, drawn attention to the fact that concepts of family, motherhood and childhood are not subject to any universally valid definition but follow specific cultural patterns (see Mead and Wolfenstein 1955). Cross-cultural comparisons provide no evidence for the so-called natural connection between pregnancy, birth and cultural practices of child-rearing, nor do comparative cultural studies attest that, always and everywhere, mothers are the most important attachment figures for their children (Mead 1962; Weisner and Gallimore 1977). Even within one society, class-based and ethnic-group-specific differences in the evaluation of motherhood are to be found. Again and again, studies draw attention to the fact that the dominant bourgeois family concept, which corresponds to the lifestyle of the upper middle class, stigmatizes single parents and working-class or migrant families, since from the middle-class perspective these deviate from the norm. Thus, the child rearing-behaviour of these groups is disparaged as inappropriate. For instance, there has been little appreciation of the solutions found by the first generation of migrants recruited to Germany who were not allowed or inclined to bring their children with them, since they hardly measured up to the bourgeois family ideal: in these cases, grandparents or other relatives have cared for the children as social parents, or older brothers and sisters have passed on their knowledge to younger ones and supported their development (see Erel 2002).

However, as long as such arrangements are judged from the perspective of the dominant, idealized family model, which is constantly propounded in public discourse and in the media, not to mention state institutions, schools, kindergartens, family support services, etc., there is a danger that self-perceptions will assimilate to and eventually be moulded by the perceptions of others; in other words, mothers will develop a guilt complex and feel like 'uncaring mothers' for having left their children behind and for falling short of the stipulated standards. In the case examples, we will come to see what negative consequences this can have for the women's self-perceptions and for their communication with their children.

6.2 Transnational family

The classic definition of the family has been under pressure for some time because it does not reflect the diversity of real people's lives. Findings from Great Britain revealed, for example, that only 15 per cent of all families now live in the classic, traditional nuclear family formation (Kumar 1997). Clinging to a romantic mirage of the nuclear family, which casts the family as a place of private security, which must be protected from the social and bureaucratic coldness of public life and which at the same time offers protection, in no way corresponds to the empirical reality.

In her notable study about family transformation processes in California, Judith Stacey (1998 [1990]) convincingly demonstrates that at the end of the twentieth century, a shift in household arrangements took place from the modern nuclear family to the postmodern family. The latter, she argues, is characterized by diversification of household forms and by very varied social arrangements and relationships, which exist simultaneously and multi-locally. From this, Stacey concludes that any definition of the family today must do justice to the 'diversity and complexity of postmodern family patterns'. Consequently, today we need a dynamic concept of family.

By way of reaction to these transformations, the German Federal Ministry of Family Affairs, Senior Citizens, Women and Youth declared in its 'Fifth report on family affairs' (Bundesministerium für Familie, Senioren, Frauen und Jugend 1994) that where there are children, there are families. Although this definition was debated positively in the broader realm of family research (on this, see the report by Strohmeier and Schultz 2005), the public discourse nevertheless clings to the notion of the *bourgeois nuclear family* as the reference category (cf. Schmidt 2002: 16). Transnational families deviate from this ideal

type in that home and family do not coincide but maintain bonds with one another even when dispersed among different countries. The forging and nurturing of these bonds are a constructive task which all family members must actively perform.

James Holstein and Jaber Gumbrium (1995) regard the current concept of the family as problematic because it prescribes a legal, moral and biological concept of relatedness, which ignores precisely those aspects which are most important in people's everyday lives, namely *commitment, involvement, loyalty, care, and self-obligation*. In their constructivist family approach, they make the assumption that it is not blood ties but interactions, public discourses and interpretations which produce the domestic order. The relevant question for research into the empirical organization of everyday families, according to the authors, is who or what defines the substance and organization of domestic life and how the parameters of the meaning of family are established. Accordingly, families must be seen as a constellation of ideas, images or terminologies, which serve to ascribe domestic meaning to the aspects of daily life.

From this it can be concluded that a new concept of family is necessary which does not neglect blood ties, but which contextualizes them and gives expression to the link between biological and social unity. Even if people generally presume that families consist of *natural* rather than *elective* relationships, the fact remains that membership, like membership of a nation or an ethnic group, is not self-evident but the result of social negotiation processes (Bryceson and Vuorela 2002: 10).

At first glance this seems a complex idea; nevertheless it is comparable with the *doing gender* and *doing ethnicity* approach already described in earlier chapters: family is established actively on the level of everyday life. It is already evident from the material in the previous chapter that there is nothing anomalous whatsoever about this thesis of 'doing family'. Indeed, it was shown that domestic workers and employers describe their relationships as quasi-familial and act accordingly. They can only do this, however, by disregarding any legal or biologically determined family concept and instead, as mentioned above, taking commitment, involvement, loyalty, care and self-obligation as the basis of such a conception of family.

Nevertheless, even this definition cannot be decoupled from legal, biological and moral ideas of the family. In her study, Rhacel Parreñas (2005) suggests combining these levels. First, family is established in the sense of everyday activities of men and women and children, meaning that daily decisions are taken about the distribution of material

resources and about mutual physical and emotional care. Secondly, the family is a legally and morally founded institution which is constructed on the basis of meanings, norms and power relations; thus, it can be ideologically charged while at the same time being perpetuated but also subject to change. It is important to note that social inequalities operate on both levels, and these have gender-specific, generational, ethnic and class-specific causes. At the same time, boundaries are drawn in order to generate and reproduce an idea of the 'proper family' shared by as many members as possible. The active production of family, 'doing family', is based on a family habitus which also acts as the glue that holds the family together and helps to establish consensus, perhaps between generations, genders, etc., and to define and enforce mechanisms of inclusion and exclusion.[5] In all family systems, however, frictions and conflicts also arise over relative power and hierarchical status. These conflicts are not easy even when household and family coincide, and all members live in one home in one place. For transnational families, complicating factors come into play, which we will come on to later.

It follows from this discussion that transnational families are social units, whose members have to move and define themselves in a contested arena of multiple relationships and places. This applies not only to family members who physically engage in cross-border mobility, but also to those who remain behind in the places of origin, for they, too, are actively involved in the construction of transnational relationships of exchange (cf. Brah 1996; Brennan 2004; Schwalgin 2004a, 2004b). With reference to the two levels introduced above, this means that the extension of geographical space also changes the coordinates associated with legal and moral meanings and power relations. As long as a migrant is denied rights of citizenship in the country in which she lives and works, the state of the country of origin retains primacy of intervention, particularly in ruling on legal issues. Over and above this, however, being especially reliant on money transfers in the form of remittances, the sending countries in particular try to exert their influence on the moral attachments, the loyalties of the migrants towards their families and their country. An example that springs immediately to mind is the award of state prizes in the Philippines to honour female migrants as 'heroes of the state' (Shinozaki 2005). This not only appreciates these women's substantial contribution to the national economy but at the same time reminds the women in question which country they are investing their wages in and where their loyalties should lie. The adaptation of family law to the transnational

family reality in the meantime has ensured that family-specific support and social security benefits take account of the extended absences of biological mothers and fathers (ibid.). Of course, the state in the destination country of migration also exerts an influence, by means of family legislation and via the migration regime, on the shape of transnational family life. The restrictive legislation in Germany, for example, leads to a situation where mothers without a residency permit lack the rights to reunite their families, and if they do fetch their children to be with them amid the greatest difficulties, they have no right to enrol them in school or to take advantage of healthcare for themselves and their dependants (see also the next chapter). This means that the agency of transnational families is subject to diverse constraints. The debordering that arose through geographical mobility is simultaneously opposed by the restriction of scope for action effected via national migration regimes, and this cannot simply be ignored (see Brennan 2004: 42). Since this situation means that individual members of the same family may be granted very different rights of citizenship, power discrepancies develop within transnational families, which also reflect gender-specific differences (see Parreñas 2005). Rhacel Parreñas describes in her study of the Philippines that the absence of fathers has impacts in terms of loss of intimacy, but they are hardly blamed for this as long as the present mothers take charge of male/fatherly tasks and compensate for the lack of proximity. The migration of mothers, in contrast, is deemed 'abnormal'. Their family responsibilities, which must be fulfilled by others in their absence, are always handed over to other women, never to men. And these 'substitute mothers' are merely regarded as an emergency solution. It thus becomes clear that in the Philippines discourse, which ultimately constructs the physical presence of the mother as irreplaceable, transnational motherhood is deemed of necessity to be a deficient model and the mothers concerned are placed under pressure (ibid.: 141–60).[6]

These examples suggest that a constructivist approach which makes the action level of 'doing family' across national borders the departure point of the analysis has found little resonance so far on the moral level. At the same time, however, it is plain that the loyalties and emotional attachments between the members of a transnational family are not weakened by migration. From this arises the question of how these ties are maintained and consolidated when intimacy and familiarity can no longer be established through shared everyday experiences and routines. What actions and substitute routines are developed in order to bring about lasting ties and loyalties in the transnational sphere?

These questions will now be analysed with reference to the following two case examples. The working assumption is that transnational motherhood and household management are substantially influenced by the historical, legal and geographical parameters in different migration regions. To bring this into focus, the next section will consist of a contrastive analysis of the transnational family lives of Anita Borner and Gizelha Santos, who originate from different migration regions. Anita Borner migrated from a small town in the Polish region of Upper Silesia to Berlin, and Gizelha Santos comes from a city in north-east Brazil and lives in Hamburg.

6.3 Opportunities and risks of system change: Anita Borner

Anita Borner leaves her small Upper Silesian home town in 1989 to move to Berlin for the first time at the age of twenty-nine. At this point in time, she has been married for ten years and has two sons. The elder son, Tomasz, is nine years old and the younger, Andrzej, is six. Anita Borner's decision to migrate has been maturing over a long period of time. She considers the process that leads to this decision not so much as an individual, intra-family decision-making process but as a reaction to a mass phenomenon. Living conditions in Poland at the time have been deteriorating drastically for nine years. The regime change in 1989 turned her life upside down; her old life is over 'from one moment to the next'. In her home town, which relies almost exclusively on mining, pits are closing down, unemployment is spreading like wildfire, and the cultural system subsidized by the Communist Party, whose offerings were a vital stimulus for Anita Borner, is falling apart.

In her Upper Silesian home town, many residents can invoke a German ancestry which entitles them to migrate or commute to Germany as 'migrants of German descent'.[7] This legal migration has consequences for the irregular migration of Poles to Germany. Many people from Anita Borner's circle of friends are leaving for the West, and many are going to Berlin. Migration is becoming a mass phenomenon, and exerting a knock-on effect among those left behind. Since more and more people had travelled to work in Germany, according to Anita Borner, their families were enjoying a better standard of living and more consumer choice. Their options are many times greater than for those who have stayed behind, and awaken dreams of social advancement in everyone. Migration is also taking place in Anita Borner's personal milieu: her brother, who met a German woman during the 1980s, moves to Munich and offers to fetch her

over to Germany. Because her children had still been too small at the time, she says, she turned down the offer. But finally, Anita Borner's small family also took steps to emigrate. Her husband submitted an application for 'late repatriation' as an ethnic German, but this was refused by the German authorities.[8] In this situation, a woman friend offered Anita Borner the opportunity to work in Berlin households.

Following the failure of the earlier attempts, her husband agreed to this project since he hoped it would improve their living standard: 'Yes, you can go.' His consent is not a matter of course, for up to that time Anita Borner had never been able to gain her husband's support for her professional and educational ambitions. She reports that her husband boycotted her plans for a long time, insisting that she was responsible for bringing up their children. For instance, about a year after the birth of her first son, when she was working as a materials inspector in a chemical plant, she had been recommended for a course of studies.

The degree programme was to be financed by the firm and undertaken by means of weekend courses. Her husband had denied her his support, however, with the words: 'My wife doesn't need to be smarter than me. I'm not staying home with the child. Forget it!' Out of jealousy, he had also boycotted her desire to take French lessons, she said, because she might have come into contact with other men.

Obviously her husband gives his consent to her migration in 1989 because the new consumption possibilities that are becoming apparent in his environment finally convince him to overcome his concerns for the sake of improving their material situation. In this case, it is not a matter of needing to secure the family's livelihood, because unlike many others, the husband has kept his job as a chemist and can fulfil his role as the family's breadwinner.

The couple's hope of using Anita Borner's income as a domestic worker to realize consumption desires that were previously beyond their economic means is rapidly fulfilled: Anita Borner finances her car, an apartment including all furnishings, language tuition for their sons, and later their university education. She would return from her working stays in Berlin 'loaded up like a dromedary with a thousand suitcases of shopping for him, for my children, food, toys'.

Her working life in Berlin is not that successful to begin with. Once she has arrived, Anita Borner works with the Polish friend, to whom she pays a DM200 'introduction fee', equivalent to her husband's monthly salary at that time, in return for which she is promised jobs as an 'associate'. The other woman does not stick to the agreement,

however, and Anita Borner returns home to her family after three months. But she does not give up and a few months later, in mid-1990, she gives Berlin a second try. She accepts a position as an au pair with a German-Polish family. It is interesting that she calls herself an au pair although by then she is already thirty years old and has no au pair contract which might have limited her working hours or made provision for language-course attendance. Essentially, this is a form of live-in employment relationship specific to Germany, which gains in prevalence over the course of the 1990s and gradually develops into a frequently chosen form of migration (see Hess and Puckhaber 2004).

Anita Borner's new employer, a Polish woman, obtains a visa for her. Anita Borner's tasks consist primarily of looking after her employers' two children and carrying out domestic duties. Her earnings are comparatively good, DM1200 per month,[9] six times as much as her husband makes, and she is satisfied with her work situation. She gets on very well with her employer and develops a close emotional relationship with the two girls she looks after.

At the same time, caring for these children reminds her of her own sons back home; the separation causes her pain. After about six months, towards Christmas, she can no longer stand the situation; she travels back to Poland. She tries to keep her job in Berlin by finding a young Polish woman to stand in for her, and plans to introduce a rotation system with her. These plans are dashed, however, because the children do not get along with the new caregiver, added to which her employer does not want to subject her children to constant changes of childcare staff. Obviously she feels responsible for Anita Borner, though, and supports her in looking for work as a domestic cleaner after she returns. There follows a start-up phase during which Anita Borner finds only a few cleaning jobs to begin with. Eventually she succeeds in establishing herself so well that she can seek a colleague with whom to share her work. At regular intervals of a few weeks she travels back to Poland to take care of her children, her husband and her own home. In between these visits, the children are left behind in the care of her husband and her mother-in-law. Like most domestic workers from Poland in Berlin, Anita Borner organizes her migration on a commuting basis. The rotating organization of work – one month in Poland, one month in Berlin – obviously works very well. Over time, Anita Borner organizes her periods of presence and absence in Berlin with the help of various colleagues – in other words she becomes an employer herself in a certain sense. On first impressions, Anita Borner appears to have accomplished the transition into

micro-entrepreneurship very successfully. But her own account is by no means entirely upbeat.

The costs of transnational motherhood

> I remember that – I had too much courage. ... Or, I didn't realize that you pay a price, how much it costs. It cost me a lot.

These are the words with which Anita Borner sums up more than ten years of experience as a transnational wife and mother. In retrospect, her assessment of the consequences of her absence for her children is mainly negative. The costs of which she speaks are entirely remote from the material plane. Obviously, trusting in her own personal strengths ('I had too much courage') she only gradually realized what disadvantages would accrue from the arrangement in the long term. To the interviewer's follow-up question, she replies:

> For example, one time I was sitting with both my children; often when I come home to Poland, it's the same even today. Funnily enough, even though they're both grown up now. When I get into bed with a book, I've always done that, an hour before going to sleep, I have to read something. It's like my sleeping pill, you know ... my two sons come to me – one on the left, one on the right, and say: 'Mum, this and that happened', 'Mum!', thousands of questions, you know. And one time, I looked, and my eldest son had grown hair on his legs. And I said: 'My God! He's not a child any more.' He was sixteen, I think. I missed the moment. I didn't see it. Simple as that, I missed it.

This sequence initially shows that Anita Borner must have managed to build up a very close relationship with her children and uphold rituals over many years once they were introduced. This story indicates that her relationship with her sons, despite or perhaps precisely because of her long absences, enabled a closeness during the phases when she was at home which few other mothers would have had with their pubescent sons. Owing to their mother's long absences, this ritual is obviously experienced by the sons as something precious which they celebrate with their mother. Anita Borner, however, presents this memory as evidence that she lost touch with her children's daily development: her son reached adulthood and she was not there. In essence, she is not so much pointing out the loss of a momentary impression, which she would probably have realized just as suddenly had she been there every day; instead, this sense of 'missing' something symbolizes the loss she has suffered through her transnational motherhood. She was

also absent for other biographical turning points in the lives of her children – for example, her youngest son's first day at school. In view of the fact that Anita Borner had constantly been available to her children up until the start of her commuting migration, since she had already been a housewife for some years (see further below), the experience is also to be read as her own evaluation of the years before her departure: she was always there for her children. The unconditional commitment that she gave to her own children for years is obviously transferred to the two little girls she looks after during her time working as an au pair. This substitute motherhood, however, seems to amplify her grief over the separation from her own children even further, because the love and care that she showers on the stranger's children produce a particular sense of loss: 'And that was terrible for me'. While she feels physically remote from her own children, in order to be able to provide them with a better future, she compensates for the closeness she misses by means of the attention that she devotes to the 'substitute children'. This leaves her in a quandary. After six months she decides to go back home, and by the time she returns to Berlin, she has decided to avoid this form of intensive caregiving to small children.

The description given by Anita Borner crops up in a similar pattern in other studies. Filipino domestic workers in Rome and Los Angeles feel helpless, guilty and lonely, and grieve about missing the development of their children and the loss of intimacy. Parreñas (2001b: 120ff.) draws the conclusion that these women develop a sense of 'surreal timelessness': given that watching their children grow up is no longer part of the domestic workers' everyday experiences, seeing them again is often an upsetting experience because it prompts the realization that a development, once 'missed', cannot be repeated or recaptured. Working as a caregiver to other children creates an especially painful awareness of their physical remoteness from their own children, which can culminate in an aversion to childcare; equally, caring for 'strangers' children' can also compensate for the feelings of guilt, since they reap the benefits of the surrogate love.[10]

Important differences exist between the types of self-organization of transnational motherhood practised by Filipinos and by eastern Europeans. While the Filipinos can bridge the geographical distance only by travelling home once a year at the most, and even then only if a holiday is guaranteed in the legal employment contract, the geographical proximity of Germany to countries like Poland or the Czech Republic offers those migrants the possibility of quick and relatively frequent visits home.

This was the case for Anita Borner, whose adoption of the strategy of commuting migration enables her to stay close to her children in Poland despite working in Berlin. The geographical proximity of Upper Silesia and Berlin, visa-free travel and good, comparatively cheap transport links allow her a degree of mobility not available to transnational mothers from Latin America. But this form of migration carries a personal cost for Anita Borner in addition to the separation from her children: the price of not being able to put down proper roots in Berlin. Only after ten years does she give up the regular commuting and remain in Berlin. At this point her elder son has embarked on university studies in another city, and her younger son is sixteen years old. Finally she can fulfil her desire to attend a language course in Berlin and learn German. This in turn requires her to maintain her interrupted presence in Berlin.

Furthermore, Anita Borner developed strategies of transnational motherhood which are comparable with those familiar from other studies. Besides her regular commuting to Poland and her children's visits to Berlin, she keeps in touch with them via daily telephone calls. A considerable portion of the money she earns is spent on her sons' education, additional language courses and subsequent university studies. She presents this as the central if not the sole driver of her migration. Supporting her children seems to be important to her because she believes that her sons are highly talented. She presents this giftedness as the continuing effect of the genealogy of her parental family: both she and her brother had been extraordinarily gifted, she says. Several times she emphasizes that her brother, who now works as a lawyer in South Africa, speaks several languages; she herself had stood out from the crowd owing to her unusual maturity and her abilities. A look at Anita Borner's family history underscores the family-biographical relevance of her motive for migration, to make it possible for her sons to advance to their rightful social status.

Distinction and advancement – perpetuating an elite social heritage
Anita Borner's parents come from families who, as she says, belonged to the elite of Polish society before the Second World War. Her paternal grandfather, an officer in the Second World War, was murdered in 1946 as a regime opponent and capitalist; his wife, she recounts, was the illegitimate child of a baron. The maternal grandparents had to give up their land ownership in Ukraine and are compensated in Poland for this loss. Dispossessed during the German occupation and conscripted as forced labourers, they lose their two daughters, Anita

Borner's mother and aunt, who are removed from them and sent to an Austrian family. The family is reunited only after the war with the help of the Red Cross. Despite their massive social descent due to the Second World War and the subsequent change of regime, both Anita Borner's parents try to cling on to the elite lifestyle of their families in the pre-war era by placing a value on education. Although they were not successful professionally, since they were precluded from studying, what little money they had, as Anita Borner emphasizes, was always spent on books. She describes her own life as a progressive attempt to escape from the class hierarchy of communist Poland, which emphasized the education of working-class children above the offspring of the former elite. The family habitus is still related to categories from the social order of the pre-war era. Distinction is realized via classical education, and here Anita Borner evokes the topos of the 'poor intellectual'. The children, i.e. Anita and her brother, are urged to get a good education to compensate for the fall in status endured by the family. Here, too, the parents appear to set their sights on gender-differentiated, grand-bourgeois or aristocratic role models: the brother is supported in his law studies and the learning of foreign languages; Anita Borner herself is brought up as a 'gentlewoman': she learns dancing, piano-playing and French, but is not destined to study. She completes an apprenticeship as a typesetter and initially works as a 'polygrapher', a role which at least keeps her in contact with books in the course of her occupation. Later she is employed as a nursery nurse, a teacher and a porcelain factory worker.

Obviously, the imperative of achieving the social advancement that was denied to her parents and herself is now transmitted to her sons. Today both sons are studying future-oriented subjects, namely economics with Chinese and Japanese. One son has spent two years immersed in fine art. The intergenerational transfer of educational ambitions is apparently successful, and Anita Borner plays her part in honouring her social heritage by means of her migration. The price she pays is the sacrifice, for many years, of a geographically compact family life, but Anita Borner nurtures the hope that, thanks to her migration, the family project of social resurgence can finally be continued in the third generation. Her sons, she says, play their own part in overcoming the problematic aspects of transnational motherhood. Today she receives recognition from them for her sacrifices. Anita Borner quotes the words of her sons: 'Mother, stop it. Normally we could never have ended up where we are today if you hadn't done what you did.' Now this commuting migration could be considered a success story, for

Anita Borner succeeded in fulfilling traditional aspects of motherhood. Nevertheless, she torments herself even today with feelings of guilt towards her sons.

Traditional motherhood and mother-blaming

> But I must say, it really was quite a high price. For a mother. Andrzej was six years old, Tomasz nine. OK, I trusted my husband, I thought everything was OK. And I didn't know that my husband was capable of hitting children. I didn't know that he could terrorize the children mentally in that way. In the end my son got a nervous disorder, with involuntary movements, like a tic.

Only in the course of the interview does Anita Borner articulate the name of the serious nervous disorder she is talking about: epilepsy. By mentioning it only hesitantly, she gives expression to feelings of guilt, which she offloads at this point by diminishing its impact as a 'tic'. So it is not only lost moments of togetherness or missed rites of passage and developmental leaps which have prompted Anita Borner's feelings of guilt. Rather, she has the feeling that her sons, more than anyone, have paid the price for her migration. Although the initial impression may be that she blames her husband for the development of her son's illness, a psychosomatic reaction to his parenting methods, it later becomes clear that, with hindsight, she sees her departure as 'a tragedy for the children and my husband. I really didn't know that he couldn't manage on his own.' Ultimately she blames herself for not having anticipated these problems. Neither her husband nor her in-laws were, in her opinion, fit to take charge of the children's upbringing.

> My parents-in-law were both aggressive, primitive, I'm very sorry to say, emotionally primitive. The child needs a beating to understand a few things. And order is all-important, Teutonic order, that's what I mean. Everything by the rules. And has to be – well, my husband unfortunately, lots of people are like that, they have bad feelings. He comes home angry from work, and because there's no dog at home, someone has to bear the brunt of his aggression. And often that was the children. That, uh, I have, uh, how can I put it, children who are difficult to love. Both are very intelligent, but of course that also means, very, how can I put it?

The interviewer offers her the words 'tiring' and 'demanding', but Anita Borner does not think they fit her meaning. Instead, she continues with the description:

I guided both of them, uh, ten years, no, nine years and six years. And I gave my children free rein to say *no*, to express their *opinion*. My Andrzej was always – he got angry with me and it didn't matter what happened, he locked himself in the bathroom [laughs] and I had to knock and [in a pleading tone]: 'Andrzej, come and see me, Andrzej!', 'No!' [laughs]. That's how it was ... We both, we come from very different worlds. And I left him with the children; before that he had nothing to do with the two of them. All he did was work, he came home, he stayed in, he got his meals and he could play with the children, just a short time, or do a course, whatever he wanted. [...] The children were always with *me*.

This passage is revealing in many respects. It is primarily a self-description by Anita Borner and elucidates a complex family dynamic. The fact that she married a man who does not match up to her own aristocratic background obviously becomes a problem at the moment when the care of her sons, whom she considers to belong to the social lineage of her own family rather than her husband's, has to be entrusted to his side of the family. It can be assumed that the class differences within the Borners' marriage were always present, but only became virulent at the moment in which Anita Borner had to relinquish her 'domain of power' to her parents-in-law and her husband. She has set herself apart from her husband's family for years by passing on her refined values to her sons and raising them to be 'free' from external repression. In this description, her husband features more as a guest in his own house than as the man of the house – all the important decisions are made by Anita Borner, who takes care that her 'highly gifted' sons need not suffer the primitive child-rearing practices of the parents-in-law. In order to bring her social legacy to fruition in the sons, Anita Borner obviously forged a particularly close bond with the children ('they were always with me; I guided them'), ultimately in order to keep them away from the 'bad' influences of her husband's family.

Such a field of conflict is sufficiently well known from family therapy; it arises anywhere where the mother's class background is higher than the father's. In the case of Anita Borner, it becomes clear that she despises her husband's family and has taken on a mission to civilize them. The family structure is therefore already characterized by latent tensions, and Anita Borner's migration finally acts as a catalyst: the conflicts become visible. At first, Anita Borner reels off a series of banal things in her lengthy description of the 'tragedy': the mother-in-law and her husband are 'pathological misers', which is manifested

in the fact that they make the family sit in the dark every morning in a bid to save electricity, or that they insist on 'Teutonic order' and thereby 'terrorize' the children. For her sons, she explains, that had been a 'shock' from which they had struggled to recover.

From the start of her migration onwards, not only does Anita Borner try to visit her children once a month at home, but also has her husband and sons visit her in Berlin.[11] On one of these occasions, her son Tomasz, aged ten at the time, wants to stay with his mother rather than returning to Poland with his father and brother. When questioned, however, he cannot explain what is on his mind. Anita Borner mentions this incident as further evidence that her children cannot manage without her and suffer from her absence. The disruption to the family routine caused by the mother's migration is obviously perceived as drastic by the children because, prior to her departure, Anita Borner was not in paid employment but a housewife, in charge of managing family life; it was she who dealt with all family matters, the official form-filling, the children's education and the well-being of her husband ('he had a very comfortable life with me, for years and years'). This description indicates that in the given circumstances her husband had such an elevated income that he could support his family as the sole breadwinner. In Poland before the system reform, the traditional model[12] that we see in the Borner family was commonplace predominantly in the well-paid mining regions. Most Polish women, on the other hand, had to take up employment, if only because one salary was not enough to live on. The state propagated the model of the woman with two professional roles: housewife and employee.[13] Since the transformation of the system, however, the traditional model has gained ground, supported not least by the Catholic Church.

Evidently the husband is not capable of filling the gap left by Anita Borner – at least not in the way that she would wish. She expects him to defend her parenting style, including the nuclear-family habitus that she has created, vis-à-vis her mother-in-law, and holds it against him that she specifically fails to do so. It is apparent from her narrative that this expectation was unrealistic from the outset, because even before her migration her husband was hot tempered and worked off his aggression at home. It is likely that she pushed her worries to the back of her mind so as not to jeopardize the migration project as a whole. In order to avoid having to delegate a share of the care work to her mother-in-law, she originally looks for a different solution:

I tried to find *somebody* to mind my children. Do a bit of cooking, clean-

ing. Forget it! The women would rather have died; *not one* would come and clean somebody else's home. They were too proud.

At the time of Anita Borner's migration at the end of the 1980s, outsourcing childcare and housework to another woman is not yet commonplace in Polish society, and not accepted. To carry out such work as paid employment is obviously felt to be degrading ('they were too proud'). In contrast, the delegation of care and child-rearing work within the extended family network, a typical feature of transnational families, is widespread. In the meantime the situation has changed. Thus, in the course of the 1990s, domestic and care work in well-off Polish middle-class families was increasingly outsourced to non-family members – Ukrainian women, for instance.[14] In this way, a female substitution model has gradually become established here, too. This has come to be known as the global care chain (Hochschild 2000; Parreñas 2001a, 2001b) and is familiar from many countries in which major economic and social disparities exist.

For Anita Borner, however, this turnaround comes too late. She evidently has to fit in with the given circumstances and delegate the care of her children to their father and grandmother. It is striking, however, that she has more faith in the care provided by a stranger than by her own family. Possibly she is familiar with the management of servants from stories told by her own grandparents, and it seems more in keeping with the aristocratic lifestyle to which she feels she belongs. These statements could be seen, in sum, as a reference to the fact that even the image of the Polish family as a harmonious, loving community is shaky and somewhat at odds with reality.[15]

Anita Borner's narrative culminates in a self-description which will be analysed more precisely in the following. She describes herself as a woman with a mother-animal's instinct who has a telepathic connection with her sons.

Something had happened, uh, it's a bit mysterious. It's my unwelcome gift, it's my higher mind, this information from dreams. I've often dreamed something that has happened. It's the emotional bond with my children; and you can believe me or disbelieve me, but that is how it works. Freud wrote about this kind of thing, but naturally he explained it a bit differently, with the sexual bond and theory of dreams. But in my case, the way it is, the emotional bond, I used to have it with my father, and now I have the same thing with my children: if something happens, I've dreamed about it. And that, I had a dream, [...] I went on a train with my children and the train came off the rails, but nothing

awful happened, the people just fell into a meadow full of flowers; they're just looking for each other; everyone is shocked but nobody is wounded, there's no blood, nothing at all. But I can't find Tomasz. And I'm terribly afraid. I hold my Andrzej's hand tightly; there's a small river, a stream and I can't find my son. And I know he's suffering. So straight away I phoned Poland and asked my husband: 'What has happened?' 'Nothing.' 'What has happened?' [raises her voice] 'Nothing.' But I couldn't stand it; a week later I went back to Poland.

It turned out that her son had been hospitalized as a result of an epileptic fit. Her husband obviously didn't want to worry her and kept the truth from her – this, too, is a familiar behaviour pattern of the relatives left at home in migration processes.

Anita Borner sees herself as having this special 'telepathic' ability, which she explains in terms of the strong mental and emotional bond between mother and children: she pays no heed to the misinformation from her husband and relies on her intuition. On arriving at the hospital, she learns that Tomasz had been heavily medicated for two full days with antipsychotic drugs to stop his hysterical crying. It was the 'horror trip' endured by the child, she explains, which triggered her nightmare. In the hospital she meets the doctor in charge of his treatment.

And strangely, the doctor, she talked at me from a strange position. She simply wanted me to – I knew it, she wanted to punish me or she wanted to make me feel guilty. Yes, she looked at his notes and said: 'So, here we have a child afflicted with a very nervous disorder, because his mother has left him. She is no longer caring for the child,' blah blah blah. [...] And then I *knew* it at once, she has all kinds of prejudices towards me [...] I might have known, typically Polish. The damned mother has left her poor children behind to go off and have a nice time in Berlin, blah blah blah.

The choice of words and turns of phrase in this fragment differs distinctly from the rest of her narrative. If we had the impression up to now that Anita Borner tormented herself with reproaches and questioned her own quality as a super-mother, what surfaces here is that the world around her also has a very clear idea of how a good mother should behave. In the eyes of the outside world – represented here by the doctor – she has failed as a mother. Whereas the narrative up to this point gives the impression that Anita Borner shares this way of looking at things, that her self-perception and perception in the

eyes of others coincide, here she distances herself emphatically from this dominant point of view ('blah blah blah'), which she generalizes as 'typically Polish'. The doctor, an authority figure, confronts her with the image that is becoming familiar from most countries with a high rate of female emigration: the women leave husbands and children behind in order to realize their own potential ('have a nice time in Berlin'). The consequences of migration, in this case the child's mental breakdown, are not blamed on the caregivers who remained behind; the responsibility is laid solely and exclusively at the door of the absent mother. The existence of an equivalent discourse on transnational motherhood that has even been taken up by the media, not only in the Philippines (Parreñas 2005; Shinozaki 2005) but also in Sri Lanka (Gamburd 2000) and in Mexico (Hondagneu-Sotelo 2001), indicates that this phenomenon is not in fact just 'typically Polish' but the expression of the patriarchal structures of traditional and modern societies, which evaluate women's migration processes differently from men's. In each of these countries there is a long tradition of male migration, but it is only when women/mothers leave that alarms are sounded about the consequences of family disintegration, and children and husbands are viewed as victims. The underlying concept of this traditional family model, which is not far removed from the dominant ideas in Germany, is that of 'intensive mothering', as analysed by Sharon Hays (1996) with reference to the example of US society. The intensive mothering paradigm denotes a historically constructed cultural model, a gender-specific ideology and practice of motherhood, which comprises the following elements: a close mother–child bond as the precondition for the child's healthy development, and the idea that the mother is primarily responsible for the child's care and upbringing, and should pursue these with selfless devotion (ibid.). Every society in which this model has become dominant has problems with the combination of intensive motherhood and women's employment. In Polish society, where the combination of paid employment with a housewife's work-load was part of socialist normality, this idea of motherhood initially seems completely unsuitable.

Above, we have already suggested that the discourse of intensive mothering is not in the interest of governments that are reliant on remittances from female migrants. The establishment of counter-discourses, which may be one motive of the Philippine government's introduction of medal ceremonies for domestic workers or its designation of these women as heroes of the nation, appears to offer a counterweight to the negative images of the bad mother. On the other hand, it is known from

the research studies cited above that, on the level of the family coping with a mother's migration, these doubts tend to linger, not only among family members but also among transnational mothers themselves. Even if the women concerned reject the guilt discourse, latent feelings of guilt remain. And these are all the stronger where self-perception and perceptions in the eyes of others are oriented to the traditional view of motherhood. Most mothers defend themselves by pointing out the economic surplus value and the additional educational and development opportunities they are providing for their families by means of their work. In Anita Borner we see yet another possible means of justifying herself: she resorts to the culturally accepted paradigm of intensive mothering, but in an individualized form.

> But I was really furious: 'Hold on a moment! I'm not a doctor, but I am a mother! And nobody can tell me what is really good for my child!' The child was confused anyway because of the fights between his parents, and I asked: 'What has given you that idea? What has happened to my child? Did you know the child was beaten by his father? Did you know the child was terrorized by his grandmother? Did you know what the child went through when I wasn't there? Do you think it's all my fault, just because we were apart, do you?' But I was really, inside I was ...
> 'Hold on a moment!' I said: 'Why are you so one-sided? Shouldn't you maybe ask me how things are, first?'

Since part of the traditional understanding of motherhood is the idea that only the biological mother can ultimately know what is good for her child, she insists on her right to disqualify other people's judgements of the situation. Moreover, in standing up to the doctor, she brings the faults of the father and the parents-in-law into the equation. Such a strategy is interesting in several respects. First, it once again marks the role allocation as self-evident: yes, ultimately she is the main person to blame and to be held responsible for the well-being of her children; secondly, she counters with the image of the disturbed family circumstances, by pointing out that her relatives had not taken on the caring duties in an appropriate manner. Her 'mother-animal instinct' never failed her, but she was let down by the people she had trusted; that was Anita Borner's justification. It is important to note here that she does not depart from the discourse of traditional motherhood, but shifts it to strengthen her own position.

Matka Polka How is it possible in Poland to reconcile the concept of intensive mothering with women's paid employment? Does the

full-time employment of women not presuppose the outsourcing of important maternal functions either to professional nursery teachers or to husbands? A look at Polish history and gender research refutes this. Likewise, in the interviews with Anita Borner, a Polish cultural concept is found which seems to reconcile the irreconcilable: *Matka Polka*. Anita Borner introduces this script, with which she identifies at different points, half ironically, half seriously, in the description of the relationship with her husband:

> I was his mother. I was never his wife, I was his mother. On the one hand. On the other hand he certainly wanted, uh, to have a lover, a mother and – uh – a domestic slave. [...] as the wife, I was there for the washing, for the cooking, for the children. In our country we call it the *Polish mother.* She has duty, pride, she is blameless and faultless.

'*Matka Polka*', the 'mother as Polish woman', which Anita Borner presents here as *the Polish mother*, is a multifaceted figure which symbolically binds a gender with a nation. It refers both to the family level, where it involves intensive mothering of the child and her husband, and to woman's devotion to the nation.[16] The phrase goes back to the famous poem '*Matka Polka*' by the Polish national poet Adam Mickiewicz, extolling the patriotic role of women during Poland's 150-year history of partition. While men were fighting, imprisoned, exiled or working in Western countries abroad, women were declared responsible for the entire running of the home and the patriotic upbringing of the children. The image of the '*Matka Polka*' conjured up by Mickiewicz certainly had a belligerent side, but its main qualities were 'maternal care, readiness for sacrifice and selfless love, in order to uphold values such as honour, courage and loyalty to principles in the husband's absence' (Hirsch 1992: 257). The *Matka Polka* 'always appeared as a tragic figure, who suffered because exceedingly great duties forced her into a life full of self-denial' (ibid.: 258). She was unerotic; earthly love was alien to her, and thus she almost resembled a saint. Mickiewicz's figure of heroic womanhood served as a gender-specific patriotic role model in the further course of history, and clearly influences symbolic Polish gender identities to this day.

Mirosława Marody and Anna Giza-Poleszczuk (2000) studied gender relations and particularly the image of women before and after the system reform. Formally, women were placed on an equal footing with men under communism, and a high proportion of working women served to confirm this propagandistically. This had two consequences: first, the role of the man as head of the family and sole breadwinner

was undermined; second, while it gave women access to working life, incomes and advancement opportunities were so low that a professional career offered no alternative to the model of starting a family (ibid.: 55ff.). By embarking on working life, women were burdened with additional duties without any relief in the domestic sphere, a phenomenon that the authors call 'selective modernization' of the woman's role. Men, for their part, lost their 'traditional' position in the family without gaining additional possibilities for social recognition. This yawning divide between the symbolic and the real dimension of the role ascriptions is highlighted by the authors as a (past and present) cause of tensions between the sexes (ibid.: 58): even if the woman works on the 'upbringing' of her husband (education, manners, etc.) at her own cost, in doing so she makes an important contribution to her family and is rewarded with the feeling that she has helped her husband and hence the entire family to gain prestige. This traditional and officially propagated image of the '*Matka Polka*' has now been transformed, in the interaction between husband and wife, into the image of the 'valiant victim'. 'Valiant' was a reference to the woman's double burden, while the patriarchal, discriminatory man's world, in both occupational and family spheres, made her a 'victim'.[17] Even today, the Polish research shows, the behavioural norm of 'being valiant' is manifested in everyday life by carrying heavy bags full of shopping, missing sleep and overcoming exhaustion; this sacrifice is compensated by the belief in being the irreplaceable manager of family life (ibid.: 58).

This description of everyday life shows astonishing parallels with Anita Borner's description. She, too, styles herself as the 'valiant victim', whose work in Berlin is done entirely for the sake of her family, and who lets her husband take it easy. 'Like a dromedary' she single-handedly hauls home 'a thousand suitcases' full of shopping for the whole family. In her portrayal, her husband is weak ('a big child'); he comes from a 'totally patriarchal family', which has formatively influenced his own patriarchal behaviour and his attitude towards her. As a 'valiant victim', she obviously also draws on this stereotype herself, and treats him like 'a big child'. In the course of interviews, Anita Borner describes the deterioration of her marriage up until her divorce in the year 2000 – coloured by the recollection of her recent divorce – as a constant battle: 'He didn't fight for me, he fought with me.' This is how she sums up the scenes of a marriage in which battles were fought not only over gender roles but also over family culture and social class. For Anita Borner, it was obviously not possible to transfer the different habitus of her families

of origin into a new, shared family culture; transmission of her social heritage is the most important thing for her, because that together with intellectual prowess and cultural refinement is the basis of her self-perception, which she has transmitted to her sons. In contrast, she constructs her husband's family as the 'other' (primitive working-class culture) from which her children must be protected. While she describes herself as courageous, ambitious, a genuine leadership type, her husband is complacently and neurotically focused on conforming to the prevailing order. These descriptions suggest that even in the socialist forms of society in which class differences allegedly no longer made any difference, social classes were maintained by means of familial distinctions.

Recalling the personality clashes between husband and wife, Anita Borner describes it as a logical consequence that she herself, rather than her husband, leaves for Berlin as a migrant worker. Although this step suits her ambitious personality, Anita Borner's evaluation of it remains ambivalent. She is proud of having reversed the allocation of roles within the family by migrating in search of employment, repositioning her husband, the family breadwinner, as her inferior. But she is angry with her husband that she alone 'rescues the chestnuts from the fire' for everyone. By this, she does not mean her economic achievements alone, but also her commitment to bringing up, caring for and educating her sons. Here, again, a similar ambivalence is apparent. On the one hand, Anita Borner expects her husband to take on the role of the caregiver who offers the children emotional security and stability; on the other hand, she clings to the image of the man as the household breadwinner, who is simply incapable of filling the care gap opened up by her absence. For him to take on her duties would, for a start, be irreconcilable with her intensive mothering self-perception and her 'mother-animal instinct'. The blurring of the rigid task allocation works here only through an expansion of one side of the gender hierarchy, namely the feminine side, which can also take on masculine tasks. The assumption of feminine caring and upbringing tasks by husbands is either considered impossible, simply because only a mother knows what her children need, or else the work brings no gratification because it is tainted as a feminized activity.

In the midst of conditions like these, which are presented to exemplify the problems that many transnational mothers have, it is necessary to talk about a deep-seated crisis of masculinity with regard to the reordering of gender relations. Men can no longer occupy their traditional position as the family breadwinner, while no new position

will be in sight until the grammatical rules of gender, which determine how 'gender is done', become more flexible. In order to make feminized migration and the concomitant transnational motherhood a success for sending countries as well, not just in the economic sense but socially, too, precisely this transformation must take place. Until it does, guilt and failure will remain the dominant feelings on both sides of the gender divide.

The negotiation of family relations In the intervening time, Anita Borner has shifted the focus of her life to Berlin, where at the time of the interview she was staying without legal residency status. Her youngest son Andrzej, who had started a university degree in Berlin, shares the apartment with her. Life together in the small, two-room apartment is not always conflict free. Because the living room overlooks a noisy highway with constant traffic, the living space cannot be made to work as a two-bedroom apartment, so mother and son share one room as a bedroom. The other room serves as a living room and doubles up as the son's study; conflicts are therefore inevitable. Having friends round or using the television becomes a problem because the son's computer is in the same room. The son accuses her of being selfish for disturbing him rather than refraining from having friends round to visit. She defends herself by saying that she is entitled to her own life as a grown woman.

A further, important source of tensions in the relationship is that the son is financially dependent on the mother. Anita Borner is financing tuition as well as living expenses for both sons. An especially tough responsibility for her, because as a result of her divorce and her status as an irregular migrant in Germany, she receives no independent welfare or pension provision, either in Poland or in Germany, apart from an apartment in Poland owned jointly by herself and her ex-husband. At the time of the interviews (2003) she has already been working in Berlin for fourteen years and it is becoming increasingly difficult for her to manage the same workload as in the early days, added to which, occupational and age-related health problems are starting to surface. The constant use of caustic cleaning agents has affected her airways. She tires more quickly than in the past, suffers from back pain, and her eyesight has deteriorated so much that she frequently needs new spectacles. A new life, perhaps in conjunction with seeking a partner, seems almost impossible in such a situation; equally, building up any provision for old age in Germany is complicated in the given circumstances.

Anita Borner also sees the various conflicts between mother and

son in their shared apartment as a consequence of her long absence. She often has the feeling that her son wishes to punish her for leaving him, aged sixteen, alone with his father and ceasing to commute back and forth to Poland. The conflicts with her husband ultimately led to divorce, which she says still hurts her son today.

And that – I think, he still expects me to give him those years back. He still wants to feel like a child. But I *can't* give him all my time any longer. That's where this disappointment comes from. I am *not* the same mother I was a few years ago, not any more. And he is not the same child either. He is an adult. And I expect things of him. And he can't go along with that. He still feels like a child.

Mother and son wear each other down with the sad realization that lost time cannot be recaptured or repeated, and that children can suffer and endure disorders from the divorce of their parents. The contribution of the father to this situation goes unspoken. Under the given conditions, any other solution to the accommodation problem is difficult to realize, since Anita Borner, as an irregular migrant, is dependent on understanding and supportive landlords (on this, see also the following chapter) and cannot afford the rent for a second apartment for her son. In such a context the son can only grow up with great difficulty, and his mother cannot simply set aside her identity as a mother; at the same time, Anita Borner's feelings of guilt are 'fed' daily by the presence of the son.

Apart from the fact that in this arrangement her feelings of guilt are reactivated on a daily basis, this case also shows that the evaluation of the 'commodified motherhood' (Parreñas 2001a, 2001b) practised by transnational mothers, i.e. compensating for the mother's physical absence by transferring material goods to be invested in the physical care and education of the children, will remain ambivalent for as long as motherhood is defined and lived in the form described. In order to analyse whether the handling of transnational motherhood can be experienced differently if those concerned come from another cultural region and the geographical distance is so great that contact with husbands and children is even more restricted than in the case of eastern Europeans, in the following section the case of a Latin American will be discussed contrastively.

6.4 The realization of a dream: Gizelha Santos

Gizelha Santos, whom we already know from Chapter 4, seizes an opportunity that unexpectedly presents itself to leave Recife, her home

city in north-eastern Brazil, to migrate to Hamburg at the end of the 1990s. She happens to meet a German tourist, Hanna, with whom she becomes friends; and they stay in touch even after her return to Germany. Gizelha Santos told Hanna that she had long nurtured the dream of spending time abroad but had never been able to realize this dream. Hanna finally helps her to turn this dream into reality, and sends her a plane ticket. Gizelha Santos is already in her mid-thirties by this time and has never previously left the country or even her home region. Against her husband's wishes, Gizelha Santos accepts the offer and – like Anita Borner – leaves her two children at home with him. The children at this time are older than in the case of Anita Borner, however; the son is seventeen and the daughter sixteen. The complexity of Gizelha Santos's motive for migration becomes clear only in the course of the total of four interviews conducted with her. Initially, she states that concern about her children's education is the central motive for her desire to migrate.

Gizelha Santos married her husband Sergio very young, at the age of eighteen. That same year, she gave birth to her son. She grew up in the house of her paternal grandparents, with her mother and three older siblings, and dreamed of becoming a doctor.[18] Although she graduated from high school during her pregnancy, as a consequence of early motherhood and the lack of support from her environment, she was unable to take her studies any further. Her desire to gain a university degree and pursue her own career had to be buried once and for all at the age of twenty, when she became pregnant for the second time and gave birth to a daughter.[19] Now she is a housewife and mother; her life is a cycle of constant repetitions:

> Taking my children to school, coming home, cooking lunch, collecting my children from school, staying at home for the afternoon and help-ing the children with their homework. The husband comes home in the evening. Then I spend the evening at home with my husband. Or we go to my mother's. At weekends, then, maybe off to the beach on a Sunday. To the beach with the children. ... Every day was the same, every day, every day, every day.

In contrast to Anita Borner, who has positive things to report about her life as a housewife and mother prior to migration, the household as the pivotal point in Gizelha Santos's narrative is presented as a place of boredom and monotony. Since she does no vocational train-ing upon leaving school, the world of work remains barred to her; the double burden of work and household, which is familiar to Anita

Borner, is something that Gizelha Santos has never experienced as a routine way of life. She would like to spare her children, especially her daughter, the repetitiveness of this life, and enable them to have the kind of future that she has been denied. Like Anita Borner, Gizelha Santos presents herself as a wife dominated by a patriarch who only fulfils his obligations as the main breadwinner sufficiently to provide for their daily subsistence.[20] Both men are reproached for having been incapable of providing better future prospects for their children. In both relationships there are arguments about this attitude, which the women criticize as a lack of ambition, and the desire to improve the situation is presented in both cases as the central motive for migration. In this, they are no different from any other mothers in our sample. While in most cases, albeit in the course of several interviews, other wishes come to light, including a desire for autonomy, self-realization and, not infrequently, a way out of a rocky marriage, nevertheless all the indications are that – in German society no less than back home – the concern to give children a better future is the most favourably viewed motive for migration, and dominates the overall narration of the migration story. At the same time, it appears to be important for women to present themselves as 'good mothers', which they do during the interviews with us and probably also with employers, and to reject any suspicion that the migration project was undertaken for the purpose of self-realization, their prime concern here being to refute the common implication of sexual freedom as a motive. One interviewee demonstrates the figure of the 'good mother' not only narratively but visually: to her first interview she wears a T-shirt bearing a photo of her two children, who smile at the interviewer throughout the conversation, while she herself describes the separation from her sons as dramatic and bursts into tears repeatedly.[21]

As a generalization, it can be said that sacrifice, suffering, loss and guilt inevitably form a focus in the narratives of transnational mothers, and are thus an aspect of transnational mothering practice. In their interaction with family members in the country of origin *and* with members of German society, there is pressure to present themselves as loving, caring mothers *despite* having left their children behind. Transnational mothers have to justify and defend themselves against the latent reproach of neglecting their children. This observation can also be seen as a reflection on the discourses of German society, for obviously even in this country, emancipation has not suppressed the discourse about 'good mothering' by any means.

Back to Gizelha Santos, who initially follows the described narrative

pattern. She concludes the legitimization narrative with the after-thought: 'But I never thought, I *never* thought of splitting up.' The divorce from her husband that did eventually follow was not some-thing she had planned. At the time of her migration, the marriage had already gone through a series of crises, but her decision to leave Brazil was apparently prompted by another event altogether. In 1997, her mother becomes seriously ill and now needs nursing care. Gizelha Santos takes on this task, which in turn causes disagreements with her husband. In 1999 both parents die, her mother and then the father she has barely heard from since her parents' separation. Thereupon she has no further obligations to deter her from migrating: 'They died in the September, and in the November I came here.' She assumes that her children are old enough to take care of themselves; like Anita Borner, she leaves her husband in charge of the family's day-to-day arrangements.

Parenting practice of a transnational mother The massive change in lifestyle and routine that Gizelha Santos has to contend with seems to be accomplished relatively successfully. She rents a room in Hanna's shared house and is supported by the group of house-sharers in every respect: she has help finding employers, in obtaining healthcare and when she needs a lawyer. Her life as an irregular migrant is buffered by this embeddedness in German normality. Like another of the domestic workers whom we interviewed, Maria la Carrera, she is thus able to integrate relatively quickly and confidently.

Despite the geographical distance she maintains close contact with her children. With regular telephone calls, which besides the rent and food costs account for the largest item in her budget, she remains emotionally bonded with her children, and her remittances smooth the path of their educational advancement. It is also important to her that she exerts a continuing influence on the children's moral education. After a two-year stay in Hamburg, she decides to invite her children to Germany – a step that is considerably easier for eastern European women to accomplish, but which is rather unusual for Latin American women. This invitation entails substantial financial sacrifices and extensive logistical preparations. She must find an apartment with enough space, as this is not the case in the shared house. She must find a sponsor for this invitation, for various conditions have to be met in order to apply for a three-month visitor's visa: a dated ticket for the return flight, health insurance and evidence of 'adequate financial means' must be shown; at the time, the latter amounted

to €25 per day, which for a stay lasting ninety days for two people comes to a sum of €4,500. Together with the two plane tickets costing around €2,200, the total amount runs to €6,700, which Gizelha Santos could never afford. An employer with whom she has become friendly agrees to act as their sponsor. In addition to the increased costs of rent for the duration of the children's stay, she also has to cover their subsistence costs for the three months. Within her network of Latin American domestic workers, this is considered an unusual way to go about things. She dismisses any suggestion that she could have invested the amount spent on this trip to better effect in Brazil. She implements her project, which she presents as part of her children's education, in the face of all resistance.

Gizelha Santos explains that she was pursuing two different objectives in having her children over to stay. First, she wanted to share the experiences she had had in Germany with her children, and in this way establish and deepen their emotional closeness. They, too, should be given the opportunity 'to see something different, different people, different minds, different thinking'. Secondly, they should learn that 'the streets of Europe are not paved with gold'. An understandable desire, not least because of the seven-day week that Gizelha Santos forces herself to endure in the first few years. For female migrants of every generation, it has always been a difficult undertaking to convey their dangerous and degrading working conditions to those who benefit from the economic enhancement. Apart from the fact that such information can be conveyed only to a limited extent under different cultural conditions, the parties concerned also risk divulging to family members back home that, socially and occupationally, they have taken a retrograde step; this is something else that many would rather avoid.

Gizelha Santos obviously has no fear of revealing the nature of her work to her children; on the contrary, during their stay in Germany she gives them a 'three-month course in domestic work'. The learning experience that she wants to pass on to her children consists of immersion in her working routine. It is not the extraordinary, the tourist attractions, which she wants to share with her children; she takes them not on a sightseeing tour around the monuments of Hamburg, but a tour of the Hamburg households in which she works. She arranges with her employers to be able to bring the children with her. She describes this 'training programme' as follows:

> We left home at seven or seven-thirty in the morning, the three of us, and we were on the road all day, and went to work, and then came

home at eight in the evening, for three months. I also organized a German course for Roberta and João. At Caritas.[22] I enrolled them for this German course, and that way they can also learn German for the time that they're here. And then I picked them up from the course, and then we met at the Central Station and off we went to work. Because I just wanted them to live and see what my life here is like, and what I, hmm, what I, what the work is like, what I actually do the whole time. And that it isn't easy for me. And that way they could see that I, uh, and understand, because I wanted them to understand that it just wasn't an easy thing for me to come over here and to leave them behind in Brazil, and everything, and to be here alone, to *stay* here as well. That was why I really wanted to bring them over here, too. So that they feel the same way as *I* felt. But not to do anything mean to them, but simply just so that they learn how it is. And that is why we spent every day from Sunday to Sunday at work and did our cleaning.

These working holidays that Gizelha Santos arranges for her children are not just to be viewed as an educational intervention. After having scraped together a vast amount of money for the children's trip, she cannot afford to sacrifice her earnings for any part of their three-month stay. She makes a virtue out of necessity, however, and declares the work a learning experience. Clearly, Gizelha Santos has a very close relationship with both her children. It is important to her that the children can put themselves in her place ('feel the same way as I felt'), can imagine all the details of her daily routine and working life, and what a sacrifice she has made in this way ('to leave them behind in Brazil ... and to be here alone'). Only when her friends beg her to give herself and the children a break, at least on a Sunday, are the Sunday duties relinquished to another domestic worker and the three of them go on a few outings instead.

It is quite possible that Gizelha Santos has indeed accomplished a successful educational intervention by means of this programme. It is known from numerous studies that children of domestic workers in the countries of origin grow up in relative material prosperity compared to others in their age group, because a lot of money is invested in their education. According to their mothers' wishes, these children should be able to concentrate wholly and exclusively on their education, and unlike their peer group, are spared any obligation to contribute to the family income. At the same time, they come under pressure to succeed, not to disappoint their mothers' expectations of advancement; conversely, the children make growing material

demands of their mothers, who are not in a position to examine the legitimacy of these demands at a distance. A spiral of expectations arises, which develops its own dynamic and not uncommonly leads to tragic outcomes. Furthermore, the children's social context frequently contributes to exacerbating their lack of appreciation of their mother's strenuous paid work, since no limits are imposed on the children's demands. Precisely this is what Gizelha Santos wanted to prevent by means of her campaign. Not to force them to be frugal, but: 'I just wanted them to see how difficult the money is to earn.' Her evaluation of this time is positive:

> I think the difference it made is that now they really put a value on the way I work. That they just see, and say: 'You work a lot! It's not a, it's a difficult job, it's hard work, it's not easy.' And if I just talk about it and say: 'Yes, I do cleaning,' then it doesn't mean anything to them, because my house was *always* clean. In Brazil as well. It's always clean. And if they think that's the same *everywhere*, then they have no idea. But here they saw that there are some houses which are clean and, or tidy, and others where you open the door and think: 'Oh my God! I want to get out of here fast!'[23]

The 'course' that Gizelha Santos puts her children through can be analysed as moral education with two lessons. Lesson number one: domestic workers' professional work in other people's apartments is not the equivalent of housework as the children know it from their own home; instead, they see dirt and mess; they experience how these must be brought back under control on a weekly basis. In this way, Gizelha Santos tries to make domestic work visible to her children as a *respectable* job. Only when the children offer to clean the bathroom does she turn them down, for fear of the illnesses they might catch from doing so.

Lesson number two: to be proud of the money earned in this way. Gizelha Santos had other jobs alongside her cleaning at that time; she also washed dishes in a restaurant kitchen and worked as a babysitter. She outsources these 'jobs' to her children. She assigns the jobs gender-specifically: both children wash up in the restaurant kitchen, while Roberta carries out the babysitting alone. When the children offer her the money they have earned as a contribution to the household budget, she turns them down; instead, they should develop a sense of satisfaction about money they have earned themselves. Apparently, Roberta and João ended up sitting at home counting their money with great 'enthusiasm'.

Along with respect for her work, Gizelha Santos also wants to give her children first-hand experience of the offputting elements of her new environment: its otherness, which she explains as symptomatic of lifestyle differences between Brazil and Germany – people who are not happy and good humoured, don't look at each other in the subway and don't talk to each other; streets without children playing in them. She intends for Roberta and João to understand that their mother did not leave them behind casually for egotistical motives, but that the cultural disparities cause her to suffer:

Yes, I didn't like it either, when I arrived here. And it was very difficult, as well. I, well, I knew that they wouldn't like it because it's a different life.

It will become apparent that she wanted to get the message across not only to her children but also to other family members back home: you are better off planning your future in Brazil! In other words, she uses the children to spread the word about the unpleasant living conditions in Germany so as to deter others from planning to migrate. The strategy does not work, however, as we shall see later.

Contrary to what their mother anticipated or planned, on arrival at the airport in Hamburg, the children gain insights into the restrictive migration controls against unwelcome immigrants, another aspect that pervades their mother's life in Germany. The children are met at the airport by the two female German friends who intend to be their sponsors. The immigration official who checks their papers reacts with suspicion to the two unaccompanied children, and repeatedly asks about their mother (but not their father, interestingly enough); he probably fears the purpose of their visit could be an illegal entry or family reunification. Only after examining the material circumstances of the sponsors for several hours does he release the children, who are now very disconcerted.

Gizelha Santos's assessment of transnational motherhood is positive overall. In contrast to Anita Borner and most of the other mothers, she does *not* present her life story as a story of continuous suffering. The costs that she talks about relate to the lack of emotional security and the comfort of the family, the risks entailed by her social position as an illegal migrant, and the lack of a partner. On the other hand, clearly she is not nursing any feelings of guilt in relation to whether Roberta and João are being well cared for in her absence. She presumes this to be the case and does not torment herself with doubts. Apart from the fact that the age of the children can make a difference here,

there is also a suggestion that Brazilian family structures are helpful to her. Northern Brazil has a long tradition of male migration, as a consequence of which matriarchally organized, multigenerational families are often left behind. Brazil's post-colonial society is also notable for a wide array of forms of informal cohabitation without marriage. Dieter Brühl (1996) refers to this form of communal life, in which extended and nuclear families coexist, as 'Family without marriage – marriage without family'. Unlike the legally safeguarded and, at the same time, heavily idealized system of monogamous nuclear or couple-based families that is established in Europe, he describes a comparatively broader diversity of family forms in Brazil, some of which have also been given legal status. According to Brühl, the resulting social relations are characterized by affectivity, tradition, reciprocality of services and obligations; relationships dominated by personal dependencies rather than rational, individualized calculation (ibid.: 218).[24]

In the case of Gizelha Santos, as of many other Latin American women, it can be assumed that not only her husband but also female relatives from the extended family are involved in caring for the children, so that she, in contrast to Anita Borner, can delegate this care to others. The cultural script of such a form of society obviously eases the transformation of care *for* the children, associated with physical presence, into a transnationally organized care *about* the children. The moral education within such a cultural script places value on passing on the reciprocality of services and obligations to the next generation. Gizelha Santos reports that in her phone calls home, she constantly reminds her daughter of her obligations to other family members; she tells her to lighten her aunt's load by helping to look after her children.

From this description of the different family systems, the overhasty conclusion could be drawn that the scope of possibilities for Latin American migrants is greater and that they are therefore subject to fewer constraints in establishing a life of their own in the course of migration than, for instance, eastern Europeans. This is by no means the case, however. Aside from the fact that the class-specific differences need to be analysed and borne in mind in order to qualify such statements, the endeavour for (some form of) autonomy seems to be a theme of the utmost complexity for *all* the mothers that we interviewed.

The shackles of the family economy It was touched upon earlier that Gizelha Santos expands upon the description of her migration motive

only in the course of subsequent interviews. She refers to her migration as the catalyst for a slow process of emancipation. She postpones her original plan to return to her home town within one year:

> But then, in fact, I started to learn lots of things here, I started to change, and at that point I thought: 'No, I can't just go back to Brazil now, and live the old life again, that won't work any more *either*.'

She likes her new-found independence, even if it inevitably brings moments of loneliness. If she returned to her 'old life', she would risk falling back into the old relationship structures: 'The way I am now in my head, I can't go back and be together with my husband.' The freedom of movement and choice that she has struggled for without her husband's help has become more and more important as time has gone on: 'Here everything depends on me. Everything I want, I have to provide for myself. I have to do everything.'

Her pride in this freedom is entirely understandable; nevertheless, it is also apparent that for Gizelha Santos, as for Anita Borner, this feeling of autonomy need not necessarily culminate in a life lived autonomously. On the contrary, family obligations stand in the way of developing autonomous perspectives on life – in this case, for example, building a future in Germany with a new partner. Her family circle is constantly beset with new financial problems, which they bring to her. Her monthly income is between €1,000 and €1,500. The cost of running her own home in Hamburg amounts to €250 for the rent, €50 for surcharges, approximately €100 or more for the regular phone calls to Brazil, and €79 for a monthly ticket on public transport; on top of that comes her food expenditure. She transfers around half of her income as monthly support to her family in Brazil. She sends her money via a bank, either to her sister or her children, mainly Roberta, who in turn sees to the further distribution of the money as her mother would wish; the children use it to finance their education and goods that their father cannot afford. Gizelha Santos likewise supports her sister Carmen, who is an unemployed single mother.

Irregular financial support also goes to her brother and his family, and to the husband who has meanwhile divorced her. For instance, when the wife of her brother, a low-paid policeman, is hospitalized, she finances the care of his children. Although she tries to, she cannot really control the distribution of the money. Who decides to what extent and how such distribution takes place remains unclear. What becomes clear in the interview, however, is that Gizelha Santos entrusts the further distribution of the money to her daughter more

than anyone else – a phenomenon that is equally familiar from the studies by Parreñas, Gamburd and Shinozaki. Obviously the mothers make the assumption that their daughters will act in accordance with their wishes, or at least that a strong relationship of loyalty exists between mothers and daughters, which allows daughters to stand in as their mothers' proxies.[25]

Gizelha Santos even instructs her children in the moral rules of the family economy described above:

> I always said: 'We don't know what tomorrow will bring.' And therefore you really have to think hard, or be very careful, about refusing help to someone. Being all stuck up and saying: 'Oh no, I can't help, I don't feel like it!' or anything like that. You must always think that tomorrow you might need help yourself.

So far she has not been able to realize her dream of establishing her own shop in Brazil, since her money goes to her relatives. Even if Gizelha Santos did have any desire to build her own life in Germany, it seems highly unlikely that this would turn out successfully in the given circumstances. Therefore she must always be able to fall back on the support of her family network. This moral economy of family loyalty also acts as a shackle upon her. For example, she tries for years to prevent her sister Carmen from following her to Germany by sending money back home to her in Brazil. In the end, clearly she bows to social pressure that is exerted on her – her sister comes to Hamburg shortly after the interviews, in January 2004, and moves in with her. Gizelha Santos thereby loses part of the independence she has built up through her efforts, and any chance of an early end to the project looks increasingly unlikely, for the responsibility for initiating her sister into the work falls primarily to her. Returning to Brazil would also mean having to move back in with her divorced husband, pending the somewhat unlikely prospect of finding her own apartment and livelihood. Like many others in comparable situations, Gizelha Santos finds herself in a position in which her options are very limited: she yearns for the Brazilian way of life, but cannot go back because she has no future there, nor has she yet been able to lay foundations for such a future. In Germany she is exposed to the risks of her irregular status. There is no future there for her either, unless she finds a German partner who will marry her.

Like Anita Borner, Gizelha Santos also *commutes*, if not physically then mentally and emotionally, between her homeland and her country of residence. Both women have undoubtedly managed to emancipate

themselves from their husbands by means of their migration projects. Against the backdrop of their legal situation as irregular migrant domestic workers in Germany, however, the long-term outlook for this emancipation project is bleak. It would tumble down like a house of cards if they could no longer earn a living as domestic employees. Any return to their home country would mean renewed dependency on their respective ex-husbands, since neither woman has put by sufficient savings to make future plans of her own. Likewise, marriage to a German citizen would be likely to bring a new form of dependency in its wake.

6.5 Provisional conclusions: is 'doing family' changed by feminized migration?

This chapter started with the assertion that female migrants decamp from their homes so as to be able to preserve their homes. After analysis of the practice of transnational motherhood, however, it can be said that by the time they come home, the home they return to is no longer the same as the one they left. On the one hand, their home changes during their absence, while on the other hand, it is anything but easy for the women concerned to establish future prospects for themselves in their homelands, a step that would facilitate their return. Time and time again, they prolong their stay in the destination country in order to fulfil newly discovered desires for consumption, to support family members in hardship, and to cover the education costs of their own children, and often also of nephews and nieces. In many countries of origin, social conditions are so disordered and risk-laden that any realistic future planning is practically impossible. In order to realize the migration project at all, migrants must put many misgivings to the back of their minds.

It has become clear that transnational migration of mothers challenges traditional family structures, gender-specific role patterns and conventional images of motherhood. On the level of everyday childcare and housekeeping practices, for example, new caring arrangements must be found. Since everyday routines that are bound up with the intimacy of family relationships fall away, transnational mothers and their relatives back home must find new routines that enable them to transmit emotional security and comfort across substantial geographical distances. In the cases discussed in this chapter, these caring arrangements are produced in the framework of the (extended) family and mainly carried out by female relatives. The women who take up gainful employment and thereby assume the breadwinner role that was previously defined as masculine are seen to change and extend their mothering practices.

Meanwhile, as far as we can ascertain from the external perspective of the migrating mothers, no such transformation is undergone by their husbands. Where fathering practices remain the same, children in nuclear families lack the more intense emotional affection and support. Undoubtedly, extended family structures represent a crucial caring resource; in this way they enable and encourage international labour migration. But this practice cannot belie the reality that the processes of intra-family outsourcing of child-rearing and caring work are conflict-laden and can entail considerable emotional risks and costs. The criteria of parenthood listed above – *commitment, involvement, loyalty, care and self-obligation* – are fulfilled by the mothers even across wide distances; and this is done in the form of financial payments that benefit not only the members of the nuclear family but also other individuals in the wider family circle, whose affection for the children and parents left behind is compensated in this way. The search for mother substitutes, for all the mothers in our sample, related to the female members of the (extended) family. The outsourcing of caring responsibilities to strangers did not crop up at the time of our research, although it has been documented in the literature. It was also found, however, that the question of whether transnational mothers can draw on a nuclear or an extended family, and what is the dominant discourse of motherhood in relation to appropriate care for children, can be of great significance for the parties concerned. A cultural context in which not only the biological mothers but also other women from the extended family circle can take on the caring function, a characteristic of Latin American and Caribbean societies, initially eases the mothers' choice to migrate as well as their feelings of guilt. They are spared the discourse of mother-blaming that is familiar to us from the (eastern) European countries. Nevertheless, problems can be observed even among Latin American women, including moral pressure to help other family members to migrate; problems engendered by the moral economy of reciprocal obligations which cannot be ignored by the mothers.

In the mother's absence, care work tends to be carried out by daughters or other female relatives. This indicates that care arrangements that arise after mothers migrate need not necessarily be established from scratch. In many cases it is rather a matter of reallocation and continuation of existing caring relationships, which include other, usually female relatives as well as the biological mother. How greatly arrangements preceding the migration have to be modified depends, as mentioned, not only on the age of the children but also on the family structures prior to the migration. Several of the mothers interviewed

by us already lived apart from their husbands or the fathers of their children, residing with their own mothers or parents. Even before their migration, then, their children were used to being cared for by other people, who carried on doing so after their mothers' migration; in such cases, children did not react to their mothers' departure with emotional disturbance. Most women try to make up for their physical absence and the danger of losing touch by means of (daily) telephone calls. Today's affordable cheap providers and phone cards for (intercontinental) calls abroad facilitate this form of communication, and the telephone becomes the 'social glue' (Vertovec 2004) for maintaining contact. The mothers attempt to carry on existing rituals and everyday routines, and also invent new ones. Providing emotional security by means of telephone calls works best with older children; involvement in their everyday joys and sorrows, encouraging their ambitions and their education, can be done by talking with them or even simply listening. This is less of a possibility with smaller children, whose physical and emotional care demands personal presence. This dimension of motherhood is withdrawn by the mothers' migration.

Telephone communication is demanding in terms of prerequisites, because it relies on the reciprocality of the need to exchange news; in the end, not every child of every age can cope with the abstraction of disembodied and faceless telephone communication. Where it can be conducted appropriately to the child's age, over time it works as a means of maintaining a pre-established bond of intimacy. This in turn gives rise to new rules and taboos concerning the form of interaction and the content of conversations: is crying permitted or expected? Is it better to keep quiet about an acute illness, an accident or mishap so as to protect the person so far away and not worry her unnecessarily? These questions must be negotiated communicatively in the course of time and revisited as necessary. Telephone conversations take place not only with the children but also with (former) husbands and other relatives responsible for care, with whom they can discuss child-rearing matters, for instance.

There are numerous signs that the transnational migration of mothers, far from weakening the relationship among family members, actually strengthens it. This relates to emotional relationships, first and foremost, but as has been shown above, the material dependencies develop in a similar manner. Far from operating in one direction only, i.e. dependence of family members on migrants, it also works the other way round because the mothers concerned will be reliant on the support of stay-home relatives upon their return. The thesis

of family fragmentation triggered by the migration of the mother is therefore in urgent need of revision.

The analysis of mothers' concrete everyday practices shows that different cultural discourses in the societies of origin regarding motherhood and family can exacerbate or alleviate the difficulty of women's migration. In the case of eastern European women, whose situation is influenced by a discourse focused on the biological mother, commuting migration is the key instrument for bringing their concept of motherhood into harmony with their migration. This form of migration simplifies the continuation of contact with relatives and can probably compensate in part for any denigration as a 'bad mother'. Another important means of maintaining contact are visits of the children to the mother, although they are not feasible in every case; this is dependent not only upon material prerequisites but also the German migration regime. While Anita Borner's children could (theoretically) visit their mother at any time, thanks to visa-free travel between Poland and Germany, the short distance between Berlin and Upper Silesia, and the comparatively cheap transport options, for Gizelha Santos a similar project demanded an enormous commitment of financial resources, painstaking logistical planning and months of preparation. Furthermore, both women found that visits from their children were affected by factors arising from their living and working situation as illegal domestic workers. To accommodate the children's visits, constrained and temporary living arrangements either had to be rearranged, as in the case of Gizelha Santos, or were a cause of disputes with other residents, as Anita Borner found. As a general comment, visits from children are distinctly harder for women from Latin America to organize because of the high costs they incur, not just for transport but also to support their dependants in Germany, where living expenses are much higher than in their home countries. For many women, this type of spending is competing with other savings goals or with financial obligations towards family members in their country of origin.

Since the German migration regime further impedes the desire to reunite families by denying children the right to healthcare or (pre-) school care, most mothers do not have the option of sending for their children to join them, or can only do so when the children reach adulthood and elect to study where their mother now resides, as in the case of Anita Borner and her sons.

The question asked at the beginning of this chapter as to how and to what degree the migration of mothers alters or consolidates hierarchical relationships between genders and generations has so far

been answered with reference to the respective discourses and practices of motherhood: members of transnational families must negotiate inequalities in relation to mobility and resources. So far, little empirical evidence has been found of role-switching in the gender distribution of work, of the kind predicted by Saskia Sassen and Mirjana Morokvašic. All that occurs is an enlargement of the range of tasks assigned to women, not only the migrant herself but other female relatives as well; the fact that women become primary breadwinners of the family by no means results in any automatic entitlement to the social privileges enjoyed by men on the strength of that status.[26]

A look at the mothers' conception of emancipation yields further pointers that may help to answer the question about altered hierarchies. Some women did not necessarily embark on migration because they sought a way out of economic hardship, but did so as a means of escaping from a conflict-laden partnership. Although women's migration is motivated by economic reasons first and foremost, and they justify it with care for their children, over the course of several interviews a desire for economic independence and a self-determined life can often also become evident. Our respondents never themselves refer to this desire as 'emancipation'. Patricia Pessar (2003) made the same observation with regard to transnational mothers in the USA; she quite rightly raises the concern that the self-assessment of the female migrants concerned does not coincide with the feminist enthusiasm of the female researchers, because the move from a patriarchal family structure to a socially marginalized and discrimination-prone position in the destination country should not be described as emancipation at all, let alone celebrated as such.

Many of the women we interviewed have indeed gained not only economic but also emotional independence from their partners, and have divorced at some point during their migration. It is questionable, however, whether this step has ultimately brought them the autonomy they desired. For in the given conditions, they may perhaps be able to push back the boundaries of the gender regime, but they immediately encounter new boundaries: those of the German migration regime.

As irregular migrants, they live their daily lives under structural constraints; permanent legalization is possible only through marriage to a German citizen. But embarking on a loving relationship under the given conditions is not easy, because so much is staked on it from the moment it starts: the partners in such a relationship are unequal from the outset. Such relationships commonly fail owing to the pressure to make the partnership, and hence the woman's residency

status, legal. Many women also talk about the stereotypes they have to battle with: eastern European women are considered to be 'marriage mad', good housewives and domestic cleaners (and are characterized as such by marriage bureaus, incidentally); Latin American women have to contend with preconceived ideas of their exotic nature and constant sexual availability.

Just a few women in our sample deploy their care-capital strategically in order to secure permanent residency status. Paulina Novak (see Appendix) plans to obtain a residence permit by marrying a sick German man in need of a carer. By contrast, many others do not contemplate any such strategic search for a partner but hope for a loving relationship that leads to marriage. Legalization is the future ambition of many irregular migrant mothers, but the majority are unwilling to realize this wish at the price of a 'sham marriage'. Even if a marriage takes place and remains stable, that is no guarantee that the mother can simply summon the children she has left behind to join her.

This form of family reunification is conditional upon the consent of the left-behind husband, who then risks losing contact with his children, whereas by keeping them with him, he retains the trump card with which to exert pressure on their mother. Transnational family ties give rise to new possibilities but also new difficulties. Transnational patchwork families with different national affiliations and citizenship rights are taking shape.

The conclusions of this chapter can therefore be summed up as follows: the gender codes in the home countries of transnational migrants are not automatically altered when mothers become the primary family breadwinners. Neither in our own society nor in the societies of the sending countries do any gratifications attach to the performance of traditionally feminine tasks; in other words, men cannot raise their social status by taking charge of 'feminine tasks'. Furthermore, the practice of *mother-blaming* continues to act as a powerful moral instrument which reminds mothers of their duties and binds them to their 'natural' tasks. Instead of the anticipated switch in gender coding in the countries of origin, there are rather signs that female migration is linked to a genuine crisis in masculine identity (failure as the family breadwinner, alcohol and drug problems, etc.). For as long as it takes to debate this masculinity crisis as such, and for as long as politics and migration research confine themselves to discussing the problems of transnational motherhood but ignore transnational and stay-behind fatherhood, the codings may shift slightly at most, but will not be altered.

7 | Being illegal

> I'd been here [about] three months, not very long. Anyway, someone was in front of me, on the bus, and then I was also asked to show my ticket. I was told to validate a single ticket, because my ticket was only valid till nine o'clock, and it was just past. Then the inspector accused me of not wanting to validate the ticket because I stood on the wrong *side*. Well, I really didn't know you need to stand in a very specific place to validate the ticket. And because I happened to stand somewhere different, the inspector said: 'Ah, aha' and so on. 'Wait, you ought to be standing *there*' and 'Ah, so you wanted to dodge the fare.'

What Gizelha Santos describes in these words is an everyday situation that starts with a misunderstanding. For most people, it can easily be resolved, but for any migrant without legal residency status, an incident of this kind can be a nightmare.

> Well, that day I was really frightened, because he then told me to get off the bus. He asked me for my papers. *My passport. 'I don't have my passport here!' And the inspectors were really quick to call the police. The police turned up in five minutes, you know?*[1] So the inspector had, um, called the police immediately, and then they came, and they asked me to tell them what had happened and so I very calmly told them that I did in fact have a ticket. So I showed them my monthly ticket, and said that I was actually trying to validate a single fare, and so on, but at that, they filled out a form and asked me for my, for my passport. And I had to come back here with them [...] because the passport was at home.

And the passport did not contain a residence permit. At that time, Gizelha Santos was living in shared accommodation with her German women friends, who were also present when she arrived with the police; the friends spoke to the police officer but he still insisted on seeing Gizelha Santos's passport. Gizelha Santos could already see herself in custody awaiting deportation; she could not speak for sheer nervousness. Then events took a different turn; the police officer was satisfied with her statement that she was visiting the country as a

tourist and would soon be returning home. He called the Hamburg transport authority and tried – in vain – to reverse the 30-euro penalty which had already been logged on their computer: 'And the policeman said: "I'm not here to endanger or harm you, I'm here to help you".'

It can be assumed that most other people in comparable situations are not graced with the good fortune that befell Gizelha Santos. Incidents of this kind normally lead to arrests and deportation orders.

It has already been alluded to at various points that the theme of 'being illegal' is one of the most important aspects of the lifestyle of the new domestic workers. After careful consideration, 'Being illegal' was chosen as the heading for this chapter, rather than labelling the affected people as '*illegals*'. There are several reasons for this decision: in the first place, the term 'illegal' applied to a person is controversial in the international migration debate, because it rides on the back of changeable and arbitrary legislation and carries pejorative connotations; secondly, it obscures the fact that a major proportion of those concerned are work-motivated migrants, even though they lack the recognition of residence and work permits, otherwise known as 'papers'. Hence these people are referred to in France as 'paperless' (*sans papiers*). Internationally, the preferred terms are 'undocumented' or 'irregular' migrants.[2] Khalid Koser (2005: 5ff.), senior policy analyst to the United Nations Global Commission on International Migration, regards the term 'illegality' as analytically and politically inappropriate for three reasons:

a) Illegality is often equated with criminality – but this combination is contradicted by the facts; b) illegality denies people their humanity; c) illegality suggests that refugees' asylum applications are unlawful, particularly in countries where any distinction between controlling migration and sheltering refugees has largely been eroded in the past few years.[3] Koser instead recommends the term 'irregularity', which is now internationally accepted.

In relation to the migrants described in this book, it will be necessary to address just the first two aspects mentioned by Koser, for none of our informants had ever applied for asylum in Germany.

7.1 Criminalization of illegality

The following discussion is prefaced with a description of the underlying legal and social conditions which determine the life situation of people in illegality. How does a situation even arise in which the lawfulness of people's existence in a country is questioned, and what problems does this consequently cause in their daily lives? To make

it clear that illegality is not innate, this chapter talks about 'being illegal' as a *consequence* of illegality and illegalization.

Historically speaking, illegality is a product of the modern era and became a relevant category of order only in the context of the emergence and worldwide ascendancy of nation-states. According to Franck Düvell (2005: 45) the German discourse prior to the 1930s made reference to 'unwanted migration' (*'unerwünschte Migration'*), 'spontaneous migration' (*'spontane Migration'*) or even 'nuisance foreigners' (*'lästige Ausländer'*). 'Illegality' entered the discourse in the post-war period only when the Federal Republic of Germany introduced its ban on foreign recruitment in 1973 (Cyrus and Vogel 2000). By the 1990s, the term was in widespread use in Germany and other European countries; and in the aftermath of 11 September 2001 it has been brought to bear not only on the discourse of the labour market and globalization but also, most significantly, on matters of security policy. However, the migration policy of the European Union (EU) to date has been founded on a paradox: on the one hand, there is a collective suprastatal effort to seal the community against unwanted migration; on the other hand, each member state of the EU reserves the right to regulate this policy area at national level in order to be able to react as appropriate to meet its own needs (for instance, in labour market regulation, citizenship rights, etc.).

Most authors who have dealt with this phenomenon in recent years emphasize that the rise in irregular migration is a consequence of the tightening of migration policy in Europe. In contrast to the present day, there have been periods when this phenomenon was handled more liberally, such as Germany's era of so-called 'guest worker' (*'Gastarbeiter'*) migration between 1955 and 1973. Anyone who entered the country on a tourist visa and rapidly found a job – for example, in one of the many industrial enterprises with an urgent requirement for workers – could be confident that their residency and work permit would be legalized forthwith. Compatriots or family members already working there helped with the smooth and rapid integration of new arrivals into the work routine. Since the ban on foreign recruitment, this form of migration has increasingly been criminalized, not least (in Germany) by the amended Foreigners Act that entered force in 1990, in which illegal residence was deemed no longer to be an administrative breach of regulations, as in the past, but a criminal offence.[4]

Our assumption today is that a fundamental tension exists between state sovereignty and control, on the one hand, and the legal claims of individual people legitimized by human rights, on the other. This

tension, which is virulent in all cases of migration and integration, takes on special relevance in the case of irregular migration, because national welfare states are essentially based on the territorial validity and enforcement of laws, and on control of their borders. Secured to this edifice are civil, social and individual political rights, curtailed to varying degrees for groups of people with non-standard residency status. National welfare states differentiate between forms of belonging, in other words, between members and non-members, regardless of how membership is legally regulated and which intermediate categories exist.[5] From the state's point of view, irregular migration undermines its political regulatory competence and the upholding of established standards under labour and social legislation; beyond a certain scale, it jeopardizes the legitimacy and affordability of welfare state systems; and finally, it challenges the established system of collective relations and free wage bargaining. From the viewpoint of the individuals concerned, however, complaints are voiced about the arbitrariness and double standards of the European Union migration regime, which proclaims freedom of movement and liberalism on the one hand but refuses legal entry, particularly to citizens of non-member states, on the other.[6] Irregular migrants appeal, above all, that although they work and contribute to social prosperity they are prevented from invoking the principles of individual autonomy and the laws of the liberal market (Jordan and Düvell 2002; Düvell 2006).

The protagonists themselves – who barely have a voice in the public debate, incidentally – are not alone in complaining about the biased nature of the discourse. Economists are also sceptical: they have shown, for instance, that there is no evidence to corroborate the argument that illegal migration is a burden on public budgets; on the contrary, positive impacts on economic development are far more likely to be noted, both in countries of origin and destination countries (Jahn and Straubhaar 1998; Giesecke et al. 1995).

Accordingly, there is a fundamental split in the debate on irregular migration between two hostile camps. The first is the coalition of those intent on safeguarding the sovereignty of the national welfare state, especially in times of global economic deregulation, who believe irregular migration to be a risk to the security and coherence of the state. The second consists of those who emphasize that humans have a right to liberate themselves, by means of migration, from poverty, environmental disasters, social fetters, oppression and discrimination, or to make a stand against the global inequality of resource distribution. 'Irregular migration is the manifestation of a conflict between

the aspirations of geographically mobile people and institutional goals' (Shrestha 1987, quoted in Düvell 2005). The restrictive approach of the state, it is argued, ultimately leads only to overblown security measures and ultra-complicated legislation, which merely exacerbate the issue of irregularity and produce 'illegality' (Engbersen 2001; United Nations General Assembly 2004; Koser 2005; Guiraudon 2002). Furthermore, all authors point out that Articles 13, 14 and 15 of the 1948 Universal Declaration of Human Rights grant every person a right to travel and freedom of movement, although the restriction to the nation-state level inserted at the time still applies today.

Between these two positions, there are others who draw attention to the inadequate rights and protection and the vulnerability of the migrants concerned, and who point out that democratic states, being legitimized by means of human rights, cannot completely ignore the individual claims of illegal migrants, e.g. with regard to their legitimate rights to legal due process, emergency medical treatment and education for their children. Non-governmental organizations, such as the German pressure group Kein Mensch ist illegal ('No person is illegal') or the European Respect network, campaign for the rights of 'illegalized' individuals and support the interests of people without residence and work permits.

7.2 Double irregularity

In his assessment of the 2004 report by the German Federal Office for Migration on 'residency-law illegality' in Germany, Norbert Cyrus describes the key concepts and facts relevant to the debate in the Federal Republic of Germany. 'The pre-eminent characteristic of residency-law illegality is the heterogeneity of legal and social situations among the persons involved' (Cyrus 2004: 3). His usage of the term 'residency-law illegality' aligns him with those critics who point out that illegality is not innate, but that the determination of illegality relates primarily to people's status with regard to the laws on residency. Since the ban on foreign recruitment in the year 1973, the closure of Germany's labour market to new immigrants has been the default state. Phases when the labour market is opened to immigrants, depending on the economic cycle, are called 'exceptions to the recruitment ban', and are used to react flexibly to the requirements of the labour market. Since the end of the 1990s, certain employment sectors, such as software development, have been covered by a 'green card' regulation, whereby highly qualified experts from outside the EU can be recruited and employed if proof can be furnished that no German workers with the skills for

this activity are available. Since there also appears to be a significant need for domestic workers in Germany, it seems reasonable to assume that – as in other European countries – the issue of green cards might alleviate this situation. But no recruitment drives or permits for this labour market have been planned or implemented to date. The sole exception to this rule, domestic helpers for people needing care in their own homes, will be described in a moment.

Today, various routes can lead to 'residency-law illegality': entering the country without documents (which was not applicable to any of our interviewees); the abuse of visa-free entry, where it serves the purpose of starting work rather than visiting as a tourist; entry with forged documents or visa, or entry on a student visa which is then used to take up employment. Migrants who enter legally, as contract workers or seasonal staff, can lose their right of residency by extending their stay beyond the permitted period; the same applies to those who entered and were issued permits as students, and whose student visas have since expired. Many individuals will go through changes of residency status over the years – for example, someone may enter the country on a tourist visa, obtain a legal right of residence as a student on expiry of the visa, and overstay after the expiry of this visa, thus losing their right of residency. Oscillation between different types of residency status is as much a characteristic of this migration as the fact that the only secure long-term possibility of residency is to marry a German citizen. All other arrangements are short-term only, including a permit as an au pair – which is still officially deemed a cultural exchange rather than an employment relationship, despite belonging to the remit of the Federal Employment Agency and local employment agencies (see Hess and Puckhaber 2005: 102).[7] But even where marriage is chosen as a means of legalization of residency status, which was a way out for half of the women we interviewed and which at least reduced the constant fear of discovery and deportation, the permanent right of abode can still be withdrawn if it is ever proved that the marriage was misused for the purpose of immigration (see also Alt 2003: 22).

Apart from residency-law illegality, the group of migrants described here is subject to labour-law illegality, for engaging in illegal employment legally invalidates a visa-free stay and constitutes a prosecutable offence; this would be documented in a criminal record. As described above, domestic workers must forgo an employment contract and the ensuing social rights and obligations. Only one form of insurance is available: this is taken out by employers through the state accident

insurers and covers employees anonymously for accidents in the home (Bundesverband der Unfallskassen 1998). Under this arrangement, the employer pays a flat monthly or yearly premium irrespective of the wage paid, and need not state the insured person's name. Accident insurance benefits can be claimed in the event of an incident.

Since the entry into force of Germany's new Immigration Act, the only possibility of a legally safeguarded employment relationship is the option of working for up to three years as a domestic helper for people needing care in their own homes.[8] This new regulation had been preceded by a heated public debate. In July 2001, the Frankfurt public prosecutor ordered raids on 350 households in central and suburban Frankfurt; around two hundred female migrants were subsequently deported in short order (see *Frankfurter Rundschau*, 6 June 2001, 26 October 2001). In response, a campaign was instigated by a journalist and the Green Party's regional foundation, the Hessische Gesellschaft für Demokratie und Ökologie (Hessian society for democracy and ecology), to end the practice of criminalization. The push for legalization led to the passing of a so-called Ordinance on Exceptions to the Recruitment Ban for Domestic Helpers from Eastern Europe, which was incorporated in amended form into Germany's Immigration Act of 2004.

Under the new Act, the remuneration payable to individuals who work as live-in carers in their clients' homes, bearing in mind that normally this means being available round the clock rather than working for only 38.5 hours, is as follows: stating the amounts for eastern and western regions of Germany respectively, they are entitled to a monthly wage of €967–1,117, from which contributions for nursing care, welfare, unemployment and pension insurance must be paid, and from which the costs of accommodation and food of up to €365.37 may also be deducted. An agreement may also be reached with employers for assistance with or full coverage of travel costs between the country of origin and the place of work.[9] How much money is ultimately left depends on the individual negotiation; however, even rudimentary example calculations show that wages of between €530 and €1,000 a month are achievable for comparable jobs and working conditions. It is foreseeable that this regulation will only represent a limited alternative to irregular employment because the pay is too low to be commensurate with the actual work done, and migrants will normally prefer a gross monthly wage without deductions for social security.

This provision is nevertheless of interest to migrants from eastern Europe, being the first regulatory acknowledgement of their need to

commute back and forth. By establishing a three-month rotation system, two migrants can share a job.

Running counter to this (half-hearted) push for legalization, a concurrent move in the opposite direction has been taking place in the past few years: an initiative to criminalize (migrant) domestic workers and their employers. The draft legislation put forward by the Ministry of Finance of the Social-Democratic/Green Party coalition government at the turn of the year 2003/04 to combat illicit work declared the illegal employment of a cleaner or babyminder to be a criminal offence. After protests about this, the draft bill was withdrawn. Resistance was directed principally against state inspections of private households and the accompanying practice of surveillance; consequently this passage was deleted in spring 2004. A breach of the ban on the illegal employment of a domestic worker is considered, at the time of writing, not as a criminal offence but an administrative offence, punishable with a fine. Following the creation of a new public agency on 1 January 2004, the Cologne-based task force for Finance Control/Illicit Work (Finanzkontrolle Schwarzarbeit), with 7,000 staff dedicated to investigating and prosecuting violations of the law on illegal employment, private households can expect to come under greater scrutiny in the long term, particularly if the detection rate in the public sphere falls short of expectations.[10]

In overall terms, the following trends are currently noted: alongside construction, agriculture, food processing and prostitution, domestic services are now considered one of the most important sectors of the so-called shadow economy (Cyrus 2003, 2004; Sachverständigenrat für Zuwanderung und Integration 2004; Alt 2003; Anderson 2003; Düvell 2005). In the view of Franck Düvell (2005: 46), the common characteristic of all these labour markets is that unlike other production sectors they cannot be offshored to low-wage countries. The cheap workers therefore need to be brought to Germany instead, and given the lack of suitable legal recruitment channels, employment relationships in these sectors tend to be more irregular in structure. There is clear evidence that regular and irregular employment relationships are very closely interlinked and affect each other over the years, so that clear-cut distinctions between them are impractical.

Official estimates of the total number of illegal residents in the Federal Republic of Germany fluctuate between 500,000 and 1.5 million (Alt 2003; Cyrus 2004; Sachverständigenrat für Zuwanderung und Integration 2004). It can already be deduced from this great variance that the existing estimates are not based on verifiable survey data. For

the sphere of domestic work, the main reason that no valid figures exist is that, as already explained, inspections are difficult and there is a strong taboo on access to the private sphere; any proceedings initiated are primarily the result of tip-offs. The economists Schneider and Enste (2000) estimated the contribution of domestic workers to the German shadow economy – albeit using a highly recondite method of data compilation – to be DM5.5 billion at the end of the 1990s. There is no regular census conducted in the Federal Republic of Germany which would yield reliable data, and even if there were, it would not be particularly informative. Norbert Cyrus (2004: 33) now claims that a stringent evaluation of existing official statistics, such as crime statistics, or mobilization of labour market inspections could address this gap in the research. In his view, systematically verified estimates could be obtained once suitable instruments have been developed. So far, however, no German researcher has succeeded in doing so, and the thesis of Cyrus (ibid.) that there is great public interest in the precise calculation of the scale of this phenomenon can be countered with the objection that precisely because of the political controversy of this phenomenon and owing to the restrictive treatment of double irregularity in Germany, a great many arguments also counsel against playing the numbers game. Unless and until serious consideration is given to transforming irregularity into legality, perhaps through the mechanism of 'earned legalization'[11] as practised in Great Britain, France, Spain or Italy, the demand for meticulous data collection should be held in check. This will be taken up once again in the concluding chapter. The most important problems for those concerned in Germany relate to the areas of education, health and accommodation; the issue in all three areas is the lack of legal security.

7.3 Education

In the legal opinion produced by Ralf Fodor and Erich Peter (2005) on the 'Right of the statusless child to education', it is stated, as in many other studies (Alt and Fodor 2001; Alt 2003; Anderson 2003; Cyrus 2004; Sachverständigenrat für Zuwanderung und Integration 2004) that Germany's Basic Law enshrines the right of the child to development of its personality. It thereby guarantees all children, regardless of their residency status, a right to education; up to the present day, however, statusless children in Germany have been denied this right. Statusless children have a 'right to equality of opportunity to develop their personality' pursuant to Article 1 para. 1, Article 2 para. 1 in conjunction with Article 3 para. 1 (Fodor and Peter 2005: 29). This basic right is

restricted – or, to be precise, counteracted – by the validity of section 87, paras 1 and 2 of the Residence Act (*Aufenthaltsgesetz*, AufenthG), previously section 76, para. 2 of the Foreigners Act (AuslG), according to which schools and education authorities in possession of knowledge about illegally resident school pupils and their parents are obliged to report this immediately to foreigner registration officials. According to the legislative position to date, Sections 95 and 96 of the Residence Act, which cover the crime of 'infiltration of foreigners' (*'Einschleusen von Ausländern'*), can also be applied for the criminal prosecution of non-reporting of illegal persons. Admittedly, the provisional guidance on application issued in December 2004 by the Federal Ministry of the Interior went on to qualify the data-notification duty of public entities in the nursery care and education sector. So far, no reports have become public of any criminal prosecutions of teachers from the school sector. But in principle, the notification duty remains in force for all civil servants and employees in the public services. Often it is not even possible to register a child for kindergarten for this reason.

The implementing law of the Federal Republic of Germany falters on a further point: Article 28 of the United Nations Convention on the Rights of the Child (which was signed by Germany in 1990 and took force in 1992) prescribes the right of the child to education; Germany ratified this convention but added a restrictive amendment at the same time. The lodging of the instrument of ratification was accompanied by the following declaration, now known as the 'Declaration on Aliens': 'Nothing in the Convention may be interpreted as implying that unlawful entry by an alien into the territory of the Federal Republic of Germany or his unlawful stay there is permitted; nor may any provision be interpreted to mean that it restricts the right of the Federal Republic of Germany to pass laws and regulations concerning the entry of aliens and the conditions of their stay or to make a distinction between nationals and aliens' (OCHCR, www2.ohchr.org/english/law/crc-reserve.htm). Legal experts are currently in disagreement as to whether this declaration (BGBl [*Federal Law Gazette*] 1992 II: 990) does not in principle cast doubt on the ratification of the Convention on the Rights of the Child.[12]

In consequence of this legal position, many migrants cannot send their children to school because they fear that their residency status will be exposed as a result. Now various education authorities, for instance in Freiburg, Munich and Berlin, have embraced the view that the educational duties of teaching staff weigh more heavily than the notification duty; nevertheless, the clauses cited above remain in force

and are causing great legal uncertainty for the schools concerned. Furthermore, schools and kindergartens that accept statusless children cannot document them in their official reports, with the consequence that the official figures do not reflect the actual number of children being taught, or the basis used for calculating school staffing, materials and finances.[13] The next problem is that of issuing school reports: school reports (at least in the case of general state schools) are state documents and cannot, therefore, be issued for pupils who are officially statusless.

Alongside the schooling of children, it is also a problem for the affected domestic employees to attend evening classes or publicly financed adult education centres; the attendance of continuing education sessions and courses becomes a legal snare, under the current legal situation, which has the intended demotivating effect. Overall, in the education sector, migrants are being denied their human and civil rights.

7.4 Health

Likewise, in the field of healthcare in Germany, numerous problems of a legal and health policy nature can be attested. 'There is a fundamental dilemma in the relationship between the sovereignty of the state, the human rights to health and physical integrity, and the question of responsibility for or apportionment of the costs of medical treatments' (Cyrus 2004: 47). The lack of health insurance and the duty of notification incumbent upon doctors and welfare agencies, who may be paying the treatment costs, present the most serious hurdles in this respect.

In order to become a member of the health insurance fund, a residence permit assuring at least a medium-term period of residence must be held – a tourist visa will not do. The necessary contributions are normally deducted from employees' pay and transferred to the health insurance funds together with the employers' share. Voluntary health insurance is not a way around this procedure in Germany, since residency status is checked by the health insurance funds. 'Even if they [the employees] pretend to their employers that they have regular residency status, the lack of a residence permit will be picked up during cross-checking of data with the registration of foreigners authorities and reported on through the system' (Stobbe 2004: 117). Various legal opinions exist (e.g. Fodor 2001, 2006), which work on the assumption that people without papers have *de jure* rights to services from the state health service, but if they have no means

of payment, doctors who are willing to treat them turn to the local welfare authorities, which in turn pass on their data to the authorities responsible for the registration of foreigners. Particularly in cities there are many medical assistance organizations which are willing to treat people without papers for a low fee; although difficulties can then arise, particularly over the settlement of the bill.

Church organizations have also engaged with this issue, one being an institution in Berlin that we visited over a period of several weeks, the St John medical centre for migrants (Malteser Migrantenmedizin, MMM). Dr Franz, the woman doctor who practised there, paid by the Catholic Church, who has since received several awards for her commitment, reported that she cooperates with consultants in Catholic hospitals to whom she can refer her patients. According to her, treatments are financed from donations which she herself has collected from various church parishes, or in instalments paid by the patients themselves. The doctor complained, however, that 90 per cent of her patients come to her only when illnesses are already far advanced and the assistance of hospital consultants is necessary. Two-thirds of her patients are women, many of them domestic employees. Alongside her medical consulting, Dr Franz has also set up a mothers' advice centre as well as free second-hand clothes outlets for infants and toddlers, to which she now refers her own patients by way of cooperation. During our participant observation it became clear that what this institution most lacks is the financial resources to be able to work effectively. Other NGOs report similar problems.

For migrant commuters from eastern Europe, who are normally insured in their home country and, moreover, try to attend the necessary doctors' appointments at the times when they are staying at home, there is also the possibility of taking out travel insurance – although many conditions are not covered by this type of policy. Overall it is evident that outpatient treatment is easier to obtain than inpatient treatment. Many migrants try to use the insurance cards of friends or relatives with regular residency status as a means of covering the necessary expenses. This carries the risk, however, that the symptoms noted by the family doctor on the record card will be distorted. Furthermore, the health insurer may initiate an investigation for incorrect billing. With increasing electronic recording of symptoms, this is another approach which will become verifiable in the long term, reducing the scope for such practices (see Stobbe 2004: 116ff.). In contrast to the Netherlands, the United Kingdom, Spain or Italy, where basic medical care is available anonymously to people without

the right of residency, there is no such institution in Germany. The German Federal Office for Migration has recommended adoption of the Dutch funding arrangement whereby the government enables the treatment of irregular migrants by paying into a fund (Sachverständigenrat für Zuwanderung und Integration 2004: 354; Cyrus 2004). At the time of writing, however – spring 2011 – this has still not happened. An exception is the city of Munich, which has already been working on this kind of fund solution (see Anderson 2003).

7.5 Living conditions

The whole of the German population is subject to obligatory registration. As a matter of principle, every move to a new place and every change of address must be notified within one week to the responsible office for the registration of residents. German citizens receive an endorsement on their identity cards; migrants living in Germany legally have an entry made in their residency papers. The following personal data are recorded: name, date of birth, gender, birthplace, civil status, employment status, nationality and religious affiliation (see Stobbe 2004: 126). Via the interconnected registers of residents, this information is passed on to various authorities. Irregular migrants residing in Germany whose status prevents them from registering usually find, when searching for accommodation, that they stumble at the following hurdle: landlords are legally obliged to ask to see a registration certificate before a tenancy agreement can be signed. It is therefore extremely difficult to rent an apartment without presenting these papers. The affected individuals either have to make contact, via their networks, with landlords who do not demand this kind of paperwork – although this kindness possibly comes at the price of over-inflated rents – or else persuade German citizens to rent the apartment, which in turn can lead to problems if there is no right to sublet the property. Most landlords insist on being shown a wage slip; this, too, is impossible for the people concerned. A further problem with renting an apartment themselves is that rent in Germany is generally paid by electronic transfer from one bank account to another. Once again, irregular migrants are at a disadvantage here, because most will have their own bank account only if they had the foresight to open one using legal papers during the initial period of their residence. To sum up, all of this means that many find themselves in a state of constant dependency. If they find accommodation with compatriots who have regular residency status, they often have to share rooms with others; people in multiple-occupancy rooms are particularly exposed

to hygiene problems, which breed diseases. German landlords are equally capable of demanding excessive rents and deposits, and male landlords (German and non-German) often expect sexual services from female tenants. Poor living conditions, in turn, have adverse health effects and lead to psychosocial problems in working life.

The lack of legal security has negative repercussions in all three areas. People put off dealing with health problems, endure non-payment of wages, sexual assaults and other forms of exploitation without making police complaints, fail to enrol at educational establishments, and miss out on cultural and leisure activities which require papers to be shown. Lawbreaking of any form in everyday life is avoided, because attracting the slightest attention can lead to discovery (as in the example at the start of the chapter). Having outlined the structural conditions and consequences of being illegal, it is time to turn to the question of how the people we interviewed live their lives, in illegality, in Germany. What are their lives really like? What support do they have? How do their lifestyles differ from those of migrants with regular residency status?

A series of answers to these questions have been given in the course of the previous chapter; for instance, in the introduction of the Latin American Maria la Carrera (Chapter 4), a former political activist who has lived for many years in the underground and in exile, and who refuses to be deprived of subjective freedoms of action even in Germany: she gives lectures for the NGO 'No person is illegal', since she assumes that the police will not seek her out and arrest her there; since legalizing her residency status, she has begun to co-produce a documentary film and is now writing an autobiography. As a 'political persona' she is certainly an extraordinarily courageous woman who is able to use this freedom of action primarily because she has the support of a German circle of friends. Many affected persons lack this security and accordingly they have to deal with uncertainties differently. In both the case studies to be presented in the remainder of this chapter, the aim is to clarify the relationships between living arrangements, health matters and working conditions. The latent fear of sexual assault and/or unplanned pregnancy is specific to females without rights of residency, and makes their situation more difficult compared to that of male migrants. The two examples to be presented here embrace two typical courses of development: the first moves from 'residency-law illegality' into legal residency; and the second makes the journey in the opposite direction.

7.6 'Welcome to Hell': Alexandra Marquez's struggle for security and freedom

Alexandra Marquez grows up in a small town in Ecuador as the third of five children of a small businessman. She is about to graduate from high school when his business collapses. The family's financial plight means that she cannot go to university. She works as a sales assistant, a secretary and a photographer, and finally takes out a loan to establish a chicken farm with a broiler unit. This enterprise rapidly becomes a success; her younger sister Samantha joins her in the business. The situation changes overnight when fowlpest breaks out and robs her of her livelihood. She is unable to repay the loans and has numerous outstanding debts. In this situation, a cousin invites her to come to Berlin, an offer that she gladly accepts – without the remotest knowledge of the challenges awaiting her. In 1996 she flies to Berlin. Her cousin's husband greets her at the airport with the words 'Welcome to Hell'. Gradually it will dawn on Alexandra Marquez what he means by this. When she finds out that the cousin, who used to work as a secretary in a government office in Ecuador, is now earning her living as a domestic cleaner, at first she is stunned. She comes from a country in which 65 per cent of the population live below the poverty line and 40 per cent of children have to work (LIS n.d.). The fact that she herself was able to attend upper secondary school shows that, in the context of Ecuadorean society, she belongs to the middle class. She perceives this work as declassing, not only because it seems to signify a decline in professional standing but also because, for her, this job is marked for ethnic difference in her country of origin: in Ecuador, around one fifth of all women in gainful employment work as domestic employees. The majority of these are indigenous internal migrants from poorer, rural regions (Radcliffe 1999). Alexandra Marquez does not mention her family's ethnic background; she herself is light-skinned.

In Berlin she initially finds work as a children's nanny, which is badly paid but at least guarantees her an income. She has to work for two years to pay off her debts, the loans and the cost of the journey.

Risks and strategies for risk reduction In the course of the interviews it becomes clear that the warning uttered by the husband of Alexandra Marquez's cousin has taken on a paradigmatic meaning for her life: her entry to 'Hell' is the entry point to a narrative about a seven-year life in illegality. It begins with the fact that about a year after her arrival she is arrested by the police. Since the criminal investigation

squad were waiting in a car outside her house, she suspects that her whereabouts were disclosed by somebody she knew. Amid her despair, there is a shred of solace: she has indeed been arrested, but the Ecuadorean consul obtains her release the very next day, thereby preventing her immediate deportation. After her release, Alexandra Marquez has to keep a low profile because she is now on record as illegal. As a consequence, she and her cousin have to leave their shared apartment. Fearing a repeated arrest, the two young women can take nothing with them except for one suitcase, which will be their constant companion for years to come. Throughout the ensuing years, Alexandra Marquez is constantly in search of a fixed abode, which she seeks largely via her ethnic networks[14] and eventually finds. To start with, the two women sleep 'a night here, a night there', then move in with a male friend for six months. This arrangement breaks down when they have a disagreement over arrears on their gas and electricity payments. Alexandra Marquez and her cousin find new accommodation with a Peruvian man; the room has several occupants and also serves as a meeting place for the landlord's male friends, who use it for sleeping off their drug and alcohol binges. Although Alexandra Marquez stresses that she has never been raped, she says that she lived in constant fear of it. Based on the scenario described, it is likely that certain violent experiences occurred in that tenancy situation even if Alexandra Marquez does not disclose them. The ongoing search for accommodation proves difficult because the women want to avoid exposure of their status as illegals at all costs. They find a German female student who rents them a room for six months on condition that the two of them find a legally registered subtenant to act as a 'straw man' and sign a subletting contract. A longer-term tenancy falls through because no such 'straw man' can be found.

As the search continues, similar experiences abound. After the cousin decides to return to Ecuador, Alexandra Marquez moves in with her then boyfriend, a migrant from Sri Lanka. The hope of having found a secure home with him very quickly turns out to be a fallacy. The boyfriend drinks, and when in a drunken state he repeatedly threatens her with a knife. Alexandra Marquez lives in constant fear that he might carry out his threats and murder her. She explains how she tried to adapt to his 'strong temperament' by becoming 'very, very quiet'. Conflict avoidance and obedience are strategies that she deploys so as not to provoke him: she serves him a hot meal when he comes home at night from the restaurant where he works, although she herself has to get up early in the morning to get to her own work.

When things escalate further, she sees returning to Ecuador as the only possible escape route from this situation. By this time, two years after her first migration, she has paid off her debts and saved some money. In December 1998, Alexandra Marquez returns home to Ecuador.

But she very soon realizes that the money she has saved is not enough to build up a new livelihood. Although she tries to go into the timber trade with her cousin's husband, this enterprise fails. In the meantime her mother has fallen ill, and Alexandra Marquez soon uses up her savings paying for her mother's medical treatment.

After seven months she decides to embark on another migration venture. She meets a French man who in return for a $70 agent's fee provides her with a legal employment contract in the gastronomy sector in Nice, and an address for the first few days. On arrival in Nice, the employment contract turns out to be a fake. She speaks little French, has only two hundred dollars with her, knows nobody in Nice, and decides to return to Berlin. She arrives back in Berlin on 1 July 1999, and the search for accommodation begins all over again.

Whereas Alexandra Marquez is able to pick up work at her old work-places with relative ease, finding accommodation remains a problem. This time, once again, she relies on her ethnic networks. She moves in with a Chilean man with German nationality, who offers her a place to sleep on a couch in a gangway room. She tries to remedy the lack of privacy with the help of a bookcase as a room divider, to shield herself from the gaze of her landlord. This does not deter him from eyeing Alexandra Marquez as a potential future wife. In essence, it is a reprise of her experiences from other tenancy constellations involving male landlords. The landlord, an alcoholic, repeatedly puts her under pressure and tries to talk her into marriage by dangling the prospect of 'papers'; she is also harassed verbally with sexual innuendos and has money stolen from her. An argument flares up and he calls the police. Alexandra Marquez takes to her heels and flees. A Spanish woman friend takes her in. This woman friend suffers from severe depression, and sharing a home with her requires psychological resources that Alexandra Marquez herself finds hard to summon.

By now, it is April 2000 and her sister, who has lost her job in Ecuador, announces that she is coming to Berlin. Alexandra Marquez now needs an apartment for two people and must scrape together travel and living expenses for her sister. Like Gizelha Santos in the previous chapter, morally shackled by the family economy, she seems to feel obliged to accommodate her sister instead of warning her of the perils of migration.

Then my sister came and – my sister couldn't sleep in that apartment, and then she understood: 'You live like *this*?' We always had, you know, at home, we always had a bed, we always had a roof over our heads, and here we had nothing. And, hmm, my sister cried and said she didn't want to stay. And uh, I had – this – sense: I've got to do something about this, I must do something, and I promised that, I told her: 'Right, tomorrow I will find something.'

The sister's arrival becomes a turning point in Alexandra Marquez's narrative. Presumably she chose not to prevent her sister from migrating because the two of them have a good relationship, and because it means the arrival of a confidante in her life, someone with whom she shares a past and can carve out a common destiny. 'A miracle' comes to pass: an Italian man friend who is going abroad for a year offers to sublet her his apartment. Five years after she first migrated to Berlin, for the first time she finds not just a place to stay, a roof over her head, but an apartment in which a social life including entertainment, recreation and relaxation will be possible. After the principal tenant's return, however, the search is back on in much the same way as ever. Alexandra Marquez and her sister are dependent on secretive subletters, and are repeatedly defrauded and exploited. At some stage they have the good fortune to meet an understanding landlord. Without warning, the 'friend' who had left them the apartment during his stay abroad closes the bank account that Alexandra Marquez and her sister were using to transfer the rent to the new landlord, whereupon the latter gives them the option to pay him the rent personally each month, in cash.

This narrative highlights the link between being illegal and experiences of denunciation, sexualized violence and exploitation. Alexandra Marquez exposes herself to a variety of risks: for instance, she inserts small-ads in the daily press offering her services. Although she dreads the first visit to any new employer, fearing that the police will be waiting, these fears are never vindicated.

She never takes such risks when looking for accommodation, but trusts in her network, even though it lets her down time after time. Here, too, the specific concern to avoid the risk of discovery leads her to place herself in risky situations. The apartment-hunting odyssey of Alexandra Marquez is familiar from many comparable interviews. What is astonishing is that she and others living in her situation, lacking any private place of retreat for years on end, are still capable of carrying out their work.

In contrast to other domestic employees whose employers assist

them in finding accommodation, Alexandra Marquez certainly nurtures personal relationships but does not utilize these to improve her living conditions in a concrete way. However, the work and the fact that her employers are very satisfied with her becomes the stabilizing element in her life: through her work she can maintain her self-esteem, and compensate psychologically for her unstable and crisis-torn living situation. Presumably it also helps that she does not isolate herself. At the time of her migration to Berlin, she is in her mid-twenties and, like many others of her age, she wants to 'have fun'. She regularly visits discotheques, although these are known as meeting places for the Latino scene and are liable to be checked by the police: these outings, then, always entail a risk of being unmasked as an irregular migrant. On the other hand, she also finds people there who offer her a place to sleep. After her sister's arrival, she feels relaxed enough to attend flamenco dances and parties. By this time she has already coped with many dangerous situations and learned 'how to survive'. She admirably describes how she has to take lightning-fast decisions in some situations in order to protect herself. She works as a nanny for a German couple with links to Latin America, who want their child to grow up speaking Spanish. One day the pushchair slips off the escalator in a subway station and the child falls out. Her greatest fear at that moment is that passers-by might call the police, the fire brigade or an ambulance, and she reacts with panic: 'I picked up the pushchair again, the subway train came and [snaps her fingers] gone!' In the heat of the moment, Alexandra Marquez reflects during the interview, 'I only thought of myself, not the child' – who, apart from the fright, escaped unscathed. Years later, she can still describe the situation in perfect detail, and still feels guilty.

The fact that she has to be especially alert whenever she passes through public places, because banal incidents can spell danger, affects her attitude to life: 'I'm always afraid', is how she sums it up. To find an answer to the question of why she put up with these adverse conditions for so long, it is useful to look at the economic and social situation in Ecuador. The year in which Alexandra Marquez first emigrates, 1996, marks the start of an emigration movement which comes to involve almost 10 per cent of the population in the following ten years. The economic situation in 1996 was already straitened; now the catastrophic impacts of the El Niño storm (end of 1997), the dramatic fall of the petrodollar on the world market in 1997 and the collapse of the national financial system combine to tip the country into a process of economic and social decline. Unemployment escalates to

unknown levels and, according to figures from the DNM (Dirección Nacional de Migración), 837,062 inhabitants leave the country between 1997 and 2004 (8 per cent of the population) and do not come back. Alexandra Marquez leaves Ecuador at a time when it is not unrealistic to hope that the economic situation will improve. Upon her return at the end of 1998, and by early 1999 at the latest when the economy collapses, it becomes clear that migration is a way out of the poverty trap, particularly for the economically stronger section of the population (Ciudad 2003).

Legalization For illegalized workers like Alexandra Marquez the question of trust, which has already been mentioned elsewhere (see Chapter 5, Section 5.1), assumes an especially high priority. While explaining her illegality to other people can lead to offers of protection, it also puts that same safety at risk, in that it renders her reportable and open to blackmail by people in the know. Acting on the basis of risk reduction therefore means weighing up the relative perils of different risks.

In the course of her seven years as an irregular domestic worker, Alexandra Marquez gradually establishes friendly relationships with her employers, so that in contrast to the situation in the early years, her network is no longer rooted exclusively in the ethnic circle. Two German employers whom she found through her network finally support her in legalizing her status. Both women are lawyers who also engage professionally with the situation of illegally resident migrants. As mentioned earlier, in the Federal Republic of Germany at the present time, a marriage for legalization purposes is the only possible way of obtaining long-term legality under residency law.

On behalf of Alexandra Marquez, the two lawyers search for a German citizen who is willing to take upon himself the arduous and risky process of entering into a marriage of convenience. In their circle of friends, they eventually find a man who declares himself willing to meet Alexandra Marquez. This proposition also presents Alexandra Marquez with a difficult decision, for she would prefer a love marriage to this arranged marriage. Before a foreigner can marry while living in Germany with illegal residency status, numerous bureaucratic hoops must be jumped through. Alexandra Marquez accomplishes this only thanks to the stalwart work of her lawyer friends. According to current legal rulings, she ought to have left Germany and returned to Ecuador to marry, and obtained the appropriate residence permit for this procedure. She can in fact remain, but steps must be taken at the same time to allay any suspicion that this is a sham marriage. The

man whom the lawyers found lives in a shared house, so Alexandra Marquez is introduced to this community and spends enough time there to enable all participants to present themselves credibly as living together, in case the immigration authorities make checks of the living environment.

Alexandra Marquez still considers it a miracle that this man demands no sexual or financial compensation from her. She herself, she says, would never have found such a nice man. This is more than just a comment on her relatively unfortunate choice of romantic partners so far; it also gives an insight into the network in which she has moved for many years. Few of its members were altruistically motivated or politically committed people.

At first, legalization changes her life only in relation to her right of residence, and not with regard to her work as a domestic employee. Nevertheless, she does not regret the marriage of convenience; she gives the following verdict:

> Actually I am so content that after seven years I can be legal; walk *freely* in the street and – if I find myself in such a difficult situation I can finally – do something, *just scream*; because we weren't, we just couldn't, scream out loud, you understand what I mean. We always have to keep very quiet, without letting them, maybe letting the neighbours notice anything. I'm so content, you know, for my soul, for my heart, it's a totally different feeling.

The freedom to be allowed to draw attention to oneself ('just scream') is a human right that she can now claim for herself. The 'we' in this quote functions as a self-affiliation, used by her to stress her ongoing sense of belonging to the collective of the disenfranchised.

From a biography-analytical perspective, Alexandra Marquez's interview can be said to contain a wealth of individual and collective knowledge and accumulated experience. One issue that came particularly to the fore was her method of dealing with structural barriers and stumbling blocks that stood in the way of her intentional action schema. She considers her migration and even the concomitant illegality as a purposive means to an end, on which the continuation of the biography depends (Breckner 2003). Her biography hinges on active 'doing' as the means of realization. The question of whether she can be viewed as a successful migrant will have to be answered differently in different contexts: for her family in Ecuador, her remittances are an important contribution to creating and maintaining a better standard of living; however, if comparisons were drawn with other Ecuadorean women

of the same age and educational background who have emigrated not to Germany but to Spain, where better opportunities for legalization enable them to leave the domestic employment sector and attain social mobility, she would fare somewhat worse.[15] For other migrants in her network, the legalization may well be deemed a success even though it gives her no immediate guarantee of better life and work prospects. And as to whether these circumstances will one day allow her to start her own family, to stay in Germany or to return to Ecuador, the outcome is difficult to predict at the present time.

One feature of Alexandra Marquez's case which can be construed as typical is that despite, and in the face of, all adverse circumstances associated with being illegal, she has persisted with her active approach. If the first migration to Germany was a relatively chance opportunity to overcome an economic crisis, and one for which she was totally unprepared, the second can be seen as a step towards the assertion of intentionality, in which she consciously accepts the entailed risks and problems. Since she is now, for the first time in years, in a position to make a decision that does not spring from a situation of distress, it may be that this situation presents her with difficulties of its own, precisely because she has had to fight throughout the last seven years to achieve normality. In other words, for the first time since her arrival in Germany, coping with everyday life no longer consumes all her energy, as it used to, and at last she can begin to think about how she might shape her future. This potentially broadens her scope for action, although she may still have to acquire the necessary knowledge and qualifications – a language examination, for instance.

The following case analysis of the Polish woman Anna Koscinska describes how an originally intentional action schema culminates in a very different 'trajectory'.[16]

7.7 A pre-unification globetrotter: Anna Koscinska

The journey undertaken by Anna Koscinska in summer 1990, single and having just turned thirty, from Poland to a western German university city, to spend the summer cleaning in various households, is not her first experience of foreign travel. In the mid-1980s, during her university studies in economics at Poznań, alone and with friends, she embarks on many trips which take her to Moscow, the Caucasus, Hungary, the German Democratic Republic and Czechoslovakia. Anna Koscinska calls these three- to four-day journeys 'business trips'.

They were kind of typical business trips [laughs]. Well, various things

that you can sell in Budapest, and other things that you can buy in Budapest and then resell in the GDR. [...] In Budapest we knew, we were studying business after all, where we could buy things and what was worth buying where.

This import-export smuggling of everyday goods that were in short supply in the respective socialist countries generates comfortable earnings, which she uses to finance the trips. In certain respects, this is the closest thing to a globetrotter lifestyle that was possible in those countries under socialism. Anna Koscinska enjoys seeing the world and earning a little extra at the same time; she does not save the money, but spends it to visit other destinations. She brings home gifts in an effort to dispel her mother's fears that she could get caught smuggling. She is in no hurry to finish her studies. Before studying economics, she completes an apprenticeship as a freight clerk. Economics is not her dream subject; she would rather have studied geography but fails to meet the prerequisites for admission. In total, she studies for eight years before she takes her final degree examination; she has to retake many of the mid-programme exams, and is finally denied recognition, despite passing the final exam, when it comes to light that she failed one exam in the eighth semester. Anna Koscinska enjoys her student years and likes to spend time with friends; she says she was the life and soul of the party, loved socializing and drank lots of alcohol. At home with her parents, on the other hand, she presented herself as 'the very virtuous, very pious daughter'. 'I have two faces.' After her studies she is once again dependent on the support of her parents, moves back in with them, and then accepts an offer from friends to work in Germany in the summer months. At that time she did not speak good German: 'I always hated German as a language.' Anna Koscinska immediately goes on to justify this very emotional statement on the basis of her experiences with the East German holidaymakers she encountered on Poland's Baltic coast, the location of her parental home. 'They were so noisy, brash and somehow, the language was so, so *harsh* for me.'

What exactly was *harsh* about the language is left unsaid. A look into her family history reveals, however, that, as for many Polish families, interaction with dominant Germans (as occupying forces, oppressors or noisy tourists) can be found in every generation.

The legacy of the family history Anna Koscinska's father is born in 1929, the son of a farmer, in a small town in the province of Łódź. The

mother is nine years younger and comes from the same town. When Poland is partitioned and occupied by German troops from September 1939, the small town belongs to the occupied part of the country, from which farmers are forcibly resettled to make space for German settlers. The father's family is forced to move to a small town in southern Poland. The mother's family manages to evade resettlement by moving to stay with relatives in the neighbouring General Protectorate. In 1940 the father's family return illegally to their home town. They are denounced and the father's parents are arrested and interned by the German occupying forces. Six months later, Anna Koscinska's grandfather is sent to the camp at Auschwitz, where he is deployed as a forced labourer to finish the construction of Birkenau. In 1942 the family is informed that he has met his death there. A brother of the grandfather is arrested in 1943, transported to Auschwitz and murdered. In the meantime, the mother and two younger siblings are deported back to southern Poland. Anna Koscinska's father, his elder brother and his elder sister performed forced labour for German farmers in Poland. The German family with whom the father was sent to live – having only just turned twelve – treated him like a son; they were good, kind people, 'absolutely decent'. For that reason, according to Anna Koscinska, her father had passed on to her a positive rapport with Germans. However, it is likely that these feelings are not unreservedly positive – at the time of the interviews with Anna Koscinska (2002), only the older brother had received a compensation payment of 500 euros, while her father was still waiting. The entire family history is scarred by deportation, forced labour and murder, from which it can be inferred that their feelings towards Germans will be ambivalent at the very least.

After his military service, the father trains in the civil service and becomes a civil registrar. It is while working in this occupation that he meets the mother. Later he becomes managing director in a housewares business. Both parents are employed throughout Anna Koscinska's childhood, and remain so until their retirement. Anna Koscinska and her sister, who is one year younger, initially grow up in a village within an extended family, where they are cared for by their maternal grandmother. After they move to a small town near by, life in the nuclear family, governed by greater social control, seems to have come as a radical change for the children. Furthermore, at the age of twelve, Anna Koscinska is diagnosed with scoliosis, and from then up to the age of seventeen she has to undergo several operations to treat this curvature of her spine. She associates this period with lengthy

spells in hospitals and convalescent homes, far away from her family. Her relationship with her mother grows worse, and she subsequently endeavours to enrol at a university a long way from her parental home.

Café Anna Probably another reason why she heads for a western German city in the summer of 1990 is that she has graduated without a proper degree and no longer wants to be dependent on her parents. She enters on a tourist visa, leaves the city after four months and returns six months later. A network of Polish male and female friends helps her to look for a job and a room. Without residency status, she lives with friends in student halls of residence from June 1991, and in October 1991 she makes another attempt to pass the missing exam in order to obtain her degree, but fails. It is important to her to legalize her residency, and with the help of friends she finally manages this in the 1992 summer semester. A small portion of her Polish studies is recognized when she enrols to study economics. Now she attends language courses, can rent her own room in a hall of residence, and her domestic work earns her enough to live on. She cares for small children, cleans doctors' surgeries and elderly people's homes. For the latter clients, she also goes grocery shopping, and will engage them in long conversations if need be. She does little studying; in principle she carries on the same lifestyle as in Poznań: she has a wide circle of friends who often congregate at her home, which is known to her friends as 'Café Anna'.

She does not save her earnings but spends them to fund her trips; she travels to Austria, Malta and Tunisia, and visits Paris and Amsterdam. Having successfully piloted the 'globetrotter principle' in the East, she can now continue to live by it in the West. She has no financial obligations towards her parents, and they still contribute towards her support. On the one hand, the focal point of her life is her circle of (Polish) friends, a network of homosexual men and women, in which she herself is a central figure. On the other hand, the recognition of her employers is important to her; in no way would she wish to carry out her work in a mechanical and distanced manner, to 'feel like a robot', but wants to work for people who 'need' her. She selects her employers according to this criterion. Particularly because of the personal conversations they have, she feels bad about keeping up the pretence ('playacting'), the deception, that she is working to support her studies, when in truth she has not attended lectures for years. She has developed friendly relations with one of the families that employ her; she minds their child, who learns Polish words from her, she does

the cleaning, goes shopping, and also works for the grandparents; she feels 'like a member of the family'.[17] Ten years after her matriculation, she has to finish her studies unless she wants to pay the high long-term tuition fees. At this point she is confronted with the alternatives of returning to Poland, or staying on and becoming illegal.

Becoming illegal In 2002, Anna Koscinska becomes 'illegal' under residency law, not for the first time since coming to live in Germany, for back in 1990 and 1991 she overstayed her tourist visa, thereby unlawfully extending her stay. The situation at that time, however, was fundamentally different: the first stay was for orientation purposes, and only later did she make up her mind to migrate for a longer period of time. She made use of the option to enrol for university studies in order to legalize her stay, hoping that this would also improve her career prospects. However, the attitude she had to her studies in Poland had not changed, and thus she lacks the motivating force to realize this hope. At the age of forty-two, she descends into a deep identity crisis, triggered by the illegalization of her status, in which she calls her own biography into question.[18]

Up to this point, Anna Koscinska has made strategic, intelligent and successful use of the options open to her. She has removed herself from the social control of her family by migrating, and has been able to turn a failure (the flunked exam) into a success, for in the eyes of her Polish family she is living an independent life abroad. Her everyday life is structured by working (more than forty hours per week) and maintaining her friendships, and it is twelve years after her first migration before she is troubled by the question of a plan that she does not have: 'Future? Plans? None.' In these sparing words, she sums up her situation in the summer of 2002.

Even prior to this, Anna Koscinska never lived entirely without a plan, but for the first time she must now make focused decisions. A strategy she has resorted to many times with success, namely geographical mobility to optimize her scope for action, with which she successfully compensated for her modest intellectual ambitions (particularly concerning her education), will no longer do the trick. Both of the alternatives that present themselves are unsatisfactory: she finds life without papers frightening and does not want to go down that road. Since she has been living away from Poland for twelve years, however, the possibility of returning there is also out of the question. 'I know my way around in Germany better than in Poland' and 'My home is where I have friends, where I have work, and where I am

more or less independent, or feel that way.' The fact that she could count on economic support from her family if she returned to Poland does not allay her concern that this would mean losing her independence. It is clear to her that her remigration would be viewed there as a *failure*. Even now, on her visits to Poland, she finds it depressing not to be able to parade the expected status symbols of a successful migration, such as a car, money to start a business in Poland, or at least a German husband. To return to Poland as a *migration loser* is just as unappealing as to press ahead and stay on in Germany as an illegal migrant. She is stuck in a social trap from which she sees no way out. There are no formal recognition procedures of any kind for the social competencies as a domestic worker that she has developed in the course of her migration project. All her years of work cannot be counted towards her unemployment, health and pension insurance, nor is any route open to her into a professionalized form of the work she does.

As she works through this personal crisis, she asks herself questions about her past, considers the present and future self-critically, almost auto-aggressively even. 'I don't understand myself.' In the second interview, these are the words with which she begins the narrative of a trajectory that lasts for forty pages in the transcription and is brought to a conclusion with the statement: 'Right now, I am totally empty'.

In retrospect, she finds no meaning in her life any more, and events that she has long suppressed from her thoughts now return to haunt her. For instance, she had hoped to find a life-partner. For a long time, she had loved a male friend in Poland from afar, until it turned out that he was homosexual, shattering the dream of a shared future. This simultaneously took away the motive for returning to Poland. Anna Koscinska, who has turned the phrase 'no problem' into a fixed and evidently important element of her self-presentation repertoire, finds herself confronted today with the problem that she has blotted out of her memory for many years: in summer 1991, she became pregnant as the result of a rape. Being illegally resident in Germany at the time, she had not called the police or made a formal complaint. Two months later she travelled to Poland for the abortion: 'Yes, and that is a real sin, and since then I have, I have not been to confession or to communion since.' As a confirmed Catholic, she goes to church twice or three times a week; today, the fact that she has not confessed for eleven years becomes the culmination point of her narrative. She cannot find any coda; time and time again, she goes back to this event. In her mind now, the 'sin' that she committed represents the

loss of her moral judgement; she can no longer differentiate between good and evil.

For years and years, she has tormented herself with the question of whether she can confide in a priest at confession. At the age of forty-two, she is not only grieving that she will never have children, but has also lost faith in herself. On the one hand, in retrospect she defends the decision she took, but on the other hand she fundamentally rejects abortion, because she has killed a potential life ('a human life, that is important') and must also judge herself, on the strength of this decision, as 'bad', in Christian terms 'sinful'. From the Church's viewpoint it is also condemnable that she socializes with the 'gay scene', another part of her life that she would prefer not to admit to.

It can be surmised that Anna Koscinska prefers to mix with a homosexual network since her rape because she feels safe there: she goes to the 'gay disco, about once a week, sometimes twice', to Christopher Street Day, and her network in these circles is constantly enlarging. She does not become aware that she is confining herself to the wrong marriage market until the moment of realization dawns that she lacks the partner she needs in order to stay in Germany. A sham marriage for legalization purposes, for which she would have to pay money, is not something that she can countenance. Nor is she familiar with the concept of a politically motivated marriage, such as the one arranged for Alexandra Marquez. This is probably more of a big-city phenomenon, and little known in her milieu. She would probably have difficulties with that, as well, for Anna Koscinska wants to marry only for love. Asked how her life will look in five to ten years' time, she replies:

> I'll find some place in the Church or else on the street, sitting there
> like a tramp with a few pennies [laughs]. I have these kinds of ideas
> because I don't have any real goal, and somehow I can't see my future,
> and maybe I'm much too gloomy about it all.

The place in the Church, she explains, could be a life as a nun, going on a mission to sub-Saharan Africa. The sole alternative to this that she mentions is that of running a gay bar. Both, according to Anna Koscinska, could help to stave off her fear of loneliness in old age.

To become a nun, however, she must make a confession and do penance; to open a bar she needs money, which she does not have. These two ideas point to her inner turmoil. They are so utterly opposed and deliberately exaggerated in the telling that it seems unlikely that Anna Koscinska is seriously considering putting them into practice. Hence, the following self-description is by no means unrealistic: 'And,

uh, my existence is always somewhere between Heaven and Earth, always. I'm not stable anywhere, not anywhere.' This instability is something that she can no longer integrate into her biography:

> My life, it's rather, um, it just has all these pieces. And these pieces are what I somehow have to, they're [not] joined up. And I must – and with me, everything is quite loose somehow, possibly, maybe. [...] So that it makes some kind of sense. Because, uh, everything makes no sense, everything is so disjointed somehow.

At this point it is clear that Anna Koscinska can no longer bring the fragments and disjunctures of her life into a continuous narrative, and that even the elements she could draw upon to do so, such as her work and her circle of friends, are not sufficiently salient to be of use in constructing this continuity.

This interview demanded a very high level of empathy, indeed therapeutic skills, from the interviewer. After all, a major part of the interview consists of discussing possible places to turn to for therapy or the issue of confession. Situations like this are characteristic when obtaining data from people who live precarious lives. The interviewer, too, finds it difficult to cope with. Shortly after the interview, Anna Koscinska travels to Poland and makes her confession about the pregnancy that she terminated, thereby taking a first step towards re-establishing an intentional action schema; nevertheless, afterwards nothing changes as regards her life situation as a single woman and an illegalized migrant.

7.8 Comparison of cases

Alexandra Marquez is in her mid-twenties at the time of her migration, and Anna Koscinska thirty years old. Both women are young and independent, and possess educational capital; incidentally, this is also conveyed by their command of German, which is good (Alexandra Marquez) to excellent (Anna Koscinska). It can be assumed that they themselves expected to be able to shape their lives autonomously and realize their dreams.

In principle, it is Anna Koscinska who has the better chances initially, since she is relatively quick to find a way to stay in Germany with legal residency status, can come and go without problems, and has a mixed network of (academic) Polish friends and German employers who can efficiently help her with problems. Meanwhile, Alexandra Marquez remains dependent for years on 'false' men friends. Whereas Anna Koscinska has previous experience of different coun-

tries, for Alexandra Marquez the trip to Germany is her first venture abroad. Alexandra Marquez leans primarily on her cousin and later on her sister for psychological support, unlike Anna Koscinska, who has no comparable close family relationships. She, instead, seeks out elective attachments, but never finds them fully satisfactory. Like many of the women we interviewed, these two have made wrong decisions in their choice of partners; in their situation as illegalized migrants, bad decisions in such matters have grave consequences because they are crucial to their existence.

Exercising self-discipline with regard to their sexual needs is so important for both women, as for all the women in our sample, because unwanted consequences such as a pregnancy would raise new problems. For both of them, the desire for intimacy, protection and security, or perhaps for a love marriage, has so far remained an unattainable dream. The danger of being exposed to sexual violence is disproportionately greater for women affiliated to an illegal or semi-legal network than for illegalized men.

In the case of Alexandra Marquez, the quest for safety and security is mirrored in the search for an apartment of her own that is more than a place to sleep or a roof over her head. Her progression from illegality to legality of residency status hinges on the help of German employers and circles of supporters. For Anna Koscinska the issue of a place to live is no problem, however, for with legal residency status she can solve the accommodation question relatively quickly.

For both women, work is an important structuring and stabilizing element in their lives; their gainful employment, and especially the relationship work that is part and parcel of it, represents the stable axis of their identity. Since being illegal has gathered a momentum of its own, however, it remains unclear how either woman is going to break away from it. Alexandra Marquez, like all female migrants legalized by marriage, could theoretically leave domestic work behind and do something better; however, she may have to undergo years of training programmes (language, vocational training, etc.) in order to improve her earning prospects. In the current labour market situation, this does not seem a very promising option. In principle, her social insurance is guaranteed via her marriage, but in virtually all such marriages of convenience, an agreement is reached to file for divorce as soon as the stability criteria for residency law have been met, i.e. after the two years of uninterrupted conjugal cohabitation that it takes to acquire an independent right of residency. After that, Alexandra Marquez will be no different from Anna Koscinska and all

the other women in having to take care of her own social security contributions and pension planning. For both women, the lack of any formal recognition of their competencies, either in Germany or in their countries of origin, remains a stubborn problem.

It can be assumed that, for Polish women like Anna Koscinska, the risk of being deported if their illegal residency is discovered has diminished since Poland became a member of the EU in 2005. Because Germany, unlike other western European countries, will not generally open its labour market to the new member states until the year 2011, the lack of a work permit continues to be a problem.

Presentation of the case studies has highlighted both the heteronomous situation and the perspective of the female protagonists in the given conditions. The entire spectrum of accommodation, health, orientation and integration problems has been set out. These are especially striking in cases where the want of adequate housing leaves the affected women completely vulnerable, and exploitative relationships of every kind converge.

When the women concerned can free themselves from mechanisms of exploitation and have the good fortune to be supported by committed friends or activists, it is possible to alleviate the precariousness of their situation; even so, in and of itself this offers no routes out of illegality. This chapter's most important finding concerns the massive variation in strategies for coping with illegality, which turn out to be less dependent on ethnic or national background than on (successful) deployment of biographical resources; whether migrants in Germany can bring their social capital to bear depends partly upon their access to supportive networks. The various offers of help available in metropolitan milieus, for instance, are not found in mid-sized and small towns, which results in locale-specific disparities in coping with illegalization.

This chapter also exemplifies the thesis that illegality is not in any way a phenomenon that takes place on the margins or beyond the bounds of German society, but one that is familiar to many employers. They deal with this knowledge in divergent ways, however, from repressing it to providing active support in a migrant's quest for routes into legality.

8 | Migrant women in the globalization trap?

Analysis and evaluation of the phenomenon of migrant domestic labour has to manoeuvre between the extremes that dominate both the academic discourse and the policy arena. Either the phenomenon is cast as 'refeudalization' (Kurz-Scherf 1995: 189), as the development of modern relationships of exploitation and violence which stifle the emergence of equality in any form;[1] or alternatively, it is argued that the household as a workplace is *the most important* sector of future expansion, and that from now on, supply and demand will be matched by means of the international, globalized labour markets (Kommission für Zukunftsfragen 1997; Young 1998).

Similarly, contrary positions are found in the research addressing the situation of the migrants who work in this sector: while some extol these domestic employees as 'agents of change' (Morokvašic 1991, 1993), with remarkable propensities for mobility and risk-taking, who contribute to the transnationalization of consumption structures and lifestyles, others see them as 'victims' and stress the precariousness of their life-situations.[2] Thus, the strategy pursued by the first group is that of *empowerment*, by making use of positive naming practices to dignify the achievements of the migrants concerned, while the second group exposes the scandalous nature of the situation in an effort to call attention to violations of labour law and human rights. It has been shown in this book that the empirical material turns up evidence in support of both positions. From this it must be concluded that they are interrelated and cannot be separated from one another. Both aspects are part of the same phenomenon, and both must appear in the presentation and analysis and be considered in conjunction, because they represent two sides of one and the same coin.

In the following, the most important findings of the study are summarized, and set in context within the wide spectrum of research and policy fields concerned with this phenomenon. Domestic and care work is as much of a challenge for gender policy as for migration and labour policy, but in none of these areas has it hitherto received the attention it merits; that is to say, under no circumstances must this theme be excluded from the debate about the future of global societies.

8.1 It's 'only' housework ...

The detailed description of the tasks carried out by the migrants in people's homes shows that the distinction made in the German debate on domestic work, between object-related and person-related services, is not applicable in practice.[3] The working routine of these employees is rather an amalgamation of these tasks; for instance, tidying, cleaning, washing and ironing may be carried out alongside cooking, minding children and old people, or doing shopping and other errands for the latter. The characteristics of these services are that they are provided in a personalized form, are extremely demanding as a result, and can be highly emotionally charged. This domain of work as a whole can be categorized as 'intimate work'. Following the theory of domestic chores put forward by Jean Claude Kaufmann (1999), it can be inferred from the dense descriptions of the field of activity (in Chapter 4) that even in households in which the service consists of laundry, tidying and cleaning work, the services provided are technically, physically and emotionally demanding. The work takes place in the space in which the employer maintains her personal habitus; which she considers to be her zone of retreat and relaxation. The domestic employee must be mindful of the topography of the private space and respect the 'order of things' intrinsic to each home, for this order, according to Kaufmann, also has a metaphorical meaning, being an important aspect of the human individual's system of emotional coordinates. The fact of working in a private household builds up mutual (emotional and material) dependencies, yet the relationship between employer and employee remains precarious; it can be unilaterally terminated at any time, if employers find themselves in financial difficulties, for instance. At the same time, particularly where children and old people are cared for, employers who are keen to avoid the disadvantages of constantly changing caregivers and are heavily reliant on dependability and continuity find themselves equally dependent on the loyalty of the employee.

Although the working relationship is often not legally safeguarded and trust takes the place of contracts, it has proved useful to retain the designations of employer/employee for the two parties involved, since in the first place, a verbally agreed employment contract exists, and in the second place, it makes the point that the matter at issue is socially necessary 'work'.

What stands in the way of the societal recognition of this work and the competencies necessary to do it, such as diligence, patience, perseverance, psychological skills, empathy, tolerance of frustration, and an ability to keep things in perspective – to name but a few – is

the fact that it is feminine-gendered, carries no prestige, and is usually performed unpaid as family work or a neighbourly service. As long as this imbalance persists in the (ideational and material) evaluations of gainful employment and family work, this domain will tend to resist efforts towards professionalization. Emotional work in the domestic setting is not only difficult to measure but also far from easy to remunerate; it rather tends to be treated as a surplus value delivered for free, which features as an important factor for employers in the selection and hiring of domestic employees.

The idea of agencies or 'service pools', advocated in the German debate as a means of offering person-related services legally (Weinkopf 2002), has not taken off as yet. In part, this is because customers are not prepared to pay the high prices that have to be charged nor, by extension, to accept the higher valuation thereby placed on family work. Another barrier is the theoretically necessary (for the purposes of establishing professional criteria) step of drawing a clear-cut distinction between person-related and object-related services in order to value the work to be done, given that such a distinction is impractical in reality, and many employers set great store by the flexibility of domestic employees – for example, when sickness requires adjustment of the normal daily routine, or special professional demands create a need for caregiving services at unusual times of day.[4]

Besides, the outsourcing of this work to a woman professionally trained in doing it would entail a further challenge to this identity-space, which is defined as feminine. As Bridget Anderson (2000: 169) rightly asks: 'If the domestic worker must be trained for her employment, how can domestic work continue to be a natural ability of women in general? In substituting a trained professional for herself, is a wife/housewife getting in someone who is better at "her" job?' In other words, the professionalization of this work, if it were possible at all, would have a deeply destabilizing effect on a core area of feminine identity work.

Unlike other segments of the transnational market in services, such as call centres, which can make use of advanced technology to offshore their tasks to low-wage workers abroad, unnoticed by the domestic customer base, domestic work cannot be exported.

Instead, the necessary labour-power comes from abroad; in a sense, it is imported. With the exception of just a few areas (such as geriatric care) in which formal recruitment procedures operate, which have certain parallels with the so-called 'guest worker' recruitment campaign of the 1960s, referral typically takes place via network contacts of the employers and migrants. State regulatory procedures are lacking and/or

virtually ineffective. Nevertheless, common characteristics with the old 'guest worker' migration can be identified: recruiters prefer to employ fully trained workers, whose training has been financed by the sending country.[5] One change since that era is that today's employers are not paying social insurance contributions, so the employees concerned are no longer covered for sickness and retirement benefits.

The 'market' in which employers seek and find flexible and loyal employees has developed in a twilight zone of the informal economy; it is characterized by multiple illegality or illegalization: a) there are no employment contracts or ensuing legal obligations upon employers; b) the migrants have no work permit, because the German state makes no provision for it; and c) many domestic workers have no residence permit. For employers, this illegality is a resource because it means that labour-power can be purchased cheaply and that domestic workers are dependent upon these earnings; but migrants also find it attractive to work under the given conditions, because it means that they pay no taxes and have their entire gross income at their disposal. Nevertheless, the relationship between employers and employees is structurally asymmetrical. All attempts to level the differences between these starting positions, and any assumption that here are two groups of people meeting under equal conditions, a proverbial win-win situation, must be roundly contradicted:[6] without the economic imbalance between rich and poor regions of the world, initiated through impoverishment processes following system transformations (in eastern Europe and the former Soviet Union), natural disasters, wars or poor governance (in Latin America, Asia and Africa), this phenomenon would not exist – at least not on this scale. In any country where, as in Germany, no formal recruitment programme exists for this sector, it is impossible to talk about 'contractual equality', simply because the potential sanctions are disproportionately harsher for the migrants than for the employers,[7] and because, as yet, little provision is made for taking court action against discrimination and harassment in the workplace or the withholding of wages.

8.2 New identities: 'doing gender' – 'doing ethnicity'

The terrain in which German employers meet migrants as employees is the private space of the domestic household, a place where people's identities change, which in turn has repercussions for the definition of this social space. When gainful employment is introduced into the private sphere, the meaning of which is bound up with being decoupled from the logic of the world of work, a shift in coordinates takes place:

it is impossible to maintain a distinct separation, either between private and public, or between productive and reproductive work. In the Anglo-American debate, some tentative steps have been taken to point out the blurring of these boundaries by making reference to 'domestic space'.[8] If something approximating gainful employment is taking place in domestic space, it is (constantly) necessary to define and redefine which objects and actions are distinctly intimate in character, and are therefore off-limits to the domestic employee, and which can be outsourced as quasi-public. It was shown particularly in Chapters 4 and 5 that emotional work in relation to other people is no longer the sole preserve of relatives and other members of the household, but is outsourced as work, whether it involves minding children or attending to the needs of elderly people (including the sick and the dying). It might be objected here that this emotional work also takes place in day-care centres and old people's homes; the difference in our case is, however, that by assigning care work to trained nursery nurses and caregivers outside the household, some degree of distribution and transfer of responsibilities is (contractually) defined. This was found not to be the case in the household, where responsibilities must constantly be renegotiated (on a daily basis). We have called this negotiation 'boundary work', a process whereby demarcation lines are reciprocally defined and differentiated notions of femininity are (or can be) reconciled. Boundary work is also characterized by paradoxes, for on the one hand, the work of migrants makes it possible or easier for the women among the employers to engage in gainful employment and to advance or pursue their careers, although at the same time, the employer's own 'doing gender' in the household, her family work, takes on a new form: she has to share this with another woman.[9] Her identity as a wife, partner and mother thereby seems to come under pressure, and consequently, control mechanisms come into play.[10] For the time being, the work does indeed remain feminine-gendered. This is seen in the tendency among heterosexual couples for women to be left in sole charge of the outsourcing of domestic work; nevertheless, as the cases presented in Chapter 5 reveal, 'doing gender' takes on a new form through 'doing ethnicity'.

Analysis of the interviews with employers reveals patterns of preference in their selection of migrants: domestic employees are selected on the basis of their ethnic difference, but their otherness should not diverge too dramatically from the employer's own lifestyle and communication style. There is, in any case, a striking preference for well-educated women who belong to the middle class in their country of

origin. Although we have not studied this sufficiently, at least the thesis can be put forward that the religious affiliation of the new migrants has a role to play as a cultural similarity factor. Eastern European and Latin American women come from a Christian cultural background; even if not all of them participate actively in church life, nevertheless the symbolic meaning of this background does not seem insignificant.

Of course, a natural concomitant of the preference for similarity is the problem that the boundaries between those involved become fluid; economic and civil-society shortcomings of the country of origin are mentioned by employers in everyday communication to evoke ethnic boundaries, and to utilize these as markers to maintain asymmetrical relationships. Similarity itself can also have counterproductive consequences, however: for some employers, e.g. self-employed people and creative freelancers, being confronted with a domestic employee who is educated and can no longer work in her profession may activate their personal fears concerning potential loss of status and precarious living situations, as evidenced in Chapter 5.

The differences in the identity work that both sides in this working relationship have to perform can be elucidated with reference to key questions. For the employer, the question is: who used to do the domestic work, and how can I best organize the delegation of it? For the employee, particularly if she has left her husband and/or children behind in her own household, the question is: who will take charge of my former tasks, who can stand in for me as a housewife and mother?[11]

Transnational motherhood is a particular challenge for the migrant women concerned, because they (must) mentally connect multiple households, the one that is their workplace and the one that they have left behind, and must be capable of establishing closeness and intimacy across great distances. Contrary to earlier assumptions that when these women become the family breadwinners and their husbands (have to) take charge of the care work a change in gender dynamics will occur, in fact it became apparent that feminine work is preferentially passed on to other female family members (mothers, daughters, female neighbours), who become substitutes for the absent mothers. Far from making gender identities more fluid, either in the countries of origin or in the destination countries, the waged work of women tends to perpetuate them, although this aspect has not, as yet, been sufficiently investigated. Other gaps in the research that remain to be filled include the question of how, where and in what circumstances the 'global care chains' come into being; and the task of investigating the crisis of masculinity in the men left behind, who lose

their role as family breadwinners but are not necessarily prepared to take on the family work, to which society attaches little or no prestige. It must be affirmed that these women show a remarkable propensity for mobility, and that they obviously integrate themselves so well into the households in which they work that, so far, their presence has never been cited as a problem category in any integration debate, nor prompted any publicly expressed misgivings.[12]

8.3 What is to be done? The necessity to recognize this work as important to society

This fact is reason enough to surmise that the work of migrants has to be considered as a component of our domestic economy. It touches on three central regimes[13] in our society: a) the gender regime, b) the migration regime and c) the welfare regime.

The gender regime Traditional emancipation policy and the demand of the women's movement for equal sharing of housework and care work must (unfortunately) be deemed to have failed, because in a globalized society, other redistributive solutions present themselves. So far, the feminist debates of the last thirty years have not succeeded in putting the gendered underlying structure of our society up for negotiation: neither the evaluation and structure of gainful employment nor the relationship between care work and gainful employment have fundamentally changed.[14] Unless this happens, however, the three Cs (cooking, cleaning and caring) will remain firmly positioned on one side of the gender dualism, and the 'odour of privacy' (Helga Krüger) that surrounds domestic work will continue to do so. Only when the scandalous asymmetry between care work and gainful employment can be comprehensively and effectively exposed and redefined will the development of care competencies across both genders pave the way for new forms of coexistence. While this is not the case, all the global market will achieve is the perpetuation of traditional gender responsibilities and thus a neo-traditionalist continuation of social patterns. So do we need a new feminism, as some highly successful women demanded in the weekly news magazine *Die Zeit*?[15] Yes, but one in which the 'women of power' do not keep quiet about the fact that successful professional women rarely have supportive men in the background but tend to rely on (a number of) women to do their 'serving background work', including growing numbers of female migrants. Likewise, the policy instrument of gender mainstreaming should no longer ignore the asymmetry that has arisen between local

women and migrant domestic employees. The former have, in fact, found their way on to the career ladder throughout Europe, and are able to keep climbing it because they can increasingly rely on the work of the latter. The only publicly discussed solution so far to the current situation is the professionalized offering of 'service pools'. The migrants on whom this book reports are excluded from this debate. Owing to their multiple illegality/illegalization, they are not accepted into these pools. Even having legalized their status, which at the moment can be permanently accomplished only by means of marriage, they can barely take advantage of any continuing education and training on offer because their educational certificates and qualifications are not recognized.

The migration regime The recognition of migrant domestic labour is primarily impeded by German migration policy, which has officially endeavoured to prevent immigration for over thirty years but has nevertheless repeatedly created openings over the decades (seasonal work in agriculture, 'green cards' for software engineers, etc.). For gainful employment in the household there is no equivalent provision, with the sole exception of so-called 'domestic helpers for people needing care in their own homes' (see Chapter 7). The restrictive immigration policy does not prevent illegal immigration but creates twilight zones of informal labour markets. An equally unacceptable solution is the introduction of penal-law sanctions for the illegal employment of domestic helpers, a step that has been proposed repeatedly but has proved politically unrealizable at each attempt, because it tends to criminalize the employers. In many EU countries, policy-makers have so far refused to negotiate on earned legalization, i.e. legalization of those concerned on the basis of recognition of their work. The 'Resolution on regulating domestic help in the informal sector' discussed in the European Parliament (2000), for example, which calls for the recognition, regularization and decriminalization of this work and these workers, was not debated in the German Bundestag.

Norbert Cyrus (2008) describes precisely this dilemma: on the European level, numerous initiatives have been launched to improve the present situation, although many resolutions of the European Parliament are not binding on member states but only carry the force of recommendations.

The welfare regime The structure for social care, which is arranged between the family, the state and the market, is under pressure. At

present, Germany is witnessing two trends in parallel: the expansion of public childcare provision, and the simultaneous privatization of state services on the so-called 'cash for care' model.[16] In the meantime, it is becoming increasingly clear that for demographic reasons alone, the welfare states of the West cannot care for their children, their sick and their elderly without relying on the 'import' of migrants. On the other hand, the 'care drain' deprives many sending countries of care competencies they desperately need themselves, even as their public budgets become dependent on these migrants' remittances. According to estimates of the World Bank and the OECD, remittances in the year 2005 amounted to $167 billion, whereas in the same year only $106.5 billion was spent on development assistance (DSW 2006). From this, the World Bank now concludes that remittances are the better supporters of development, and particularly underscores the role of feminized migration in this context. As important as it is to document this phenomenon, mention must equally be made of the price paid individually by those affected, particularly by the stay-behind children. Research into the long-term consequences of the absence of parents is urgently required, and can be counted among the most important research desiderata.[17] The interdependence of demand and supply, highlighted in this book, also means that development policy must be seen as part of welfare-state policy.

In Germany, the main bodies speaking up for the concerns of domestic workers to date have been organizations such as AGISRA (Arbeitsgemeinschaft gegen internationale sexuelle und rassistische Ausbeutung – Organization against international sexual and racial exploitation), the Catholic Church and various non-governmental organizations; at European level, the key actors can be identified as the Platform for International Cooperation on Undocumented Migrants (PICUM), the Brussels-based NGO Respect, and Human Rights Watch. Political parties and trade unions tend not to be involved in this area.

Although the European Trade Union Confederation (Mather 2006) has addressed the issue of domestic workers in Europe, its preferred solution of household cheques and formalization of the domestic work setting cannot be seen as a solution for the migrants employed in such settings today. Admittedly, the Confederation of German Trade Unions does offer advice to victims of forced labour, but overall it has barely engaged with the domain of domestic work as yet (see Cyrus 2006).

In order to prevent migrants who work in private households from landing in the globalization trap, the public must be reminded that

- Articles 13, 14 and 15 of the Universal Declaration of Human Rights of 1948 grant all people the right to freedom of movement;
- a human right exists to healthcare, education, healthy living conditions and a family life;
- the work done by the female migrants is socially necessary and must be covered by the normal safeguards of labour law.

Globalization is a process in which new options for action and new social inequalities are developing side by side. Therefore analysis of the phenomenon of domestic work and care work must not confine itself to a single plane but must take different planes of action and structural levels into account. In addition to the micro level (individual practices, identities and positions), the meso level (networks, support structures, work organization) and the macro level (labour markets, migration policies, etc.) also come into play (see also Lutz 2010). Accordingly, an adequate description of the 'new maids' cannot be limited to the analysis of agency (individual scope for action), nor can it focus on structure (labour markets and regimes) to the exclusion of all else; rather, it calls for an integrated appraisal. On close scrutiny, antagonisms emerge on every level which cannot be resolved with moral appeals.

The extensive body of international research that has accumulated in the last decade demonstrates that the topic has earned its place in the gender research discourse. For the sake of social policy, however, it is now important to take up this debate and move it beyond gender research to stimulate a wider discussion in society as a whole about the future of work – a future in which care work is duly regarded as 'work' and placed at the heart of a redefined concept of work. As utopian as that may sound, by all indications the time for such a reappraisal has never been more ripe.

Appendix 1: breakdown of the domestic workers interviewed

Name; Age; Country of origin; Family status; Education/training, occupation/ profession; Location and length of stay; Type of domestic work, other jobs; Pay; Residency status; Date of interview/s

Anita Borner; 43; Poland; Divorced, two sons (23, 20); Qualified skilled typesetter, also worked as materials inspector, nursery teacher and teacher; First came to Berlin 14 years ago; 10 years migrant commuting; now based in Berlin; Cleaning, some childcare; 9–10 €/h; No legal status; June/July 2003

Maria la Carrera; Mid-50s; Uruguay; Second marriage, two children; Textiles designer; In Hamburg for approx. 7 years; Cleaning private apartments and commercial premises, restaurant work; Cleaning: 14 €/h, one employer pays 10 €/h; Entered as tourist, no legal residency status for several years, finally legalized by marriage; June/July 2002, June/July 2003

Daniela Failer; 26; Ecuador; Second marriage, one son (3); Tourism degree at professional college, worked as pre-school teacher and as commercial representative; In Hamburg for 2 years; Cleaning, work in a restaurant kitchen, initially also childcare; Cleaning: in one household 8 €/h + 3 € travel allowance, otherwise 9–10 €/h; Childcare: 4.50 €/h, paid even when family is on holiday; Now has permanent legal status through marriage; December 2003

Inez Ferrer; Early 30s; Spain; Living with a partner; Secretary; In Münster for 5 years; Childcare; Legal; March 2002

María García; 26; Ecuador; Married; Attended various university courses in Ecuador; In Hamburg for 3 years; Childcare, cleaning; Cleaning: one employer pays a flat rate of 30 € for 3 h initially, dropping to 2 h + travel once cleaning is routine; Without legal status; December 2003

Ursula Hell; 48; Poland; Married, two children; Graduate economist, also works as a singer; Migrant commuting from 1998, settled in Berlin since 2002; Cleaning; 8–8.50 €/h; No legal status; able to apply for German nationality based on proof of German ancestry; July 2003

Tamara Jagellowsk; 28; Ukraine; Married; Nursery teacher, began but dropped out of degree in German language and literature, now training as multilingual secretary; In Hamburg for 8 years; Au pair; Started on 200 DM/month with free board and lodging, now 300 €/month; Legalized by au pair visa three months after entry; further visas as language student and student; now permanently legalized by marriage; August 2003

Karolina Jany; 29; Poland; Single; Degree in German language and literature in Poland, more recently sociology degree; In Hamburg for 7

years; Au pair, cleaning; no longer a domestic worker at time of interview; Au pair: 300 DM/month with free board and lodging; Cleaning: 10 DM/h; Entered as tourist, later obtained student visa; July 2002

Natascha Kavtaradze; 36; Georgia; Single; Journalism graduate, now studying education in Münster; In Münster for 3 years; Cleaning; With student visa; February 2002

Anna Koscinska; 42; Poland; Single; Completed apprenticeship in transport industry, university studies in economics; In Münster for 12 years; Cleaning, for past 2 years also childcare; 8 €/h; Initially without legal status, later with student visa; student status expiring at time of interview; July/August 2002

Olga Kovacz; Late 50s; Hungary; Married; Qualified art teacher; In Münster for 2 decades; Childcare; Legal; January 2002

Lena Krause; 28; Poland; Married; Studied German language and literature in Poland but did not graduate; degree in eastern European studies; In Berlin since beginning of 1990s; Initially au pair, then childcare, other jobs in a restaurant, a toy shop and as student academic assistant; Au pair: 200 DM/month with free board and lodging; Childcare: 10 DM/h, or 15 h babysitting per week for free accommodation; Cleaning: 15 DM/h; Initially without legal status, then with student visa; Permanently legalized following marriage; July 2003

Weronika Krzeminski; Early 30s; Poland; Single; Administrator, now student; First came to Germany 11 years ago, returned home to Poland in the interim, then came back to Berlin; Cleaning, later live-in attendant and carer for an elderly gentleman; now works for museum service; Cleaning: average 15 DM/h, but in one household as much as 25 DM/h; Care/nursing: 1,100 DM/month; Has now obtained student visa; July 2003

Alexandra Marquez; 32; Ecuador; Single at time of interview, marries later; University entrance qualification, no vocational training, various types of work in Ecuador, owned a chicken farm before migrating; In Berlin for 7 years, briefly interrupted by one return visit to Ecuador; Childcare, cleaning in private homes and business premises; Childcare: 6 €/h; Cleaning: 8–9 €/h; Without legal status for a long time, now legalized by marriage; May/June 2003

Magda Niemen; 30 years; Poland; Living with a partner; Initially taking degree in Hungarian, broke off studies and worked for an advertising free sheet; In Münster for four years; Cleaning; 8 €/h, one employer pays more; some pay travel costs; With student visa, obtained after some time; January 2003

Paulina Novak; Mid-30s; Czech Republic; Single; Nursery teacher, now studying Eastern European studies; In Berlin for six years; Childcare, cleaning; 6–8 €/h; 8 €/h in homes where she only cleans; Entered as a tourist, later obtained student visa; June 2003

Adam Pavel; 32 years; Czech Republic; Single; Theatre designer; In Berlin for three years; Cleaning, sporadically also childcare; Payment has changed over time; currently: Cleaning: 9-10 €/h + 5 € travel allowance; Entered with fixed-term employment contract, later without valid work or residence permits; June 2003

Sylwia Pavel; 25 years; Czech Republic; Single mother of a son (3) who lives with her mother and sister; Nurse; In Berlin for one year, migrant commuter; Childcare, cleaning; Childcare: 8 €/h; Cleaning: 10 €/h; Without permanent legal status; regularly enters and leaves the country on a tourist visa; June 2003

Rosa Perez; 46; Chile; Separated from husband, one son (18); No vocational training, various types of work in Chile, including sewing machinist; In Germany since beginning of 1990s; Worked as domestic, then kitchen assistant; today, permanent job as chef, also does cleaning in several households; Cleaning: 10 €/h; One employer pays 15 €/h and a generous Christmas bonus; Status dependent on that of husband, who has a residence permit; October/ November 2003

Mónica Yaneth Ríos; Mid-40s; Colombia; Single mother of two sons (12, 26), who live in Colombia; No vocational training; In Hamburg for 3 years; Cleaning, childcare, sex work, cooks for colleagues; Cleaning: 8 €/h; Childcare: 5 €/h; Cooking: 8 € per lunch, sometimes just 5 €; Sexual services: usually 20–30 €; Without legal status; October/ November/ December 2003

Tatjana Romanoff; Late 20s; Lithuania; Living with a partner, one daughter (7 months); Degree in economics in Lithuania, now studying in Berlin; In Berlin for four years; Cleaning, also worked as coffee maker in an embassy, as an office assistant and buffet assistant; at time of interview not working; Cleaning: 15 DM/h; Has now obtained student visa; July 2003

Fahimeh Said; Early 40s; Iran; Single; Nursing diploma; In Hamburg for 6 years; Childcare, work for a private nursing agency; Childcare: 7 €/h; Recognized as a political refugee; July 2002

Aurora Sanchez; Early 30s; Ecuador; Married, one son (8); Managed a kiosk in a school in Ecuador; In Hamburg for 4 years; Cleaning; 9 €/h; Without legal status; December 2003

Gizelha Santos; 40 years; Brazil; Married, two children (18 and 21) who live with their father; University entrance qualification, no further vocational training; In Hamburg for 4 years; Cleaning: 8–9 €/h, sometimes + travel allowance; Without legal status; November/ December 2003

Rita Tomek; Early 30s; Poland; Married, 2 children; Degree in librarianship in Poland; In Berlin for 7 years; Au pair, later cleaning assistant, office assistant; at time of interview not working; Au pair: 500 DM/month with free board and lodging; Initially entered on a tourist visa; following marriage, permanent legal status; June 2003

Justyna Wachowiak; Early 30s; Poland; Married, 1 child; Degree in economics by distance learning in Poland; In Hamburg for 10 years; Cleaning, later head of own agency, recruiting cleaning assistants; at time of interview no longer working; Legal; July 2002

Marta Wisniewski; 22; Poland; Single; University entrance qualification in Poland, currently attending pre-university preparatory course; In Germany for 1 year; Childcare, cleaning; Childcare: 5 €/h; Cleaning: 8–10 €/h; Entered with visa for a language course, later legalized by enrolling for pre-university studies; August 2002

Appendix 2: breakdown of the employers interviewed

Name; Location; Age; Family status; Household composition; Education/ training, occupation/profession; Type of work outsourced; Duration of employment arrangement; Pay; Date of interview/s

Gudrun Bäumer; Berlin; 35; Single mother of a daughter; 1 adult, 1 child; Doctoral candidate; Childcare, cleaning; Approx. 1 year; Childcare: 8 €/h + 5 € travel allowance; Cleaning: 10 €/h + 5€ travel allowance; May 2003

Friedrich Berger; Berlin; 70; Divorced; 1 adult; Retired journalist; Cleaning; Fifteen years; 7 €/h; Rent fully offset by wages for 4 h per week cleaning; June 2003

Maria Brand; Hamburg; 37; Single; 1 adult; Senior role in the advertising industry; Cleaning; Approx. 6 months; has employed domestic workers for 12 years; 9–10 €/h; June 2002

Frieda Hansen; Hamburg; 32; Living with a partner; 2 adults; Film set designer; Cleaning; 1 domestic worker for 1 year, Maria Garcia for 6 months. At time of interview, no longer employing domestic staff owing to financial constraints; Flat rate of 30 € for 3 h initially, dropping to 2 h once cleaning is routine; March 2004

Franz Heinrichs; Berlin; Over 80; Married; 2 adults; Cleaning; Has employed domestic workers for 15 years, current arrangement in place for approx. 1 year; 8 €/h; May 2003

Iris Jungclaus; Hamburg; 37; Living with a partner; 2 adults; Arts administrator; Cleaning; 6 or 7 years; 10 €/h; December 2003

Ingeborg Kalfhues; Münster; 79; Divorced, 4 children; One adult; Unqualified geriatric care worker and night nurse; Cleaning; Has employed domestic workers for approx. 1 year; current arrangement in place for approx. 6 months; 8 €/h, usually pays a 1 € tip; March 2003

Dorothea Klaasen; Münster; Mid-70s; Single; 1 adult; Emeritus university professor; Cleaning; Approx. 2 years; 10 €/h; March 2003

Andrea and Mark Landau; Berlin; 40 (Andrea), 45 (Mark); Married, 3 children (12, 9, 7); 2 adults, 3 children; Theatre journalist and playwright (Andrea), professionally qualified surgeon and clinic director (Mark); Cleaning, renovation works; Over past 14 years, have employed 4 domestic workers, 2 childminders, 3 au pairs; current arrangement in place for 3 years; Cleaning: 8 €/h Renovation works: 9 €/h; February 2003

Anneliese Metzer; Münster; 73; Single; 1 adult; Retired middle-grade civil servant in a federal government office; Cleaning; Has employed domestic workers for more than 15 years, frequently changing arrangements; current arrangement has lasted for several years, however; 25 € for 3 h; March 2003

Simon Nickel; Hamburg; 38; Single father of a daughter (18); 1 adult, 1 child; Theatrical director and writer; Cleaning; Approx. 6 months; 9 €/h; December 2003

Ursula Pelz; Hamburg; 48; Single mother of 2 sons; 2 adults, 2 children; Academic researcher and lecturer; Childcare, cleaning, housekeeping; 9 years; 300 €/month with free board and lodging (au pair); May 2003

Katharina Schirmer; Berlin; Early 40s; Single mother of 1 son; 1 adult, 1 child; Television journalist; Childcare, housekeeping; Has employed domestic workers for 10 years, initially an older woman, then for the last few years the woman's daughter-in-law, occasionally also her husband; 8 €/h; 'supplemented' with worn (children's) clothing, etc.; June 2003

Brigitte Schmidt; Berlin; Mid-60s; Married, 3 children; 2 adults; Housewife; Cleaning; 4 years; 8 €/h; June 2003

Andrea Schreiner; Hamburg; 38; Married, 1 child (3); 2 adults, 1 child; Historian; Childcare; Almost 3 years; 7 €/h; June 2002

Elsbeth Steiner; Münster; 72; Divorced; 1 adult; Retired civil servant; Cleaning; Has employed domestic workers for 5 years, for 1.5 h/week; 8 €/h; also gives the current domestic employee free language tuition; April 2003

Sybille Thomas; Münster; Married, 2 children (2, 4); 4 people: 2 adults, 2 children; Teacher; Childcare; Approx. 6 years; March 2002

Anne von Uhlen; Münster; Married, 2 children; 4 people: 2 adults, 2 children; Teacher; Childcare; Approx. 5 years; March 2002

Karin Vogel; Münster; Mid-40s; Married, 2 children; 4 people: 2 adults, 2 children; Teacher; Childcare, cleaning; 1 year; 350 €/month for 11.5 h work per week; 10–11 weeks' paid holiday and an extra half-month's pay at Christmas; July 2002

Notes

1 The new division

1 In the former GDR, as in most countries of the 'socialist bloc', women's employment was normatively anchored from as early as the 1950s, and non-compliance was subject to socio-economic sanctions; at the same time, a comprehensive system of care for children and old people was established. In the wake of the system transformation, however, the social care system in all eastern European countries has been 'liberalized' since the 1990s, which has resulted in the disappearance of many of those support services.

2 Similar findings are available from other European countries (see also Lutz 2007b).

3 Throughout this book, all passages quoted from non-English publications and sources are rendered in English for convenience.

4 On this, see also Cox (2007).

5 Further references to individual studies can be found in Gather et al. (2002).

6 The works by Dorothee Wierling (1987) and Karin Walser (1985) give an excellent insight into the young women's daily lives.

7 Prior to that, the domain of servanthood was dominated by men, who did not, however, perform the same tasks.

2 The household as a global market

1 In addition there are an estimated 67 million refugees, the majority of whom are women and children.

2 See also Chapter 7 on this.

3 Only a small minority of the many studies published can be mentioned here.

4 For Germany, see the agencies specializing in recruitment of Polish and Hungarian home-helps for people in need of care: www. arbeitsmarkt-polen.de, and www. arbeitsmarkt-ungarn.de.

5 It is estimated that 850,000 women from Indonesia and Sri Lanka work in Saudi Arabia alone. In some regions of the world, the proportion of child workers (younger than sixteen years of age) among them is regarded as alarming: there are thought to be 700,000 in Indonesia and 20,000 in El Salvador (Human Rights Watch 2006: 3).

6 In the Philippines, Indonesia and other sending countries, courses at public or church-organized training centres teach not only how to handle ultramodern household equipment but also how to deal with problems relating to loneliness, isolation and sexuality. Many countries have also introduced pension entitlements with compensation mechanisms that take into account the lengthy periods that domestic workers spend abroad.

7 Many historical studies cite this very aspect as the reason for the periodically higher proportion of

girls from rural areas who are sent to work in city households.

8 Until recently, there were no studies investigating these questions for eastern Europe – a geopolitically new sending region that has been supplying western and southern European markets since the system change of the early 1990s. However, for the first results of my latest study on care drain and care provision from Ukraine to Poland and from Poland to Germany, see Lutz and Palenga-Möllenbeck (2010, 2011).

9 This term does not denote the conversion of money into economic goods, but the buying and selling of reproductive labour.

10 Chapter 6 examines the resultant difficulties.

11 On the debate concerning transnationality and transnational spaces, see also Faist (2000); Pries (2000); and Lutz (2005).

12 Here, it need only be mentioned that today even communal student households may use the services of a 'cleaning lady'. See, for example, the celebrated *zeitgeist* novel *Generation Golf*, by Florian Illies (2001).

13 Countries that have formally recognized this sector also have a better data basis on this theme at their disposal.

14 To give some idea of volume: Italy and Spain 500,000 (Scrinzi 2008; Escrivá and Skinner 2008), Britain 14,300 (Williams and Gavanas 2008).

15 Garfinkel (1967); Goffman (1977); West and Fenstermaker (1995).

16 Also helpful is Pierre Bourdieu's approach in *Masculine Domination* (2001), which analyses 'doing gender' as the conversion of a physical into a symbolic order:

socialization in the home, says Bourdieu, leads to the acquisition of a gendered and gendering habitus that produces and establishes the somatization of culture as a construction of the unconscious.

17 Resistance to change despite emancipatory rhetoric can also be analysed in terms of Karl Mannheim's (1928) concept of inter-generational cultural transmission. Mannheim explains that, although cultural codings can face scrutiny in times of rapid social transformation, it takes a long time for changed attitudes to be inscribed in the cultural memory.

18 See Chapter 5 on this.

19 Gender as a social marker does appear locally in different variations all around the world, but in the context of this discussion it has been constructed as an anthro-pological constant.

20 The term derives from Kimberlé Crenshaw (1989), who made 'intersection' a metaphor for describing links and overlaps between social positionings.

21 See also Lutz et al. 2011 (forthcoming), Lutz (2001, 2002b) and the special issue on 'Intersectionality' of the *European Journal of Women's Studies*, 2006, edited by Ann Phoenix and Pamela Pattynama.

3 Domestic work and lifestyles

1 With few exceptions, the women we interviewed are all 'live-outs', i.e. they do not live in the household in which they work. For the situation of live-in domestics, see Sabine Hess's work on au pairs (Hess and Puckhaber 2005).

2 See, for example, the work of Mary Chamberlain (1997) on family forms in the Caribbean, where a decades-long tradition of female

emigration has been cushioned by the matrilineal organization of households. This development has also been seen in the last twenty years among Mexican women who emigrate to the USA (Hondagneu-Sotelo and Avila 1997; Hondagneu-Sotelo 2001).

3 German government plans for a new law to combat illegal employment had become known in the summer of 2003. The original draft stipulated that failure to declare quasi-domestic service work would no longer be regarded as an administrative offence liable to a fine of up to 25,000 euros, but as a criminal offence punishable by up to ten years' imprisonment in severe cases. Towards the end of the year 2003, the draft law was discussed publicly: whether illegal work in the home should be regarded as a crime or just a minor offence was a controversial debate. Mainly as a result of protests from the Christian Democratic opposition and the Taxpayers Association, a redrafted 'Law on More Intensive Combating of Illegal Employment and Related Tax Evasion' was eventually passed in February 2004 and came into force on 1 August 2004. Illegal domestic work continues to be punished as a mere administrative offence – see also Chapter 7 on this.

4 A social institution linked to the Catholic Church.

5 In our sample, however, there is only one woman in this category. When asked explicitly, experts in the field assured us that this phenomenon does exist, but only to a very limited extent. This contradicts Maria Rerrich's thesis (2002b) that it is very common for women to combine the two areas of work.

6 It is already possible to state that the introduction of tuition fees and stringent checks on the progress of study prescribed in the recently introduced bachelor's and master's degree courses will have negative consequences for these migrant workers.

7 Sabine Hess (Hess and Puckhaber 2005) had similar experiences in her research on au pairs. In no case did she manage to interview both parties.

8 Małgorzata Irek (1998) conducted her research 'under cover', i.e. she posed as a domestic worker and, as such, was employed in private homes and conversed with other female Polish domestic workers on the commuter train from Warsaw to Berlin. As fascinating as this method may appear, it is nevertheless dubious from an ethical perspective. Any reflection on these difficulties is omitted from Irek's study, which also fails to provide a precise description of the procedure or systematic analysis of the material.

9 The majority of interviews were carried out by the project's research associate, Susanne Schwalgin; those in Spanish and Portuguese were conducted and translated by Karla de la Barra. Umut Erel and Bettina Völter also carried out interviews, the latter with the assistance of Monika Kisiali, who at various points translated from Polish into German or vice versa.

10 This was the ethnologist Karla de la Barra, who also found and referred contacts by virtue of her own Latin American origins. The Spanish parts were transcribed by Birte Uhlig, and in the course of the transcription the translation was checked again and revised where necessary.

11 In preparation for publication

of the first German edition of this book, i.e. Lutz (2007a).

12 See also the important works on this issue by Pierre Bourdieu (1992) and Basil Bernstein (1975).

13 The same applies to the linguistic behaviour of members of the lower classes.

14 Conversely, it might be argued that the data should have been collected only by native speakers of the migrants' mother tongues, since then the interviewees' linguistic competence in German would no longer have been an issue. However, such an approach would have exceeded the financial resources of the project and constrained the diversity of regions of origin from which informants could be drawn.

15 I have since conducted a follow-up study, 'Landscapes of care drain. Care provision and care chains from Ukraine to Poland and from Poland to Germany' (2007–10, a German National Science Foundation-funded project), in which not only care workers, but also their families and children left behind in the sending countries were interviewed.

4 Domestic work

1 This method derives from the Symbolic Interactionism approach, which analyses everyday actions from an ethnological outsider perspective, on the principle of 'Making the familiar strange' (see Blumer 1986).

2 Adam Pavel is the only man in our sample who was willing to give an interview (see Chapter 3).

3 In the extracts from interviews, pauses in speech are indicated thus: ..., and omissions from quotations thus: [...].

4 The researcher in question

is Bettina Völter, who conducted an observation at the home of the Landau couple, as well as an interview with the couple and several conversations with their Polish domestic worker, Ursula Hell.

5 Single parents pay 75 cents an hour for the Berlin SHIA (Self-Help Initiative for Single Parents), while the public authority funds the wages and social security contributions.

6 This sum was indeed higher than the usual going rate of three to five euros for childcare. Most employers agree a rate for a fixed part of a day.

7 Ironically, one might conclude from this indication that for former citizens of the GDR, the harassment and regimentation they were used to in the old days are proving useful experience for the post-GDR times.

8 It can be assumed that her professional training as a social anthropologist contributed to this ability.

9 'Czechia' (*die Tschechei*) has negative resonances in German because of its use in 1930s Nazi propaganda as a derogatory name for Czechoslovakia.

10 A counter-example to this is the case of Tamara Jagellowsk, who lives in her employer's home. It will be presented and analysed in the next chapter.

11 Here: origin represented by language.

12 This name is assembled from a first name chosen by the informant herself, and a surname we added that fits this interview partner's personality. The Spanish word *carrera* has the meanings 'run', 'race', 'study/university course' and 'career'; *a la carrera* means 'on the run'.

13 In Chapter 5, the emotional

aspect and the cultural surplus value of her work will be explored using the example of the relationship with her employer Iris Jungclaus.

14 On the theme of quasi-familial relationships, see also the next two chapters.

15 As we shall see in the next chapter, Tamara Jagellowsk was an exception.

5 Exploitation or alliance of trust?

1 On the sociological debate on trust, see Endress (2002); Misztal (2001); Giddens (1990); Simmel (1992); Lewis and Weigert (1985); Garfinkel (1967); Goffman (1977).

2 His wife Andrea Landau is also present during this interview.

3 The concept of 'othering' describes processes of social exclusion and discrimination on the basis of social background, ethnicity, race, skin colour, culture and gender. The process of 'othering' involves social boundary-setting for the establishment of social positioning.

6 Transnational motherhood

1 In Ecuador, for example, remittances already amounted to 1 per cent of gross national product in the year 2000 (Plan Migración 2002). For Poland in the late 1990s, remittances from Germany – not from irregular migrants but seasonal employees and contract workers – were estimated at around DM700 million per year (Kaczmarczyk 2004). The migration researcher Antoni Rajkiewicz, referring to national census data from 2002, estimates that annual money transfers currently exceed 2 billion euros, and assumes that one in eight multi-person households in Poland is directly or indirectly affected by migration (Rajkiewicz 2004).

2 See also Brennan (2004: 123–31); Gamburd (2000: 198ff.); Hondagneu-Sotelo and Avila (1997); Parreñas (2001a); Shinozaki (2003).

3 Jacklyn Cock (1984) studied the working conditions of black maids as a component of the apartheid system.

4 On the transnational parenting practices of Filipino domestic employees of both sexes, see Shinozaki (2003, 2005).

5 On this, see earlier works by Norbert Elias (1991) and Elisabeth Stone (1989).

6 Michele Gamburd (2000), who studies the impacts of transnational motherhood on the stay-behind children of Sri Lankan female domestic employees, arrives at similar findings; it is said that the children's psychological development and school progression are impaired, and both husbands and children can become alcoholics.

7 The political and economic situation in Poland is reflected in the statistics on emigration of Polish citizens of German ancestry. The year martial law was imposed in Poland, 1981, marked the first dramatic rise in emigrants from Poland, and a similar peak occurred from 1987 to 1990, the year when it was made more difficult for Poles with German descent to migrate (see Pallaske 2000: 54f.).

8 His family had emigrated from Bamberg to Poznan 200 years earlier. His application was refused by the German consulate on the grounds that his ancestors had been ethnic Poles born within the German Empire.

9 Two comparable cases from our sample: Tamara Jagellowsk,

who comes to Berlin in 1995 as an au pair, initially earns DM200 per month, including free board and lodging, for six hours or more of childcare and housework daily; Karolina Jany has also worked as an au pair since 1995 and receives DM300 (see Appendix).

10 These two ways of processing experience are also found among the Filipino domestic workers interviewed by Kyoko Shinozaki (2003, 2005) in her study.

11 In contrast to many other families with transnational mothers, the Borner family was able to afford these visits financially and to find accommodation with sufficient space.

12 A variant of the partiarchal family model, in which hard work and the smooth running of the family are seen as women's natural tasks, regardless of whether they are in gainful employment or not.

13 It is astonishing, however, that according to the Polish census of 1988, only 57 per cent of all women of working age were employed. It may be that the large numbers of women working in agriculture were not taken into this calculation. After the system reform, women's unemployment rose, especially among educated groups, reaching 51.4 per cent in 2002 (see Firlit-Fesnak 2002).

14 The estimated number of undocumented Ukrainians residing in Poland at the turn of the millennium was 200,000. A sizeable proportion of these people were female and employed in domestic work; see Kindler (2008).

15 The divorce rate in Poland during the communist period was quite high owing to liberal divorce laws (e.g. 1.2 per 1,000 inhabitants

in 1975) and initially fell in the years after the collapse of that system. In the early 1990s the divorce rate in Poland (0.88) was about half that of the Federal Republic of Germany's (1.68) (Haller et al. 1996: 98f.). Since then a slowly rising trend can be observed (Ciszewski 2005). The major resurgence of Catholicism following the system change militates extremely strongly against the gradual loosening of socio-economic family dependencies.

16 This discursive link between female reproductive work and self-sacrifice for the nation has been studied extensively by Nira Yuval-Davis (1997); on the connection between the transnational family and the nation see Bryceson and Vuorela (2002); Parreñas (2005).

17 Up to the present day, women's pay in Poland has remained significantly lower than men's, although women on average are better educated than men. Women continue to do the lion's share of family work and their under-representation in the highest income group (20 per cent) is dismaying (see Firlit-Fesnak 2002).

18 The mother had left the father, who worked as an air steward, when he met another woman and wanted to move in with her. She had moved in with the husband's parents in the north of the country. The grandparents had cared for the children while their mother worked as a secretary. Apparently, in the last years of his life, the father also returned to his parental home and to his first wife.

19 The two unwanted pregnancies led Gizelha Santos to have herself sterilized shortly after the birth of her daughter, overcoming her doctors' resistance to carrying

out the procedure on such a young woman.

20 The husband, Sergio, works as a warehouse worker, a musician and a master of ceremonies, and carries out administrative work. He had no higher-secondary education.

21 Parreñas (2005) shows in interviews with stay-behind children in the Philippines that rituals are developing in the telecommunication between mothers and children which interactively give expression to this legitimization pressure: the mother's tears are interpreted by the children as an expression of love and sacrifice on their behalf.

22 A Catholic charity.

23 On this last passage about 'de-ranged homes', see Section 4.2.

24 Dieter Brühl is quoting the Brazilian family sociologist Maria Isaura Queiroz here.

25 Since the children of transnational mothers could not be interviewed for this project, it is impossible to comment on the question of any shift or redistribution of power between the generations. For further reading on a new project, see Lutz and Palenga-Möllenbeck (2011).

26 Furthermore, earning money of one's own by no means implies having control over how it is spent. For example, in Anita Karnofsky's documentation of the living situation of irregular migrant domestic employees in Argentina, she describes how the father of a Paraguayan domestic employee travels from Paraguay to Argentina at regular intervals to collect the money earned by his daughters from their employers (Karnofsky 2005).

7 Being illegal

1 The interview with Gizelha Santos was conducted through an interpreter. At the passage in italics, Santos overrode this technique and switched into German.

2 The United Nations Global Commission on International Migration (see www.gcim.org) emphasizes that the Council of Europe, the International Organization for Migration (IOM), the Organization for Security and Co-operation in Europe (OSCE) and the Office of the United Nations High Commissioner for Refugees (UNHCR) speak exclusively in terms of 'irregularity'. In contrast, the term 'illegals' continues to feature in the language usage of the European Union and the Federal Republic of Germany.

3 Apart from 'irregular' and 'undocumented' migration, other terms in international use are 'unauthorized', 'uncontrolled' or 'clandestine' (see Stobbe 2004: 8).

4 This provision has also been incorporated into the German Immigration Act of 1 January 2005 under Sections 95ff.

5 Dual nationality can be considered an intermediate category, for example (see Faist 2004).

6 Franck Düvell (2005: 49) points out that since the Schengen Agreement, and particularly since the Amsterdam Treaty of 1999, freedom of movement within the European Union has been combined with tighter controls on the exterior and of foreigners in the interior. This has the consequence of shifting the external borders inwards, since not only do checks take place at airports and train stations but international trains and motorways within 30 kilometres of national frontiers are also kept under surveillance.

7 Two German regulations serve as the juridical basis for the issue of a 'work permit' (sic!) for an au pair:

the Ordinance on Exceptions to the Recruitment Ban (*Anwerbestoppausnahmegenehmigung*, ASAV section 2, para. 2 no. 4) as amended in 1997, and the Ordinance on the Admission of Foreigners for the Purpose of Taking up Employment (*Beschäftigungsverordnung*, BeschV), which provides that 'A residency permit can be issued to persons with basic knowledge of the German language who are up to twenty-five years of age and are employed as an au pair for up to one year in a family in which German is spoken as the native language' (Section 20, BeschV 2004, www.gesetze-im-internet.de/beschv/BJNR293710004.html).

8 See the Ordinance on the Admission of Foreigners for the Purpose of Taking up Employment (BeschV), *Federal Law Gazette*, 1(62), section 21, p. 2940. This paragraph is a revised and adapted version of section 4 para. 9a of the Ordinance on Exceptions to the Recruitment Ban (ASAV).

9 Payment is dependent on the definition of the field of activity of housekeeping and basic care in Book XI of the German Social Code (*Sozialgesetzbuch*, SGB XI, section 14 para. 4). The national care workers' professional associations do not welcome these regulations because they fear competition at low-wage levels and overlaps between the fields of activity, which do occur in reality.

10 See Finanzkontrolle Schwarzarbeit 2006; Customs online: www.zoll.de/english_version/fo_aentg/ao_info_ag/eo_pruefungen/index.html.

11 A procedure whereby applicants must show that they have been employed for a particular period of time and have therefore 'earned' legalization.

12 So far, numerous initiatives to enforce the ratification have been to no avail. Schools policy in Germany is devolved to the regional states (*Länder*), and while the *Länder* have a certain latitude for action, the tension between federal German law and *Länder* legislation will continue to cause confusion in schools policy.

13 Threats of prosecution are not merely hypothetical, as is shown by the case of the Bonn Public Prosecutor's Office: in spring 2005 it compelled the city's Youth Welfare Department to carry out checks on city-run and church-run daycare centres on the grounds that city employees had aided and abetted breaches of residency law (*Bonner Generalanzeiger*, 12 May 2005, 15 May 2005).

14 'Ethnic network' or 'community', as used here, refers not just to the particular ethnic or national group of the persons concerned, but to migrants from Spanish-speaking countries in general.

15 On this, see Angeles Escrivá (2004) and Escrivá and Skinner (2008).

16 The term 'trajectories of suffering' (*Verlaufskurven des Erleidens*) described by Fritz Schütze (1996) denotes the loss of an intentional action schema, which can be caused by critical life-events (illnesses, deaths, divorces, drug and alcohol addiction, etc.), and which leads the biographee to a severe identity crisis. It is equivalent to the idea, in everyday speech, of a person going into a downward spiral, their life going off the rails.

17 This family also helps her out with legal matters; see the short passage in Chapter 4.

18 The experience of a migration-related crisis generates a biographical crisis, as the dynamic

might be described in line with the analysis of Roswitha Breckner (2003).

8 Migrant women in the globalization trap?

1 Similar assessments are found in Becker-Schmidt (1992: 221), Anderson (2000), Anderson and Phizacklea (1997), Andall (2003), Ehrenreich and Hochschild (2002) and Parreñas (2001b), to name but a few.

2 For instance: Respect-Initiative Berlin (2000); PICUM (2005); Human Rights Watch (2006).

3 On this, see the critique delivered in Barbara Thiessen (2004).

4 Here, too, employers very much expect the caregiver to ensure continuity.

5 The level of education and training attained by the domestic workers is usually even better than that of the (skilled) workers recruited from abroad.

6 This evaluation is taken not only from a section of the literature but also from some of the employers we interviewed; see Chapter 4, Section 4.6.

7 See Chapter 7, Sections 7.1 and 7.2.

8 An excellent review of the literature is given in Moors (2003).

9 Or, in rare cases, with another man; see Chapter 4.

10 See examples of this in Chapter 4.

11 See Moors (2003: 392).

12 There is a suspicion that the opinion leaders in this debate have a personal interest in allowing this to be a non-issue.

13 On the concept of regimes, see Chapter 2.

14 On this, see also Lutz (2007b).

15 See *Die Zeit*, 35, 24 August 2006, pp. 49ff.

16 See the papers by Fiona Williams (Williams and Gavanas 2008; Williams 2010).

17 On the issue of care replacement in Poland and Ukraine as sending countries, see Lutz and Palenga-Möllenbeck 2012.

Bibliography

Alt, J. (2003) *Leben in der Schattenwelt. Problemkomplex 'illegale' Migration. Neue Erkenntnisse zur Lebenssituation 'illegaler' Migranten aus München und anderen Orten Deutschlands* [Life in the world of shadows. The problem-complex of 'illegal' migration. New findings on the life situation of 'illegal' migrants from Munich and other locations in Germany], Karlsruhe: von Loeper Literaturverlag.

— (2005) 'Life in the world of shadows: the problematic of illegal migration', *Global Migrant Perspectives*, 41, September, Geneva: GCIM, pp. 1–19.

Alt, J. and R. Fodor (2001) *Rechtlos? Menschen ohne Papiere. Anregungen für eine Positionsbestimmung* [Rightless? Paperless people. Proposals for determining a position], Karlsruhe: von Loeper Literaturverlag.

Andall, J. (2000) *Gender, Migration and Domestic Service. The Politics of Black Women in Italy*, Aldershot: Ashgate.

— (2003) 'Hierarchy and interdependence: the emergence of a service caste in Europe', in J. Andall (ed.), *Gender and Ethnicity in Contemporary Europe*, Oxford: Berg, pp. 39–60.

Anderson, B. (2000) *Doing the Dirty Work? The global politics of domestic labour*, London: Zed Books.

— (2006) *Doing the Dirty Work? Migrantinnen und die Globalisierung der Hausarbeit*, Berlin: Assoziation A.

Anderson, B. and A. Phizacklea (1997) *Migrant Domestic Workers. A European Perspective*, Report for the Equal Opportunities Unit, DGV, Commission of the European Communities, 1997, Brussels, May.

Anderson, P. (2003) *'Dass Sie uns nicht vergessen ...' Menschen in der Illegalität in München. Eine empirische Studie im Auftrag der Landeshauptstadt München* ['Don't you forget about us ...' People in illegality in Munich. An empirical study commissioned by the Bavarian regional capital Munich], Munich: Sozialreferat, Stelle für Interkulturelle Zusammenarbeit.

Anttonen, A. and J. Sipilä (1996) 'European social care services: is it possible to identify models?', *Journal of European Social Policy*, 6(2): 87–100.

Arendt, H. (1998 [1958]) *The Human Condition*, Chicago, IL: University of Chicago Press.

Beck, U. (2000a) 'Wohin führt der Weg, der mit dem Ende der Vollbeschäftigung beginnt?' [Where does the road lead that begins where full employment ends?], in U. Beck (ed.), *Die Zukunft von Arbeit und Demokratie*, Frankfurt: Suhrkamp, pp. 7–66.

— (2000b) *The Brave New World of Work*, Cambridge: Cambridge University Press.

Becker-Schmidt, R. (1987) 'Die doppelte Vergesellschaftung – die doppelte Unterdrückung' [Double socialization – double oppression], in L. Unterkirchner and I. Wagner (eds), *Die andere Hälfte der Gesellschaft*, Vienna: Österreichischer Soziologentag 1985, pp. 10–27.

— (1992) 'Geschlechterverhältnisse und Zusammenhänge' [Gender relations and correlations], in C. Kuhlke, H. Kopp Degetoff and U. Ramming (eds), *Wider das schlichte Vergessen*, Berlin: Orlanda, pp. 216–36.

Bernstein, B. (1975) *Sprachliche Kodes und soziale Kontrolle*, Düsseldorf: Pädagogischer Verlag.

— (2003) *Class, Codes and Control*, New York: Routledge.

BeschV (*Beschäftigungsverordnung*, Ordinance on the Admission of Foreigners for the Purpose of Taking up Employment) (n.d.), www.gesetze-im-internet.de/beschv/BJNR293710004.html, accessed 18 February 2011.

Blumer, H. (1986) *Symbolic Interactionism. Perspective and Method*, Los Angeles: University of California Press.

Bock, G. and B. Duden (1977) 'Arbeit aus Liebe – Liebe als Arbeit. Zur Entstehung der Hausarbeit im Kapitalismus', in Gruppe Berliner Dozentinnen (eds), *Frauen und Wissenschaft. Beiträge zur Berliner Sommeruniversität für Frauen*, Berlin: Courage, pp. 118–99.

— (1984) 'Labor of love – love as labor. On the genesis of housework in the West', *Development*, 4: 6.

Bourdieu, P. (1982) *Ce que parler veut dire: l'économie des échanges linguistiques*, Paris: Fayard.

— (1992) *Language and Symbolic Power*, Cambridge: Polity Press.

— (1998) *La domination masculine*, Paris: Seuil.

— (2001) *Masculine Domination*, trans. R. Nice, Cambridge: Polity Press.

Brah, A. (1996) *Cartographies of Diaspora: Contesting identities*, London: Routledge.

Breckner, R. (2003) 'Migration – ein biographisches Risiko?' [Migration – a biographical risk?], in J. Allmendinger (ed.), *Entstaatlichung und soziale Sicherheit*, Opladen: Leske + Budrich, pp. 236–53.

— (2005) *Migrationserfahrung, Fremdheit, Biografie: zum Umgang mit polarisierten Welten in Ost-West-Europa* [Migration experience, otherness, biography: on dealing with polarized worlds in East-West Europe], Wiesbaden: VS-Verlag.

Breckner, R., D. Kalekin-Fishman and I. Miethe (eds) (2000) *Biographies and the Division of Europe: Experience, action, and change on the 'Eastern side'*, Opladen: Leske + Budrich.

Brennan, D. (2004) *What's Love Got to Do with It? Transnational Desires and Sex Tourism in the Dominican Republic*, Durham, NC: Duke University Press.

Brühl, D. (1996) 'Familie ohne Ehe – Ehe ohne Familie? Zur Familienentwicklung in Brasilien' [Family without marriage – marriage without family? On family development in Brazil], in F. W. Busch and R. Nave-Herz (eds), *Ehe und Familie in Krisensituationen*, Oldenburg: Isensee, pp. 213–36.

Bryceson, D. and U. Vuorela (eds) (2002) *The Transnational Family. New European Frontiers and Global Networks*, Oxford: Berg.

Bukow, W.-D. and S. Spindler (2006) 'Die biographische Ordnung der Lebensgeschichte – eine einführende Diskussion [The biographical ordering of the life story. An introductory discussion], in W.-D. Bukow, M. Ottersbach, E. Tuider and E. Yilidz (eds), *Biographische Konstruktionen in multikulturellen Bildungsprozessen*, Wiesbaden: VS-Verlag, pp. 19–36.

Bundesministerium der Finanzen (n.d.) Customs online website of the German Federal Ministry of Finance, English version. Inspections pursuant to section 5 of the *Arbeitnehmer-Entsendegesetz* (Posted Workers Act), www.zoll.de/english_version/fo_aentg/ao_info_ag/eo_pruefungen/index.html, accessed 18 February 2011.

Bundesverband der Unfallkassen (1998) *Gesetzlicher Unfallversicherungsschutz für Haushaltshilfen* [Statutory accident insurance cover for domestic helps], Munich.

Bundesministerium für Familie, Senioren, Frauen und Jugend (ed.) (1994) *Fünfter Familienbericht: Familien und Familienpolitik im geeinten Deutschland – Zukunft des Humanvermögens* [Fifth report on family affairs by the German Federal Ministry of Family Affairs, Senior Citizens, Women and Youth: families and family policy in the unified Germany – future of human resources], Bonn: Bundestag-Drucksache.

— (ed.) (2006) *Siebter Familienbericht: Familie zwischen Flexibilität und Verlässlichkeit. Perspektiven für eine lebenslaufbezogene Familienpolitik* [Seventh report on family affairs: families caught between flexibility and reliability.

Prospects of a career-related family policy], Berlin.

Burawoy, M., J. A. Blum, G. Sheba, Z. Gille, T. Gowan, L. Haney, M. Klawiter, S. H. Lopez, S. Ó Riain and M. Thayer (2000) *Global Ethnography. Forces, Connections and Imaginations in a Postmodern World*, Berkeley: University of California Press.

Castles, S. and M. J. Miller (2009 [1993]) *The Age of Migration. International Population Movements in the Modern World*, Basingstoke: Macmillan.

Chamberlain, M. (1997) *Narratives of Exile and Return*, London: Macmillan.

Ciszewski, J. (2005) 'Emanzipation vs. Tradition – Magdalena Środas Kreuz mit der Kirche' [Emancipation vs. tradition – Magdalena Środa's gripe with the Church], *Deutsch-Polnische Gesellschaft der Bundesrepublik Deutschland e.V.* [Online magazine of the national German-Polish society of the Federal Republic of Germany], 2, www.polen-news.de/puw/puw73-02.html, accessed 7 September 2006.

Ciudad (2003) *Nada Volverá a Ser Como Antes: Composición Sociodemográfica de la migración ecuatoriana 1997–2003. Informe de Investigación* [Nothing will again be as it was before. Socio-demographic composition of the Ecuadorean migration 1997–2003. Investigative report], Quito.

Cock, J. (1984) *Maids and Madams. A Study in the Politics of Exploitation*, Johannesburg: Ravan Press.

Cox, R. (2007) 'The au pair body – sex object, sister or student?', *European Journal of Women's Studies*, 14(3): 281–96.

Crenshaw, K. (1989) 'Demarginal-

izing the intersection of race and sex: a black feminist critique of antidiscrimination doctrine, feminist theory and antiracist politics', *University of Chicago Legal Forum*, pp. 138–67.

Cyrus, N. (2001) 'Wie vor hundert Jahren? Zirkuläre Arbeitsmigration aus Polen in die Bundesrepublik Deutschland' [Like one hundred years ago? Circular labour migration from Poland to Germany], in C. Pallaske (ed.), *Die Migration von Polen nach Deutschland. Zu Geschichte und Gegenwart eines europäischen Migrationssystems*. Baden-Baden: Nomos Verlagsgesellschaft, pp. 185–203.

— (2003) '... als alleinstehende Mutter habe ich viel geschafft.' Lebensführung und Selbstverortung einer illegalen polnischen Arbeitsmigrantin ['... as a single mother I've achieved a lot.' Lifestyle and self-contextualization of a work-motivated Polish illegal migrant], in K. Roth (ed.), *Vom Wandergesellen zum Greencard-Spezialisten. Interkulturelle Aspekte der Arbeitsmigration im östlichen Mitteleuropa*, Münchner Beiträge zur Interkulturellen Kommunikation 14, Münster: Waxmann Verlag, pp. 227–63.

— (2004) *Aufenthaltsrechtliche Illegalität in Deutschland. Bericht für den Sachverständigenrat für Zuwanderung und Integration, Nürnberg* [Residency-law illegality in Germany. Report for the German government's Council of Experts on Immigration and Integration, Nuremberg], Berlin.

— (2006) *Menschenhandel und Ausbeutung in Deutschland. Studie für das ILO-Sonderprogramm zur Bekämpfung der Zwangsarbeit* [Human trafficking and exploitation in Germany. Study for the ILO Special Action Programme to Combat Forced Labour].

— (2008) 'Being illegal in Europe. Strategies and policies for a fairer treatment of migrant domestic workers', in H. Lutz (ed.), *Migration and Domestic Work: A European Perspective on a Global Theme*, Aldershot: Ashgate, pp. 295–328.

Cyrus, N. and D. Vogel (2000) 'Immigration as a side effect of other policies – principles and consequences of the German non-immigration policy', in A. Triandafyllidou (ed.), *Migration Pathways. A historic, demographic and policy review of four European countries*, Report prepared for the project 'Does implementation matter? Informal administration practices and shifting immigrant strategies in four member states' (IAPASIS), pp. 9–37, www.iue.it/RSCAS/Research/IAPASIS/IAPASISfinal.pdf, accessed 18 August 2006.

Dalla Costa, M. and S. James (1972) *The Power of Women and the Subversion of the Community*, London: Falling Wall Press, libcom.org/library/power-women-subversion-community-della-costa-selma-james, accessed 4 March 2011.

Deutscher Bundestag (2005) 'Bericht der Bundesregierung über die Situation und Entwicklung der Au-Pair-Vermittlung' [Report of the German federal government on the situation and development of au pair recruitment], *Drucksache*, 15/4791.

Die Zeit (2004) 'Deutschlands neue Dienstmädchen' [Germany's new maidservants], 19 August, pp. 17–19.

— (2006) 'Wir brauchen einen neuen Feminismus' [We need a new feminism], 24 August, pp. 49–54.

Douglas, M. (1988) *Reinheit und Gefährdung. Eine Studie zu Vorstellungen von Verunreinigung und Tabu*, Frankfurt: Suhrkamp.

— (2002 [1966]) *Purity and Danger: An analysis of concepts of pollution and taboo*, London: Routledge.

DSW (Deutsche Stiftung Weltbevölkerung) (2006) *Weltbevölkerungsbericht 2006. Der Weg der Hoffnung: Frauen und internationale Migration* [World Population Annual Report 2006. The way of hope: women and international migration], DSW press release, 6 September.

Düvell, F. (2005) 'Illegale Migration: Soziales Konstrukt der Neuzeit, Charakteristikum von Ungerechtigkeit und Ausdruck politischen Versagens' [Illegal migration: social construct of the modern age, characteristic of injustice and expression of political failure], in K. Jünschke and B. Paul (eds), *Wer bestimmt denn unser Leben? Beiträge zur Entkriminalisierung von Menschen ohne Aufenthaltsstatus*, Karlsruhe: von Loeper Literaturverlag, pp. 41–56.

— (2006) *Illegal Immigration in Europe Beyond Control?*, London: Palgrave Macmillan.

Ehrenreich, B. and A. R. Hochschild (eds) (2002) *Global Woman. Nannies, Maids, and Sex Workers in the New Economy*, New York: Metropolitan Books.

Elias, N. (1991) *The Society of Individuals*, Oxford: Blackwell.

EMMA (2006) '... und immer das schlechte Gewissen' [... and always that guilty conscience], Interview by Alice Schwarzer with German Minister of Family Affairs Ursula von der Leyen, March/April, www.emma.de/06_2_interview_vonderleyen.html, accessed 7 September 2006.

Endress, M. (2002) *Vertrauen* [Trust], Bielefeld: Transcript-Verlag.

— (2004) 'Foundations of trust. Introductory remarks on the sociology of trust', in H. Schrader (ed.), *Trust and Social Transformation. Theoretical approaches and empirical findings from Russia*, Münster: LIT, pp. 15–30.

Engbersen, G. (2001) 'The unanticipated consequences of panopticum Europe: residence strategies of illegal immigrants', in V. Guiraudon et al. (eds), *Controlling a New Migration World*, London: Routledge, pp. 222–46.

Erel, U. (2002) 'Reconceptualizing motherhood: experiences of migrant women from Turkey living in Germany', in D. Bryceson and U. Vuorela (eds), *The Transnational Family. New European Frontiers and Global Networks*, Oxford: Berg, pp. 127–46.

Escrivá, A. (2004) *Securing Care and Welfare of Dependants Transnationally: Peruvians and Spaniards in Spain*, Working Paper WP404, Oxford: Oxford Institute of Ageing.

Escrivá, A. and E. Skinner (2008) 'Domestic work and transnational care chains in Spain', in H. Lutz (ed.), *Migration and Domestic Work: A European Perspective on a Global Theme*, Aldershot: Ashgate, pp. 189–214.

Esping-Andersen, G. (1990) *The Three Worlds of Welfare Capitalism*, Cambridge: Polity Press.

— (1996) (ed.) *Welfare States in*

Transition, National Adoptions in Global Economies, London: Sage.

European Foundation for the Improvement of Living and Working Conditions (2006) *Working Time and Work–Life Balance in European Companies*, Establishment Survey on Working Time 2004–2005.

Faist, T. (2000) 'Grenzen überschreiten. Das Konzept transstaatlicher Räume und seine Anwendung' [Crossing borders. The concept of transnational spaces and its application], in T. Faist (ed.), *Transstaatliche Räume. Politik, Wirtschaft und Kultur in und zwischen Deutschland und der Türkei*. Bielefeld: Transscript Verlag, pp. 9–56.

— (2004) 'Border-crossing expansion of social space: concepts, questions and topics', in T. Faist and E. Özveren (eds), *Transnational Social Spaces: Agents, networks, and institutions*, Aldershot: Ashgate.

Finanzkontrolle Schwarzarbeit (Finance Control/Illicit Work) (n.d.), www.zoll.de/do_zoll_im_einsatz/bo_finanzkontrolle/io_aufgaben/index.html.

Firlit-Fesnak, G. (2002) *Polnische Frauen in der Transformation – Chancen und Barrieren 1992–2002* [Polish women in transformation – opportunities and barriers 1992–2002], Lecture, Deutsch-Polnische Fraueninitiative (German-Polish women's initiative) Berlin-Warschau, 24 November, www.frauenini-berlin-warschau.de/webseitendeutsch/ueberpolen/fraueninpolen.htm, accessed 18 August 2006.

Fischer-Rosenthal, W. (1995) 'The problem with identity: biography as solution to some (post) modernist dilemmas', *COMENIUS*, 15, pp. 250–65.

Fodor, R. (2001) 'Rechtsgutachten zum Problemkomplex des Aufenthalts von ausländischen Staatsangehörigen ohne Aufenthaltsrecht und ohne Duldung in Deutschland' [Legal opinion on the complex of problems concerning the residency of foreign nationals without residence rights and without short-term residence permits in Germany], in J. Alt and R. Fodor (eds), *Rechtlos? Menschen ohne Papiere*, Karlsruhe: von Loeper Literaturverlag, pp. 125–223.

— (2006) *The Legalisation of Undocumented Migrants: Ideal Solution, Wrong Track or Pragmatic Way?*, European Expert Panel, Freiburg, February.

Fodor, R. and E. Peter (2005) *Das Recht des statuslosen Kindes auf Bildung? Rechtsgutachten* [The right of the statusless child to education? Legal opinion], www.joerg-alt.de/Recht/Bundeslaender/Hessen/Hessen_Gutachten.pdf/search/das-recht-des-statuslosen-kindes-auf-bildung, accessed 7 September 2006.

Fog Olwig, K. (1999) 'Narratives of the children left behind: home and identity in globalised Caribbean families', *Journal of Ethnic and Migration Studies*, 25(2): 267–84.

— (2002) 'A respectable livelihood. Mobility and identity in a Caribbean family', in N. N. Sørensen and K. Fog Olwig (eds), *Work and Migration. Life and Livelihood in a Globalizing World*, London: Taylor and Francis, pp. 85–105.

Frankfurter Rundschau (2001a) 'In Hessen gibt es 35 000 "schwarze Perlen"' [In Hesse there are

35,000 'black pearls'], Bettina Behler, 6 June.

— (2001b) 'Etwa 270 000 Menschen brauchen zu Hause Hilfe' [Around 270,000 people need help in the home], Volker Trunk, 26 October.

Fraser, N. (1990) *Unruly Practices: Power, Discourse and Gender in Contemporary Social Theory*, Cambridge: Polity.

— (1994) *Widerspenstige Praktiken. Macht, Diskurs, Geschlecht*, Frankfurt: Suhrkamp.

— (2003) 'On the cultural turn in social theory: against the reduction of capitalist society to its recognition order', in N. Fraser and A. Honneth, *Redistribution or Recognition?: A political-philosophical exchange*, London: Verso.

Friese, M. (1996) 'Frauenarbeit und soziale Reproduktion. Eine Strukturanalyse zur Herausbildung weiblichen Proletariats im Übergangsprozeß zur bürgerlich-kapitalistischen Gesellschaft – dargestellt an der Region Bremen' [Women's work and social reproduction. A structural analysis on the formation of female proletariats in the transition process to the bourgeois-capitalist society – with reference to the Bremen region], *Forschungsreihe des Forschungsschwerpunkts 'Arbeit und Bildung'*, vol. 20, Bremen: University of Bremen.

Galbraith, J. K. (1973) *Economics and the Public Purpose*, Boston, MA: Houghton Mifflin.

Gamburd, M. (2000) *The Kitchen Spoon's Handle. Transnationalism and Sri Lanka's Housemaids*, Ithaca, NY: Cornell University Press.

Garfinkel, H. (1967) *Studies in Ethnomethodology*, Cambridge: Polity Press.

Gather, C. and H. Meissner (2002) 'Informelle Erwerbsarbeit in privaten Haushalten. Ein blinder Fleck in der Arbeitssoziologie?' [Informal gainful employment in private households. A blind spot in the sociology of work?], in C. Gather et al. (eds), *Weltmarkt Privathaushalt. Bezahlte Haushaltsarbeit im globalen Wandel*, Münster: Westfälisches Dampfboot, pp. 120–39.

Gather, C., B. Geissler and M. S. Rerrich (eds) (2002) *Weltmarkt Privathaushalt. Bezahlte Hausarbeit im globalen Wandel* [Private household as global market. Globalization and paid housework], Münster: Westfälisches Dampfboot.

Gavanas, A. (2010) *Who Cleans the Welfare State? Migration, Informalization, Social Exclusion and Domestic Services in Stockholm*, Research Report 2010/03, Stockholm Institute for Future Studies.

Gerhard, U., T. Knijn and A. Weckwert (2005) *Working Mothers in Europe: A Comparison of Policies and Practices*, Cheltenham: Edward Elgar.

Giddens, A. (1990) *The Consequences of Modernity*, Stanford, CA: Stanford University Press.

Giesecke, A., U. Heilemann and H. D. von Loeffelholz (1995) 'The economic implications of immigration into the Federal Republic of Germany', *International Migration Review*, 29: 693–709.

Goffman, E. (1977) 'The arrangement between the sexes', *Theory and Society*, 4(3): 301–32.

Gransow, B. (2003) 'Gender and

migration in China: feminisation trends', in M. Morokvašic-Müller, U. Erel and K. Shinozaki (eds), *Gender on the Move*, Opladen: Leske + Budrich, pp. 137–54.

Gregory, A. and S. Milner (2009) 'Editorial: work–life balance: a matter of choice?', *Gender Work and Organization*, 16(1): 1–13.

Grunow, D. (2007) 'Wandel der Geschlechterrollen und Väterhandeln im Alltag', in T. Mühling and H. Rost (eds), *Väter im Blickpunkt. Perspektiven der Familienforschung* [Spotlight on the fathers. Perspectives on family research], Opladen: Barbara Budrich, pp. 46–76.

Guiraudon, V. (2002) 'Controlling the EU border by proxy? The delegation of migration control in practice', Unpublished paper presented at the 13th International Conference of Europeanists, 14–16 March, Chicago.

Hall, S. (1992) 'New ethnicities', in J. Donald and A. Rattansi (eds), *'Race', Culture and Difference*, London: Sage, pp. 252–60.

Haller, M. et al. (1996) 'Kinder und getrennte Eltern. Voraussetzungen und Strategien zur Bewältigung der Ehescheidung im Lichte neuer sozialwissenschaftlicher Studien' [Children and separated parents. Preconditions and strategies for coping with divorce in the light of new studies in the social sciences], *Schriftenreihe des ÖIF*, 3, Vienna.

Hartz, P. et al. (2002) *Moderne Dienstleistungen am Arbeitsmarkt. Vorschläge der Kommission zum Abbau der Arbeitslosigkeit und zur Umstrukturierung der Bundesanstalt für Arbeit (Hartz-Kommission)* [Modern services in the labour market. Proposals of the Hartz Commission to reduce unemployment and restructure the Federal Employment Agency], Berlin: BMA.

Harzig, C. (ed.) (1997) *Peasant Maids – City Women: From the European Countryside to Urban America*, Ithaca, NY: Cornell University Press.

— (2003) 'Immigration policies: a gendered historical comparison', in M. Morokvašic-Müller et al. (eds), *Crossing Borders and Shifting Boundaries. Gender on the Move*, Opladen: Leske + Budrich, pp. 35–58.

Hays, S. (1996) *The Cultural Contradictions of Motherhood*, New Haven, CT: Yale University Press.

Henkes, B. (1993) 'German maids in prosperous "Guldenland"(Guilderland) and the land of moral threat: nation images and national identity during the interbellum period', in A. Galema, B. Henkes and H. te Velde (eds), *Images of the Nation – Different Meanings of Dutchness 1870–1940*, Amsterdam: Rodopi, pp. 133–57.

— (1995) *Heimat in Holland. Duitse Dienstmeisjes 1920–1950* [Homeland in Holland. German maids 1920–1950], Amsterdam: Babylon–De Geus.

Henkes, B. and H. Oosterhof (1985) *Kaatje, ben je boven? Leven en werken van de Nederlandse dienstbodes 1900–1940* [Kaatje, are you upstairs? Life and work of Dutch maids 1900–1940], Nijmegen: SUN.

Hess, S. (2002) 'Au Pairs als informelle Haushaltsarbeiterinnen – Flexibilisierung und Ethnisierung der Versorgungsarbeiten' [Au pairs as informal domestic workers – flexibilization and

ethnicization of care work], in
C. Gather et al. (eds), *Weltmarkt
Privathaushalt. Bezahlte Hausar-
beit im globalen Wandel*. Münster:
Westfälisches Dampfboot,
pp. 103–19.

Hess, S. and R. Lenz (2001)
*Geschlecht und Globalisierung. Ein
kulturwissenschaftlicher Streifzug
durch transnationale Räume*
[Gender and globalization. A
cultural studies foray through
transnational spaces], Königstein
im Taunus: Helmer.

Hess, S. and A. Puckhaber (2004)
'"Big sisters" are better domestic
servants?! Comments on the
booming au pair business',
Feminist Review, 77(1): 65–78.

— (2005) *Globalisierte Hausarbeit:
Au Pair als Migrationsstrategie von
Frauen aus Osteuropa* [Globalized
housework: au pair work
as a migration strategy for
women from eastern Europe],
Wiesbaden: Verlag für Sozialwis-
senschaften.

— (2006) 'Transmigration of eastern
European women as transforma-
tion strategy', *Acta Ethnographica
Hungarica*, 51(1/2): 31–42.

Hirsch, H. (1992) 'Frauen' [Women],
in E. Kobylińska, A. Lawaty
and R. Stephan (eds) *Deutsche
und Polen. 100 Schlüsselbegriffe*,
Munich/Zurich: Pieper,
pp. 256–61.

Hochschild, A. R. (1995) 'The culture
of politics. Traditional, post
modern, cold modern and warm
modern ideals of care', *Social
Politics*, 2(3): 331–46.

— (1997) *The Time Bind: When Work
Becomes Home and Home Becomes
Work*, New York: Metropolitan.

— (2000) 'Global care chains and
emotional surplus value', in
A. Giddens and W. Hutton (eds),
*On the Edge. Living with Global
Capitalism*, London: Jonathan
Cape, pp. 130–46.

— (2002) *Keine Zeit. Wenn die Firma
zum Zuhause wird und zu Hause
nur Arbeit wartet* [The time bind:
when work becomes home and
home becomes work], Opladen:
Leske + Budrich.

— (2003) *The Commercialization of
Intimate Life: Notes from Home
and Work*, Berkeley: University of
California Press.

Holstein, J. and J. Gumbrium
(1995) 'Deprivatization and the
construction of domestic life',
*Journal of Marriage and the Fam-
ily*, 57(4): 894–908.

Hondagneu-Sotelo, P. (2001) *Domés-
tica. Immigrant workers cleaning in
the shadows of affluence*, London:
University of California Press.

— (2003) 'Blowups and other un-
happy endings', in B. Ehrenreich
and A. R. Hochschild (eds),
*Global Woman: Nannies, Maids,
and Sex Workers in the New
Economy*, New York: Metropolitan
Books, pp. 55–69.

Hondagneu-Sotelo, P. and E. Avila
(1997) '"I'm here, but I'm there":
the meanings of Latina trans-
national motherhood', *Gender
and Society*, 11(5): 548–71.

Human Rights Watch (2006) 'Swept
under the rug. Abuses against
domestic workers around the
world', 18(7), July.

Illies, F. (2001) *Generation Golf. Eine
Inspektion* [Generation Golf. An
inspection], 2nd edn, Frankfurt:
Fischer.

IOM (International Organization for
Migration) (2005) *World Migra-
tion Report 2005*, Geneva: IOM
Publications.

Irek, M. (1998) *Der Schmugglerzug:
Warschau – Berlin – Warschau;*

Materialien einer Feldforschung [The smuggler train: Warsaw – Berlin – Warsaw; materials from a field study], Berlin: Das Arabische Buch.

Isaksen, A. E. W., U. D. Sambasivan and A. R. Hochschild (2008) 'Global care crisis. A problem of capital, care chain, or commons?', *American Behavioral Scientist*, 52(3): 405–25.

Jaehrling, K. (2004) 'Die politische Regulierung des Arbeitsmarktes Privathaushalt. Marktregulative Politik im französisch-deutschen Vergleich' [Political regulation of the private domestic labour market. French–German comparison of market-regulatory policy], *ZSR*, 50(6): 617–45.

Jahn, A. and T. Straubhaar (1998) 'A survey of the economics of illegal migration', *South European Society and Politics*, 3(3): 16–42.

Jordan, B. and F. Düvell (2002) *Irregular Migration. The Dilemmas of Transnational Mobility*, Cheltenham/Northampton: Edward Elgar.

Jurczyk, K., M. Schier, P. Szymenderski, A. Lange and G. Voss (2009) 'Entgrenzte Arbeit – Entgrenzte Familie. Grenzmanagement im Alltag als neue Herausforderung' [Debordered work – debordered family. Boundary management in everyday life as a new challenge], *FamilyReihe: Forschung aus der Hans-Böckler-Stiftung*, vol. 100, Berlin: Sigma.

Kaczmarczyk, P. (2004) 'Znaczenie migracji sezonowych dla migrantów, ich rodzin i społeczności wysyłających' [The importance of seasonal migration for migrants, their families and societies of origin], in P. Kaczmarczyk and W. Łukowski (eds), *Polscy pracownicy na rynku Unii Europejskiej* [Polish workers in the EU market], Warsaw: Scholar, pp. 165–90.

Kalwa, D. (2007) "So wie zu Hause". Die private Sphäre als Arbeitsplatz' ['Just like at home'. The private sphere as a workplace], in M. Nowicka (ed.), *Von Polen nach Deutschland und zurück. Die Arbeitsmigration und ihre Herausforderungen für Europa*, Bielefeld: Transcript Verlag, pp. 205–25.

Karnofsky, A. (2005) *Besenkammer mit Bett. Das Schicksal einer illegalen Haushaltsarbeiter in Lateinamerika* [Broom cupboard with bed. The fate of an illegal domestic worker in Latin America], Bad Honnef: Hornemannverlag.

Karsten, M.-E. (2000) 'Personenbezogene Dienstleistungen für Frauen. Aktuelle Tendenzen und Professionalisierungserfordernisse' [Person-related services for women. Current trends and professionalization requirements], in M. Friese (ed.), *Modernisierung personenorientierter Dienstleistungen. Innovationen für die berufliche Aus- und Fortbildung*, Opladen: Leske + Budrich, pp. 89–109.

Kaufmann, J. C. (1999) *Mit Leib und Seele: Theorie der Haushaltstätigkeit* [With body and soul: theory of domestic activity], Konstanz: Universitätsverlag Konstanz.

Kettschau, I. and B. Methfessel (2003) *Neue Haushalts- und Familienarbeit* [New domestic and care work], Module produced on behalf of the Federation of German Consumer Organizations, Bundesverband der Verbraucherzentralen und Verbraucherverbände (VZBV), for New Home Economics,

online course for multipliers in domestic and family-related adult education, Berlin.

Kindler, M. (2008) 'Risk and risk strategies in migration: Ukrainian domestic workers in Poland', in H. Lutz (ed.), *Migration and Domestic Work: A European Perspective on a Global Theme*, Aldershot: Ashgate, pp. 145–59.

Kofman, E. (1996) 'Feminism, gender relations and geopolitics: problematic closures and opening strategies', in E. Kofman and G. Youngs (eds), *Globalization: Theory and Practice*, London: Pinter, pp. 208–24.

Kommission für Zukunftsfragen der Freistaaten Bayern und Sachsen (Zukunftskommission [Joint Commission on the Future]) (1997) *Erwerbstätigkeit und Arbeitslosigkeit in Deutschland. Entwicklung, Ursachen und Maßnahmen. Teil III: Maßnahmen zur Verbesserung der Beschäftigung* [Employment and unemployment in Germany. Development, causes and measures. Part III: Measures to improve employment], Bonn: Kommission für Zukunftsfragen.

Koser, K. (2005) 'Irregular migration, state security and human security', Paper for the Policy Analysis and Research Programme of the Global Commission on International Migration (GCIM), www.gcim.org/attachements/TP5.pdf, accessed 7 September 2006.

Koser, K. and H. Lutz (1998) 'The new migration in Europe: contexts, constructions and realities', in K. Koser and H. Lutz (eds), *The New Migration in Europe. Social Constructions and Social Realities*, London/Basingstoke: Macmillan, pp. 1–20.

Krüger, H. (2001) 'Gesellschaftsanalyse: Der Institutionenansatz in der Geschlechterforschung' [Societal analysis: the institutional approach in gender research], in G. A. Knapp and A. Wetterer (eds), *Soziale Verortung der Geschlechter. Gesellschaftstheorie und feministische Kritik*, Münster: Westfälisches Dampfboot, pp. 63–90.

— (2003) 'Professionalisierung von Frauenberufen – oder Männer für Frauenberufe interessieren? Das Doppelgesicht des arbeitsmarktrechtlichen Geschlechtersystems' [Professionalization of women's occupations – or interesting men in women's occupations? The two faces of the gender system in labour law], in K. Heinz and B. Thiessen (eds), *Feministische Forschung – Nachhaltige Einsprüche*, Opladen: Leske + Budrich, pp. 123–45.

Kumar, K. (1997) 'Home: the promise and predicament of private life at the end of the twentieth century', in J. Weintraub and K. Kumar (eds), *Public and Private in Thought and Practice. Perspectives on a Grand Dichotomy*. Chicago, IL: Chicago University Press.

Kurz-Scherf, I. (1995) 'Vom guten Leben. Feministische Perspektiven diesseits und jenseits der Arbeitsgesellschaft' [On the good life. Feminist perspectives on and beyond the work society], in W. Belitz (ed.), *Wege aus der Arbeitslosigkeit*. Reinbek: rororo.

Lan, P.-C. (2003) 'Maid or Madam? Filipina migrant workers and the continuity of domestic labor', *Gender and Society*, 17(2): 187–208.

— (2006) *Global Cinderellas. Migrant domestics and newly rich employers in Taiwan*, Durham,

NC, and London: Duke University Press.

Leuther, M. (2000) 'Zwangsarbeit in Privathaushalten und Landwirtschaft. "Fremdarbeiter" von Entschädigung ausgeschlossen' [Forced labour in private households and agriculture. 'Foreign workers' excluded from compensation], *ak – analyse und kritik. Zeitung für linke Debatten und Praxis*, 434: 1–4.

Lewis, D. J. and A. Weigert (1985) 'Trust as a social reality', *Social Forces*, 63(4): 967–85.

Lewis, J. (1992) 'Gender and the development of welfare regimes', *Journal of European Social Policy*, 2(3): 159–73.

— (2004) 'Auf dem Weg zur "Zwei-Erwerbstätigen"-Familie' [On the way to the 'two-earner' family'], in S. Leitner, I. Ostner and M. Schratzenstaller (eds), *Wohlfahrtstaat und Geschlechterverhältnisse im Umbruch. Was kommt nach dem Ernährermodell?*, Wiesbaden: VS, Verlag für Sozialwissenschaften, pp. 62–84.

Lewis, J., M. Daly, H. Land, T. Knijn and I. Ostner (1998) *Gender, Social Care and Welfare State Restructuring in Europe*, Aldershot: Ashgate.

LIS (n.d.) Country information pages on Ecuador, www.inwent. org/v-ez/lis/ecuador/ seite3.htm, accessed 18 August 2006.

Lutz, H. (1994) 'Konstruktion von "Fremdheit". Ein blinder Fleck in der Frauenforschung?' [Construction of 'otherness'. A blind spot in women's research?], in R. Nestvogel (ed.), *Fremdes oder Eigenes? Rassismus, Antisemitismus, Kolonialismus, Rechtsextremismus aus Frauensicht*, Frankfurt: IKO Verlag, pp. 138–52.

— (2000) 'Biographisches Kapital als Ressource der Bewältigung von Migrationsprozessen' [Biographical capital as a resource for managing migration processes], in I. Gogolin and B. Nauck (eds), *Migration, gesellschaftliche Differenzierung und Bildung*, Opladen: Leske + Budrich, pp. 179–210.

— (2001) 'Differenz als Rechenaufgabe? Über die Relevanz der Kategorien Race, Class und Gender' [Difference as an arithmetical problem? On the relevance of the categories of race, class and gender], in H. Lutz and N. Wenning (eds), *Unterschiedlich verschieden. Differenz in der Erziehungswissenschaft*, Opladen: Leske + Budrich, pp. 215–30.

— (2002a) 'Transnationalität im Haushalt' [Transnationalism in the household], in C. Gather et al. (eds), *Weltmarkt Privathaushalt. Bezahlte Hausarbeit im globalen Wandel*, Münster: Westfälisches Dampfboot, pp. 86–102.

— (2002b) 'The long shadows of the past. The new Europe at a crossroad', in I. Lenz et al. (eds), *Crossing Borders and Shifting Boundaries. Gender, Identities and Networks*, Opladen: Leske + Budrich, pp. 57–73.

— (2005) 'Der Privathaushalt als Weltmarkt für weibliche Arbeitskräfte' [The private household as a global market for female workers], *Peripherie*, 25(97/98): 65–87.

— (2007a) *Vom Weltmarkt in den Privathaushalt. Die neuen Dienstmädchen im Zeitalter der Globalisierung* [The new maids in the age of globalization (original German edn of the present work)], Opladen: Barbara Budrich.

— (2007b) 'Editorial', Special issue on domestic work, *European Journal of Women's Studies*, 14(3): 187–92.

— (2008) 'Introduction: coming to terms with domestic work in Europe', in H. Lutz (ed.), *Migration and Domestic Work: A European Perspective on a Global Theme*, Aldershot: Ashgate, pp. 1–19.

— (2010) 'Gender in the migratory process', *Ethnic and Migration Studies*, 36(10): 1647–63.

Lutz, H. and K. Davis (2005) 'Geschlechterforschung und Biographie-forschung: Intersektionalität als biographische Ressource am Beispiel einer außergewöhnlichen Frau' [Gender research and biography research: intersectionality as a biographical resource, exemplified by an extraordinary woman], in Bettina Völter et al. (eds), *Biographieforschung im Diskurs*, Wiesbaden: VS-Verlag, pp. 228–47.

Lutz, H. and E. Palenga-Möllenbeck (2010) 'Care work migration in Germany: semi-compliance and complicity', in M. Kilkey, H. Lutz and E. Palenga-Möllenbeck (eds), 'Domestic and care work at the intersection of welfare, gender and migration regimes: some European experiences', Special issue, *Journal of Social Policy and Society*, 9(3), Cambridge: Cambridge University Press, pp. 419–30.

— (2011) 'Care workers, care drain and care chains: reflections on central perceptions in the debate about care and migration', in E. Umut, 'Transnational care: changing formations of citizenship, family and generation', *Social Politics*, 18(4).

— (2012) 'Care, gender and migration: towards a theory of transnational domestic work migration in Europe', *Journal of Contemporary European Studies*, Special issue: 'Crises and the gendered division of labour in Europe today' (in preparation).

Lutz, H. and S. Schwalgin (2006) 'Globalisierte Biographien: Das Beispiel einer Haushaltsarbeiterin' [Globalized biographies: the example of a female domestic worker], in W.-D. Bukow et al. (eds), *Biographische Konstruktionen im multikulturellen Bildungsprozess*, Wiesbaden: VS-Verlag, pp. 99–113.

Lutz, H., M. T. Herrera Vivar and L. Supik (eds) (2011) *Framing Intersectionality*, Aldershot: Ashgate.

Mannheim, K. (1928) 'Das Problem der Generationen' [The problem of generations], *Kölner Vierteljahreshefte für Soziologie*, VII(2): 157–85, and VII(3): 309–30.

— (1952) 'The problem of generations', in K. Mannheim, *Essays on the Sociology of Knowledge*, New York: Oxford University Press.

Manske, A. (2005) 'Eigenverantwortung statt wohlfahrtstaatlicher Absicherung. Anmerkungen zum Gestaltwandel sozialer Absicherung' [Self-responsibility instead of welfare state safeguards. Remarks on the changing form of social security], *Berliner Journal für Soziologie*, H. 2: 241–58.

Marody, M. and A. Giza-Poleszczuk (2000) 'Być kobieta być mężczyzną', in M. Marody (ed.), *Między rynkiem a etatem. Spoleczne negocjowanie polskiej rzeczywistości* [Being a woman, being a man, or changes in gender identity in present-day Poland], Warsaw: Scholar, pp. 44–74.

Mather, C. (ed.) (2006) *Organising and Protecting Domestic Workers in Europe: The Role of Trade Unions*, Brussels: ETUC.

Mayer-Ahuja, N. (2004) 'Three worlds of cleaning: women's experiences of precarious labor in the public sector, cleaning companies and private households of West Germany, 1973–1998', *Journal of Women's History*, 16(2): 116–41.

Mead, M. (1962) 'A cultural anthropologist's approach to maternal deprivation', in M. D. Ainsworth et al. (eds), *Deprivation of Maternal Care: A Reassessment of its Effects*, Genf: Weltgesundheitsorganisation, pp. 45–62.

Mead, M. and M. Wolfenstein (1955) *Childhood in Contemporary Cultures*, Chicago, IL: University of Chicago Press.

Mendel, A. (1993) *Zwangsarbeit im Kinderzimmer. 'Ostarbeiterinnen' in deutschen Familien von 1939–1945* [Forced labour in the nursery. 'Maids from the East' in German families 1939–1945], Frankfurt: DIPA-Verlag.

Misztal, B. (2001) 'Normality and trust in Goffman's theory of interaction order', *Sociological Theory*, 19(3): 312–24.

Momsen, J. H. (1999) 'Maids on the move', in J. H. Momsen (ed.), *Gender, Migration and Domestic Service*, London: Routledge, pp. 1–20.

Moors, A. (2003) 'Migrant domestic workers: debating transnationalism, identity politics, and family relations. A review essay', *Comparative Studies in Society and History*, pp. 386–94.

Morokvašic, M. (1991) 'Fortress Europe and migrant women', in *Feminist Review*, 39: 69–84.

— (1993) '"In and out" of the labour market: immigrant and minority women in Europe', *New Community*, 19(3): 459–84.

— (1994) 'Pendeln statt Auswandern. Das Beispiel der Polen' [Shuttle migration instead of emigration. The example of the Polish people], in M. Morokvašic and H. Rudolph (eds), *Wanderungsraum Europa. Menschen und Grenzen in Bewegung*, Berlin: Edition Sigma, pp. 166–87.

Morokvašic, M. and A. de Tinguy (1993) 'Between East and West: a new migration space', in H. Rudolph and M. Morokvašic (eds), *Bridging States and Markets*, Berlin: Edition Sigma, pp. 245–63.

Morokvašic-Müller, M. (2003) 'Transnational mobility and gender: a view from post-wall Europe', in M. Morokvašic-Müller et al. (eds), *Crossing Borders and Shifting Boundaries. Gender on the Move*, Opladen: Leske + Budrich, pp. 101–33.

Morokvašic-Müller, M., S. Metz-Göckel and A. Senganata Münst (2008) *Migration and Mobility in an Enlarged Europe. A Gender Perspective*, Opladen: Barbara Budrich.

OECD (1999) *A Caring World. The new social policy agenda*, Paris: OECD.

— (2001a) *Starting Strong. Early Child Education and Care*, Paris: OECD.

— (2001b) 'Employment outlook', in *Balancing Work and Family Life: Helping parents into paid employment*, ch. 4, Paris: OECD.

— (2007) *Babies and Bosses. Reconciling Work and Family Life. A Synthesis of Findings for OECD Countries*, Paris: OECD.

OHCHR (Office of the United Nations High Commissioner for Human Rights) (n.d.) *Declara-*

tions and Reservations to the Convention on the Rights of the Child, Germany, www2.ohchr.org/english/law/crc-reserve.htm, accessed 18 February 2011.

Oishi, N. (2002) 'Gender and migration: an integrative approach', Working Paper no. 49, Center for Comparative Immigration Studies (CCIS), University of California, San Diego.

Okólski, M. (2004) 'New migration movements in central and eastern Europe', in D. Joly (ed.), *International Migration in the New Millennium*, Aldershot: Ashgate, pp. 36–56.

Ozyegin, G. (2001) *Untidy Gender. Domestic service in Turkey*, Philadelphia: Temple University Press.

Pallaske, C. (2000) *Migrationen aus Polen in die Bundesrepublik Deutschland in den 1980er und 1990er Jahren. Migrationsverläufe und Eingliederungsprozesse in sozialgeschichtlicher Perspektive* [Migrations from Poland to the Federal Republic of Germany in the 1980s and 1990s. Migration trajectories and integration processes in social-historical perspective], Münster: Waxmann Verlag.

Parreñas, R. S. (2001a) 'Mothering from a distance. Emotions, gender and intergenerational relations in Filipino transnational families', *Feminist Studies*, 27(2): 361–89.

— (2001b) *Servants of Globalization. Women, Migration and Domestic Work*, Stanford, CA: Stanford University Press.

— (2002) 'The care crisis in the Philippines: children and transnational families in the new global economy', in B. Ehrenreich and A. R. Hochschild (eds), *Global Woman. Nannies, Maids, and Sex Workers in the New Economy*, New York: Metropolitan Books, pp. 39–54.

— (2005) *Children of Global Migration. Transnational Families and Gendered Woes*, Stanford, CA: Stanford University Press.

Pessar, P. (2003) 'Engendering migration studies: the case of new immigrants in the United States', in P. Hondagneu-Sotelo (ed.), *Gender and US Immigration. Contemporary Trends*, Berkeley: University of California Press, pp. 20–42.

Pessar, P. and S. J. Mahler (2003) 'Transnational migration: bringing gender in', *International Migration Review*, 37(3): 812–46.

Pfau-Effinger, B. (2000) 'Conclusion: gender cultures, gender arrangements and social changes in the European context', in S. Duncan and B. Pfau-Effinger (eds), *Gender, Economy and Culture: The European Union*, London: Routledge, pp. 262–79.

Phizacklea, A. (1998) 'Migration and globalisation: a feminist perspective', in K. Koser and H. Lutz (eds), *The New Migration in Europe. Social Constructions and Social Realities*, London/Basingstoke: Macmillan, pp. 21–33.

— (2003) 'Transnationalism, gender and global workers', in M. Morokvašic-Müller et al. (eds), *Crossing Borders and Shifting Boundaries. Gender on the Move*, Opladen: Leske + Budrich, pp. 79–100.

Phoenix, A. and P. Pattynama (eds) (2006) 'Intersectionality', Special issue, *European Journal of Women's Studies*, 13(3), August.

PICUM (Platform for International

Cooperation on Undocumented Migrants) (2005) *Ten Ways to Protect Undocumented Migrant Workers.*

Plan Migración (2002) *Communicación y Desarrollo: Ecuador-Espana: Las remesas de los emigrantes y sus efectos en la economía Ecuadoriana*, National Statistics Ecuador.

Platzer, E. (2006) 'From private solutions to public responsibility and back again: the new domestic services in Sweden', *Gender and History*, 18(2): 211–21.

Plomien, A. (2009) 'Welfare state, gender, and reconciliation of work and family in Poland. Policy developments and practice in a new EU member', *Social Policy and Administration*, 43(2): 136–51.

Pries, L. (2000) '"Transmigranten" als ein Typ von Arbeitswanderern in pluri-lokalen sozialen Räumen' ['Transmigrants' as a type of labour migrants in pluri-local social spaces], in I. Gogolin and B. Nauck (eds), *Migration, gesellschaftliche Differenzierung und Bildung*, Opladen: Leske + Budrich, pp. 415–38.

Rabe-Kleberg, U. (1997) 'Professionalität und Geschlechterverhältnis Oder: Was ist "semi" an traditionellen Frauenberufen?' [Professionalism and gender relations, or: what is 'semi' about traditional women's occupations?], in A. Come and W. Helsper (eds), *Pädagogische Professionalität. Untersuchungen zum Typus pädagogischen Handelns*, Frankfurt: Suhrkamp, pp. 276–302.

Radcliffe, S. A. (1999) 'Race and domestic service: migration and identity in Ecuador', in J. H. Momsen (ed.), *Gender,*

Migration and Domestic Service, London: Routledge, pp. 83–97.

Rajkiewicz, A. (2004) 'Nad danymi NSP 2002 o migracjach zagranicznych ludności', *Polityka Społeczna*, 3: 8f.

Rerrich, M. S. (1993) 'Auf dem Weg zu einer neuen internationalen Arbeitsteilung der Frauen in Europa? Beharrungs- und Veränderungstendenzen in der Verteilung der Reproduktionsarbeit' [On the way to a new international division of labour for women in Europe? Tendencies for persistence and change in the distribution of reproductive work], in B. Schäfers (ed.), *Lebensverhältnisse und soziale Konflikte im neuen Europa*, Frankfurt/New York: Campus, pp. 93–102.

— (2002a) 'Von der Utopie der partnerschaftlichen Gleichverteilung zur Realität der Globalisierung von Hausarbeit' [From the utopia of equal distribution between partners to the reality of the globalization of housework], in C. Gather et al. (eds), *Weltmarkt Privathaushalt. Bezahlte Hausarbeit im globalen Wandel*, Münster: Westfälisches Dampfboot, pp. 16–29.

— (2002b) 'Bodenpersonal im Globalisierungsgeschehen. "Illegale" Migrantinnen als Beschäftigte in deutschen Haushalten' [The ground crew in the globalization process. 'Illegal' migrants as employees in German households], *Mittelweg 36*, 11(5): 4–23.

Respect-Initiative Berlin (2000) www.respect-netz.de.

Riemann, G. and F. Schütze (1991) '"Trajectory" as a basic theoretical concept of analyzing suffering and disorderly processes', in D. R. Maines (ed.), *Social*

Organization and Social Process. Essays in Honor of Anselm Strauss, New York: Aldine de Gruyter, pp. 333–57.

Rosenthal, G. (1995) *Erlebte und erzählte Lebensgeschichte: Gestalt und Struktur biographischer Selbstbeschreibungen* [Experienced and narrated life history: form and structure of biographical self-descriptions], Frankfurt: Campus-Verlag.

— (ed.) (1998) *The Holocaust in Three Generations: Families of Victims and Perpetrators of the Nazi Regime*, Bath: Bookcraft.

— (2004) 'Biographical research', in C. Seale, G. Gobo, J. F. Gubrium and D. Silverman (eds), *Qualitative Research Practice*, London: Sage, pp. 48–64.

— (2005) *Interpretative Sozialforschung: Eine Einführung* [Interpretative social research: an introduction], Weinheim: Juventa-Verlag.

Sabel, C. F. (1993) 'Studied trust: building new forms of cooperation in a volatile economy', *Human Relations*, 46: 1133–70.

Sachverständigenrat für Zuwanderung und Integration (ed.) (2004) *Migration und Integration – Erfahrungen nutzen, Neues wagen. Jahresgutachten* [Migration and integration – utilizing experience, daring to innovate. Annual report of the German government's Council of Experts on Immigration and Integration], Nuremberg: Bundesamt für Migration und Flüchtlinge.

Sainsbury, D. (1999) 'Gender, policy regimes, and gender politics', in D. Sainsbury (ed.), *Gender and Welfare State Regimes*, Oxford: Oxford University Press, pp. 245–75.

Sarti, R. (2008) 'The globalisation of domestic service – an historical perspective', in H. Lutz (ed.), *Migration and Domestic Work: A European Perspective on a Global Theme*, Aldershot: Ashgate, pp. 77–98.

Sassen, S. (1991) *The Global City – New York, London, Tokyo*, Princeton, NJ: Princeton University Press (repr. 2001).

— (1998) 'Toward a feminist analytics of the global economy', in S. Sassen (ed.), *Globalization and Its Discontents: Essays on the New Mobility of People and Money*, New York: New Press.

— (1999) *Guests and Aliens*, New York: New Press.

— (2006) *Territory, Authority, Rights – From Medieval to Global Assemblages*, Princeton, NJ: Princeton University Press.

Schmidt, U. (2002) *Deutsche Familiensoziologie. Entwicklung nach dem zweiten Weltkrieg* [German family sociology. Development after the Second World War], Wiesbaden: Westdeutscher Verlag.

Schneider, F. and D. Enste (2000) *Schattenwirtschaft und Schwarzarbeit: Umfang, Ursachen. Wirkungen und wirtschaftspolitische Empfehlungen* [Shadow economy and illicit work: scale, causes, effects and economic policy recommendations], Munich: Oldenbourg Verlag.

Schupp, J. (2002) 'Quantitative Verbreitung von Erwerbstätigkeit in privaten Haushalten Deutschlands' [Quantitative prevalence of employment in private households in Germany], in C. Gather et al. (eds), *Weltmarkt Privathaushalt. Bezahlte Hausarbeit im globalen Wandel*, Münster: Westfälisches Dampfboot, pp. 50–70.

Schütze, F. (1981) 'Prozeßstrukturen des Lebenslaufs' [Process structures of the life history], in J. Matthes, A. Pfeiffenberger and M. Stosberg (eds), *Biographie in handlungswissenschaftlicher Perspektive*, Nuremberg: Nürnberger Forschungseinrichtung, pp. 67–156.

— (1984) 'Kognitive Figuren des autobiographischen Stegreiferzählens' [Cognitive figures in impromptu autobiographical narration], in M. Kohli et al. (eds), *Biographie und soziale Wirklichkeit*, Stuttgart: Klett, pp. 78–117.

— (1996) 'Verlaufskurven des Erleidens als Forschungsgegenstand' [Trajectories of suffering as a research subject], in H.-H. Krüger and W. Marotzki (eds), *Erziehungswissenschaftliche Migrationsforschung*, Opladen: Leske + Budrich, pp. 116–57.

Schwalgin, S. (2004a) 'Why locality matters: diaspora consciousness and sedentariness in the American diaspora in Greece', in W. Kokot (ed.), *Diaspora, Identity and Religion: New Directions in Theory and Research*, London: Routledge, pp. 72–92.

— (2004b) *'Wir werden niemals vergessen!' – Trauma, Erinnerung und Identität in der armenischen Diaspora Griechenlands* ['We will never forget!' – trauma, memory and identity in Greece's Armenian diaspora], Bielefeld: Transcript-Verlag.

Scrinzi, F. (2008) 'Migrations and the restructuring of the welfare state in Italy. Change and continuity in the domestic work sector', in H. Lutz (ed.), *Migration and Domestic Work: A European Perspective on a Global Theme*, Aldershot: Ashgate, pp. 48–71.

Shinozaki, K. (2003) 'Geschlechterverhältnisse in der transnationalen Elternschaft. Das Beispiel philippinischer HausarbeiterInnen in Deutschland' [Gender relations in transnational parenthood. The example of Filipina domestic workers in Germany], *Beiträge zur feministischen Theorie und Praxis*, 3: 67–85.

— (2005) 'Making sense of contradictions. Examining negotiation strategies of contradictory class mobility in Filipina/Filipino domestic workers in Germany', in T. Geisen (ed.), *Arbeitsmigration. WanderarbeiterInnen auf dem Weltmarkt für Arbeitskraft*, Frankfurt: IKO Verlag, pp. 259–78.

Simmel, G. (1972) *On Individuality and Social Forms*, Chicago, IL: University of Chicago Press.

— (1992) 'Soziologie. Untersuchungen über die Formen der Vergesellschaftung', in G. Simmel, *Gesamtausgabe* [Complete works], vol. 2, ed. O. Rammstedt, Frankfurt: Suhrkamp (1st edn 1908).

Slany, K. (2008) 'Female migration from central-eastern Europe: demographic and sociological aspects', in S. Metz-Göckel, M. Morokvašic and A. S. Münst, *Migration and Mobility in an Enlarged Europe. A Gender Perspective*, Opladen and Farmington Hills: Barbara Budrich, pp. 27–51.

Smith, M. P. and L. E. Guarnizo (eds) (1998) *Transnationalism from Below*, New Brunswick, NJ: Transaction Publishers.

Sørensen, N. N. (2005) *Migrant Remittances, Development and Gender*, DIIS Brief, Copenhagen: Dansk Institut for Internationale Studier.

Stacey, J. (1998 [1990]) *Brave New Families: Stories of domestic upheaval in twentieth century America*, Berkeley and Los Angeles: University of California Press.

Statistisches Bundesamt (2003) *Wo bleibt die Zeit? Die Zeitverwendung der Bevölkerung in Deutschland 2001/2* [Where does the time go? The German population's use of time 2001/2], Wiesbaden: German Federal Statistical Office.

Stobbe, H. (2004) *Undokumentierte Migration in Deutschland und den Vereinigten Staaten. Interne Migrationskontrolle und die Handlungsspielräume der Sans Papiers* [Undocumented migration in Germany and the United States. Internal migration control and the options open to 'sans papiers'], Göttingen: Universitätsverlag Göttingen.

Stone, E. (1989) *Black Sheep and Kissing Cousins. How Our Family Stories Shape Us*, New York: Penguin.

Strohmeier, K. P. and A. Schultz (2005) *Familienforschung für die Familienpolitik. Wandel der Familie und sozialer Wandel als politische Herausforderung* [Family research for family policy. Changing families and social change as a political challenge] Study commissioned by the Ministry for Health, Social Affairs, Women and Families of the State of North-Rhine/Westphalia, Bochum.

taz (*Tageszeitung* newspaper) (2004) 'Sie gehörte doch fast zur Familie. Wenn man dahinter kommt, dass die Putzfrau schummelt, ist das ein schmerzlicher Erkenntnisprozess für alle' [She was almost part of the family. Discovering your cleaner has been hoodwinking everyone is a painful reality check], Barbara Dribbusch, 13 May.

— (2006) 'Eine Kanzlerin ist besser als die Frauenquote' [A female Chancellor is better than the women's quota], Interview by Heide Oestreich and Bascha Mika with the German Minister for Family Affairs, Ursula von der Leyen, 18 February, pp. 3–4, www.taz.de /pt/2006/02/18/a0157.1/text, accessed 1 September 2006.

Thiessen, B. (1997) 'Individualisierung und Reproduktion – Analyse prekärer Arbeitsverhältnisse im Privathaushalt' [Individualization and reproduction – analysis of precarious employment relationships in the private household], *Werkstattreihe des IBL*, 5, Universität Bremen, Bremen: IBL.

— (2004) *Re-Formulierung des Privaten: Professionalisierung personenbezogener haushaltsbezogener Dienstleitungsarbeit* [Reformulation of the private: professionalization of person-related domestic service work], Wiesbaden: Verlag für Sozialwissenschaften.

Thomas, C. (1993) 'De-constructing concepts of care', *Sociology*, 27: 649–69.

Thomas, W. I. and F. Znaniecki (1920) *The Polish Peasant in Europe and America; Monograph of an Immigrant Group*, Boston, MA: Gorham Press.

Tronto, J. (2008) 'Feminist ethics, care and citizenship', in H. G. Homfeldt, W. Schröer and C. Schweppe (eds), *Soziale Arbeit und Transnationalität*, Weinheim: Juventa, pp. 185–202.

Trotha, T. von (1994) *Koloniale Herr-*

schaft. *Zur soziologischen Theorie der Staatsentstehung am Beispiel des 'Schutzgebietes Togo'* [Colonial rule. On the sociological theory of state of state formation, using the example of the 'Togo Protectorate'], Tübingen: Mohr.

United Nations General Assembly (2004) *Report on the Human Rights of Migrants, submitted by the Special Rapporteur of the Commission on Human Rights*, Geneva: UN.

Vertovec, S. (2004) 'Cheap calls: the social glue of migrant transnationalism', *Global Networks: A Journal of Transnational Affairs*, 4(2): 219–24.

Völter, B. (2003) *Judentum und Kommunismus: Deutsche Familiengeschichten in drei Generationen* [Judaism and communism: German family histories in three generations], Opladen: Leske + Budrich.

Walgenbach, K. (2005) *'Die weiße Frau als Trägerin deutscher Kultur': Koloniale Diskurse über Geschlecht, Rasse und Klasse im Kaiserreich* ['The white woman as the bearer of German culture': colonial discourses on gender, race and class in the German empire], Frankfurt/New York: Campus.

Walser, K. (1985) *Dienstmädchen, Frauenarbeit und Weiblichkeitsbilder um 1900* [Maids, women's work and conceptions of femininity around 1900], Frankfurt: Extrabuch.

Weinkopf, C. (2002) '"Es geht auch anders" – reguläre Beschäftigung durch Dienstleistungspools' ['There are other ways' – regular employment through service-provider pools], in C. Gather et al. (eds), *Weltmarkt Privathaushalt. Bezahlte Hausarbeit im*

globalen Wandel, Münster: Westfälisches Dampfboot, pp. 154–66.

— (2005) 'The role of temporary agency work in the German employment model', 26th Conference, 'International Working Party on Labour Market Segmentation', Berlin.

Weisner, T. and R. Gallimore (1977) 'My brother's keeper: child and sibling caretaking', *Current Anthropology*, 18: 169–89.

Welz, G. (1998) 'Moving targets. Feldforschung unter Mobilitätsdruck', *Zeitschrift für Volkskunde*, 94(2): 177–94.

West, C. and S. Fenstermaker (1995) 'Doing difference', *Gender and Society*, 9(81): 8–37.

Wierling, D. (1987) *Mädchen für alles. Arbeitsalltag und Lebensgeschichte städtischer Dienstmädchen um die Jahrhundertwende* [Maid of all work. Working life and life history of urban maidservants around the turn of the century], Berlin: Dietz Verlag.

Williams, F. (2010) 'Migration and care: themes, concepts and challenges', *Social Policy and Society*, 9(3): 385–96.

Williams, F. and A. Gavanas (2008) 'The intersection of child care regimes and migration regimes: a three country study', in H. Lutz (ed.), *Migration and Domestic Work: A European Perspective on a Global Theme*, Aldershot: Ashgate, pp. 20–47.

Winkler, U. (2000) '"Hauswirtschaftliche Ostarbeiterinnen" – Zwangsarbeit in deutschen Haushalten' ['Housekeeping maids from the East' – forced labour in German households], in U. Winkler (ed.), *Stiften gehen. NS Zwangsarbeit und Entschädigungsdebatte*, Cologne: Papy Rossa Verlag, pp. 148–69.

Yeates, N. (2009) *Globalizing Care Economies and Migrant Workers. Explorations in Global Care Chains*, Basingstoke: Palgrave Macmillan.

Young, B. (1998) 'Globalisierung und Gender' [Globalization and gender], *PROKLA*, 111: 168–74.

Yuval-Davis, N. (1997) *Gender and Nation*, London: Sage.

Zentralstelle für Arbeitsvermittlung (2003) *Erfahrungsbericht zu der Vermittlung von Haushaltshilfen zur Beschäftigung in Haushalten mit Pflegebedürftigen nach § 4 Abs.9a Anwerbestoppausnah-megenehmigung (ASAV)* [Report of findings on recruitment of domestic helpers for employment as live-in carers pursuant to section 4 para. 9a of the German Ordinance on Exceptions to the Recruitment Ban], Bonn, 28 July (unpublished).

Websites

www.arbeitsmarkt-polen.de (accessed 18 August 2006)

www.arbeitsmarkt-ungarn.de (accessed 18 August 2006)

www.iom.int (accessed: 18 August 2006)

www.filmo.com/maids.htm (accessed 18 August 2006)

www.respect-netz.de (accessed 18 August 2006)

www.spiegel.de (accessed 18 August 2006)

www.tampep.com (accessed 18 August 2006)

www.zoll.de/do_zoll_im_einsatz/bo_finanzkontrolle/index.html (accessed 18 August 2006)

www.zoll.de/english_version/fo_aentg/ao_info_ag/eo_pruefungen/index.html (accessed 18 February 2011)

www.gcim.org (accessed 18 August 2006)

Index

About Zed Books

Zed Books is a critical and dynamic publisher, committed to increasing awareness of important international issues and to promoting diversity, alternative voices and progressive social change. We publish on politics, development, gender, the environment and economics for a global audience of students, academics, activists and general readers. Run as a co-operative, Zed Books aims to operate in an ethical and environmentally sustainable way.

Find out more at:

www.zedbooks.co.uk

For up-to-date news, articles, reviews and events information visit:

http://zed-books.blogspot.com

To subscribe to the monthly Zed Books e-newsletter, send an email headed 'subscribe' to:

marketing@zedbooks.net

We can also be found on **Facebook**, **ZNet**, **Twitter** and **Library Thing**.